This is a highly distinctive and historically revisionist account of the relationship between journalism and celebrity. Drawing upon her personal experience as a reporter in the UK as she engages in a thoroughly critical manner with the research literature and media commentary, Bethany Usher presents an account of the role of celebrity within the news industry that is nuanced, thoughtful and compelling. Most importantly, she retrieves the category of the political as the third element required in any contemporary understanding of the cultural function of celebrity journalism. A most welcome and original contribution to the field.

Professor Graeme Turner, author of Understanding Celebrity

Bethany Usher has produced a remarkable rewriting of how we understand the relationship between celebrity and journalism. With clarity of images, brilliant charts and deep research, she makes sense of the close relationship that the emergence of celebrity has had to both journalism and politics. Her insightful account maps this interweaving of ordinariness, visibility, political and moral value into the contemporary manifestations of new attack journalism and social media reconstructions of the public self. Her work builds to valuable claims about how journalism must understand its affinity with celebrity in our current world and negotiate a better role in this transformed era of "neo-populism", "panopticism" and "synopticism" that are part and parcel of our online culture constitutions of shared – sometimes "celebrified" – selves.

Professor P. David Marshall, author of Celebrity and Power.

We're not short of books on celebrity, but what distinguishes *Journalism and Celebrity* is its focus both on journalism's role in creating celebrity and the place of celebrity as a founding discourse of journalism. Refusing both populist and pessimistic approaches to the celebritisation of news, Bethany Usher takes a nuanced approach that stresses the need to understand the complex relations between celebrity, journalism and politics. This involves acknowledging and critiquing the worst tendencies of all three whilst at the same time exploring the elements of celebrity and its associated journalism that might contribute positively to the public sphere. The book combines an extremely well-informed historical sweep with a challenging and thought-provoking approach to its subject.

Professor Julian Petley, editor Journal of British Cinema and Television

JOURNALISM AND CELEBRITY

This insightful book traces the development of journalism and celebrity and their relationship to and influence on political and social spheres from the beginnings of capitalist democracy in the 18th century to the present day.

Journalism and Celebrity provides the first account of its kind, revealing the people, places, platforms, and production practices that created celebrity journalism culture, following its origins in the London-based press to its reinvention by the American mass media. Through a transdisciplinary approach to theory and method, this book argues that those who place celebrity in binary to what journalism should be often miss the importance of their mutual dependency in making our societies what they are.

Including historical and contemporary case studies from the UK and US, this book is excellent reading for journalism, communication, media studies and history students, as well as scholars in the fields of journalism, celebrity, cultural studies and political communication.

Dr Bethany Usher worked as a journalist for regional and then national tabloid newspapers before quitting industry and speaking out about some of the practices she encountered. She now leads postgraduate journalism provision at Newcastle University where her recent work has focused on the intercommunications between journalism, celebrity and politics and their societal and democratic impacts.

COMMUNICATION AND SOCIETY
Series Editor: James Curran

This series encompasses the broad field of media and cultural studies. Its main concerns are the media and the public sphere: on whether the media empower or fail to empower popular forces in society; media organisations and public policy; the political and social consequences of media campaigns; and the role of media entertainment, ranging from potboilers and the human-interest story to rock music and TV sport.

For a complete list of titles in this series, please see: https://www.routledge.com/series/SE0130

JOURNALISM AND CELEBRITY

Bethany Usher

Routledge
Taylor & Francis Group

LONDON AND NEW YORK

First published 2021
by Routledge
2 Park Square, Milton Park, Abingdon, Oxon OX14 4RN

and by Routledge
52 Vanderbilt Avenue, New York, NY 10017

Routledge is an imprint of the Taylor & Francis Group, an informa business

© 2021 Bethany Usher

British Library Cataloguing in Publication Data
A catalogue record for this book is available from the British Library

Library of Congress Cataloging-in-Publication Data
A catalog record has been requested for this book

ISBN: 9780367200862 (hbk)
ISBN: 9780367200886 (pbk)
ISBN: 9780429259531 (ebk)

Typeset in Bembo
by Taylor & Francis Books

I dedicate this book to all the Catholic "boomer" women who fought their way into classrooms, from the generation of girls behind them who are grateful they did.

And in my case, particularly the women who taught me to think

My mother, Norma Usher (English and special needs, St Aidan's, Sunderland).

Di Lynn (History, St Anthony's, Sunderland).

Lavinia Charlton (English, St Anthony's, Sunderland).

Anne Lacey (Law, St Aidan's Sunderland.

CONTENTS

FIGURES

ACKNOWLEDGEMENTS

This book began as part of a journey of understanding and reconciling myself with my experiences in the journalism industry. During that process, some wonderful people helped me do so.

I would like to thank my PhD supervisor David Hesmondhalgh. I asked him to supervise because of wide reports of his kindness, which was what I needed most. I also would like to thank my deputy supervisor Adrian Quinn, Bethany Klein and the wider Leeds University Media and Communications research community.

I would like to thank those who at varying stages, offered critiques and insights. In particular, James Curran, who championed this work; P.David Marshall and the *Persona Studies* journal team for their unwavering support; Graeme Turner who was the external examiner of my PhD and whose feedback helped to reshape that into this; and the *Celebrity Studies* conference organisers, delegates and peer reviewers who allow space to think about journalism differently.

I would like to thank former colleagues at Teesside and current ones at Newcastle University, who listened and students, past and present, who provided critical and thoughtful discussions. I particularly want to acknowledge Rebecca Lawrence, my PhD student who I worked with from her first day as an undergraduate and who sadly passed away last year. I wish I had told her how much our joyful debates meant to me.

Finally, thank you to my family. My mother Norma Usher made me cups of tea, sandwiches and looked after babies. My husband Neil Ogle kept everything on track at home and nodded his calmly while I discussed my worries. My two children Elodie and Tobias grew from embryos to primary age while Mammy was writing and always knew when to intervene to stop me doing so and demand I play instead. Love you.

1

INTRODUCTION

Celebrity journalism is more visible than ever. Its capacity to attract clicks, shares, comments and likes makes it a substantial part of digital news agendas. Politicians and journalists use it to shore up their own influence and diminish that of others. It networks, snaking across social media timelines and websites, television and the pages of newspapers and magazines and mixing presentation of self with representation of others. It can take on a life of its own, framed and reframed again; debated, dissected and disseminated. Celebrification can be brutal and aggressive, tearing at the image of an individual, simultaneously raising their public visibility and casting them as beyond the pale. However, individuals can also find professional and personal liberation and empowerment when it celebrates their achievements, talents or opinions, and audiences can take comfort and hope from their displays. Relationships between journalism and celebrity are politicised, contradictory, ambivalent and everywhere.

Few industries have a "pack mentality" like journalism. If a story is important to one news outlet, it piques the interest of others and is often republished without further verification. Early research into news culture identified how it works to frame our understanding of others and ourselves, our leaders and our institutions (Schudson, 1978, 2000; Tuchman, 1978). More recently, there is focus on how celebrity journalism shapes the boundaries for "standardised lifestyles" (Dubied and Hanitzsch, 2014: 140) and constructs potentials and barriers to how we should – and can – live. It can ostracise those who threaten political, social and economic orders or the cultural hegemony of journalism itself. Dynamics of journalism and celebrity work together to create noisy discourses of "us" and "other" and maintain versions of identity which perpetuate "the symbols, values and beliefs which govern society" (Skils, 1975: 3; Sonwalker, 2005: 269). Individualised attacks – an adversarial discourse of celebrification – can fuel political polarisation and limit engagement in public spheres (Patterson, 1994, 2000; Fallows, 1997; Barnett,

2002). Conversely, journalists use dynamics of celebrity culture to challenge the hegemony of governments and corporations and to expose corruption and social control as reflective of normative expectations of their role.

Through a critical, transdisciplinary approach that focuses on structure and agency and uses journalism, celebrity, political and cultural theory and biography, this book offers a chronological interrogation of the relationships between journalism and celebrity. This is the first account of its kind, which looks to historicise journalism and celebrity manifestations in relation to the people who made these cultures, critical debates from and about their time and both in relation to and beyond lenses of cultural decline in news and the imperatives of markets. I argue that we can only fully understand the true nature of journalism and celebrity cultures – and contemplate whether they can be better – through mindful integration of both together and through intertwined examination of the social, cultural and political aspects of capitalist democracies.

The narrative here is of a transatlantic cultural sphere, developed initially, at least for the English-speaking world, in Britain but extended and reshaped by the mass industrialisation of the American press and with increased integration between our cultures and political worlds. Such analysis is scarce because the genre of celebrity news "falls between a number of disciplines, none of which have devoted sufficient attention" (Dubied and Hanitzsch, 2014: 140). Those that have are sometimes too quick to judge or to celebrate. Binary "populist" and "pessimist" approaches (Curran, 2002) miss many complexities of social functions. For example, too many scholars start from a position that places tabloid and celebrity cultures in opposition to what journalism *should* be. Some blindly follow this path, without meaningful interrogation of how and why cultures of politics and the political, the social and the personal might *depend* on populist discourses of celebrity. This is not my starting point.

This book found roots during my twenties when I worked as a red-top reporter and in the reasons I quit and spoke out. Vitriolic cultures of celebrification governed my practice, initially without me realising it, and I have since discussed my disillusionment, working for those who seemed to view "human suffering as fodder for news pages" and were more interested in X Factor than exposés (Usher, *The Guardian,* 1 December 2011).[1] However, because of – or perhaps despite – my experiences, I do not view celebritisation of news as *of itself* damaging to our public discourse. There was value for both an industry suffering from economic pressures – which on a human level means more journalists in work – and clearly for vast audiences who buy or click on content. There were also instances where journalistic rituals of celebrification offered opportunities to give voice to people who needed help and were ignored.

Advocation for a more nuanced approach does not seek to negate the cruelty of personalised attacks, the damages of pack mentality or the criminality of some journalists seeking celebrity stories. James Curran's (2018: 180) discussions of how individuals are "lied about, vilified and their wellbeing utterly disregarded" are an accurate representation of some of the dynamics I encountered in tabloid

newsrooms. Rampant rituals of celebrification fuel gung-ho attitudes of the press, contributed to phone-hacking, encourage "fake news" and now drive a toxic degeneration of political debate. However, by acknowledging the place of celebrity as a founding discourse of news, we can better understand how the two were *inseparable* from origin and are crucial to one another. If we want to unpack, for example, the influences of celebrity on politics and society, it is important to understand how it has, and can, work differently and what potential values it *might* have to the public interest and public spheres. The worst examples should not blind us to the whole.

Against the maelstrom of opinion and scholarship about what journalism and celebrity cultures are, were, and might be, this book considers how journalism and celebrity cultures work together as part of complex webs of socio-political and media systems. What do their histories reveal about celebrity's place in politics, society and identity? Why does this matter? Can celebrity journalism be better? When do journalism's rituals of celebrification become harassment and how might we tackle this? I start from the simple premise that we must better understand the nature of relations between journalism, celebrity and political cultures if we are going to counter their worst tendencies. The rest of this introduction sets out this foundational premise within a critical and contextual framework of "politics and the political"; "society and identity". But first, let's try to define the curious and often contradictory beast of *celebrity journalism*.

What is celebrity journalism?

On the eve of an international celebrity studies conference held in London in 2014, *Channel 4 News's* Cathy Newman penned a scathing attack on the idea that celebrity culture could have political value. "Katy Perry can't teach our children anything about politics", she declared, outlining how she found organiser James Bennett's arguments that celebrities can make information more accessible "bizarre, if not frankly depressing". For Newman, celebrity journalism should be limited, and while she acknowledged that the odd celebrity can "add impetus to a story" (she singled Angelina Jolie out for special mention), there are a host of others, she argued, whom journalists should ignore. A little of celebrity, Newman argued, "goes a long way" (*The Telegraph*, 18 June 2014: online).

Newman's concerns about the pernicious influence of celebrity are familiar and reflect broader journalistic degradation of any attempt to understand the impacts of popular culture. From *MailOnline* lamenting the number of students taking "Mickey Mouse" media studies courses (Clarke, 12 September 2007) and gaining degrees "with much less effort" (Harris, 17 May 2012), to criticism of "ridiculous" university programmes such as "Beyoncé Studies" (Sanghani, *The Telegraph*, 30 January 2014: online), there is decided unease about studies of celebrity by the press. But celebrity culture influences news far beyond the showbiz desk. Political correspondents on the election trail, crime hacks reporting murders or heists, foreign correspondents discussing the actions of dictators and terrorists, and financial

writers analysing the latest economic downturn, all use the dynamics of celebrity journalism to personify stories. Inquisitive journalists surely should recognise this as an important area of research and perhaps some emotive attacks might even be deliberate attempts to blind the public to the reasons behind their incessant focus on celebrity.

There are also those within the academy who consider the term "celebrity news" an oxymoron. This was central to a special edition of *Journalism: Theory, Practice and Criticism* (2014) which included position pieces from leading cultural theorists P. David Marshall and Graeme Turner (2014b) and journalism studies scholars such as Thomas Hanitzsch and Martin Conboy. There were some risky starting positions that reflect gaps in research and how "populist" and "pessimist" binary readings can drive debate about this topic. The first was that celebrity news and "traditional" journalism are distinct and emerged at different times. Chapters 2 and 3 evidence that celebrity culture has *always* been part of printed news as mass media and certainly not distinct from "proper" journalism, but helped shape its conventions, constructs, agendas and rituals. This links to another assumption – that journalism builds from objective and impartial facts in "the public interest", whereas celebrity news only focuses on emotion and private interests, primarily through gossip. Tuchman (1978), Schudson (2000) and Allan (1999 [2010], 2005) among many others identified the centrality of the notion of objectivity and impartiality to the formation of the journalistic profession and its role in deliberative democracies. This too easily assumes "that the coverage of celebrity does not match a higher set of ideals" (Conboy, 2014: 171) and ignores that, as explored in this book, notions of press objectivity and impartiality developed *later* than celebrity news.

Over the last 320 years, journalism and celebrity have done many of the things that they are accused of, celebrated for, and more. Journalism as the first mass-circulated media made celebrity "a very public form of discourse about the dimensions of what is public and what is private, and ultimately what is intimate" (Marshall, 2014b: xii). Celebrity did not "restyle" news or democratic systems of governance in the 20th century (Corner and Pels, 2003; Washbourne, 2010), but shaped capitalist democracies from their origin, including their best and worst tendencies (Rojek, 2001). Press coverage of the famous helped grow democratic freedoms (Ponce de Leon, 2002; Connell, 1992; Conboy, 2002, 2004) *and* primarily satisfied the financial motivations of an industry desperate for readers (Cashmore, 2006) and advertisers (Curran and Seaton, 2018; Hickey, 1998; Williamson, 2016). It shaped the ideal that journalism should "hold to account and to facilitate and maintain deliberation" (Fenton, 2010: 3), but has recently worked primarily to undo it, not least through its current propensity to mindless tittle-tattle as a result of the incessant demand of owners for more for less (Fenton, 2012). It appears to speak the language of the disenfranchised (Van Zoonen, 2003), but this is often the language of politically and commercially motivated tabloids, which (possibly) "replaced radical popular with celebrity gossip" (Williamson, 2016) or, perhaps, as we explore in chapters 3, 4 and 5, *removed* the radical *from* celebrity

news. It shaped different ideas for self-identity and made these more visible in public spheres (Connell, 1992; Hartley, 1996), but has also perpetuated inequalities of social structures through offering narrow versions of self against the priorities of capital (Littler, 2004; Couldry, 2000, 2002), not least because of its incessant focus on self-fulfilment through consumerism (Marshall, 1997, 2010; deCordova, 1990). It should not be "dismissed as external to the world of public issues" (Couldry and Markham, 2007: 404), but acknowledged as one of the principal means by which they were "moulded" (Hepp, 2013: 2). Its developments across history have reflected and responded to the technological advancements of the "culture industries", and developments offer paths to help understand the, "relationship of technologies to economic, political and cultural forces" (Hesmondhalgh, 2013: 94). Its pervasive displays of consumerism make repressive social ambiences (Usher, 2018) and its constructs have reshaped professional identities of journalists to make their work one of opinion spectacle, rather than information exchange (Usher, 2020). Celebrity journalism is a fuzzy, noisy, contested mess of contradictions, a force for both good and bad and neither of these things in and of itself. As such, binary positions make little sense.

Celebrity has long-established and significant functions in how news constructs realities (Tuchman, 1978) and therefore deserves equal examination to other areas. The transformation of individuals into "human pseudo-events" (Boorstin, 1961) has always had multiple purposes, with journalists using celebrities to rationalise capitalist and democratic society and the agendas of their publications. Sparks (1992: 37–38) argues that the linguistic patterns of tabloid papers – grounded in the everyday and personal – instinctively place stories which fit a publication's own values (whether political or economic) at the top of the agenda. This sustains audiences and attracts advertisers, using the commodification of celebrities in a similar way as other areas of the cultural industries, for example, use the star system (Hesmondhalgh, 2005; 2013). As readers share, discuss, interpret and examine celebrities, they rationalise the hegemonic power of capital (Gramsci, 1988 [1935]; Williamson, 2016), and apply this lens to their own lives in ways that intensify the social inequalities in which they live (Rojek, 2001; Littler, 2004). From origin, celebrity news – like other aspects of journalism – focused on the construction of everyday experience to perpetuate social order and the systems of capital which make up modern society (Curran, 1978).

This book identifies how coverage of the lives of public figures helped to form the gathering, production and dissemination of news more broadly. Celebrification is a process and journalism a powerful tool for constructing reality through value(s) of visibility. This may be a self-advantaging exchange with a celebrity and journalists mutually engaged in fame building because it suits the financial, social or political agendas of them or their employers. However, it might not always be consensual activity. Celebrification, therefore, comprises "changes at the individual level [and] the process by which ordinary people or public figures are transformed into celebrities" (Driessens, 2013: 643). Celebritisation, by contrast, is both the reason for – and an extension of – the individual processes, and it happens to

discourses, news agendas, industries or societies at *institutional levels* and often for commercial or political gain. Dreissens' clarification fits institutionalist approaches to reading media, which view industrial contexts as (more or less) independent social institutions with their own "sets of rules", to which different social systems, such as politics or commerce, adapt. However, he suggests pre-existing institutions were *then transformed* by celebrity and my argument here is it developed with journalism from origins. Similarly, when Joshua Gamson (1994) discussed *processes of celebrification* to describe how politics was adapting to methods of Hollywood, he began from the premise that there was a time when celebrity and politics were separate things. This book demonstrates that the representation of politics and political leaders was a part of celebrity news and journalism as they developed.

In broadest strokes, I extend social-constructivist traditions which consider journalism, celebrity and politics as conjoined discourses that work towards "communicative construction of social and cultural realit[ies]" (Couldry and Hepp, 2013: 196). I emphasise the complexities of media as institutions, technologies and corporate markets in the process of making journalism and celebrity in relation to one another. Journalism developed many rituals of celebrification and the priorities of the press and its owners are the institutional reasons for doing so. To clarify Gamson's (1994: 186) discussion of the *celebrification process* as a principal "*means* to power, privilege and mobility" (italics added), this should also focus on the people who made changes and the differences between celebrification and celebritised institutional practices as a result, for example, of market forces. Here, I examine how these things ritualised to form the wide-scale and familiar discourses of journalism and celebrity.

Given the current propensity of journalism and celebrity to drive hyperconsumerism and neopopulism (explored further in chapter 6) it is, of tempting to embrace "pessimistic" condemnations of celebrity culture as part of a tabloidisation of news that is inherently damaging to journalism's democratic functions. One of the most damning critiques, Bob Franklin's 1997 *Newzack & News Media*, bewailed a rapid decline in the quality of newspaper and television media as a reflection of an industry more interested in profit than its ideological functions. Franklin argued that journalism was placing the "trivial" before the "weighty" by featuring stories that interested the public above "stories that are within the public interest" (p. 4). He identified increases in celebrity and human-interest journalism from the 1970s onwards and declared this as damaging to both journalism and society. Jostein Gripsrud (2008 [2000]: 34) considers how the term "tabloid" is a buzzword that "connotes decay" and advocates for a third way that might "capture "the complexities of actual journalism practice" rather than looking too the "very enthusiastic" or "very critical". For example, many "pessimists" accept Habermasian logics of rationality and balance as key to its functions in effective democracy, without meaningful interrogation of whether these functioned in practice. Habermas (1989 [1962]) early discussions of the public sphere are often canonised despite later clarifications in works such as the *Theory of Communicative Action* (1984 [1981]), which argued the need for closer examination of pragmatics and counter-

examples rather than transcendental ontological assumptions. As Charles Ponce de Leon (2002: 17) highlighted in his examination of early 20th-century celebrity journalism in the USA, the bourgeois public sphere was "equally open to polemics, propaganda and self-promotion, much of it to arouse emotional response, be it sympathy, contempt, or outrage" and was accessed equally by "muckrakers" as it was "philosophers". Conboy (2014: 175) adds that, "comparisons of tabloid media with idealized versions of what the news ought to be doing, ignore the historical evidence that tabloid news – and its predecessors in popular print culture – have always sought to contest dominant bourgeois values".

Celebrity journalism in the 18th century as it first appeared *was part* of bourgeois culture (as explored in chapter 2) and helped to establish the nuances in the realms of what is described in the next section as *the political* aspects of our lived experiences. In his important overview of contemporary tabloid cultures for *Understanding Celebrity*, Graeme Turner (2014a: 86) outlines how many critiques are "grounded in a conventional and longstanding hostility to popular culture itself". His discussion of the "demotic turn" (pp. 91–94) highlights that while there is no *automatic* link between widening visibility of ordinary people through celebrification and democratic action (that is in the realm of "politics"), increased visibility can have *political* impacts. Örnebring and Jönsson (2008: 24) look to counter publics and resistance to argue that "emotionalism, sensation and simplification are not *necessarily* opposed to serving the public good" (original italics). They, like Turner, Gripsrud, Conboy, Dalghren and Sparks, are open to both "populist" and "pessimist" approaches in order to explain media's socio-political roles and lived experiences in capitalist democracies, and so am I.

In *Celebrity: Capitalism and the Making of Fame*, Milly Williamson (2016) advises that we must look "beyond the idea that celebrity news helps us navigate a cornucopia of choice for the self … to examine how celebrity content comes to be placed in front of us in the first place" (p. 90). Williamson focuses on the political economy of celebrity news as a reflection of an industry "some distance from the idea of … a public good" because the principal focus is always money (p. 96). She takes on the institutions of news and criticises their business decisions as "not inevitable, but a product of economic conditions" such as diversified ownership and profit culture (p. 97). "What we have witnessed," she succinctly puts, "is the deployment of celebrity gossip to ensure the financial health of the news industry, but at the cost of news itself." Williamson and I agree that there are times when the use of celebrity in mainstream journalism has been a "public good". We appear to differ on whether that has happened when market also governed editorial decision-making and celebrity representation. Certainly, I think that the bottom line is not always the bottom line and particularly not at the coal-face of news production. But, we share a central principle that in order to understand the nature of celebrity news – and more broadly the multifaceted links between journalism and celebrity – we must challenge those "analyses that accept (and apologise for) the news media as we find it" and look to those who seek to understand in order to "improve its democratic functions". I hope to achieve the latter, but to get there

I argue we must be open to different forms and functions of news and focus on people and their practices as much as the institutional contexts that governed them. This book aims to plug gaps in research about the human decisions that shaped political functions of celebrity by the press and the motivations of the individual journalists and celebrities who made them; and to consider these things against the conditions of politics, society and identity of their time.

Politics and the political

Celebrity journalism influences both "politics" and "the political", which are related, but different, realms. While much debated, here I use "politics" in relation *to the system* – parties, elections, campaigning and government – and "the political" in relation *to everyday life* – our shared and individual experiences as part of a politically organised society. Natalie Fenton (2016: 7) describes the "injustice" of living in such societies as the "passion that drives politics", which she refers to as the "*'politics of being*' ... [an] often visceral response to the symptoms of problems of the prevailing social system" [original emphasis]. This she casts as an alternative perspective to Gramsci's (1991: 147) discussion of life as apolitical until you act (fight back, resist), something Fenton describes as "extraordinary politics". Here, I explore examples of such direct political action during "counter attacks" by publics in defence of public figures and when journalists and celebrities campaign for social or political changes *against* dominant social forces. To return to Turner's discussions of the "demotic turn" (2014a), I often look to the moments that aimed to stop slippage between the political aspects of life (such as the demotic turn) and politics itself.

My understanding of "the political" sits between these positions. By offering versions of "being" through the displays of celebrity culture, journalism is of course acting politically. On one hand it sustains systems of hegemony, circulating individuals and representing events that work to prop up capital, patriarchy, white privilege and so on. It perpetuates apathy in order to maintain socio-political orders through set versions of what we *should want* to be. Journalism's rituals of celebrification, at their most febrile, become a culture of attack, which target those who step beyond such boundaries. On the other hand, journalists challenge power and see their idealised function as the watchdog of the people. They combat those who exert their privilege or dominate others, using illustrations of hypocrisy or wrongdoing. From this dichotomy, I argue, the many ways journalism shaped celebrity culture (and vice versa) have grown.

Celebrity journalism's influence on politics and political communication is widely discussed, particularly in relation to networked and digital media spheres, where leaders and journalists act as epicentres for opinion spectacle, discussions and debate (Usher, 2016, 2020). West and Orman's (2003: 29) considerations of how "proliferation of media outlets" means an emphasis on images and "tabloid style gossip" demonstrates how political leaders rely upon celebritised news to "sell" their message and attract voters. Gamson (1994), Marshall (1997), Corner and Pels

(2003), Street (2003) and Turner (2014a) argued variously that the political leader should be viewed in relation to the logics of celebrity culture – a commodity presented and negotiated through the systems of public relations and marketing – and how this relies on attracting news coverage. The central debate is often whether this helps revitalise political spheres (Street, 2003; West and Orman, 2003) or whether it is damaging to democracy and its functions (McChesney, 1999; Corner and Pels, 2003). The early chapters of this book clarify that as the discourses of celebrity journalism developed, they achieved both these things and sometimes even at once.

For some journalists when they look for *newsgenic* subjects, the "appearance of honesty and humanity" is "more important than the proof of honesty and humanity" (Corner and Pels, 2003: 7). Politicians must "embody the sentiments of the party, the people and the state", in a similar way to how "a celebrity must somehow embody the sentiments of an audience" (Marshall, 1997: 203), and when these align with the politics of the newspaper there can be a sweet spot of mutually beneficial content. In *Constructing the Political Spectacle*, Edelman (1988: 1) highlighted how journalists "effectively protect and promote their own interests and the public interest" through celebrifying politicians and seeking political and personal scandals. Journalism and celebrity cultures work together to transform politicians into "symbols to other observers: they stand for ideologies, values or moral stances and they become role models, benchmarks, or symbols of threat and evil". Guy Debord's (1967) seminal *Society of the Spectacle* outlined how symbolic discourses work towards social and political separation and how celebrities are the "spectacular representations of a living human being" in all its many forms. Celebritised news can simultaneously extend and unpick political visibility. Image-based logics of media culture have transformed society, and while this may be read as a symptom of a contemporary political journalism – propelled by "sensationalism, infotainment and political scandal and contestation" (Kellner, 2010: 117) – these dynamics were visible in journalism from its earliest manifestations.

Authority in democratic spheres has always relied on individual ability to act as "legitimating symbols" for "anxieties and aspirations, insecurities and reassurances" (Edelman, 1988: 123). However, equally when news industries place commercial interests above the public interest, then "the necessary conditions for effective democratic governance" are compromised (McChesney, 1999: 8). As Corner and Pels (2003) argued, news coverage of politics now resembles that of reality television contests because the same rituals of celebrification are applied by journalists to both politicians and TV personalities. Voters' decision-making is mediated, mediatised and relies on social construction of accepted ambiences, perhaps even more so than attention-grabbing spectacles.

Society and identity

Antonio Gramsci (1988 [1935]: 200–204) considered the press as a dominant instrument in producing ideological legitimation and hegemonic constructs which

developed and sustain society and social order. My argument here is that inter-communications between journalism and celebrity cultures played a significant role in this process. When we consider important early works in the articulation of mass media, social development and modernity, such as those of Marshall McLuhan (1967), who tracked the impact of media on society, it is important to identify *pragmatic* examples of how these things worked and to tease out the nuances resulting from different *purposes*. Celebrity news and journalism spanned platforms, historical periods and purposes, but in broadest strokes it had always looked to mould society through shaping our self-identities and channelling us towards action.

Anthony Giddens (1991: 24) argues that McLuhan established "modernity", and experience within it, as "inseparable from its own media: the printed text and subsequently the electronic signal". As media "re-organise(s) time and space" (p. 24), it "does not mirror realities, but in some part form(s) them" (p. 27). Giddens' discussion of the significance of "the notion of lifestyle", particularly in relation to standardising influences such as commodification and consumerism, demonstrates the role of journalism in the construction and maintenance of *notions* of Western capitalist democratic societies and of individual self-identity within them. Celebrity news is shaped by its immediacy to an event. It tends to use the inverted pyramid structure and the trope of "Who, What, When, Why, Where and How" to make something remote real and prescient to audiences (see also Van Dijk, 1988: 50). The broader, extended discourses of celebrity journalism include comment, inter-views and features, and are more complex in their instructions to audiences about themselves, others and the time/society/space reorganisation that create such things. News brought about the "deep structural changes in social, cultural and political life" (Barnhurst and Nerone, 2009: 17), which turned distant occurrences and ideas into personal events and thoughts. Journalism, as explored further in chapters 2 and 3, developed other mechanisms by which "virtually all" human experiences were "mediated – through socialisation and in particular the acquisi-tion of language" (Giddens, 1991: 23). In newsrooms, job titles such as "reporter" and "correspondent" reflect the differences between news and the broader working practices of journalism.

The press situates individualised emancipation within the parameters of capital and democracy as a reflection of modern identity as formed around narratives of "consumer" and "citizen" (explored further in the next chapter). This can be achieved through representation of exemplars and equally through rejection and attacks on individuals, for how we *should* live. These shape what might be described as "cultural citizenship" (Stevenson, 2003) and as Bauman (2005) argued, public vis-ibility can become a *social function* that not only reveals but also makes human conditions. Examples of such dynamics shaped Richard Dyer's (1979; 1986) dis-cussions of how Hollywood stars came to represent "what it is to be human in contemporary [early–mid-20th-century] society" and "the particular notion we hold of ... the 'individual'" (1986: 7). In and beyond newspapers, they "articu-lated ... ideas of personhood ... shoring up the notion of the individual, but also at

times registering the doubts and anxieties attendant on it" (Dyer, 1979: 9). Similarly, P. David Marshall (1997: 14) argued that "the celebrity is specifically an engagement with an external world", based "predominantly on the text and its ability to engage the spectator in a form of identification", although he leans more towards how this ensures compliance to social norms, rather than helping to circulate doubts about them. Celebrity journalism, in brief, helps to regulate behaviour by "assigning pronounced significance to symbols, signs and metaphors in the conduct of social life" (Rojek, 2001: 38).

For Debord (1967), what made postmodernity a society of simulation is that it disregards the "real" in favour of false rituals of celebrification in print and images (see also Baudrillard, 1983, 1994). But spectacles need parameters for display and a society where individuals have mutual understanding of what is spectacular and what is not. For example, Colley (2009: 6) argues that the very notion of British society was forged by newspapers in "response to contact with" or "in conflict" with the "other" – that is, the "in-group" (offered for emulation) and the "out-group" (cast out from public spheres). Debord (1967), Boorstin (1961) and Baudrillard (1983) – for all their post-Marxist pessimism about the nature of celebrity and image-based logics of mass mediated societies – contain important messages around how journalism and celebrity work towards societal cohesion, control and separation. Their emphasis on consumption, passivity and the real and the unreal has much to teach us about why narratives of "them" and "us", bias and balance, privilege and disenfranchisement, and "truth" and "fake" dominate contemporary news. In all these things, celebrity news and journalism play a part. However, like celebrities themselves, this is often paradoxical because it depends on not only the spectacular but often also the intrinsically ordinary.

Everyday mediated ambiences equally help define the societies in which we live and our understanding of our places within them. Baudrillard's earliest considerations of simulative dimensions of life in relation to consumer culture, *Les Systems des Objects* (1968) and *La Societe de Consummation* (1970), argued that consumerism works as an "ambience" rather than "aggression" in a purist Marxist sense. He built from Marcuse's (1955, 1968) discussions of "repressive affluence and consumption" to consider how symbols and simulative exchanges shape our understanding of lived experience. This book highlights that rituals of celebrification rely not only on the construction of spectacles but also on ambiences that can become repressive or emancipatory, political or consumer-driven, and sometimes all these things. Journalism and celebrity are intertwined mediated reflections of democracy and capital and therefore perpetuate *their many* priorities.

Williamson (2016: 9) clarifies the main problem with those who view the cultural industries only through the lens of *passive* consumption and refers principally to Adorno (1963) and Adorno and Horkheimer's (1977 [1944]) accounts of the cultural industries, discussed further in chapter 4 in relation to 20th-century stardoms. The other side of the exchange – the populace – is "atomised and sutured into consumer capital". She argues that Adorno's unblinking belief in the "alienation and separation from the collective" only "presents one side" of the relations of

production (and representations) under capitalism, which are often contradictory. This book demonstrates that the powers of audiences and the activities of journalists are not just passive, but sometimes actively part of and often radically act against hegemonic forces, including those of capital. To turn to another postmodern critique of the media's role in social constructions, Michel Foucault's *Discipline and Punish* (1975), such arguments were extended into many facets of life and the institutions that govern it. Foucault's use of the "panopticon" jail as a metaphor to describe how social institutions such as schools and industry enforce beliefs that we are constantly under the watchful eye of authority, helps explain *how* celebritised news discourses work to *modify our behaviour*. John Steel (2012: 192) argues that "panopticism" drives us to internalise the role of suppressors, with the press acting as a powerful moral censor. Revelations of "misdeed and wrongdoing" of public figures keep us all in check, not least through directions by the press to internalise ("What do you think?" "Share your views!") and to publicly demolish those celebrities who step beyond the boundaries (Holmes, 2005).

How journalism created rituals of celebrification which are both positive and exclusionary, consecrate and desecrate, and make both extraordinary spectacles and ordinary ambiences, is key to understanding the place of this area of news culture in the complex web of social relations (Schudson, 1978, 2000) and the simulative dimensions of journalism and celebrity (Baudrillard, 1983). Over a 320-year time period, this book identifies the significant role celebrity journalism has played in shaping not just political and celebrity discourses but also the way we understand our place in Western capitalist and democratic societies. Journalism creates and sustains celebrities as publicly visible images with whom we identify or, alternatively, reject and vilify. If news "shapes the way we see the world, ourselves and each other" through the construction and maintenance of our "shared realities" (Wahl-Jorgensen and Hanitzsch, 2009: 3) and celebrity is an inter-textual performance that articulates what it is like to be an "individual" (Dyer, 1979; Marshall, 1997; Turner, 2014a), then the primary goal of celebrity journalism is to influence us. Journalism and celebrity cultures work together to shape who we are and the societies in which we live.

Chapters

This book demonstrates how journalism and celebrity work together to maintain and challenge political, cultural and economic hegemonies of government, corporations and media. It considers questions of inclusion and exclusion as *driving forces* for structure and agency of the press. Frameworks of both journalism studies (often focusing on structure) and cultural studies (focusing on agency) are used together to analyse the *people, politics, production and purposes* of journalism's use of celebrity. Each chapter considers key developments within their historical and theoretical context to situate why they occurred, how they worked towards construction of social and cultural realities and, by extension, how they shaped our sense of self and external presentation – what we might describe as our *personas*

(Barbour et al., 2014) – to negotiate and butt against the superstructures of capitalist democracies.

Unlike binary approaches of celebrity or political cultures, I consider them as mutually and interdependent facets of news and journalism from the start. While my work relies on transmethodological and theoretical frameworks – in the first two chapters particularly, which cover contested historical territory for the existence of journalism and celebrity – quantifying content *evidences* celebrity in the 18th- and 19th-century press. Such an approach is unusual in media and cultural studies, but is more commonplace in histories such as Lilti's (2017) *Invention of Celebrity* which looks to "meld traditional methodology with the techniques of statisticians" in order to challenge the dominance of privileged voices (Darcy and Rohrs, 1995: 1). Quantitative analysis balances what can become a narrow representative lens, "because it broadens perspective away from the dominant voice of masculine elites" (Hudson, 2000: 7).

As we dive into the clearer waters of 20th-century mass-industrialised media, numerical evidence becomes less important, although throughout this book a pattern of historicisation and contextualisation, evidence (largely gathered through content, data and critical discourse analyses), visualisation and analysis shapes arguments. By the final chapters, this offers opportunities to map networked communication and cultural ecosystems of the 21st century and the place of celebrity news and journalism in them through critical approaches that deliberately challenge academic silos.

The next chapter – 'Journalism and celebrity during the consumer revolution and bourgeois public sphere' – explores how the genre emerged as a component of early celebrity and political journalism, specifically as part of the press' endeavours to develop and create boundaries for what it meant to be a "consumer" and a "citizen". As capitalism and democracy began their tracks towards societal dominance, celebrity news in the 18th-century London press widely circulated those who best embodied these cultures and discussions of self-identity and the Romantic and Enlightenment movements underpinned such narratives. This established many existing relationships between journalism, celebrity and politics including the blurred lines between public, private and intimate and the thematic and linguistic patterns of *attack journalism* as one of the longest and most sustained mediatised cultures of socio-political control. Analysis of key figures, discourses and platforms highlights the development of tools of representation towards commercial and political agendas and, indeed, at times, both at once. These challenge idealised accounts of newspapers during the bourgeois public sphere, with celebrity news demonstrated as being constructed – and deconstructed – as an overlooked hallmark of it.

In the Victorian era, journalism and celebrity cultures reflected nations which valued innovation and invention, empire building, enterprise and endeavour, urbanisation and the capitalist values that underpinned these things. The press became the "context in which people lived and worked and from which they derived their view sense of the outside world" (Shattock and Wolff, 1982: xv) and

as described by leading "New Journalist" W.T. Stead (1849–1912), this was like a "transatlantic ocean liner" filled with a socially mobile, educated and politically liberal people. Conboy (2004: 172–175) identifies how New Journalism developed many of the newsgathering, structures and the commercial models of the press which dominate to this day. Chapter 3 – 'Celebrity and the New Journalism' – focuses on its place in developing many rituals of how journalism, celebrity and politics work together to maintain the superstructures of capitalism and democracy in a way that is still familiar. Newspapers and periodical magazines reflected the liberal morality and enterprise of editors and publishers, against the backdrop of mass industrialisation, urbanisation and increased literacy. I demonstrate how processes and impacts of celebrification developed, including the parasocial "bonds of intimacy" (Horton and Wohl, 1956) between journalists, celebrities and audiences and the rituals of celebrification whereby ordinary people were given visibility for democratic purposes. Such shifts played an important part in circulating images of liberalism, broader public spheres and active citizenship.

In the 20th century, multi-mediated stardom emerged as a hyperreal, glittering adjunct of celebrity. The established rituals of celebrification intertwined with moving images, which could raise certain individuals to the heavens but also bring them back down to earth with a bang. Early American Hollywood magazines reimagined New Journalism to "consecrate" stars as part of the creation of Hollywood in the early part of the 20th century. Discourse circulated modern identity – particularly self-exploration and psychoanalysis – and increased the power of "the political" influence of stars. Chapter 4 – 'Acts of consecration and desecration: Journalism and 20th century stardoms' – examines the place of the rituals of celebrity journalism in creating Hollywood, political and pop stardoms. It argues that celebritisation and celebrification were effective tools for both commercial and political propaganda and as support for audiences negotiating the traumas of the age. The power of journalism and stars to construct realities – even at times beyond common-sense realities of what could be "real" – is considered across different phases and in reference to the religious dimensions of star cultures (Rojek, 2001). The dramatic sea change of the moving image irrevocably shifted relationships between journalism, celebrity and politics and with significant consequences for our sense of self.

Television offered new dimensions for journalism, celebrity and political cultures. The popularity and endless numbers of television personalities – from chat show hosts as a new breed of journalistic interviewers, to soap opera actors, rolling television news and "fly-on-the-wall" reality – formed parallel narratives of celebrity to the star. As a result, *networked* – multiplatform and seemingly concurrent – *constructions of reality* reimagined economic and political ideologies. Chapter 5 – 'Television, tabloids and the neoliberal soap opera' – considers how gripping storylines remade tabloid journalism as it represented complex personalised displays of celebrity and politicians alike. This supported a more conversational tone in the press and mass-marketed self and suffering. Across tabloid newspapers and TV, dynamics of celebrity shifted away from the "extraordinary" star and towards

"ordinary" people made famous. As befitting the "kin and skin" nature of neo-liberal-model tabloidism, this narrative intertwined political spheres with the personal and demanded a new "human" face for politics, but this often masked the power dynamics between capitalism and democracy.

In the first twenty years of the 21st century, digital media transformed journalism, celebrity and political cultures. Intercommunications between "presentational" social and "representational" news media (Marshall, 2014a) transformed rituals of celebrification and celebritisation, which blurred together as part of a continuous construction of reality. This, in turn, reshaped audience reception of them, within and beyond temporal, instantaneous digital environments. The complex media and cultural ecosystems that emerged still forced celebrity journalism to focus on its principal purposes of perpetuating consumerism and negotiating politics in the UK and US, but two dominant ideologies – hyperconsumerism and neopopulism – became the first stories of the 21st century. Against this landscape, changing professional practices of celebrities and journalists reframed the cultural frameworks and responsibilities of both. Chapter 6 – 'The story of the 21st century: Networked hyperconsumerism, neopopulism and applications of journalism and celebrity' – explores how this transformed journalistic cultures too, both within newsgathering environments and in relation to increased individualisation of professional practice. This favours self-performativity over objectivity and discursive representations of subjective "truth" over objective "fact".

In the conclusion, I argue that binaries are nonsensical starting points if we want to understand how journalism, celebrity and political cultures work. We must move past these and the moralistic if we want to consider whether there are parts of celebrity journalism that might aid democracy, what elements we should tackle head on, and why. It is possible to diminish the power and social consequences of some of the most damaging forms of journalism as a multipronged charge across media, communication and research, the working practices of journalists, training in higher education, regulation and codes of practice. If we want to fight for ideals of liberal democracy such as inclusivity, economic and social stability and the value of private life (which I do, for all capitalist democracy's flaws), then we must tackle head on the current propensity of journalism and celebrity to perpetuate inequalities.

This book, therefore, is both a study of journalism, celebrity and political cultures and a call to arms. It argues that the nature of long-standing relationships is a missing link that maps the place of the press in mediatisation, socio-cultural and political reality making. As one schooled by dominant figures of late 20th- and early 21st-century tabloid journalism, I argue it is time to rethink how things currently operate and remind ourselves of how things once were.

Note

1 Discussed further in chapter 5.

References

Adorno, T. (1963) "Culture Industry Reconsidered". *New German Critique*, [1975 translation] 6: 12–19.

Adorno, T. and Horkheimer, M. (1977 [1944]) "The Culture Industry: Enlightenment and Mass Deception", in J. Curran et al. (eds) *Media and Society*. London: Edward Arnold.

Allan, S. (2010 [1999]) *News Culture*. 3rd edn. New York: Open University Press.

Allan, S. (2005) "Hidden in Plain Sight: Journalism's Critical Issues", in S. Allan (ed.) *Journalism: Critical Issues*. Maidenhead, UK: Open University Press, pp. 1–16.

Barbour, K., Marshall, P.D. and Moore, C. (2014) "Persona to Persona Studies". *M/C Journal*, 17(3). Online.

Barnett, S. (2002) "Will a Crisis in Journalism Provide a Crisis in Democracy?" *Political Quarterly*, 73 (4): 400–408.

Barnhurst, K. and Nerone, J. (2009) "Journalism History", in K. Wahl-Jorgensen and T. Hanitzsch (eds) *The Handbook of Journalism Studies*. Abingdon, UK: Routledge, pp. 17–28.

Baudrillard, J. (1968) *Le Systeme des objects*. Paris: Deneol.

Baudrillard, J. (1970) *La Societe de consummation*. Paris: Gallimard.

Baudrillard, J. (1983) *Simulations*. New York: Semiotexte/Smart Art.

Baudrillard, J. (1994) *Simulacra and Simulation*. Ann Arbor, MI: University of Michigan Press.

Bauman, Z. (2005) *Liquid Life*. Cambridge:Polity Press.

Boorstin, D. (1961) *The Image: A Guide to Pseudo-Events in America*. Harmondsworth, UK: Penguin.

Braudy, L. (1986) *The Frenzy of Renown: Fame and its History*. New York and Oxford: Oxford University Press.

Carey, J.W. (2002) "American Journalism on, before and after September 11", in B. Zelitzer and S. Allan (eds) *Journalism after September 11*. London and New York: Routledge, pp. 72–90.

Cashmore, E. (2006) *Celebrity Culture*. London: Routledge.

Clark, L. (2012) "Schools Earn More Money from Students Taking Media Studies than Maths". *MailOnline*, 27 March.

Clark, L. (2007) "Media Studies and Other Trendy "Micky Mouse" Degrees Leave Student Dissatisfied". *MailOnline*, 12 September. Online.

Colley, L. (2009) *Britons: Forging the Nation 1707–1837*. Yale: Yale University Press.

Conboy, M. (2002) *The Press and Popular Culture*. London: Sage.

Conboy, M. (2004) *Journalism: A Critical History*. London: Sage.

Conboy, M. (2014) "Celebrity Journalism: An Oxymoron? Forms and Functions of a Genre". *Journalism Theory, Practice and Criticism. Special Issue: Celebrity News*, 15 (2): 171–185.

Connell, I. (1992) "Personalities in the Popular Media", in P. Dalghren and C. Sparks (eds) *Journalism and Popular Culture*. London: Sage, pp. 64–84.

Corner, J. and Pels, D. (2003) *Media and the Restyling of Politics: Consumerism, Celebrity and Cynicism*. London: Sage.

Couldry, N. (2000) *Inside Culture*. London: Sage.

Couldry, N. (2002) "Playing for Celebrity: Big Brother as a Ritual Event". *Television and New Media*, 3 (3): 295–310.

Couldry, N. and Hepp, A. (2013) "Conceptualizing Mediatization: Contexts, Traditions, Arguments". *Communication Theory*, 23 (3): 191–202.

Couldry, N. and Markham, T. (2007) "Celebrity and Public Connection: Bridge or Chasm?". *International Journal of Cultural Studies*, 10 (4): 403–422.

Curran, J. (1978) "The Press as an Agency of Social Control: A Historical Perspective", in G. Boyce, J. Curran and P. Wingate (eds) *Newspaper History from the 17th Century to the Present Day*. London: Sage, pp. 51–75.

Curran, J. (2002) *Media and Power*, London: Routledge.

Curran, J. (2018) "Moral Decline and the British Press", in J. Curran and J. Seaton (eds) *Power Without Responsibility*. 8th edn. Abingdon: Routledge, pp. 172–192.

Curran, J. and Seaton, J. (2018) *Power Without Responsibility*. 8th edn. Abingdon: Routledge.

Dalgren, P. and Sparks, C. (eds) (1992) *Journalism and Popular Culture*. London: Sage.

Darcy, R. and Rohrs, R.C. (1995) *A Guide to Quantitative History*. Westport, CT: Greenwood Publishing.

Debord, G. (1967) *The Society of the Spectacle*. 1st edn. New York: Zone Books.

deCordova, R. (1990) *Picture Personalities: The Emergence of the Star System in America*. Urbana, IL: University of Illinois Press.

Driessens, O. (2013) "The Celebritization of Society and Culture: Understanding the Structural Dynamics of Celebrity Culture". *International Journal of Cultural Studies*, 16 (6): 641–657.

Dubied, A. and Hanitzsch, T. (2014) "Studying Celebrity News". *Journalism: Theory Practice and Criticism*, 15 (2): 137–143.

Dyer, R. (1979) *Stars*. 1998 edn. London: BFI.

Dyer, R. (1986) *Heavenly Bodies: Film Stars and Society*. New York: St. Martin's Press.

Edelman, M. (1988) *Constructing the Political Spectacle*. Chicago, IL: University of Chicago Press.

Fallows, J. (1997) *Breaking the News: How the Media Undermine American Democracy*. New York: Vintage.

Fenton, N. (ed.) (2010) *New Media, Old News*. London: Sage.

Fenton, N. (2012) "Telling Tales: Press, Politics, Power and the Public Interest". *Television and New Media*, 13 (1): 3–6.

Fenton, N. (2016) *Digital, Political, Radical*. Cambridge: Polity Press.

Foucault, M. (1995 [1975]) *Discipline and Punish*. New York: Random House.

Franklin, B. (1997) *Newzack and News Media*. London: Arnold.

Gamson, J. (1994) *Claims to Fame: Celebrity in Contemporary America*. Berkeley, CA: University of California Press.

Giddens, A. (1991) *Modernity and Self Identity*. Cambridge: Polity Press.

Gitlin, T. (1997) "The Anti-Political Populism of Cultural Studies". *Dissent*, 44–77.

Gramsci, A. (1988 [1935]) "Selections from the Prison Notebooks", in D. Forgacs (ed.) *The Antonio Gramsci Reader*. London: Lawrence & Wishart.

Gramsci, A. (1991) *Prison Notebooks*. J. Bittiegieg (ed.). New York: Columbia University Press.

Gripsrud, J. (2008) "Tabloidization, Popular Journalism, and Democracy", in A. Biressi and H. Nunn (eds) *The Tabloid Culture Reader*. New York: Open University Press, pp. 23–44.

Habermas, J. (1989) [1962] *The Structural Transformation of the Public Sphere*. Cambridge, MA: MIT Press.

Habermas, J. (1984 [1981]) *The Theory of Communicative Action*. Trans. T. McCarthy. Boston, MA: Beacon Press.

Hartley, J. (1996) *Popular Reality: Journalism, Modernity, Popular Culture*. London: Arnold.

Harris, S. (2012) "Degrees without the Hard Work". *MailOnline*, 17 May.

Hepp, A. (2013) *Cultures of Mediatization*. Trans. K. Tribe. Cambridge: Polity Press.

Hesmondhalgh, D. (2005) "Producing Celebrity", in J. Evans and D. Hesmondhalgh (eds) *Understanding Media: Inside Celebrity*. Maidenhead and Milton Keynes: Open University Press, pp. 97–130.

Hesmondhalgh, D. (2013) *The Culture Industries*. 3rd edn. London: Sage.

Hickey, N. (1998) "Money Lust: How Pressure for Profit is Perverting Journalism". *Columbia Journalism Review*. July/August: 1–4.

Holmes, S. (2005) "'Off-guard, Unkempt, Unready'?: Deconstructing Contemporary Celebrity in *heat* Magazine". *Continuum: Journal of Media & Cultural Studies*, 19 (1): 21–38.

Horton, D. and Wohl, R. (1956) "Mass Communication and Para-social Interaction: Observations on Intimacy at a Distance". *Psychiatry*, 19: 215–229.

Hudson, P. (2000) *History by Numbers*. London: Hodder Education.

Innis, H. (1950) *Empire and Communications*. Oxford: Oxford University Press.

Kellner, D. (2010) "Media Spectacle: Presidential Politics, and the Transformation of Journalism", in S. Allan (ed.) *The Routledge Companion to News and Journalism*. Abingdon, UK: Routledge, pp. 116–126.

Lilti, A. (2017) *The Invention of Celebrity*. Cambridge: Polity Press.

Littler, J. (2004) "Celebrity and 'Meritocracy'". *Soundings: A Journal for Politics and Culture*, 26: 118–130.

Mah, H. (2000) "Phantasies of the Public Sphere: Rethinking the Habermas Historians". *Journal of Modern History*, 72: 153–182.

Livingstone, S. (2009) "On the Mediation of Everything". *Journal of Communication*, 59 (1): 1–18.

Marcuse, H. (1955) *Eros and Civilization*. New York: Beacon.

Marcuse, H. (1968) *One Dimensional man*. London: Sphere.

Marshall, P.D. (1997) *Celebrity and Power: Fame in Contemporary Culture*. Minneapolis and London: University of Minnesota Press.

Marshall, P.D. (2001) "Intimately Intertwined in the Most Public Way", in S. Allan (ed.) *Journalism: Critical Issues*. Maidenhead: Open University Press, pp. 19–29.

Marshall, P.D. (2010) "The Promotion and Presentation of the Self: Celebrity as a Marker of Presentational Media". *Celebrity Studies*, 1 (1): 35–48.

Marshall, P.D. (2014a) "Persona Studies: Mapping the Proliferation of the Public Self". *Journalism Theory, Practice and Criticism, Special Issue Celebrity News*, 15 (2): 153–175.

Marshall, P.D. (2014b) "Celebrity in the Digital Era: A New Public Intimacy", in *Celebrity and Power*. 2nd edn. Minneapolis, MN: University of Minnesota Press.

McChesney, R. W. (1999). *Rich Media, Poor Democracy: Communication Politics in Dubious Times*. Urbana, IL: University of Illinois Press.

McLuhan, M. (1967) *Understanding Media*. London: Sphere Publishing.

Newman, C. (2014) "Katy Perry Can't Teach Our Kids Anything About Politics". *The Telegraph*, 18 June.

Örnebring, H. and Jönsson, A.M. (2008) "Tabloid Journalism and the Public Sphere: A Historical Perspective on Tabloid Journalism", in A. Biressi and H. Nunn (eds) *The Tabloid Culture Reader*. New York: Open University Press, pp. 23–33.

Patterson, T. (1994) *Out of Order*. New York: Vintage.

Patterson, T. (2000) *Doing Well and Doing Good*. Cambridge, MA: Joan Shorenstein Center, Harvard University.

Ponce de Leon, C.L. (2002) *Self-Exposure: Human Interest Journalism and The Emergence of Celebrity in America*. Chapel Hill, NC: North Carolina University Press.

Richards, B. (2012) "News and the Emotional Public Sphere", in S. Allan (ed.) *The Routledge Companion to News and Journalism*. London and New York: Routledge, pp. 301–310.

Rojek, C. (2001) *Celebrity*. London: Reaktion.

Sabato, L. (2000 [1991]) *Feeding Frenzy: Attack Journalism and American Politics*. Baltimore, MD: Lahan Publishers.

Sanghani, R. (2014) "Beyoncé Studies, Anyone?" *The Telegraph*, 30 January.

Schudson, M. (1978) *Discovering the News*. New York: Basic Books.

Schudson, M. (2000) "The Sociology of News Production Revisited (Again)", in J. Curran and M. Gurevitch (eds) *Mass Media and Society*. London: Arnold, pp. 175–200.

Shattock, J. and Wolff, M. (1982) "Introduction", in J. Shattock and M. Wolff (eds) *The Victorian Periodical Press*. Toronto: University of Toronto Press.

Sonwalker, P. (2005) "Banal Journalism: The Centrality of the Us-Them Binary", in S. Allan (ed.) *Journalism: Critical Issues*. Maidenhead: Open University Press, pp. 261–273.

Skils, E. (1975) *Centre and Periphery: Essays in Macrosociology*. Chicago: University of Chicago Press.

Sparks, C. (1992) "Popular Journalism: Theories and Practices", in P. Dalghren and C. Sparks (eds) *Journalism and Popular Culture*. London: Sage, pp. 24–44.

Steel, J. (2012) *Journalism and Free Speech*. Abingdon: Routledge.

Street, J. (2003) "The Celebrity Politician: Political Style and Popular Culture", in J. Corner and D. Pels (eds) *Media and the Restyling of Politics*. London: Sage, pp. 85–98.

Stevenson, N. (2003) *Cultural Citizenship: Cosmopolitan Questions*. Maidenhead, UK: Open University Press.

Tuchman, G. (1978) *Making News: A Study in the Construction of Reality*. New York: Free Press.

Turner, G. (2014a) *Understanding Celebrity*. 2nd ed. London: Sage.

Turner, G. (2014b) "Is Celebrity News, News?" *Journalism: Theory Practice and Criticism*, 15 (2): 144–152.

Usher, B. (2011) "Bethany Usher Claims She Aways Adhered to the PCC Code". *The Guardian*, 1 December.

Usher, B. (2014) "Former NoW Journalist Reflects on the Hacking Trial: 'I was often asked to do things I couldn't square with my conscience'". *Press Gazette*, 4 July.

Usher, B. (2016) "Me, You and Us: Constructing Political Persona on Social Media during the 2015 UK General Election". *Persona Studies*, 2 (2). Online.

Usher, B. (2018) "Rethinking Microcelebrity: Key Points in Practice, Performance and Purpose". *Celebrity Studies*: 1–18. Online.

Usher, B. (2020) "The Celebrified Columnist and Opinion Spectacle: Journalism's Changing Place in Networked Public Spheres". *Journalism*: 1–19. Online.

Van Dijk, T. (1988) *News as Discourse*. Hove, UK: Lawrence Erlbaum Associates.

Van Zoonen, L. (2003) "After Dallas and Dynasty, We Have … Democracy?: Articulating Soap, Politics and Gender", in J. Corner and D. Pels (eds) *Media and the Restyling of Politics: Consumerism, Celebrity and Cynicism*. London: Sage, pp. 99–117.

Wahl-Jorgensen, K. and Hanitzsch, T. (2009) "On Why and How We Should Do Journalism Studies", in K. Wahl-Jorgensen and T. Hanitzsch (eds) *The Handbook of Journalism Studies*. New York and London: Routledge.

Washbourne, N. (2010) *Mediating Politics*. Maidenhead and New York: Open University Press.

West, D.M. and Orman, J. (2003) *Celebrity Politics*. Upper Saddle River, NJ: Prentice-Hall.

Williamson, M. (2016) *Celebrity: Capitalism and the Making of Fame*. London: Polity Press.

2

JOURNALISM AND CELEBRITY IN THE CONSUMER REVOLUTION AND BOURGEOIS PUBLIC SPHERE

The 18th century was an age of transition, which "seemed to usher in the type of industrial civilization with which we are familiar today" (Marshall, 1956: 2). Discussions of the idealised functions of journalism often build from Jürgen Habermas' (1989) concept of the bourgeois public sphere at this time, to consider how newspapers negotiated "citizens" within new "nations", loosely defined by Colley (2009: 5) and Anderson (1991: 6) as "imagined political communit[ies]". Philosophical liberalism "insist[s] on common language and nations as prerequisites for effective citizenship" (Miller, 2012: 401) and once these are formed, public spheres could help establish consensus and governance as functions of deliberative democracy. This chapter argues that celebrity news is an *overlooked hallmark* of bourgeois public spheres because political debates in both physical spaces and in print *depended* on visible individuals who strategically constructed public personas to argue for change. Journalism and celebrity cultures developed together as representations of citizenry and authentic self-identity within emerging capitalist and democratic societies and in thoughtful reflection of them. Together they helped to establish a "new regime of identity" (Wahrman, 2004: xiv) built around individual self-fulfilment displayed in cultural, consumer, political and media realms.

Many studies of celebrity culture argue later origins and insist on its "fundamental modernity" often in relation the logics of image (Turner, 2014: 11). This chapter clarifies how celebrity began in journalism as part of what might be described as a movement of "cultural citizenship" (Stevenson, 2003), where political aspects of life were publicly performed and questions of the entitlements and duties of citizens were symbolically represented. Newspapers created rituals of celebrification in order to consider issues of "recognition and respect, responsibility and pleasure, visibility and marginality" (Allan, 2003: xi). They framed and filtered self-fulfilment through lenses of purchase power, leisure activities, familial bonds and freedoms of speech. Public visibility could destabilise, challenge and reshape,

but also naturalise, stabilise and maintain social norms. From this starting place, separating celebrity from citizenry or politics from the popular – as many cultural and citizenship studies suggest (Stevenson, 2003: 4) – makes little sense. From the beginning they materialised what Raymond Williams (1989: 4) described as "a whole way of life – the common meanings; to mean arts and learning – the special process of discovery and creative effort" as the intertwined mediations of dramatically changing societies.

Celebrities in print: the reflection of new societies and identities

Several recent historical studies have argued that celebrity culture emerged in the 18th century. Stella Tillyard (2005) claims it reflected the limited power of the monarchy, publics interested in new ways of thinking and the "free-wheeling commercial development of [the] Georgian era". Similarly, Fred Inglis (2010: 39) built from *The Birth of a Consumer Society* (McKendrick et al., 1982) to demonstrate how celebrities reflected a passion "for going to market not to subsist, to buy and sell necessities, but to buy for the joy of it". The consumer revolution was "characterised by a longing to experience in reality those pleasures created and enjoyed in imagination [...] both the central institutions [of] fashion and romantic love" (Campbell, 1987: 205). Newspapers reflected the bustling and imaginative social marketplace of the city, not least in expanded advertising sections, which included items to improve personal appearance and related to hobbies and leisure activities. These ranged, for example, from Roman historical antiquities to decorate the home to elixirs for stomach cramps; toothpaste to improve the "whiteness of teeth" and fashionable "apparel" to pamphlets about public figures and their private lives (*Daily Courant*, adverts 1722–1742). Newspapers quickly became the principal site of display for consumer culture and encouraged their readers to buy and to take pleasure from doing so.

The term "celebrity" as both a description of fame and a wider culture emerged with linguistic specificity in newspapers in the 1760s. First, "celebrated" appeared in adverts and editorial to describe public figures from across society, politics and entertainment. For example, the "celebrated Daniel Wildman" exhibited "several amazing experiments" (*London Gazetteer*, 5 June 1772); "the celebrated Comedian" Mr King entered into a business deal with other entertainers (*Lloyd's Evening Post*, 3 January 1770), while a new opera was said to be written by G.A. Stevens, "the celebrated Lecturer on Heads" (*Independent Chronicle*, 5 January 1770). Next, the word "celebrity" came to describe public visibility. Antoine Lilti (2017: 103–104) mapped the use of the term "celebrity" in both British and French news publications and found it increased significantly between the 1760s and 1810s. The press were particularly interested in accounting *the means* by which individuals achieved celebrity status. For example, a young German author's work on "experimental agriculture" led to his "celebrity, even in England" (*Public Advertiser*, 19 March 1771); the son of a country attorney who became a member of parliament began to "rise in fame: and his celebrity soon established" (*Morning Post and Daily*

Advertiser, 3 January 1773). Mrs Saunderton, "a female performer" who was "as capital in her profession as she was amiable as a woman", had a "private character" which equalled her "celebrity" (*London Chronicle*, 1 February 1777). This last description offers an early indication of the public/private dichotomy of fame (Dyer, 1986; Holmes and Redmond, 2007; Marshall, 1997; Turner, 2014), which ties authenticity to a self only revealed behind closed doors, but then represented by news media for public consumption.

Newspapers and periodical magazines circulated commercial and political liberties, "made possible by the terrific expansion of economic activity and social imaginativeness" (Inglis, 2010: 37). Mole (2009) highlights late 18th-century Romanticism as the founding discourse of celebrity culture's idealisation of self as artistic soul and Morgan (2011: 96–97) argues for greater understanding of the "historical processes" which developed at this point and continue to sustain it. Rojek (2001: 104–105) clarifies that the press, theatre and nobility *together* created the first "national popular". Milly Williamson (2016: 1) focuses particularly on the theatre star system and how it "correspond[ed] to the enormous social changes wrought by the emergence of capitalism: the rise of bourgeois modernity and the commercialization of culture, the development of technology and the processes of industrialisation, the growth of democracy". Lilti (2017) also considers how cultural and political relationships between Britain and France, including Romantic art movements and Enlightenment debates, "invented" celebrity roughly from the 1760s. He argues that in urban societies, ceremony and celebrations created *theatrum mundi* – the "world stage" – where "life is a performance, a permanent spectacle" (p. 24). Each of these scholars highlight the importance of the French Revolution in setting trends "in motion, which include[d] the paradoxical nature of bourgeois society and culture" (Williamson, 2016: 18).

But many of the discourses of celebrity emerged in print long before the French revolution and, as we will explore, were part of the debates that led to it. Julia Fawcett's (2016) fascinating exploration of the *Spectacular Disappearances* of celebrities across the full course of the 18th century, explores the self-agency of public figures as they negotiated their public image, particularly though autobiographies. She considers how different celebrities from the worlds of literature and the performing arts constructed "legibility that guaranteed his or her citizenship within the ideology of 'unique, expressive identity'", and here I explore similar processes, particularly focused on the place of the press in it. In sum, these studies argue that the emergence of celebrity reflected developments in mass culture and media, the arts and significant commercial shifts that underpinned these things. But principally, celebrities emerged in printed news as reflections of new senses of self where personal relationships became as important as public ones and where leisure activities, consumer spending and citizen-self became part of both private and public aspects of life. News media created celebrity culture in order to shape citizenship as cultural and political, private and public phenomena from the early 1700s onwards. Some journalists and celebrities attempted to make sense of rapid socio-cultural and economic changes and to articulate them to audiences. News media was the *key site*

of performance for thundering London and its lusty inhabitants at once and in reflection.

Charles Taylor's *Sources of the Self* (1989: 204), for example, discussed tensions between Enlightenment celebration of grounded, reasoned life and the older notions of fame of the aristocracy which "stressed glory won in military pursuits". News about celebrities often reflected and discussed such changes. Desire for the virtues of "citizen life" were placed in opposition to "wildly destructive" grasps for "fame and renown" and confronted the "ethic of glory" with "a fully articulated alternative view, of social order [and] political stability" (p. 204). The press often celebrated "a multifaceted notion of the self" defined by "powers of disengaged reason – with its associated ideals of … freedom and dignity – or self-exploration, and of personal commitment" including through descriptions of consumer habits, social activities or political stances of the famous (p. 211). For example, many "celebrated" philosophers, such as David Hume, Adam Smith and Jean Jacques Rousseau, optimistically discussed the potentials of the individual in public, and their private lives were written about as negotiations of such ideals. Taylor (1989: 344) describes how their works aimed "to show the house that as humans we had to live in" and explored "a way of seeing our normal fulfilments as significant even in a non-providential world". They affirmed the significance of "production and reproduction, that is labour, the making of the things needed for life, and our life as sexual beings, including marriage and the family" (p. 211). Newspapers represented these dynamics through accounts of celebrity production (artistic labour, consumption, promotion) and reproduction (private, familial life, sexual affairs, and flirtations). More people were famous than ever before, and some became powerful symbols of what it meant to "be" in rapidly changing socio-political realms. Later in this chapter I consider key celebrity figures that embodied such changes by becoming part of an emerging *celebrity class*. But first, it is important to evidence the significance of celebrity for the 18th-century press.

Achieved, ascribed and attributed celebrities in the 18th-century press

Leo Braudy (1986: 4) claimed that with the expansion of media, "human images" are "intensified and the number of individuals celebrated expands" and was one of the first to pinpoint 18th-century printed news as marking such a shift. The lapse of the Print Licensing Act in 1695 allowed publishers greater freedom, and contemporary reports described how "city, town and country, are over-flow'd every day with an inundation of newspapers" (*St. James's Weekly Journal*, 31 October 1719). Stamp duty returns for August 1712 and May 1714 both list 12 London-based newspapers, but by the 1760s historian Robert Rea (1963: 7) identified at least 86, including daily, weekly, tri-weekly and fortnightly news publications. Coffee house tables were so full of news they looked like the counters of pamphlet shops, and owners were dismayed at the proliferation and often refused to take more (Black, 1987: 9–15).

Most studies of journalism, like cultural studies of celebrity, argue later origins, although some acknowledge developments in news culture as a "response to the political and economic conditions of the age" (Conboy, 2004: 67). Newspapers employed only a "few journalists in the modern sense" and instead relied often on "news furnished by readers" or "contributors paid by the paragraph" (Lilti, 2017: 68). Barnhurst and Nerone (2009: 19) and Conboy (2014: 172–173) identify that "journalism" entered the English language in the 1830s and it was roughly that time when the profession and many practices (such as interviewing and some news conventions) first formed. Certainly, many of the parameters by which we judge journalism today were 19th-century inventions. But there were discussions of the practices of the "journalist" from the 1760s onwards. The earliest surviving record of this word to denote a media professional highlighted its "constitutional" role (*Royal Westminster Journal and London Political Miscellany*, 4 December 1762). Soon newspapers also discussed practices in relation to the famous. For the *Sun* (1783–1800), it was the "business of a Daily Journalist to pay every tribute" to the "memory of those who die in the service of their country", until "the pen of the Historian shall consecrate it the esteem of prosperity" (29 March 1793) – a news value upheld to this day. The *Oracle and Public Advertiser* (9 October 1798) discussed how some journalists "seem to place themselves like sentinels in our public gardens" in order to observe people of fashion and to "use their pens to draw amusing caricatures". Journalists were described as "puny witlings", willing to write whatever grabs the public attention "to amuse and divert" (*Critical Review*, July 1763) – an early critique on news as popular culture. Newspapers also discussed fandom and the "new English mania … that an actress is the first of human characters" (*Morning Chronicle and London Advertiser*, 25 January 1783). In newspapers, audiences debated the character of celebrities and journalists, celebrated and criticised their displays and works and discussed their potentials. Pages were awash with news, pseudo-events, and vibrant editorial commentary about the societal implications of the famous.

Historian Jeremy Black categorised the 18th-century London press as "predominantly political" (1987: 19), with advertising as the only other consistent feature, but also clarified that as editors needed to "provide a product … that people wished to read", populist items increased too. While Black did not believe such content – such as reports on sexual scandals, the theatre and crime – significantly shifted the news agenda, we can place much of it under an umbrella of celebritised news. Growth demonstrates that discourse about the famous as symbolic representations of life in this new modern nation was popular with audiences and this is the principal driving dynamic of the relationships between journalism and celebrity to this day. Figure 2.1 evidences how such content reflects the emergence and equality between members of the new *celebrity class* in newspapers, using Chris Rojek's (2001: 17–29) "taxonomy of fame" as a methodological and theoretical framework for categorising celebrities. Britain's first morning and Fleet Street newspaper the *Daily Courant* (1702–1797) – which later merged with the *Daily Gazetteer* [1] – increased its coverage of celebrities from all "three forms: *ascribed,*

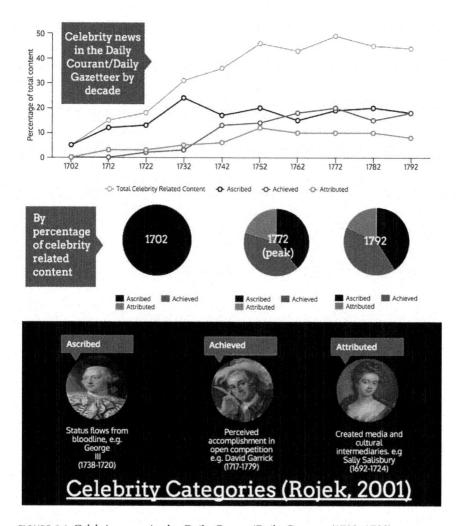

FIGURE 2.1 Celebrity news in the *Daily Courant/Daily Gazetteer* (1702–1792)

achieved and attributed" (p. 17: original emphasis) [2] across the course of the century. In 1702, celebrity news accounted for just 5 per cent of content with the *Courant*, a half folio sheet printed front (with news) and back (predominantly advertising), focused largely on foreign, often military, affairs. By the end of the century, it was a significant component with public figures celebrified in more than 40 per cent of content.

While we will consider how this balanced across each category of Rojek's taxonomy in more detail, in short, numerical patterns of change across the century reflect shifts in identity and society as described in Taylor's (1989) *Sources of the Self* and evidence how celebrity developed in print at this time. *Ascribed* celebrities – predetermined by lineage, such as European royalty and the aristocracy –

dominated until the 1760s. As the consumer revolution took hold, they were then usurped by *achieved* celebrities – derived from "perceived accomplishments of an individual in open competition" (Rojek, 2001: 18) – often from the middle classes such as entrepreneurs, artists, authors and actors. The fame of *attributed* celebrities such as socialites, dandies, prostitutes and criminals – what Boorstin (1961) might have referred to as "human pseudo-events" – was constructed by journalists for the first time and sometimes in negotiation with the individuals themselves who sent accounts of their private lives or staged public appearances and tipped off the press. Content related to this category peaked in the 1750s when this group accounted for more than 10 per cent of celebrity editorial. They largely represented the sub-figures whom Rojek categorised as "celetoids" – compressed fleetingly famous figures, often involved in political or social scandals – and "celeactors" – fictional characters who embodied facets of social identity or malaise at this time (p. 18). Famous prostitutes and mistresses were included in the former and the first-person protagonists of novels and novellas – a genre that also developed at this time – shaped the latter.

Ascribed celebrities often featured in news about events of political importance. In the introductory paragraph to many news stories, the aristocracy were "semiotic hooks" (Conboy, 2014: 179) used to explain military and political manoeuvres. For example, on 8 June 1712, the *Courant* reported that the "King of Spain had send (sic) the Order of the Golden Fleece to Count d'Arcos", a general of the Bavarian forces and the Duke of Modena "desired" his protection. The Princess of Mirandola wrote to the "Duke de Vendome" to excuse her conduct at a recent court encounter. As the century progressed, day-to-day activities, intrigues and fashions featured more regularly, peaking in the 1730s. Focus moved from military and political spheres towards personal and private ones. While reports that the "former Queen of England dined privately" with the King of France or the Dauphin was suffering from sickness (*Daily Courant*, 7 June 1702) were also politically significant, there was more detail about the colour of court, rumour and gossip. For example, "Mme de Beaujolis", a favourite of the French king, was "indisposed for some days at the Palace Royal" and Spanish aristocrat Don Carlos' face was described as "far from being pitted" after smallpox (8 March 1732). State visits and matters of politics intertwined with tantalising private scenes and sexual innuendo, and this helped make celebrity gossip part of news.

Increased levels of news about "achieved" celebrities focused on the "new model of civility ... in which the life of commerce and acquisition gains[ed] an unprecedented positive place" (Taylor, 1989: 204). Talent, beauty and enterprise were praised above birthright or military glory, and entertainers were made visible representations of achievement, both following "the nobility in fashion, manners and conduct" (Mole, 2009: 13) and leading social trends. By publicly associating with the stars of the London stage, for example, the nobility gained cultural value and furthered their visibility in print media. Fame was a new social equaliser and celebrity news portrayed each as members of the *celebrity class*. Campbell (1987: 205) argued that authors, artists and actors were "virtuoso in feeling [and] also

pleasure" and such achieved celebrities both *produced and became* cultural products, which "yielded pleasure in others". Eighteenth-century celebrity culture was the kind of multi-media phenomenon described by Richard Dyer (1986: 4–6) is his examinations of 20th-century cinema stars, formed across "literature, theatre, music and visual culture, fashion" (Mole, 2009: 2). As most of the population were unlikely to see celebrities in the flesh, print news media was the main place where they accessed them. Thus, celebrities – as figures of titillation, emulation and symbols of social change and liberation – emerged first as complex cultural products of early news media.

For example, in both his writings and private life as reported widely in print, philosopher Jean Jacques Rousseau aimed to embody Romantic and Enlightenment debates. His "great exempla" (Taylor, 1989: 289) for the celebrity autobiography *Confessions* (completed 1769, published 1782) and his novel *La Nouvelle Heloise* (1761) "helped more than any other to define and spread the new outlook" (p. 295) and resulted in his widespread fame. Lilti (2017: 13) describes him as the "first real European celebrity" who also was the first to describe fame as "a burden and alienation". He was a newspaper favourite and they often offered "some account of his private life" (*Lloyd's Evening Post*, London, 31 January and 6 February 1766) such as how the "celebrated Monsieur Rousseau" was "banished from Geneva" and "landed in Dover" to stay with David Hume (*Public Advertiser*, 23 January 1766). While his works placed personal reflection and solitude above all things, paradoxically Rousseau was swamped by crowds and inundated by fan mail. He was both a site of celebrity spectacle and an "eloquent critic of these spectacles" (Lilti, 2017: 25) and as such became a hot topic for news.

However, while the most enduring and influential example, Rousseau's *Confessions* was by no means the first autobiography of its kind and certainly not the only to attempt strategic construct of public persona. Fawcett (2016) discusses a range of other titillating autobiographies, including those of popular thespians and comedians. Discussions in the press of the private lives and public work of entertainers – particularly those of the London stage – also reflected the increased cultural significance of such "achieved" celebrities. David Garrick (1717–1779) and Sarah Siddons (1755–1831) were billed higher than the plays they were in, a dynamic that did not happen in cinema until the late 1910s and is hailed as a significant moment in the formation of Hollywood stars (Dyer, 1979). News focused not only on their work but also on their private self, articulated as "a crucial part of what makes life worthy and significant" (p. 292). For example, the "very amiable" marriage (*Public Advertiser*, 22 March 1758) of David Garrick was honoured with large anniversary parties attended by "several of the nobility" (*London Evening Post*, 18 August 1774) and in an anonymously penned, widely circulated ode (*Morning Post and Daily Advertiser*). Their marital bed was saved for national posterity and currently resides in London's Victoria and Albert Museum. Similarly, reports of Sarah Siddons' love for her children became a "national concern" after she insisted on taking them to court and tipped off the press beforehand (*Morning Chronicle and London Advertiser*, 25 January 1783), and, as a result of public appearances in

childhood, their illnesses, marriages and ultimately deaths were newsworthy too. These were amongst the first of new ascribed celebrities from beyond the traditional bloodline of aristocracy or royalty who were made famous by newspapers simply because their parents had achieved public visibility.

Both Lilti (2017: 28–29) and Williamson (2016: 30–33) argue the important place of English theatre as part of the creation of the spectacle of celebrity and particularly the first commercial "star systems". Certainly, the theatre was a dominant cultural form, but most of the British public were never audience members and so their encounters with those who tread the boards was primarily in ink. And in newspapers and periodicals, theatre stars (as both Lilti and Williamson refer to them), like other celebrities, were contested figures. Sarah Siddons was criticised for being self-absorbed and uncharitable. Mary Robinson was referred to as Perdita in reference to the role the Prince Regent saw her play before asking her to become his mistress, and 17 years after Rousseau's confessions she penned her own *Memoirs*, which were not published until after her death (Fawcett, 2016). The *Morning Herald and Daily Advertiser* (12 February 1780) described how she placed herself directly opposite the prince and, "by those wanton airs, peculiar to herself, contrived at the least to bewitch him", before being thrown out by the managers. The account finished with a short bawdy poem that suggested she better "milk her ewes" rather than "Queen it". Williamson (2016: 53) argues that the theatre offered one of the earliest expressions of what "illusions of intimacy" (Schickel, 1985) through displays of "actresses' growing economic independence and, paradoxically, their simultaneous sexualisation". But sexualisation was also part of the narrative of liberation-of-self and news media focused on sex in relation to many other types of celebrities too. For example, sales increased when they included private details of celebrities' lives, such as in *A Picture of England* (1789), a periodical that told "curious and interesting anecdotes" about a range of public figures including "Mrs Siddons, Mr Garrick, Mr Fox, Mr Pitt, the Duchess of Devonshire and Mr Wedgewood" (*The World*, 23 July 1789). The celebrity class came from across the worlds of entertainment, politics, fashion, aristocracy and enterprise (and other realms too) and, across the board, the press reported private and public lives as the counterparts of one another.

Some achieved celebrities were journalists, such as Daniel Defoe, who applied construction patterns of periodicals and pamphlets to build the fame of people from outside of the traditions of achievement (such as criminals) and to create fictional celeactors as part of the construction of *attributed celebrity*. For example, while writing his morality tale *The Fortunes and Misfortunes of Moll Flanders* (1722), Defoe also edited real-life accounts of criminals, and it was these two activities together that helped make Moll the most famous celeactor of the age. The entwined influence between celebrity, news and literature is illustrated, for example, through comparison of Moll and the pamphlets, novellas and column inches dedicated to real-life prostitute and celetoid (compressed and media-created celebrity) Sally Salisbury in the 1720s.

This Day is publish'd, with her Effigies curiously engraven,
Authentick Memoirs of the Life, Intrigues
and Adventures of that celebrated Courtezan SALLY SALISBURY.
With true Characters of her moſt conſiderable Gallants: Containing,
I. An Account of her Birth, Education, and firſt ſetting out in the
World. II. Of her Religion and Politicks. III. Her Progreſs to
New-Market with the Lord C—d, and the melancholly Adventure
of Boſon F—g. IV. The merry Preſent ſhe made her Footman, and
the Entertainment ſhe gave a celebrated Comedian. V. The original
of her travelling Name of Salisbury, ſome Specimens of her Ingrati-
tude, and her vile Treatment of the Baron Leonardo. VI. Her A-
mours with a Nonjuror, a Non-Conformiſt Parſon, and a certain
Dean. VII. Of her Dancing for a Smock at the Bath, and ſeveral
other Adventures there. VIII. How ſhe reduced a Shropſhire 'Squire,
and banter'd a Country Grazier, &c. Printed for the Author ; and
ſold at Jones's Coffee-Houſe in Drury-Lane, over-againſt Long-Acre,
and by all Bookſellers. Price 2 s. 6 d.

To Morrow will be publish'd,
The Fortunes and Misfortunes of the famous Moll
Flanders, &c. who was born in Newgate, and during a Life of con-
tinued Variety for Threeſcore Years, beſides her Childhood, was 12
Years a Whore, 5 Times a Wife (whereof once to her own Brother,)
12 Years a Thief, 8 Years a tranſported Felon in Virginia, at laſt
grew Rich, lived Honeſt, and died a Penitent. Written from her own
Memorandums. Printed for and ſold by W. Chetwood at Cato's-Head
in Ruſſel-ſtreet in Covent-Garden ; and T. Edlin at the Prince's Arms
over againſt Exeter Exchange in the Strand.

FIGURE 2.2 The "Celetoid" and "Celeactor" (Rojek, 2001) in the 18th-century press

Salisbury, real name Sarah Priddon, was a "celebrated Lady of Pleasure" who
shocked respectable society by having a "chariot … a coachman and two footmen"
(*Weekly Journal*, 12 September 1719), usually reserved for the aristocracy. She was
already famous when she became the lead story for many newspapers after she
stabbed a "gentleman" client (*British Journal*, 9 February 1723) and her arrest and
trial, by surviving records, featured across no fewer than a dozen newspapers. Her
acquittal for attempted murder followed a campaign of sympathetic coverage (she
was gaoled for two years for assault instead) and sparked "public demonstrations of
joy in … venerable parts of Town" (*Daily Journal*, 26 April 1723). Hundreds of

letters from readers, influential clients and even her victim cried for her release (*Daily Journal*, 5 November 1723) across dozens of newspapers. When she died in Newgate after serving six months, her death and funeral became an event of mourning involving news media, celebrities and the public. She was cited as an inspiration for Defoe's *Moll* (Howson, 1969; Swaminathan, 2003) – published the year before the stabbing incident – and thus, there emerged a two-way relationship between "celetoid" and fictional "celeactor". Such intercommunications between news media and the early modern novel in relation to celebrity culture were both structural and thematic. No fewer than ten pamphlets were published giving accounts of Salisbury's "genuine history" or "authentick memoirs" which, in turn, echoed the construction patterns and style of *Moll*. As Figure 2.2 shows, advertising for these print products was strikingly similar, with both accounts presented as authentic first-person memoirs, despite one written about a real person and the other by a journalist-come-author about a fictional one. News media and fiction worked together to reflect and construct these powerful and scandalous representations of living in this modern world. There are complex social and political aspects to this. On the one hand, the fact that women and female characters from outside the "attributed" worlds of social elites were visible was a step towards acknowledgement of their place in public society. On the other, such discourses demonstrate how journalists were coming to understand the symbolic power of celebrities to construct realities, even *beyond the remit* of who or what was real. Such dynamics played a particularly important part in the emergence of a new type of political celebrity who both argued for and embodied radical social change.

Private, public and political spheres

Habermas (1989) highlighted how 18th-century European public spheres facilitated dialogue in order to hold states to account and that this formed the model of Western deliberative democracy. The bourgeoisie gathered in physical spaces – salons in France, dining societies in Germany and coffee shops in Britain – where, he claimed, merit of argument was more important than social hierarchy (1989: 35–36). As dozens of newspapers and pamphlets flooded the market and distribution improved, there were significant increases in literacy, which meant more people could join conversations. But while political discussions may have been accessible to more people via print media, those involved in them at source were still narrow – largely middle-class and aristocratic men. Habermas' suggestion of a "golden age" of media production (Hallin, 1994) is, therefore, often described as elitist (e.g. Dalghren, 2003; McGuigan, 2002), only counting property-owning "gentlemen" as "citizens" and not acknowledging the impacts of social exclusion (Calhoun, 1992; Fraser, 1992). Some contest Habermas' description of rational debate because politics is inherently passionate, emotional and often conflicted (Goodwin, 2005; DeLuca and Peeples, 2002). But even in such critiques, the place of celebrity culture is often overlooked. It is too far beyond established narratives of political news and the normative ideals of deliberative democracy. By inserting

celebrity news clearly into journalism's role in the bourgeois public sphere, we can understand its importance in developing both "politics" and "the political" aspects of life in capitalist democracies and therefore celebrity's place in establishing citizenship as a cultural phenomenon.

Habermas (1989) argued that at the time of the bourgeois public sphere newspapers generally levelled up in the interest of self-education and cultivation. This contrasted with the 19th and 20th centuries when editors commoditised newspapers to meet the demands of advertisers. Such differences underpin much research into the damaging effects of tabloidisation and celebrity news in relation to journalism's democratic functions and the influence of corporate media. According to Barnhurst and Nerone (2009: 18), newspapers became instruments "of continual political argumentation and deliberation" and appealed to "norms of universal rational supervision", although they acknowledge that newspapers were also impassioned and partisan (citing Lake and Pincus, 2006; Raymond, 2003). They argue that newspapers saw their *ideological purpose* as the facilitation of rational debate in order to effect political change. However, Habermas' claim that only issues in the public interest were a viable topic for discussion in the public sphere ignores both matters of exclusion and private need (see Benhabib, 1996), but also the realities of discursive activity as both public and private exchanges. As a result, his work is used to dismiss celebrity and popular journalism in ways that were never the intention as stated. Certainly, I do not dispute nor criticise Habermas' principles of deliberative models of democracy as normative ideals or the importance of his work. But by casting an alternative light on established historical narratives and examining celebrity news as part of bourgeois public spheres, the next two sections demonstrate that public and private spheres were rarely separate, that celebrity culture in news was also politically revolutionary and that these dynamics together helped make news media a "portal for public opinion" (Rea, 1963: 2).

Anonymous commentators and letter writers produced the majority of 18th-century political journalism. Barnhurst and Nerone (2009: 18) offer Cato and Publius – pseudonyms for political leaders James Madison, Alexander Hamilton and John Jay – as examples of early newspaper writers who reflected Habermasian ideals of rational debate and the public interest. Rea (1963: 3) described how, through newspapers, politicos became popular and influential without royal favour and beyond the demands of the ballot box. Debates about press freedom first emerged in relation to stories that detailed personal scandals and this, by extension, facilitated challenges to "the privilege of the House" and journalists to defend against libel (Rea, 1963: 142–173). For those who enjoyed the patronage of parliament – such as Tobias Smollett writing for the *Briton* – the fact that lowly "forlorn grubs and gazetteers" provided information by which "prentices ... porters ... discarded draymen and hostlers" could judge the "wheels of Government" (*Briton* No. 15, September 1762) was scandalous and even a step towards violent revolution. For others, such as politician, journalist and radical John Wilkes, the "liberty of the press" was "the birthright of a Briton, and ... the firmest bulwark of

the liberties of this country" (in Rea, 1963: 6) and participation in its discourses was crucial to building active citizenry.

Junius, an anonymous political writer working between 1769 and 1772, is a familiar figure in histories of British journalism and politics and almost universally viewed in heroic terms. His letters "raised journalism to a much more important position than ever before" (Fox-Bourne, 1998: 190; Conboy 2004: 84) and he "stood forth in unchallenged mastery" of the field of early political comment (Rea, 1963: 175). Junius' power lay in the mystery of his anonymity and his combination of "ruthless sarcasm, keen invective, and political daring" (Rea, 1963: 175). Rea highlighted the trials of his publishers as key to forming press freedom as a defining principle of democracy (pp. 174–185). These paved the way for Fox's Libel Act (1792), which resulted in several high-profile acquittals in trials over the next fifty or so years and greater freedom of the press (see also Curran, 2018b: 9). Conboy (2004: 84) highlights that the *Public Advertiser* – Junius' publisher – was populist, in terms of both adverts and content relating to "polite society". However, Junius also helped to establish an important journalistic ritual of celebrification – "attack journalism" – through which he deliberately linked conduct in public office to private life. His journalism was both celebrity gossip and political commentary, and it was the inventiveness of such content that "assured him a great popular following" (Rea, 1963: 175; see also Tillyard, 2005). He revealed adultery, alcoholism and spats with friends and made lewd sexual references, even in relation to genitalia. For Junius (30 May 1769), "public conduct" was "the counterpart of … private history", which directly contradicts arguments that at this time "public" and "private" were separate spheres.

For example, Junius described how the Duke of Grafton was "recovered from the errors of his youth, the distraction of play and the bewitching smiles of burgundy" (21 January 1769), but still somewhat prey to the "heat of midnight excesses". He urged the Duke of Bedford not to "take back [his] mistress, attend Newmarket" (21 April) or engage in the same "busy agitations, in which your youth and manhood were exhausted" (19 September). Junius particularly vilified those who placed personal gratification over public propriety, such as Grafton when he "frequently led his mistress into public, burying "shame and decency" under the ruins of "an ancient temple of Venus" and even parading her "in front of the Queen" (12 June). When he turned such attention towards the Crown on 19 December 1769, his work was "destined to make publishing history" (Rea, 1963: 176) as the criminal trials of his publishers established the first legal public interest balance with privacy. His column urged King George not to adopt "Stuart principles" of opulent spending and political dictatorship, issuing a stark warning that "while [the Crown] was acquired by one revolution, it may be lost by another". It was an immediate commercial success, with circulation almost doubling to 4,800 (Rea, 1963: 176). Prosecution promptly followed for publisher H.S. Woodfall and six others and when the first trial resulted in a guilty verdict for outspoken politico John Almon, there was public outcry, both in print and on the streets of London. All other publishers were subsequently cleared which "prepared

the way for a broader, a higher, consideration of press law and the press in politics" (Rea, 1963: 187).

Junius *celebrified* politicians (raised their individual visibility) in order to highlight political tyranny and in doing so helped to establish institutional celebritised discourses of attack journalism. Readers' letters in response, published across multiple newspapers, demonstrate many fascinating similarities with contemporary criticisms of tabloid and celebrity cultures. His loudest critics, friends of those who fell afoul of his pen, described him as the "high priest of envy, malice and uncharitableness" (William Draper, *Public Advertiser*, 26 January 1769) – a pre-echo of James Curran's discussions of how in red-top tabloids individuals are often "vilified and [their] wellbeing utterly disregarded" (2018a: 180). Reverend Mr Horne's argument that Junius felt "no reluctance to attack the character of any man, the throne is not too high, nor the cottage too low" (31 July 1771) is also a familiar denunciation of the worst tendencies of celebrity news. Draper lamented that "political questions" could focus on "the most odious personalities" (7 October 1769), which reflects arguments that still reverberate throughout criticisms of the celebrification of political news and communications particularly.

But Junius is often hailed as a pioneer of political journalism as what it *should* be, and behaviours so universally condemned in relation to contemporary political journalism are simply not applied to him. The question becomes, why do some scholars of journalism and politics who have celebrated Junius, decry contemporary examples of his methods? It appears to be the *purpose* and *impact* of this example of attack journalism from which different perceptions stem, rather than the *techniques* of personalised attacks. Karin Wahl-Jorgensen (2007: 13) argued that what constituted the public interest in the bourgeois public sphere was defined by the most powerful, "in such a way as to sustain their privilege" and that was clearly not Junius' intention. When he revealed impropriety of the ruling classes, it was to *dismantle* their political power and broaden the parameters of debate, whereas counter attacks from audience members aimed to sustain ruling privilege. By unpicking such nuances in relation to politics, celebrity and journalism in the early stages of their development, we can begin to understand how celebrity journalism can work as both a mechanism for control and as a tool to break hegemonic power.

Examination of the relationship between journalism and celebrity cultures and newspaper letters pages demonstrates the public/private dichotomy in Habermas' work. Habermas (1989: 3) viewed the *polis* as public interactions between citizens in the political realm and as separate from the *oikos* as a private sphere founded on hidden interactions between free individuals in domestic realms. Simon Susen (2011) argues that while Habermas' discussions suggested private and the public are "relatively autonomous" spheres, they were in fact mutually dependent and intertwined. Visual cultural representations of the public sphere, such as William Hogarth's etching of a late-night debate at his father's coffee house (and childhood home) in St John's Gate (1733), show that rather than rational, formal or objective they were often inebriated, licentious and as informal as a bordello, with hats and

wigs cast aside and piss-pots in the corner. While he did not name those depicted, there was much debate in letters as to which celebrities they might be, and in response Hogarth stated, "We lash the vices but the persons spare". There is as much evidence to dispute that the public sphere and private sphere were independent spaces, particularly as white property-owning men were masters of both and behaved precisely as they liked. So, what truly levelled up the general population to begin to understand themselves as citizens and as personally autonomous? Was it these powerful men as they debated each other in their public/private spaces? Was it those who used dynamics of celebrification to challenge their public dominance, such as Junius and as we will see next Thomas Paine? Or maybe it was other celebrities, including women, who used their fame to demand inclusion in public spheres as explored later in the chapter? The next section considers these questions in relation to the revolutionary pamphlet movement. I examine how celebrity news *about* leading pamphleteers and their own disclosures about private lives aided circulation of their works, and how "attack journalism" became a means by which the press can ostracise those who demand social change from public spheres.

The celebrification of the revolutionary pamphleteers

Marilyn Butler (1984: 1) identified the "Revolution Controversy" as lasting from France's "new dawn" in 1789 to December 1795 when "Pitt's Government introduced measures to stop the spread of radicalism by the printed and spoken word". Junius' writings influenced discussions in newspapers between and about pamphleteers, which often linked accusations of personal impropriety directly to political argument. Both Edmund Burke's pro-aristocratic *Reflections on the Revolution in France* (1789) and Thomas Paine's *Rights of Man* (1791) used personalised experiences as semiotic hooks to engage the reader, and in Paine's case to argue for a model of citizenry with political and economic emancipation and universal male suffrage. Paine had established a personal voice, which spoke to the reader as if a friend, while working as an (anonymous) journalist and the editor of the *Pennsylvania Magazine* leading up to the American War of Independence. He transformed it into a personal companion, covering news, science, reviews and featured profiles of famous figures and regularly attacking the privilege of British ruling power. Within months it became the biggest selling periodical in America where, for example, it made the first case for the abolition of slavery (*Melvyn Bragg's Radical Lives*, 9 August 2014). He brought this new style – forged in the fires of developing American society – with him when he returned to Britain, and many histories of journalism identify the pamphlet movement as the next big step after Junius in the formation of journalism as political discourse (e.g. Conboy, 2004; Barnhurst and Nerone, 2009; Rea, 1963). Paine was the very first transatlantic journalist as celebrity.

Well-trodden paths that look to the "rationality" and "levelling up" of discussions in newspapers during the bourgeois public sphere often disregard the

significance of celebrity news *about* the pamphleteers' private lives. Across newspapers, gossip, innuendo and the banal were discussed alongside political ideas. Surviving material demonstrates that journalists viciously targeted Paine, who threatened the social order, while remaining more measured about Burke, who was an established parliamentarian who argued against major political reform. Figure 2.3 analyses surviving newspaper discourse relating to Burke and Paine, using Butler's six-year timeframe of the "Revolutionary Controversy" as an established parameter and shows how discussions were equally formed in relation to private realms as public works. Butler (1984: 108) identifies Burke and Paine's publications as the most popular of the 25 main voices of the Revolutionary Debate,[3] as evidenced in their circulation figures,[4] although Paine's cheaper pamphlet outsold Burke's more than six times over and was copied by activists and given away freely too. Certainly, as Rojek (2001: 108) argues, he was the most "celebrated ideologist" of revolutionary politics. Examination of all surviving Burney Archive newspaper content, including advertising, ascertains levels of public visibility, the role of celebrification in the circulation of their ideas and how political and celebrity discourses intertwined. I categorise content in three ways: firstly "public", only discussing professional work as political writers and, in Burke's case, as a member of parliament; secondly "personal", related only to private life, character or physical appearance; and finally "combined", which – to steal a phrase from Junius – made private life the counterpart of public work and political arguments. While Burke's *Reflections* was published towards the end of 1789, the entire year is included in order to consider shifts in visibility.

Both Paine and Burke were subjects of gossip-based celebrity news and information about their personal lives, which fuelled audiences' sense of "knowing" them and numerous letters from readers evidence this dynamic. They addressed both men familiarly and often discussed aspects of their private lives. Schickel might argue such mediated discussions only create an "illusion of intimacy" (1985: 4), but as Turner (2014: 26–30) explores there are social functions and powers in such "parasociality" which can affect audiences' understanding of their self-identity (see Horton and Wohl, 1956; Giles, 2010; Usher 2018). Details of Burke's private life, without any link to his political or public career, were frequent, accounting for just over 8.5 per cent of editorial. These described his insomnia (*Morning Post*, 23 April 1789), visits to Bath (*The Times*, 13 February 1790) and how he performed "the duties of a fond husband and good man ... for the benefit of Mrs Burke's health" after she made an "unfortunate mistake in administering medicine" – perhaps insinuating a suicide attempt (*The Times*, 17 September 1792).

More than a fifth (21 per cent) of all news relating to Thomas Paine *only* offered details of his private life reflecting his position, primarily, as an "achieved celebrity" and newspapers often discussed the nature of this fame.[5] *The Whitehall Evening Post* (16 August 1791) described how he "arrived to much celebrity by his political writings" and ran extracts from a biography offering details from childhood, published first in *The Times* (30 July 1791). These fake, scurrilous and often vicious accounts were advertised and syndicated in newspapers within six months of the

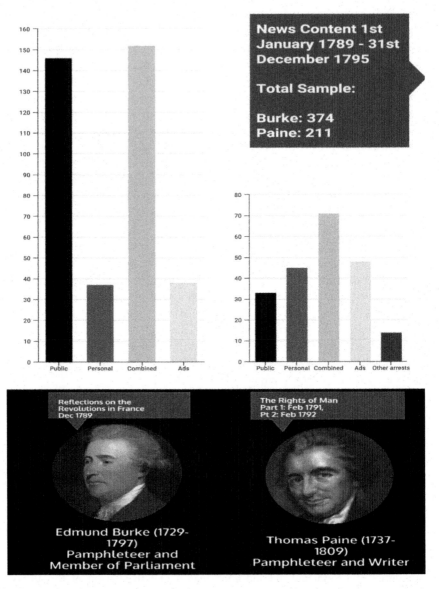

FIGURE 2.3 Newspaper discourse relating to Edmund Burke and Thomas Paine in British newspapers (1789–1795)

publication of *Rights of Man*, fuelling public curiosity about the famous pamphleteer, and in turn, boosting sales of his works. Celebrity news and even the attack itself allowed for a *cycle of empowerment* by which his public visibility increased because of ordinary people's purchases of his works, which, in turn, increased his fame and then sales again. For Paine, unlike Burke, accounts of his professional

work were *less frequent* than details of his personal life, indicating that he was understood far more as a celebrity than the long-standing "celebrated politician" (*World*, 12 November 1790). He established the model for the *celebrified journalist* whereby political beliefs and activism link to journalistic writing and performance of self.

From this stems a crucial issue with those who dispute or ignore significance of celebrity journalism during this period and its place in public spheres. When men entered coffee houses to discuss political ideas, can we really believe they checked their knowledge of celebrity status and the personal life of pamphleteers and politicians at the door? Audience letters were an important part of newspapers as public spheres and a form of popular culture that helped to form citizenry (Raymond, 2003). They were also key sites where fans showed their adoration of celebrities (Lilti, 2017: 68). As such, can we honestly separate these things? And if not, could the bourgeois public sphere really be as objective, disregard hierarchy and be more focused on the rational than the human, as Habermas described?

News about Burke and Paine evidences the "material contingency of the public/ private dichotomy" (Susen, 2011: 39) with both public and private lives often together. Discussions and debates about journalism and celebrity cultures more broadly also evidence the "ideological contingency" as conceptual representations of the historical variability of public and private spheres (p. 39). Indeed Butler (1984: 6–10) identified that many Revolutionary Debate writers viewed pamphlets and newspapers as *interconnected ways* to publicise their ideas and spark debate, and in each their own writings and discussions of them were often personalised. Their vision of citizenry shaped both cultural and political spaces. News about Burke and Paine not only concentrated on the personal but also in both cases was dominated by content, which *linked* private life to political ideas in order to support or attack (Figure 2.3: Combined category). As with the work of Junius, public and private lives were counterparts. In Burke's case, for example, this focused on breakdowns in friendships with fellow Whigs, Samuel Johnson and Charles Fox, as a reflection of political mistakes, including lengthy verses (*The Times*, 13 February 1790, "To Edmund"; *Woodfall Register*, Thursday, 11 July 1793). There were also accounts from readers about their appearances at social events, not unlike how contemporary celebrity magazines publish readers' "spots" of celebrities in public (e.g. *Public Advertiser*, 31 December 1790). Discussions focused on the authenticity of Paine's friendships too, particularly with James Macintosh, John Hooke (*Morning and Public Advertiser*, 25 November 1791) and Romantic poet William Cowper (*Woodfall Registrar,* 26 May 1791). Newspapers even imagined conversations between these friends (e.g. "Citizen Paine to Citizen Tooke", *Evening Mail*, 22 February 1793) – and also Burke and Paine – in a kind of journalistic fan fiction which considered how they might debate face to face (*Whitehall Evening Post*, 18 August 1791). This of course may well have happened. As many newspapers discussed, Burke and Paine were once friends and had even briefly shared lodgings. The nature of their personal relationship was one reason why audiences were so interested in their arguments against the other's ideas.

The cultural impact of their celebrity status was a popular topic for journalists and readers in letters too. Burke's supporters emphasised his "widely diffused share of public estimation and private deference" (*True Briton*, 16–18 April 1792) and how his writings would last "far beyond" the current age. But the anonymous "Cassandra" questioned his decision to leave the Whigs, and claimed that while it may have added to his current "celebrity", if loyal he "would have received the plaudits of the present age and of posterity" (*Public Advertiser*, 26 November 1761). By contrast, in most newspapers Paine's popularity was considered dangerous to the social order. His use of his personal life and "radical goal of communication with a wider audience in a common language" (Butler, 1984: 17) made his works so popular. And it was this, rather than the content, that ultimately led to his conviction and death sentence in 1792, by which time he had fled to France. Paine used everyday vernacular and worked with printers to make his writing affordable for all (Butler, 1984: 8). He also *maintained* his celebrity status – for example, sending letters to newspapers in which he described details of his life in exile. This strategic approach to production, dissemination and publicity shaped both the professional patterns and populist approaches of journalism and created models for journalist-as-celebrity where spectacles of opinion can direct news agendas (Usher, 2020). It also led to one of the earliest journalistic "feeding frenzies" (Sabato, 2000 [1991]), whereby multiple news publications increased levels of content specifically to vilify and humiliate in order to limit engagement with political ideas.

Put simply, in order to make the news, an event or person passes through a series of values tests that include the agendas of the publication and its owners and the values of the individual journalist (see Elias, 1994; Sonwalker, 2005: 269). If it *directly threatens those values* then it can lead to newspapers "attacking" individuals involved in it, which is simultaneously a ritual of celebrification that raises visibility of the individual and exclusion as it demands audiences reject the person and what they represent (Usher, 2018). Paine's popularity risked social and political orders and so those newspapers who wished to maintain it tried to make him the enemy. Wahl-Jorgensen and Franklin (2008: 179) discuss the "heavy ideological baggage" of journalistic language, which can linguistically exclude people based on their class, race, gender or sexuality. Criticisms of Paine were often class based; he had a "mind not disciplined by early education" and was part of the "greasy multitude" (*Oracle*, 3 October 1792). This coverage coincided with arrests and trials for booksellers caught with copies of *Rights of Man* after it was banned in late 1792 ("Other arrests" column in Figure 2.3). The impact of these events on the news agenda should not be underestimated – Paine's exile to France in September was described as the "Principal Occurrence of 1792" in the New Year lists of publications across the political spectrum, including *The Oracle, Sun* and *True Briton*. His celebrity status became a weapon, yielded by journalists to prevent their readers from engaging with his views.

It was in this attack that the use of belittling adjectives and cross publication – a familiar spectacular ritual of celebrification to readers of British tabloid newspapers and American broadcast news[6] – first emerged. Newspapers described Paine as an

outcast and traitor who was "hissed and hooted" at by crowds when making his escape into exile (*Public Advertiser*, 19 September 1792). His effigy was burnt in Devizes (*The Oracle*, 24 December 1792), Essex (*Morning Herald*, 22 December 1792), Taunton (*Morning Chronicle*, 25 December 1792) and North Yorkshire (*Morning Chronicle*, 7 January 1793). He was a devil – a "Beelzebub" (*The Times*, 14 July 1792; *Morning Herald*, 15 June 1792); a "Traitor" (*Morning Herald*, 22 December 1792) and a "public pest" who was "envious" of the wealthy (*The Times*, 7 May 1792; *Oracle*, 3 October 1792). He was "seditious" and "scandalous" (*Morning Herald*, 22 January 1793) and belittled as "Mad Tom" or "Poor Tommy" (*The Times*, 14 July 1792). Newspapers reported that they had managed to access military records from the American Revolution, which "reveal[ed] he was a thief" (*Public Advertiser*, 28 December 1792). They questioned his sexuality, with reports suggesting that his "breeches" were often found in the "water closet" (*The Times*, 11 May 1792).

While this attack had the opposite aim to Junius' – turned towards maintaining established social orders rather than challenging them – there were similarities in shape and theme. The political and personal linked together and gossip was news and comment. Another component – the inclusion of audiences – crystallised, with letters chosen because they helped to sustain the attack. Readers offered their own interpretations of him, picking through and analysing "the complexity of the image" and constructing "the variations, inflections and contradictions that work [ed] for them" (Fiske, 1991). They engaged in both semiotic and textual pro-ductivity, interacting with Paine as a celebrity product made through news media. There were also new dimensions of "othering" based on characteristics of differ-ence – in this case, Paine's class. Such "othering" became an ever more prevalent tool when more people from outside the realms of property-owning middle-class men built their own fame in order to demand a place in public spheres.

However, while the aim was to cast Paine out from public spheres, the level of interest had the opposite effect. Just as a song banned from a radio station might become number one – or how banned films become cult classics – increased visi-bility attracted more people to his arguments. The next section further explores components of attack journalism as an element of celebrity news to clarify how values of visibility offered by the emerging celebrity class in print media worked as part of the bourgeois public sphere. We will see how politics, the political, and consumer culture were brought together in order to offer a vision that women matter too in the celebration and attack on "it" girl of this age – and the first celebrity of her kind – Georgiana, Duchess of Devonshire.

The public contestation of Georgiana, Duchess of Devonshire

McKendrick et al. (1982: 11) identified a "key role to the part of the rich" who "led the way" in ushering in the new era of consumption through a "veritable orgy of spending". They described how the middle ranks of society imitated the decadence of the aristocracy both in purchase of goods and in leisure activities and

how promotion and advertising made products widely known. McKendrick et al. (1982) and Inglis (2010) also highlight emulation of the aristocracy by the middle classes as a driving force of the "consumer revolution", and how "leisure activities simply could not thrive without the endorsement and the money of the mighty" (p. 38). During the last twenty years of the 18th century, Georgiana, Duchess of Devonshire, personified this dynamic. Her celebrity chops should not be underestimated. She was a commercial brand, with retailers, manufacturers and theatre producers using the value of her visibility to advertise everything from skin powders and potions to theatre productions (Foreman, 2008). Copies of her portrait and pamphlets offering "amusing anecdotes" of her life sold in numerous print shops and the London press hailed her as "Empress of Fashion" (*The World*, 23 July 1789). Her unique clothing and beauty regimes – including hair so high she had to sit on the floor of her carriage – were widely detailed, boosting circulation for newspapers and sales of products. Devonshire was a major influencer.

She was also, arguably, the earliest *complete* example of the complex multi-media celebrity phenomenon described by Dyer in relation to 20th-century film stars (1986: 4–6). Her fame formed across literature – in self-biographical poems, a thinly veiled anonymous autobiography *The Sylph* and in numerous poems and letters by others, such as *Ode to Georgiana, Duchess of Devonshire* Romantic-poetry icon Samuel Taylor Coleridge (*Morning Post*, 24 December 1799). She was a darling of theatre and music, as subject, muse, patron and audience member (Foreman, 2008). She influenced visual culture, with numerous miniature prints of her portrait and figurines of her sold as keepsakes and many other women copied her costume and pose in a famous Gainsborough portrait for their own. As one of the earliest "celestial" goddesses of celebrity culture (*Morning Herald and Daily Advertiser*, 24 April 1785), perhaps it is unsurprising that Devonshire was also vilified. Visibility makes targets. However, it was the threat perceived by her unique brand of proto-feminism – and I use that term to indicate how she deliberately promoted "the political" through branded-self displays – which makes her a fascinating example for an examination of journalism and celebrity. For her, like the "battle-cry of second wave feminism", "the personal" was "political" (Ross, 2017: 11).

Before discussing the vitriolic attack that she endured during the 1784 parliamentary election campaign, I want to first discuss the criticism of the "political" dimensions to Devonshire's celebrified self-presentation which led up to it. To do so, it is important to unpick the differing ways the public, private and personal helped create her celebrity and politics. First, she intertwined "women's stuff" like motherhood and fashion with "men's stuff" such as electioneering and debate. She also widely performed notions of social equality through befriending those considered her inferiors, ranging from up-and-coming Whig politicians, to middle-class women and struggling artists and poets. She famously spent time talking with an Irish dustman in the street and later declared that all other compliments from men were "insipid" by comparison to his (Hone, 1838: 344). These details about her personal life were widely reported in newspapers as celebrity gossip – but there

are political dimensions to such acts too. She *embodied* a new kind of social equality, which demanded a place in public spheres for her and for those others excluded too.

Campbell (1987: 33) suggests that understanding consumer culture as driven by the desire to copy the aristocracy as one's "betters" does not allow for how the "emerging bourgeoisie … functioned as the taste-makers of society", and Devonshire also co-opted the popular aspirations and the attitudes of "polite" middle-class society into her mediatised performances of self. Paul Langford's (1998, 2002) work on middle-class "politeness" links it to fashion and describes how first it raised social aspiration and then became synonymous with the "basic standards of civil behaviour" (2002: 311). He describes how politeness and the idea of "polite society" was "paraded, described, characterised, applauded" and that this had an "enabling capacity, permitting people who lacked formal education … a place in the political hierarchy", through using "codes of behaviour" (p. 312). Devonshire's behaviour displayed this change. She popularised social behaviours and acceptance of those argued by some newspapers to be "beneath her" through widely circulated public presentations of them. Descriptions of how fashionable young "ladies", "quite in the middle class of life", followed Devonshire's "absurd fashions" (*London Gazetteer*, 1 July 1782) show influence worked both ways.

Her public friendships with people from outside the nobility was another example of such displayed social equality. For example, newspapers reported the actor David Garrick and his wife, the playwright James Sheridan and several middle-class women as part of her social circle (Foreman, 2008). By associating with different kinds of celebrities, she furthered their visibility and vice versa. Crucially, regardless of birth or rank, both sides were famous and news about them demonstrated social equality as part of the celebrity class. However, for many members of patriarchal aristocratic society – and in the newspapers that spoke for and to them – such displays were scandalous in any woman, let alone an aristocratic one. From the early 1780s, Devonshire increasingly challenged masculine dominance over both her public and private realms. In one sense, her celebratory performance of middle-class ideals of family, love and the significance of the mother during this period comment on her unhappy arranged marriage and the public indiscretions of her unaffectionate husband – her own misery as, ultimately, the property of a powerful man. However, as Deborah Chambers (2001: 42) highlights, patriarchal dominance over private realms also frames the exclusion of women from public spheres. Devonshire challenged this by displaying, for example, her motherhood and using her celebrity power to bring female labour and maternal love from the shadows through newspaper coverage of it. She sent her favourite papers copies of a poem she had written when visiting Italy, "To My Children" (*Lloyd's Evening Post*, 23 December 1799) and displayed the intimacy she shared with them in a Joshua Reynolds painting of her playing with her baby – described at the time as a glimpse into a private scene (1784). She was also the first aristocratic woman to publicly announce that she breastfed her children, for which she was praised and condemned across various newspapers. The *Morning Post*

described it as "sad ... that females in high life should generally be such strangers to the duty of a mother, as to render one instance to the contrary so singular". Charlesworth (2014) identifies that there is socio-political relevance in such celebrity displays of motherhood and her direct actions aimed to show that *it mattered* to be a mother, even perhaps as much as it mattered to be a privileged man.

While criticised for spending habits and mixing with those "below her station", it was when she *overtly* applied the value of her visibility towards party politics that celebrity news became feeding frenzy. By the turn of 1780 Devonshire was at the social epicentre of the Whig party, initially in private spheres as hostess at the bequest of her husband. In 1784, she strode confidently into politics' public spheres by campaigning for the party on the streets of London. Her politics worked differently to two models for women identified during this period by Karen Ross (2017) in her examination of *Politics, News and Gender: A Game of Three Sides*. It was neither the "quiet influence" of the wife, such as that of US First Lady Abigail Adams (1789–1802), nor the open call to arms for women of Mary Wollstonecraft's *A Vindication of the Rights of Women* (1791). Rather, she used the level and narrative of her fame – born from extravagance, spending, social impropriety, motherhood, female importance in private spheres – to challenge her marginalisation from public spheres. Her displays of social equality or celebration of middle-class values and motherhood became a model through which Devonshire celebritised, feminised and even revolutionised political campaigning.

Biographer Amanda Foreman (2008: 141–148) describes personalised interaction, including holding the babies of people she met on the street, drinking tea with the wives of merchants and ale with tradesmen as she debated with them in taverns. Devonshire developed a new range of affordable "Whig coloured" fans for women sold at hustings (*The London Chronicle*, 3 April 1785). Her message was clear – both *her and their* political opinions mattered. Although hailed by the Whig-supporting press as resembling those "fair celestials of the Grecian bard ... forming a shield for the heroic leader of an oppressed people" (*Morning Herald and Daily Advertiser*, 24 April 1784), there was widespread condemnation which declared that these women were simply "too ignorant to know that they meddle with what does not concern them" (*The Morning Post*, 8 April 1784). Tory-supporting papers, such as *The Morning Post* (1772–1937), the *World and Fashionable Advertiser* (1787–1790) and the *Morning Herald* (1780–1869), particularly used misogynistic language that reflected many of the ways newspapers still reinforce sexual difference in order to "bring into question the nature of democratic discursive space and women's participation in it" (Holland, 1998: 28).

Patricia Holland (1983; 1998) identified how by limiting women to the gendered roles of wife, mother or sexual object there is little room in newspapers "for the expression of women's democratic aspirations and public participations" (1998: 28). As Devonshire's behaviour was an outrage to "common decency in a married woman" (*The Morning Post*, 8 April 1784), it was fair game to question her sexual decency too. They insinuated that she bought votes with kisses, slept with shopkeepers (*Morning Post*, 31 March and 8 April 1784) and printed pornographic

cartoons of her in bed with politicians, including a particularly lewd set sold in print shops in April 1784. A spell "out of town" was described as being for "the benefit of - - - the country", where "the horses are crying out for quarter and the Foxes would do the same", a thinly veiled insinuation that she and Whig leader Charles Fox were having an affair (*World and Fashionable Advertiser*, 20 February 1787). This early account of celebrity electioneering helped to establish the many ways newspapers represent women when they challenge masculine dominance over social and political fields. First, newspapers represent women specifically in relation to their domestic roles – wife, mother – as a mechanism to show them as "other" to the expert voice of the white male (Hartley, 1996: 138–139) and thus the value placed on their opinions. Second, they may sexually humiliate as a mechanism to shame them into silence.

While the role of celebrity in political advocacy and its impact on journalistic coverage of elections is a focus of much recent scholarly activity, Devonshire's campaigning shows it has been part of mediated political campaigning since the time of the bourgeois public sphere. Journalists attacked because she dared to *use* her celebrity status in order to claim a political voice. They used public humiliation to attempt to marginalise her from public spheres – a dynamic that continues to this day when the sex lives, spending habits and misdemeanours of youth are used against contemporary female politicians as a means to limit their voice (Ross, 2017: 81–116). Publicly at least, she made light of it all and even attempted to turn the narrative to her own ends. She appeared with a huge foxtail in her hat as a response to newspaper accounts of her having an affair with Fox, much to the delight of the campaign-trail crowds (*London Chronicle*, 5 April 1784). However, personal letters with family discussed how she felt humiliated and was concerned about the impact on her "reputation" and children (*Papers and Correspondence of the Spencer Family*, 11 April and 13 April 1784).

As the attack continued across several newspapers, like that against Thomas Paine, the productivity of readers perpetuated it. Numerous newspapers published anonymous letters, some of which joined the attack and others defending her through celebration of her role as a fashion icon, maternal displays and political life. These letters indicated the significance of the audience "at the centre of the power of celebrity" from the start and as a means to both construct "norms of individuality" (Marshall, 1997: 61) and naturalise new socio-political realities. Some letters questioned whether women such as her – and by extension any woman claiming individualised emancipation – had any sort of place in press discourse or public spheres. Such participation appeared to reflect increased freedoms of speech, but reinforced social hierarchies that limited a woman's right to it. As today, audiences located the discourses around these celebrities from their own ideological positions. This early example of attack journalism demonstrates how it emerged as both a process of moral argumentation and a mediated ritual of celebrification.

Towards the 19th century

The intercommunications between journalism and celebrity at the time of the 18th-century consumer revolution and bourgeois public sphere have much to teach us about how and why democratic politics, celebrity, society and identity intertwine in news media. Capitalist democracy established itself in relation to notions of citizenship and consumerism, each viewed as crucial to self-identity and fulfilment. Celebrity allowed for effective circulation of images of identity and society and offered figures for emulation parts of their use by promotional and news cultures to this day. This established the need for mechanisms to reject those who challenged the parameters of new systems, which governed the political, and politics in everyday life. Such things shaped the use of celebrity in relation to citizenry made culturally and politically throughout the subsequent Chartist and early Victorian periods.[7]

Newspapers, at the bequest of the powerful, old and new – parliamentary patronage, the aristocracy, entrepreneurial middle-class owners – worked hard to establish a vision of citizenry linked to commercial and political consensus and stability rather than revolutionary politics. The authentic self, the citizen self and the consumer self were established together via the lenses of capital and political power structures and in relation to dominant representations in culture. Junius' attacks on the aristocracy in the 1770s coincided with the demise of the aristocracy's position as the most prominent social group. As middle-class "achieved" celebrities usurped their place, newspapers simultaneously rejected old societal structures and identity (through attack), offered replacements (celebrities for emulation) and turned both towards the construction of systems of consumer capital and political consensus. The Duchess of Devonshire straddled both social groups and turned her unique value of visibility towards challenging aristocratic and patriarchal dominance over public and private spaces. This made her a considerable threat. Perhaps the most fascinating thing we can take from the paradoxes of public and private in journalism and celebrity – and as reflections of both deliberative democracy and consumer capital – is that they were only made possible because of freedoms of speech and press won by publishers who revealed the secrets of the famous. The press quickly turned discourses that challenged political and social hegemony towards maintaining the new versions of it they supported. Freedom of expression became a means by which some argued against other people's rights to it and "other" to cast them from public spheres. This contradiction – how celebrity journalism can wrap itself in the cloak of freedom of speech while working to limit it – is one of its longest-standing dynamics. As we move next from the 18th to the 19th century, we will explore New Journalism as the next wide-scale change in the development of journalism and celebrity cultures and how its dynamics and rituals reformed to establish tabloidism as a transatlantic cultural sphere.

Notes

1 The *Daily Courant* (1702–1735) first published in Fleet Street by Elizabeth Mallett. It changed names to the *Daily Gazetteer* (1735–1746), *Daily Gazetteer and London Advertiser* (1746–1748), *London Gazetteer* (1748–1753), *Gazetteer & London Daily Advertiser* (1753–1764), *Gazetteer & New Daily Advertiser* (1764–1796), *The Gazetteer* (1796–1797).
2 Of course, there is slippage between these categories, both ascribed (from lineage) and achieved (talented) celebrities are media products like attributed celebrities. Throughout this text I use these terms to refer to the *primary* reason for press attention and action.
3 Butler (1984: 6) discusses the "closely knit circle" who devised pamphlets around "Johnson's dinner table".
4 Sales of Burke's *Reflections* exceeded 30,000 copies in two years. By comparison, conservative estimates claim Paine's *Vindication* sold more than 150,000 copies in two years and the author himself claimed more than a million had been sold by 1809 (Butler, 1984: 108).
5 Paine first became a public figure in Britain after publication of *Common Sense* and because of his role in the American Revolution (1776), but his fame rapidly increased during this period.
6 See chapter 5, 'Tabloids, television and the neoliberal soap opera'.
7 For example, in news produced about the Tolpuddle Martyrs who were "conferred prominence" through increased content about them in the radical newspaper the *Northern Star* and vilified across mainstream newspapers (Curran, 2018b: 15).

References

Allan, S. (2003) "Foreword", in N. Stevenson, *Cultural Citizenship*. Maidenhead, UK: McGraw Hill.
Anderson, B. (1991) *Imagined Communities: Reflections on the Origin and Spread of Nationalism*. London: Verso.
Barnhurst, K. and Nerone, J. (2009) "Journalism History", in K. Wahl-Jorgensen and T. Hanitzsch (eds.) *The Handbook of Journalism Studies*. New York: Taylor & Francis.
Benhabib, S. (ed.) (1996) *Democracy and Difference: Contesting the Boundaries of the Political*. Princeton, NJ: Princeton University Press.
Black, J. (1987) *The English Press in the 18th Century*. London: Routledge.
Boorstin, D. (1961) *The Image: A Guide to Pseudo-Events in America*. New York: Random House.
Braudy, L. (1986) *The Frenzy of Renown*. New York: Oxford University Press.
Butler, M. (1984) *Burke, Paine, Godwin and the Revolution Controversy*. Cambridge: Cambridge University Press.
Calhoun, C. (1992) "Introduction: Habermas and the Public Sphere", in C. Calhoun (ed.) *Habermas and the Public Sphere*. Cambridge, MA: MIT Press.
Campbell, C. (1987) *The Romantic Ethic and the Spirit of Consumerism*. London: Blackwell.
Carey, J.W. (1974) "The Problem of Journalism History". *Journalism History*, 1(3/5): 27.
Chambers, D. (2001) *Representing the Family*. London: Sage.
Charlesworth, D. (2014) "Performing Celebrity Motherhood: Courting Homage and Disaster". *Celebrity Studies*, 5(4): 508–520.
Cohen, R. (1994) *Frontiers of Identity*. London and New York: Longman.
Colley, L. (2009) *Britons: Forging the Nation 1707–1837*. New Haven, CT: Yale University Press.
Conboy, M. (2004) *Journalism: A Critical History*. London: Sage.
Conboy, M. (2014) "Celebrity Journalism: An Oxymoron? Forms and Functions of a Genre". *Journalism* 15(2): 171–186.

Curran, J. (2018a) "The Moral Decline of the Press", in J. Curran and J. Seaton (eds) *Power without Responsibility*. 8th edn. London: Routledge. pp. 172–192.

Curran, J. (2018b) "The Struggle for a Free Press", in J. Curran and J. Seaton (eds) *Power without Responsibility*. 8th edn. London: Routledge, pp. 8–20.

Dalghren, P. (2003) "Reconfiguring Civil Culture in the New Media Milieu", in J. Corner and D. Pels (eds) *Media and the Restyling of Politics*. London: Sage.

DeLuca, M. and Peeples, J. (2002) "From Public Sphere to Public Screen: Democracy, Activism, and the 'Violence' of Seattle". *Critical Studies in Media Communication*, 19(2): 125–151.

Dyer, R. (1979) *Stars*. 1998 edn. London: BFI.

Dyer, R. (1986) *Heavenly Bodies: Film Stars and Society*. New York: St Martin's Press.

Elias, N. (1994) *The Established and the Outsiders: A Sociology Enquiry Into Community Problems*. London: Sage.

Eronen, M. (2014) "Moral Argumentation as a Rhetorical Practice in Popular Online Discourse". *Discourses and Communication*, 8(3): 278–298.

Fallows, J. (1997) *Breaking the News: How the Media Undermine American Democracy*. New York: Vintage.

Fawcett, J. H. (2016) *Spectacular Disappearances: Celebrity and Privacy 1696–1801*. Ann Arbour, MI: University of Michigan Press.

Fiske, J. (1991) "The Cultural Economy of Fandom", in L. Lewis (ed.) *The Adoring Audience: Fan Culture and Popular Media*. London: Routledge, pp. 30–39.

Foreman, A. (2008) *The Duchess*. New York: Penguin Random House.

Fox-Bourne, H.R. (1998) *English Newspapers*. London: Routledge.

Fraser, N. (1992) "Rethinking the Public Sphere: A Contribution to the Critique of Actually Existing Democracy", in C. Calhoun (ed.) *Habermas and the Public Sphere*. Cambridge, MA: MIT Press.

Giles, D. (2010) *Psychology of the Media*. Basingstoke, UK: Palgrave.

Goodwin, J. (2005) "The Public Sphere and the Norms of Transactional Argument". *Informal Logic*, 25(2): 151–165.

Habermas, J. (1989) *The Structural Transformation of the Public Sphere*. Cambridge, MA: MIT Press.

Hallin, D. (1994) *We Keep America on Top of the World: Television Journalism and the Public Sphere*. London and New York: Routledge.

Hartley, J. (1996) *Popular Reality: Journalism, Modernity, Popular Culture*. London: Arnold.

Holland, P. (1983) "The Page Three Girl Speaks to Women, Too". *Screen*, 24(3): 84–102.

Holland, P. (1998) "The Politics of the Smile: 'Soft News' and the Sexualisation of the Popular Press", in C. Carter, G. Branston and S. Allan (eds) *News, Gender and Power*. New York and London: Routledge.

Holmes, S. and Redmond, S. (eds) (2007) "Introduction: What is a Reader", in *Stardom and Celebrity: A Reader*. London: Sage.

Hone, W. (1838) "Beauty: A Natural Compliment". *The Every-day Book and Table Book*, vol. 3, ed. William Hone. London.

Horton, D. and Wohl, R. (1956) "Mass Communication and Para-social Interaction: Observations on Intimacy at a Distance". *Psychiatry*, 19: 213–229.

Howson, J. (1969) "Who Was Moll Flanders?" *Times Literary Supplement*, 18 January.

Hume, D. (1757 [1777]) *The Dissertation of the Passions*. London: A. Millar.

Inglis, F. (2010) *A Short History of Celebrity*. Woodstock: Princeton University Press.

Lake, P. and Pincus, S. (2006) "Rethinking the Public Sphere in Early Modern England". *Journal of British Studies*, 45(2): 270–292.

Langford, P. (1998) *A Polite and Commercial People*. Oxford: New Oxford Press.

Langford, P. (2002) "The Uses of 18th Century Politeness". *Transactions of the Royal Historical Society*, 12: 311–331.

Lilti, A. (2017) *The Invention of Celebrity*. Cambridge: Polity Press.

Luckhurst, M. and Moody, J. (2005) *Theatre and Celebrity in Britain. 1660–2000*. Basingstoke, UK: Palgrave Macmillan.

Marshall, D. (1956) *English People in the Eighteenth Century*. London: Longmans, Green.

Marshall, P.D. (1997) *Celebrity and Power: Fame in Contemporary Culture*. Minneapolis, MN: University of Minnesota Press.

McGuigan, J. (2002) *Culture and the Public Sphere*. London and New York: Routledge.

McKendrick, N., Brewer, J. and Plumb, J. (1982) *The Birth of Consumer Society*. London: Europa Publications.

Miller, T. (2012) "Journalism and the Question of Citizenship", in S. Allan (ed.) *The Routledge Companion to News and Journalism*. Abingdon, UK: Routledge, pp. 397–406.

Mole, T. (2009) *Romanticism and Celebrity Culture 1750–1850*. Cambridge: Cambridge University Press.

Morgan, S.J. (2010) "Historicising Celebrity". *Celebrity Studies*, 1(3): 366–368.

Morgan, S.J. (2011) "Celebrity". *Cultural and Social History*, 8(1): 95–114.

Raymond, J. (2003) *Pamphlets and Pamphleteering in Early Modern Britain*. New York: Cambridge University Press.

Rea, R. (1963) *The English Press in Politics, 1760–1774*. Lincoln, NB: University of Nebraska Press.

Richards, B. (2012) "News and the Emotional Public Sphere", in S. Allan (ed.) *The Routledge Companion to News and Journalism*. London and New York: Routledge, pp. 301–311.

Roberts, J.M. and Crossley, N. (2004) "Introduction", in N. Crossley and J.M. Roberts (eds) *After Habermas: New Perspectives on the Public Sphere*. Oxford and Malden, MA: Blackwell Publishing.

Rojek, C. (2001) *Celebrity*. London: Reaktion.

Ross, K. (2017) *Politics, News, Gender: A Game of Three Sides*. Oxford: John Wiley Press.

Sabato, L. (2000 [1991]) *Feeding Frenzy: Attack Journalism and American Politics*. New York: Lanahan.

Schickel, R. (1985) *Intimate Strangers: The Culture of Celebrity in America*. Chicago: Ivan R. Dee.

Sonwalker, P. (2005) "Banal Journalism: The Centrality of the 'Us-Them' Binary", in S. Allan (ed.) *Journalism: Critical Issues*. Maidenhead: Open University Press, pp. 261–273.

Stevenson, N. (2003) *Cultural Citizenship*. Maidenhead, UK: McGraw Hill.

Susen, S. (2011) "Critical Notes on Habermas' Theory of the Public Sphere". *Sociological Analysis*, 5(1): 37–62.

Swaminathan, S. (2003) "Defoe's Alternative Conduct Manual: Survival Strategies and Female Networks in Moll Flanders". *Eighteenth Century Fiction*, 15(2): 185–200.

Taylor, C. (1989) *Sources of the Self: The Making of the Modern Identity*. Cambridge: Cambridge University Press.

Tiger, R. (2015) "Celebrity Gossip Blogs and the Interactive Construction of Addiction". *New Media & Society*, 17(3): 340–355.

Tillyard, S. (2005) "Celebrity in 18th Century London". *History Today*, 55(6): 20–27.

Turner, G. (2014) *Understanding Celebrity*. 2nd ed. London: Sage.

Usher, B. (2018) *(ed) The State of the Media*. London: Byline Media.

Usher, B. (2020). "The Celebrified Journalist and the Opinion Spectacle: Journalism's Changing Place in Networked Public Spheres". *Journalism*, 20 January. Online.

Wahl-Jorgensen, K. (2007) *Journalists and the Public: Newsroom Culture, Letters to the Editor and Democracy*. Cresskill, NJ: Hampton Press.

Wahl-Jorgensen, K. and Franklin, B. (2008) "Journalism Research in Great Britain", in M. Löffelholz and D. Weaver (eds) *Global Journalism Research: Theories, Methods, Findings, Future*. New York: Blackwell, pp. 172–184.

Wahrman, D. (2004) *The Making of the Modern Self: Identity and Culture in Eighteenth-Century England*. London and New Haven, CT: Yale University Press.

Weaver, K., Motion, J. and Roper, J. (2006) "From Propaganda to Discourse (and Back Again): Truth, Power, the Public Interest, and Public Relations", in J. E'tang and P. Magda (eds) *Public Relations Critical Debates and Contemporary Practice*. Mahwah, NJ: Lawrence Erlbaum, pp. 7–21.

West, D.M. and Orman, J. (2003) *Celebrity Politics*. Upper Saddle River, NJ: Prentice-Hall.

Williams, R. (1965) *The Long Revolution*. Harmondsworth, UK: Penguin.

Williams, R. (1989) *Resources of Hope*. London: Verso.

Williamson, M. (2016) *Celebrity: Capitalism and the Making of Fame*. London: Polity Press.

Press (cited 18th-century newspapers)

British Journal & Daily Journal (1720s)
Diary or Woodfall Registrar (1789–1793)
General Evening Post (1710–1732)
Independent Chronicle (1776–1840)
London Chronicle (1757–1823)
London Evening Post (1727–1797)
Lloyd's Evening Post (1757–1808)
London Packet or New Lloyd's Evening Post (1770s)
Morning Chronicle and London Advertiser (1769–1865)
Morning Herald and Daily Advertiser (1780–1869)
Oracle and Public Advertiser (1770–1794)
Public Advertiser (1752–1793)
St James' Chronicle (1761–1843)
The Critical Review (1756–1817)
The Morning Post (1772–1937)
The Daily Courant/Daily Gazetteer (1702–1797)
The Times (1788–present)
Weekly Journal (1704–1720s)
Whitehall Evening Post (1718–1801)
The World and Fashionable Advertiser (1787–1802)
True Briton (1723–1793)

3

CELEBRITY AND THE NEW JOURNALISM

Victorian New Journalists reimagined print news as a reflection of reshaped nations that valued innovation, invention, empire, enterprise and the capitalist values that underpinned all these things. Print news developed sets of language that linked "individual to individual in [a] massive agglomeration of power" (McLuhan, 1964: 188) and the press became the "context in which people lived and worked and from which they derived their sense of the outside world" (Shattock and Wolff, 1982: xv). New Journalism emerged as a fully commercialised press model, where human interest and celebrity stories "differentiate[d] … from the dull routine of news agencies" (Conboy, 2004: 174) to make popular products that attracted both audiences and advertisers (Curran et al., 1980; Williamson, 2016). Politically, socially and commercially radical journalists on both sides of the Atlantic developed many of the cultures, constructs and commercial powers of contemporary celebrity journalism and reshaped the celebrity class to include the first narratives of stardom as a glittering, entirely mediated vision of self-identity. What emerged was the first combined image and textual representations of the famous and, as a result, spectacular media discourses that became familiar in the 20th century as part of what Guy Debord (1967) described as a *Society of the Spectacle*.

"New Journalism" was initially a derisory term coined by poet and cultural critic Matthew Arnold (1822–1888), who, in *Culture and Anarchy* (1869), criticised it as "feather-brained" despite it being full of "ability, novelty, variety, sensation, sympathy and generous instincts" (pp. 689–689). This has similarities to Debord's (1967) discussions of 20th-century mass media and many contemporary condemnations of the tabloidisation and celebritisation of news. They argue, in brief, that the priorities of corporate capital result in news as popular culture and that its symbolic and sensational constructions of reality distract audiences from significant political, social and economic events. To sustain what Boyce (1978: 21) described as the "political myth" invented by the 19th-century press that journalists hold a unique "place in the sun" as arbitrators of democracy, then other aspects of news culture are often classed as "lesser", not journalism, or their existence at this time even denied. However, doing so can miss some of its most important social and political

functions. Popular journalism linked the construction of public self to both textual and visual representations of the private made for public consumption. There were, of course, elements of the spectacular to this and certainly, as this chapter identifies, New Journalists shaped much of corporate media and political communications' uses of celebrity as a means towards social domination. But this was not the only – indeed, not often even the principal – aim of many journalists who developed significant and "spectacular rituals of celebrification" (Couldry, 2002; Turner, 2014). Pioneers of tabloid news often had radical visions for social liberalism and inclusion, the tearing down of systems of privilege, universal suffrage and greater protections for the poorest.

Indeed, we cannot fully understand the ideological, political and subliminal environments of journalism without consideration of how it used celebrity to *both* perpetuate the social structures of capitalism *and* to battle for radical social and political changes. As American scholar Ponce de Leon (2002: 4) argued, celebrity news as it emerged in this period was "not some grotesque mutation afflicting an otherwise healthy organism, but one of its central features". Many British histories of newspapers consider the place of celebrity in their populism and active approach to both use of language and relationships with readers. Martin Conboy (2002, 2004, 2010), for example, has produced several accounts of how newspapers moved towards formats and contents that are familiar to contemporary audiences. To understand the place of New Journalism in the development of celebrity culture and as part of societies shaped by their media spectacles, this chapter focuses primarily on how celebrification developed through relationships between British and American news pioneers who strove for commercial success and social inclusion and to shape citizenry in relation to these things. On both sides of the Atlantic, such trailblazers invented the celebrity interview as a language of stardom, linked it to photographic images, and developed both glamorous front-of-house and intimate behind-the-scenes insights into the lives of the famous. They expanded linguistic and thematic tools of gossip and the way that ordinary people are celebrified to shape cultural citizenship and political activism. As journalists and celebrities too, these men turned narratives of individuality and the value of their own visibility towards the creation of news discourses and campaigns that balanced "ordinary" and "extraordinary" and developed key facets of both celebrity culture and stardom (Braudy, 1986; Dyer, 1979; Turner, 2013). Before we examine some of these important individuals and their works in more detail, let us first consider how relationships between journalism and celebrity changed as part of the political and socio-cultural transformations of this time.

Transatlantic journalism and celebrity cultures

By the end of the 19th century, British and American editors were attune to the commercial opportunities of populist news, against a backdrop of social upheaval, commercial and industrial revolution, emigration and immigration, new ideas of self-identities and propriety and control, and ordinary people trying to make their

way through it all. Both Schudson (1978) and Ponce de Leon (2002) argued that we should view developments of the American industrial press and the modern city together, with celebrities in print reflecting the "changing web of social relations" (Schudson, 1978: 102). Similarly, Inglis (2010: 115–117) highlighted how newspaper gossip columns and the "glittering novelty" of "stop press", "latest news" and "simple headlines" enabled "400 people in fashionable New York" to become the lens through which American capitalism came to "tell itself what was going on and how things ought to be" (p. 118). Williamson (2016: 50) argues that the American industrialised press developed many techniques of reporting that "continue to sustain celebrity culture across the world". Both pinpoint Pulitzer as the first newspaper proprietor to make gossip a routine of news and his influence on Randolph Hearst, who bought and transformed newspapers with lightning speed and filled them with "revelation, exposure and 'muckraking'" (Inglis, 2010: 119). Certainly, Hearst provided the mould for the 20th-century press baron through his acquisition or launch of a diverse portfolio of publications, investment in new media technologies and demands for political influence.

In the UK, Alfred Harmsworth (later Lord Northcliffe) climbed from lowly freelancer for periodical magazines, gossip pamphlets and "penny dreadfuls" to the national newspaper market. Within a decade he launched the *Daily Mail* (1896–current), the *Daily Mirror* (1903–current) and their Sunday sister papers. He then rescued the *Observer* (1791–current) and *The Times* (1788–current), which were on the brink of bankruptcy, and in doing so ensured they survived to become the world's longest surviving Sunday and daily newspapers respectively. Northcliffe coined the word tabloid (Örnebring and Jönsson, 2008: 27–28) and made many of the rules of influence between newspaper magnates and British government, and it was perhaps because of this that publications survived when many of the others considered in this chapter fell away. Williamson (2016: 57–58) describes how he imported "the techniques of journalism from the US including the innovations in reporting style" of American media magnates and the advertising-revenue business model of the press. However, as I explore here, Northcliffe's main influences – not least, because he worked as a freelance reporter under their editorships and alongside them – were British New Journalists who had already, in their own words, "acclimatised" American news techniques. They built industrialised news production into the British press's established discourses of celebrity as a means to shape the politics of readers and build commercially viable publications.

Ponce de Leon (2002: 41) argued US public figures only became celebrities when subjected to models of presentation via conventions of journalism that developed "in the mid-19th century" but was "not complete until the 1920s" and Marshall (2005: 20) identified this as when "reportage on the personality of the famous" first appeared. Last chapter, I evidenced how journalism and celebrity developed together in the 18th century because of radical changes in society and self-identities that were *mass circulated* for the first time. Here I argue that in the late 19th century there was a second boom in celebrity journalism and that this, once again, reflected increased urbanisation, consumer spending and advertising and

improved literacy. The first *mass-industrialised* media – as facilitated by the invention of the mechanised printing press, wires and the telephone – perpetuated these things. Within thirty years (1880–1910), no fewer than 120 newspaper titles launched in the UK and 65 in the US cities of New York, Boston, Washington, Chicago and Philadelphia alone (Wiener, 1988; Conboy, 2002). Celebrity journalism as a broader discourse than just news was made here through creation of symbolic mediated spectacles that influenced social interactions and audiences' capacities to read and understand them.

James Curran (1978: 67–70) explored how New Radicals and Chartists earlier in the 19th century had simplified the language of news, which, when combined with commercial and popular interests of press owners, formed the model of the "free press". Radicals adopted rituals of celebrification to raise the visibility of their leaders and to attack those in positions of power. At the same time, the "penny press" emerged in the USA – and New York particularly – to speak *to* the "common man", including the *New York Sun* (1833–present), *New York Herald* (1835–1924) and then with the launch of the *New York Tribune* (1841–1866), also began to speak *for* them and campaign for their rights (Örnebring and Jönsson, 2008: 29–30). These redefined "the concept of news" into something more accessible and sensational, and employed veteran British reporters to pioneer new ways to tell stories (p. 29). This included early use of direct speech, although interview practices, for example, were very different to the newsgathering process they became in the UK. By the end of the 19th century, ownership of the popular press had moved almost entirely "into the hands of capitalist entrepreneurs" (Curran, 1978: 68). Curran was one of the first scholars to challenge understandings of the press as agent *between* government and people – that is, free forums for ideas and purveyors of public information (pp. 51–52). He argued it was better understood as an "agent of social control" and challenged orthodoxy that this was a "Golden Age" for journalism, built around "objectivity, balance and accuracy" (p. 51). Ponce de Leon (2002: 31) claimed that ideals of balance and objectivity shaped US celebrity reportage because, as "self-styled arbiters of truth, reporters and editors were compelled to view public figures with a new scepticism". But this is simplistic, not least because "celebrity gossip" and "attack journalism" – as we explored in the last chapter – had been around for at least a century and therefore predated notions of journalistic objectivity.

Williamson (2016) brings some elements of such discussions together to highlight that before market forces moved in, many British newspapers of the late 19th century were both populist and politically radical. But the New Journalism examined here was radically opinionated, shrewdly political *and* commercial. Conboy (2002: 77) discussed how the mainstream press played a significant role in "creating a sense of continuity across space better understood as a national community" (see also Anderson, 1991; Colley, 2009). This reflected Britishness and empire in the UK and the unification of immigrant communities and urbanised living in the USA, which formed the idea of the "American" and their "Dream". Celebrity journalism functioned as a *social ambience* that depicted, for example, potentials of

self-fulfilment through consumer cultures and leisure activities and thus encouraged "positive identification with the social system[s]" of capitalism and democracy (Curran, 1978: 72). It also challenged political and social status quos.

As Charles Taylor identified (1989: 393), the two "big and many-sided cultural transformations" of the Enlightenment and Romanticism, with their "accompanying expressive conception of man [...] made us who we are". The first principle of celebrity culture, as explored in the last chapter, was how it facilitated social cohesion by encouraging the public to view themselves as both citizens and consumers within newly formed nations. Editors realised both the commercial and the political opportunities afforded by celebrity news and produced more. By the late 19th century the "dominant principle became language" (p. 415) and celebrity journalism led linguistic explorations of moral imperatives of the age, such as the "idea of universal benevolence"; an "imperative to reduce suffering"; the continued significance of "ordinary life" and the right of "universal justice" (pp. 394–395). These intertwined with Romantic sentimentalism, individualist self-fulfilment and Enlightenment rationality as the original themes of celebrity as national-press-popular and, as a result, more "ordinary people" became visible in the pages of newspapers and magazines than before. There were social implications to this, not least that together these ideologies supported steady rises of democracy, capital and consumerism, activism and individualism, which through the lens of celebrity news and journalism are, not opposed concepts, but points on the same sphere. Visions of self-identity circulated in spectacular celebrity news and journalism at this time therefore were *liberating*, if, for example, we accept individual freedom, social mobility and democracy as liberations. They were also *repressive*, if, for example, we view consumer culture, capital and individual over community, as not.

One of the reasons celebrity news flourished once more is it helped to sell newspapers, but it was not only a question of economics. Liberal politics and the spirit of commercial enterprise motivated leading New Journalists in both Britain and America, such as W.T. Stead (1849–1912), George Newnes (1851–1910), T.P. O'Connor (1848–1929) and Randolph Hearst (1863–1951). Stead and Newnes were educated together at Silcoates – then a radically liberal school for the sons of Congregational ministers and missionaries (Jackson, 2001: 20–21) – and championed universal suffrage, healthcare and education. Newnes and O'Connor were both Liberal MPs, with the latter viewed as revolutionary because of his demands for workers' rights and Irish republicanism. His mainstream appeal and place in parliament despite his radicalism demonstrates how far freedoms of speech had come in a hundred years (see chapter 2). American press baron Randolph Hearst was Stead's professional ally and firmly in the liberal political camp and they shared their ideas about "governance through journalism". He stood as a Democratic congressional representative and aimed to use the popularity of his newspapers to effect social and political change. Each were not only populists in terms of the construction, production and dissemination of news content but also celebrities in their own right, and their public visibility was a key component of their journalism's popularity and vice versa. These men *embodied* links between the radical,

celebrity, political journalist from the Chartist era and the commercial and professionalised 20th-century journalist.

Given well-documented contact between them, it is disappointing that so few examinations of journalism's histories consider personal connections and their impacts on news development. Joel Wiener (1988, 1994) examined "transatlantic journalism" in most detail, but he viewed it as largely a West to East exchange and similarly it is the mass-industrialisation of the American press that Williamson (2016: 49–51) and Ponce de Leon (2002) consider as the driving force of increased use of celebrities in print. But rather than simply adopting American techniques, W.T. Stead described New Journalism as a process of *acclimatisation* to British news and how this influenced American developments too (1901: 293). In a "character sketch" of Hearst, W.T. Stead described their shared vision for news as an "Atlantic liner, fitted up with the latest improvements, with the best machinery, a first-class crew, a crowded complement of passengers" (*The Review of Reviews*, October 1908). He was thrilled when Hearst adopted principles of "governance through journalism" and pondered "what impression my unceremonious discourse had made upon the mind of Mr. Hearst". New Journalism refocused and reformed celebrity journalism as a cross-cultural social phenomenon and, in doing so, developed many of its current forms and shapes. When writing his prophetic *The Americanization of the World or The Trend of the 20th Century* (1901), Stead contemplated the changes in terms of both British and American societies. He spanned politics, language, colonisation, literary and cultural influences in music, sports, arts and, in the "How America Americanizes" section, focused on journalism. Stead argued that innovations in news would provide key tools to aid US cultural dominance over the rest of the English-speaking world and that such a change was a *natural progression* from British cultural dominance:

> If we are inflicted with national vanity we can console ourselves by reflecting that the Americans are only giving to others what they inherited from ourselves. Whatever they do, all goes to the credit of the family. It is an unnatural parent who does not exult in the achievements of his son, even though they eclipse the triumphs of his sire.
>
> *(1901: 2)*

Wiener (1988: 58–59) argued New Journalists were "fathers of the popular press" in Britain because they celebrated American methods, refocused foreign news from Europe to America, experimented with genres and expanded readerships. But what this demonstrates is the "back and forth" nature of the exchange. This was underpinned by the reframing and extension of 18th-century traditions of celebrity culture explored in the last chapter. In addition, British new journalists recruited other London-based creatives – such as photographer and inventor Henry Van der Weyde, typographer and illustrator Cathinca Amyot and authors Joseph Conrad Doyle – to create new discourses that reflected and expanded the celebrity class. Celebrity journalism at this time formed at the crossroads of cultural influence and

creative dynamism as the balance of global power shifted from the old world to the new.

It would be a mistake to consider New Journalism as an entirely cohesive movement, and indeed one of the gaps in some examinations of journalism is that they look to broad institutional dimensions and transcendental ontological assumption, but not intricacies, nuances and people. T.P. O'Connor's parliamentary and celebrity gossip columns reflected his advocacy of the "more personal tone of the modern methods" (1889: 423) to make the workings of government accessible to the newly literate working classes. He created fast-paced spectacles that blurred lines between celebrities from the world of entertainment or High Society and politicians in order to engage more people in the systems of democracy and his own campaigns. Stead used the force of his own personality to express his political and social views, whereas O'Connor focused on "object" and the deeds and personalities of celebrities as a tool of social and political representation (Salmon, 2000: 28). Stead and Newnes, while childhood friends and erstwhile business partners, also had different views, as outlined in a letter from Newnes when they parted company just three months after they co-launched *Review of Reviews* in 1890:

> There is one kind of journalism which directs the affairs of nations; it makes and unmakes cabinets; it upsets governments; builds up Navies and does many other great things. It is magnificent. This is your journalism. There is another kind of journalism, which has no great ambitions. It is content to plod on, year after year, giving wholesome and harmless entertainment to crowds of hardworking people, craving for a little fun and amusement. It is quite humble and unpretentious. This is my journalism.
>
> *(George Newnes to W.T Stead (1890) in Friederichs (1911: 116–117))*

Such tensions and differences shaped different components of journalism and celebrity cultures and underpin its ambivalent and multifunctional relationships to this day.

A brief timeline of key developments clarifies how many of journalism's rituals of celebrification emerged through cross-cultural, radically commercial and political relationships. As explored further in the next section, 22-year-old W.T. Stead became editor of regional newspaper the *Northern Echo* in 1871, whereupon he set about turning it into a popular newspaper. London and American newspapers syndicated many of his interviews, particularly in relation to the Mary Ann Cotton serial killer case (1873–1874). By the 1880s, interviewing was a norm for the British press and inspired Edmund Yates' "Celebrities at Home" (1877–1879, see Salmon 1997), which Stead then adapted and extended for his infamous *Pall Mall Gazette* interviews (1883–1885). Shortly beforehand, Stead advised school friend George Newnes as he launched his new magazine *Tit-Bits* (1881–1989) – analysed later in the chapter – which Alfred Harmsworth (later Lord Northcliffe) was so impressed by, he volunteered as a freelance writer. The future media magnate described how "this man who has produced Tit Bits has got hold of a bigger thing

than he imagines. He is only at the beginning of a thing that will change the whole face of journalism. I will try and get in with him" (in Pemberton, 2016: 23). In 1887, Randolph Hearst launched "Mainly About People", a column in his first newspaper the *San Francisco Examiner* (1863–current) which focused primarily on public displays and private lives of socialites and entrepreneurs. In 1889, T.P. O'Connor reimagined this for the front page of his new paper *The Star* and included both the public and private lives of politicians and ordinary people whom he celebrified as a tool of inclusion and to promote radical demands for universal suffrage and Irish Home Rule, as explored further later in this chapter. The same year, cross-column headlines as exclamations, appeared in both O'Connor's *Star* and Pulitzer's *New York World*.

Throughout the 1890s, Hearst and Pulitzer competed to attract advertising revenues and came to rely on "scandal stories and sensational reports" from wire services (Williamson, 2016: 52), including from Britain. In 1890, Stead and Newnes launched the *Review of Reviews*, but their partnership ended after just three months because Newnes was outraged at his partner's commercial recklessness in courting controversy and ever more radical demands for equality for the poor and women (Jackson, 2001). Shortly afterwards Newnes launched *The Strand* (1890) where he developed "Portraits of Celebrities" and later the Strand Club to deliberately foster "parasocial" bonds of intimacy between him, the celebrities in its pages and a dedicated fan base. He linked such press parasociality to models for self-improvement and to the hard sell of branded products and, from this viewpoint, celebrity studies canon *Mass Communication and Para-social Interaction* by sociologists Donald Horton and R. Richard Wohl (1956), revealed insights into how broadcast personalities made parasociality more prescient and powerful, rather than identified a new phenomenon. In the mid-1890s, Alfred Harmsworth brought many of these elements together as part of the "Northcliffe Revolution" of British newspapers (Williams, 1961; Williamson, 2016), which included the launch of *The Daily Mail* in 1896 and the *Daily Mirror* in 1903. He turned the tools and techniques established by New Journalists' liberal founding fathers towards support of the Conservative Party, anti-European jingoism, antisemitism and mass commercialisation (Greenwall, 1957: 47). As such, this was less a revolution and more a revolt against the liberal ideals of early tabloidism and its vision of celebrity. Northcliffe took the spectacle, but not its bleeding, open heart and made greed – of money, of influence, of empire – part of the genre. The impacts were far-reaching and long lasting, particularly in relation to the commercialism of the British press (Williams, 1961; Williamson, 2016) and established many of the more damaging impacts of contemporary tabloid cultures' spectacular constructions and uncaring commercialism, which are explored further in chapter 5.

Scores of meetings at events, in private and direct back and forth conversations happened between these men across their lifetimes. But in terms of journalism's rituals of celebrification and commercial appeal, three things stand out which influenced the textual and image-based logics of early stardom, the spectacular nature of tabloidised news and the celebritisation of politics. These are W.T.

Stead's *Pall Mall Gazette* interviews, George Newnes' "Portraits of Celebrities" and T.P. O'Connor's "Mainly About People" gossip column. Through close analysis of these, we can better understand how discourses of stardom began to form at the turn of the century to pave the way for powerful 20th-century manifestations and how British and American models of celebrity together helped make tabloid and celebrity cultures the commercial and political forces they are today.

W.T. Stead and the celebrity interview

Bakhtin (1984) argued that to analyse dialogue we must understand the way truth is "born *between people* ... in the process of their dialogic interaction" (1984: 110, original emphasis). The interview emerged as a journalistic production practice during a period when reports of direct speech became part of British news media as a discursive means to establish fact and consensus. Salmon (1997: 160) identifies that the technique was widespread in Britain and the United States by the early 1890s, but W.T. Stead interviewed – and discussed its implications for journalism – from the early 1870s. He later claimed that he had "acclimatised" this "distinctively American practice" into British news cultures (1901: 293). When interviews first emerged in America in the 1830s (Dunlevy, 1988) journalists reported the entire conversation. Early in his career in a letter to his brother Herbert – then working as a journalist in the US – Stead argued that journalists should instead see it as a process of newsgathering:

> Remember that your aversion to interviewing, as you call it, arises from a misuse of the word. Interviewing in the sense you understand it, is unknown to the English press. To interview in the American meaning of the term, is to call upon a person to publish every word, question and answer of the conversation. To interview as I use the term is to seek to imitate Sir Walter Scott who is said never to have spent a quarter of an hour with any man without learning something from him and tapping the reservoir of knowledge, which however small, everyone has in his head.
>
> *(W.T. Stead 1875, in Dunlevy 1988: 73).*

At this time Stead was editor of British regional newspaper the *Northern Echo* (1870–present), and there he developed newsgathering practices of gathering direct speech to add opinion, information, emotion and colour. This began a life-long project of developing populist and personalised journalism to effect meaningful social change.[1] Under his stewardship (1871–1879) the *Northern Echo* transformed from a small pamphlet to a popular and commercially viable daily newspaper, with reports of crime, society events and political meetings, comment on national and international news and politics, investigations, campaigns, opinion and a "House-wives' Corner" – his first bold step into New Journalism. Stead interviewed working-class people caught up in news events, conducted in a range of settings including prison cells (5 January 1874) and working men's clubs (17 April 1874)

and often presented these as relaxed "conversations" between equals. He spoke to the father of "West Auckland Poisoner" Mary Ann Cotton – the first prosecuted female serial killer in the UK – immediately after a prison visit (24 March 1874) as well as her neighbours and friends (21 and 22 March, 1874), and these were widely syndicated to the national and American press. This was his first rung on the ladder of his own fame, no better evidenced than when he died on the Titanic, both UK and American newspapers declared him the most famous person on board.

Stead's fame and his project to reform the interview reached its pinnacle when he was headhunted by the nationals in 1883 because of his support for William Gladstone and the Liberal Party during the 1880 General Election. The new prime minister personally thanked him in a letter where he described it as "a sincere regret to me that I cannot read more of the Echo, for to read the Echo is to dispense with the necessity of reading other papers. It is admirably got up in every way – admirably got up" (Lloyd, *Northern Echo*, 4 January 2020: online). As shown in Figure 3.1, within two years he produced no fewer than 126 interviews during his tenure as newsroom editor of the *Pall Mall Gazette* (1883–1889)[2] (now the *London Evening Standard*) with ordinary members of the public, experts and celebrities. Through this work he directly influenced British society and politics.

Salmon's (1997: 163) analyses of the first "systematic codification of these journalistic techniques", Edmund Yates' *Celebrities at Home* (*The World* 1877–1879), argued that Yates pioneered the "rhetorical strategies, which came to distinguish the interview as a discursive form". However, Yates appears to have adapted Stead's interview techniques from the *Northern Echo* and, in turn, Stead was inspired to conduct more interviews with public figures than he had before also facilitated by increased access to them from moving to the capital. His first *Pall Mall Gazette* "sit-down", with Liberal politician and philanthropist W.E. Forster (31 October 1883), came with a caveat that it was a "departure from the conventionalities of English journalism" but that "its convenience is indisputable and its utility obvious". He also installed the first newspaper telephone line and conducted the oldest surviving archived telephone interview in the UK ("Mr Whitley – an interview by Telephone", 11 February 1884). Stead helped to make interviews a daily journalistic practice and gave direct speech consistent construction patterns. In the next section, we will explore this as a first step towards 20th-century stardoms. But first I want to examine how Stead's liberal professional project aimed to reshape citizenry through establishing interviews as a *ritual of celebrification* which facilitated social and political empowerment.

Stead used dialectical models for news as a display of equality and inclusivity and balanced the voices of "celebrities" (46 per cent of interviews), "experts" (28 per cent) and "ordinary people" (26 per cent) with his own commentary and witty interjections. His narrative was broadly one of tolerance, benevolence, personal fulfilment through endeavour and making the most of talents. However, the *Pall Mall Gazette* interviews also coincided with "high imperialism" (Cohen, 1994: 21) and this economic, ideological and political construct was also reflected in interviews that emphasised "heroism" in exploration and commerce, such as tradesmen

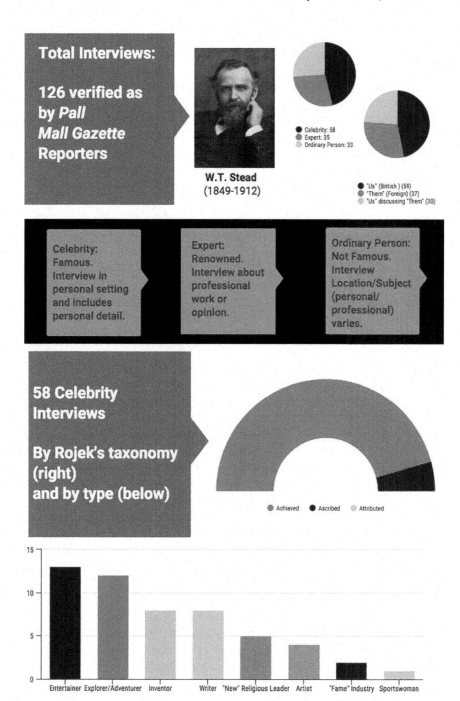

Total Interviews:

126 verified as by *Pall Mall Gazette* **Reporters**

W.T. Stead
(1849-1912)

- Celebrity: 58
- Expert: 35
- Ordinary Person: 33

- "Us" (British) (59)
- "Them" (Foreign) (37)
- "Us" discussing "Them" (30)

Celebrity:
Famous.
Interview in
personal setting
and includes
personal detail.

Expert:
Renowned.
Interview about
professional
work or
opinion.

Ordinary Person:
Not Famous.
Interview
Location/Subject
(personal/
professional)
varies.

58 Celebrity Interviews

By Rojek's taxonomy (right) and by type (below)

- Achieved
- Ascribed
- Attributed

Entertainer Explorer/Adventurer Inventor Writer "New" Religious Leader Artist "Fame" Industry Sportswoman

FIGURE 3.1 *Pall Mall Gazette* interviews (Oct 1883–Oct 1885)

furthering British "mercantilism" and military leaders squashing resistance abroad.[3]Colley (2009: 6) argues that the British nation forged in "response to contact with" or "in conflict" with the "other" and Stead's interviews often used voices of "Us" (British merchants, politicians and celebrities) to discuss "Them" (foreigners and other nation states). Sonwalker (2005) explains that discursive boundaries of "Other" and "Us" establish society's "power geometry" and frames the discourse of "nations". This was evident particularly in Stead's heroic representation of General Gordon, the most infamous of his interviews because it demanded Gladstone send him back to the Sudan, which he did. Gordon was massacred with his men and both Stead and the prime minister were roundly criticised.

Stead mixed the personal with the public. He interviewed Gordon at his "sister's house" and his description of the military man in this relaxed setting was linked to his professional status as the "ablest Englishman who ever held command in Equatorial Africa" because of his "friendship" with the Sudanese people. This blend of private and public made what was a dangerous demand for military invention seem as natural as the living room in which the interview was set and, once more, the public/private dichotomy of celebrity journalism worked as political action (see last chapter). Billig (1991: 112) argues that journalistic routines perpetuate "hegemonic relations" and inequality and certainly Stead's interviews focused on British exploration, invention and conquest, which celebrated High Imperialism, in all its bloody, shameful glory. However, he did not report "Us" in conflict with "Them", but emphasised similarities. His interview with General Gordon discussed the kindness and civility of the Sudanese. He asked Marori Arinmori, the Japanese ambassador, about similarities between the nations, which the ambassador responded to with discussions of geography and national pride (26 February 1884). When interviewing Oko Jumbo of Bonny, Stead described him as "genial and gentleman-like" and discussed his son – an "agreeable gentleman … educated in Liverpool" (29 June 1885). This reflected his own radical social liberalism (Robinson, 2012), also evident in interviews with "Socialists" (10 September 1885; 8 October 1885); former prisoners who discussed the horrific conditions in British "gaols" (9 October 1885); and the celebrity leaders of new religions, such as "modern prophetess" Madame Blavatsky (24 April 1884) and "well-known" evangelist Dwight Moody (4 July 1884).

It is not just that these people were visible in the *Pall Mall Gazette* that was significant, but that Stead demonstrated equal civility and valued their voice, regardless of social position or nationality. Turner's (2014: 87–91) useful overview of the "tabloidization debate" includes discussions of whether increased visibility for ordinary people through, for example, appearances on talk shows and reality TV, has any democratic benefit. He considers Hartley's (1996: 88) optimistic arguments that through increased visibility ordinary people help audiences construct their own "cultural identities", "citizenry" and "knowledge" through "performances of domestic discourses". Stead's work certainly made ordinary people visible as mechanisms to show the "semiotic furniture" of life. He not only offered the

opportunities for liberal and radically different self-determination, but also the means by which ordinary people passed through the interview as a ritual of celebrification to make their voices heard. His dialogues with prison inmates, for example, was presented as no different to those with celebrities such as William Morris (23 September 1885), Ford Maddox Brown (24 September 1885) or the America actress "Lotta" (22 December 1883). Stead's *purpose* was to use journalism to *include* ordinary people in public spheres via processes of celebrification in order to make his social liberalism and popular news culture a guide for political citizenship. In doing so, he created patterns for the interview as a "performance of self". In his seminal *The Performance of Self in Every Day Life,* Erving Goffman (1956: 13) argued that as we negotiate our world, we engage in difference performances. These are "marked by [...] continuous presence before a particular set of observers" as a means to influence them in some way, particularly in relation to their understanding of who we are. The place where performances happen is the "front" (for example, here, the newspaper interview) and if a performance might be replicated, then a pattern or routine forms. Goffman argued that the construction of persona can either be sincere, where the performer believes "the impression of reality which he stages is the reality", or cynical – only aimed at influencing observers of the exchange (p. 10). Performances are "moulded to fit into the understanding and expectations of society" and will tend to "exemplify the officially accredited values of the society" (pp. 23–24). New Journalists established the interview as a key facet of how journalism and celebrity work together to facilitate performances of self for commercial, political and social ends.

Stardom before cinema: textual and visual invention and the new celebrity "light"

W.T. Stead's choice of interviewees often emphasised talent and endeavour and, like celebrities throughout the 20th century, he used this to offer, "the general community [...] an avenue through which to discuss issues of morality – family neighbourhood, of production and consumption" (Marshall, 1997: 16). He was concerned with the hard work and talent of "achieved celebrity" (Rojek, 2001) and more than 10 per cent of *Pall Mall Gazette* interviews were with entertainers, including actors (6), balloonists (2), musicians and singers (2), a magician (1), tightrope walker (1) and a "thought reader" (1). Visibility was the counterpart of talent, endeavour and artistic self-fulfilment and women featured more than men.

Four out of six interviews with actors were women and these focused on beauty, unique talents, achievements and a discussion of popularity as a reflection. Stead described their beauty, dress, home furnishings and décors. His questions focused on stage success, consumer and leisure habits and linked public adoration to private self-contemplation. Only one person was interviewed by Stead twice – the now largely forgotten American actor Mary Anderson (1859–1940) – who represents a tantalising embodied link between the old world and new – in this instance actresses of the London stage and the soon-to-emerge stars of US Hollywood

studios. Anderson went on to act on screen and featured in – although sadly was not interviewed by – *Motion Picture Magazine* (1911–1977) following her appearances in silent films *Heart of Oak* (1916) and *Eve's Daughter* (1918).

In their second exchange (5 December 1883), Anderson and Stead engaged in dialogic persona construction, which linked her fame directly to that of British 18th-century Romantic-era actresses and created a narrative of proto-stardom. Stead – with one eyebrow firmly raised – described how Anderson swept "into the room with that ease and grace which are remarkable among […] many qualifications for the stage" and the gifts sent as a "tribute to her art", including from the author Henry Irving and the famous English actors "Mr and Mrs Kendal". She described how she had watched the sunset while leaning on the railings at Sarah Siddons' grave, in deep contemplation of their shared craft, and showed him "stacks of letters" from "the perfect sea of faces" of her "audience", before casting "them into the fire" and declaring, "[…] unmeasured praise … has no value". They both name-dropped Longfellow and his advice when she was "just a girl of fifteen" to "never pass a day without seeing a beautiful picture, reading a beautiful poem or hearing beautiful music". This ritual of celebrification and self-advantaging exchange portrayed Anderson as a star some twenty years before the visibility of Hollywood stardom.

Richard deCordova's (1990) *Picture Personalities: The Emergence of the Star System in America* argued that Hollywood studios and the press worked together to construct stardom as a discourse. Anderson and Stead's interaction displayed many constitutive elements of interviews in Hollywood magazines, as explored further in the next chapter. Four narrative threads became those of stardom – displays of consumerism and fashion; description of "extraordinary" talent balanced against glimpses of the "private" person behind the glamorous public image; romantic artistry as the true reflection of authentic self; and the adoration by audiences, peers and/or journalists. Jarvie's (1990) analysis of the dominant narratives of stardom identifies "striking photographic looks, acting ability, presence on camera, charm and personality, sex appeal, attractive voice and bearing" and certainly this interview alluded to all these things bar, of course, on-screen impact.

Mary Anderson's persona construction was also visual. She used appearances on stage, journalism and photography as intertwined discourses to raise her profile. Richard Dyer's (1979) explorations of how cinema actors became more important than their roles reflected a shift from "endeavour" towards "image". Anderson's endeavour *was* her image and she explored ways to use new textual and visual tools to build her visibility. Around the same time as the *Pall Mall Gazette* interviews, she posed for a series of photographs at the fashionable 182 Regent Street studio of photographer Henry Van der Weyde. The self-branded "American Portrait Artist" (actually a Dutch immigrant who moved to New York in his teens) experimented with imagery as part of the processes of photography. He built gilded backdrops decorated as if "the most fashionable salon" (Van der Weyde, interview, *Tinsley's Magazine*, January 1892: 190) and used fabric, draping and frames which flattered the subject, such as lights shone from above and cameras held below. He filed a

patent for his "dynamo to produce electric-arc lighting to illuminate his studio" (Van der Weyden, 1999: 68),[4] one of 75 inventions that created the unique "VanDerWeyde Light". This cast a "soft light … upon the sitter as from a white cloud" (*Tinsley's Magazine*, January 1892: 190). "High lights" drew focus to the eyes, and he taught his subjects "posing" and "how to look" at the camera (p. 191). This "revolution in the evolution of photography" offered the basis for iconographic images later associated with Hollywood stars and enabled the first "on street" night snaps, sold in newspaper booths as a forgotten part of what Rojek (2001) described as *carte-de-viste* visual representations of celebrity (p. 126) and one of the earliest examples of what would become paparazzi culture. Van der Weyde was also a favourite "society photographer", for example taking official portraits of London society at the Devonshire House Fancy Dress Ball in July 1897, which were printed in a keepsake magazine for attendees. He was at the centre of making the visual representations of celebrity culture as they emerged at this time.

If Stead and Anderson's interactions demonstrate pre-cinema examples of the textual dimensions of stardom, then Henry Van der Weyde imagined many visual components. "The VanDerWeyde Light" self-brand – featured in the bottom corner of the reprinted image – has many similarities with early headshots of Hollywood studio stars. Van der Weyde described how artistry, experimentation and iconographic images of the famous were key components of his craft (*Tinsley's Magazine*, January 1892: 190). His pictures showed actors both in character and behind the scenes, such as the images of Mary Anderson in Figure 3.2. In the first, she looks away from camera – the shy retiring Juliet, lifting a mask away from her face. In the second – with messed natural hair – she looks confidently, even defiantly, to camera while a bright light from above highlights her dark eyes. A picture of comedian and music hall favourite Bill Nye shows him lighting a cigarette and half laughing down the lens at the viewer. Van der Weyde's most famous image of Richard Mansfield used double exposure to show the actor as both Dr Jekyll and Mr Hyde and influenced early cinema adaptation of the novel (Danahay, 2012).

Tinsley's Magazine (January 1892: 190) declared that Van der Weyde's "name" was "inextricably connected to artistic photography in England" and he declared that this was because of his determination to "flatter[s] … people and make them good looking". By 1892, Van der Weyde had taken pictures of "almost all the celebrated people of the day including the Royalties" (p. 192) and these pictures sold in many London newsagents and from his studio in Regent Street. His images made the subjects iconographic, through use of fabric and backgrounds associated with Grecian gods and beautifully tangible, carefully framed and lit close-ups. When printed in George Newnes' *The Strand* (1891–1949), his iconographic VanDerWeyde Light became a recognisable frame for celebrity images for a larger scale, transatlantic audience and this, as we will see next chapter, influenced the glamorous imagery of Hollywood magazines. By adding text to such pictures, Newnes offered his audience processes by which they might *read* the images of celebrities and better *understand* production processes of news and celebrity cultures.

FIGURE 3.2 The "VanDerWelde" Light and the Victorian "star"

FIGURE 3.2 The "VanDerWelde" Light and the Victorian "star"

George Newnes, "Portraits of Celebrities" and press parasociality

In *Tit-Bits* (1881–1984), *The Strand Magazine* (1891–1949) and *The Million* (1892–1895), George Newnes adapted "popular American styles ... to the British market" (Conboy, 2002: 167) with extraordinary success. His publications created two- and three-way interactions between celebrities, audiences and journalists, and then channelled these towards the promotion of media brands and associated consumer products. He acted as editor, publisher, proprietor and writer and, as Kate Jackson (2001: 87) describes in her detailed biography and analysis of his life and work, while each magazine talked to different target audiences, the creation of intimacy between them and him was a hallmark of his work.

Tit-Bits aimed for the aspirational and newly literate working and lower middle classes who were literate after the introduction of Board Schools. Bridget Griffen-Foley (2008) argues that the "audience participation" of the publication set in motion aspects of tabloid culture right through to early 21st-century reality television, although there are some leaps in terms of tracking such influence. But certainly, the magazine acted as a "familiar companion" (Jackson, 2001: 54) and included gossip, sport, crime, recipes, weather and cultural commentary. It relished the banal, particularly in relation to celebrities and described "Favourite Dishes" (19 November 1881) or which celebrities had taken the new fashion of wearing "wedding rings" (4 March 1882). Readers were encouraged to join in with the production and promotion of the news brand through sending "lines of inquiry", entering competitions, purchasing *Tit-Bits* insurance policies and branded merchandise. The magazine "offered connection, interaction and creative potential to a community of readers" (Jackson, 2001: 54), with intimacy between celebrities, audiences and journalists at the centre of structure and narratives. Sister publication *The Million* (1892–1895) pitched for a different social group – the new semi-professional commuter class. "Millionaires" – the collective name for the readership – were of the weekend variety, who worked hard six days a week and enjoyed leisure activities on Sundays. Newnes viewed them as aspirational and seeking models of self-improvement. The relationship encouraged readers to "enhance the presentation of personality, refine lifestyle skills and expand social appeal", similar to that described by Chris Rojek (2012: 139) in relation to contemporary lifestyle TV. Newnes developed a *press parasociality*, which became a key part of tabloid cultures as explored further in chapter 5, and which was far more active than the "para-social" by-product of television viewership as it was first described by Horton and Wohl (1956).

Simply put, parasociality in Newnes' publications was carefully fostered to achieve and sustain popularity. Bonds of intimacy between Newnes, the celebrities featured in his magazines and readers used "the illusion of face-to-face" to form a discourse in which the audience were actively involved and offered pathways for life. Technical and linguistic developments of journalistic production furthered parasociality through "personal connection with the otherwise impersonal capitalistic structure of the developing press" (Jackson, 2001: 64). "*The Millions*" were a

"democratic mass" to whom the editor had to "account himself", and Newnes' editorial voice rang out as "innovator and preacher, patriarch and pioneer, democratic representative, business partner, adviser and friend" (p. 63). He created "sympathetic intimacy" and presented as an "everyday man" (p. 45), through what Chris Rojek (2012: 133) later described in relation to contemporary celebrity as "fraternisation ... the impression of friendship, shared understanding, common ground and other features of reciprocity". While Rojek's chapter on parasocial relationships in *Fame Attack* (2012) mentions Victorian print cultures and how authors such as Dickens turned the "neurotic and obsessional tendencies of fans" towards promotion (p. 124), exchanges between *parasocial relationships* (with individuals) and *parasocial interactions* (during acts of media use) were more complex (Giles, 2010). Newnes acted as conduit and gatekeeper, fan and celebrity, and opportunities for direct interaction with him were ever-present but rarely fulfilled. His famous team of writers and artists, which included T.P. O'Connor, Arthur Conan Doyle, Aldous Huxley, J.M. Barrie and many more, extended this narrative. Journalism "like the music hall, created its celebrities" (Jackson, 2001: 101) and working for Newnes became a pinnacle of professional success and fame.

If *Tit-Bits* and *Million* established Newnes' "place in the world of journalism" and press parasociality, "*The Strand* represented his consolidation and celebration" of it (Jackson, 2001: 87). When it closed in 1949, *Time Magazine* described its importance to British culture and American understanding of it, "from the drawing room to below stairs", and how it influenced a generation of magazines on both sides of the Atlantic (Pound, 1966: 192). Pitched at the affluent and established upper middle classes – but attracting an aspirational lower middle- and working-class audience too – *The Strand* balanced artistic quality and journalistic innovation and included short stories and serial fiction. In its pages, Doyle's Sherlock Holmes first appeared (January 1891) who, like Moll Flanders discussed last chapter, was a fictional "celeactor" (Rojek, 2001: 18) – a powerful representative of a broader social group. Intelligent, artistic, cultured, erudite and of course a celebrity within the boundaries of Conan's stories too, Holmes primarily represented everything *The Strand* reader should be. Giles (2010: 99–100) describes such fictional characters as "second order figures" in parasociality as there isn't meaningful belief in the chance for interaction, but inclusion of such fictional characters within a broader celebrity journalism – that also used inventive production in terms of text, image and page design – *affirmed* parasocial bonds with the media brand. *The Strand* offered "unification of literary tradition and journalistic innovation, of commercialism and professionalism and of inclusivity and exclusivity" (Jackson, 2001: 92). As many of its writers and designers were celebrities in their own right, it offered inside dope on their lives and work. Most members of the club were men, but female contributors such as Madame Cathinca Amyot, "the clever painter of Tit-bits" (*The Strand*, June to December collection, 1891: 607), were portrayed as equals of their male counterparts. As the popularity of the magazine grew, so did reader interest in those who worked for it and, in response, the editor launched a

new feature – "Chronicles of The Strand Club" (1905) – which occasionally included the lives of readers who saw themselves as members too.

Jackson (2001: 92) describes how the magazine offered a "confirming, consolatory rigidity, which was based on social and professional distinction, corporate identity, individual example and commercial viability". This was "comforting to a middle-class audience who, beset by anxiety change and uncertainty, sought reassurance" in its models for lifestyle. However, the way this worked depended on the social place of the individual reader. If, like "The Strand Club", they were educated, affluent and middle class, then it reflected and reinforced their position. For members of the aristocratic establishment, it offered reassurance of a place in the new social order, by including them as part of the celebrity class featured in its pages. For working-class readers it offered aspirational windows into lifestyles and methods of cultural, social and educational improvement.

It was also for *The Strand* that Newnes developed his most influential ritual for celebrification, "Portraits of Celebrities", devised when he flicked through a photo album at the home of his friend Sir Richard Webster. This was a key, and often overlooked, moment in the transition of celebrity from a textual to a *visual culture*, which, as Rojek described, "vastly enlarged and intensified the phenomenon" (2012: 124). In the first 18 months of *The Strand*, 125 "Portraits" were published and analysis of these (Figure 3.3) offers insights into the makeup of celebrity class at this time. Text and image worked together and Newnes invested heavily in technology to improve the quality of image reproduction and page layout. Each "portrait" featured three or four pictures, alongside brief descriptions of appearance, private lives and anecdotes from childhood. For example, readers learned that Thomas Hardy was born in "a Dorsetshire Village" and "trained as an architect" (July–December 1891: 475) and that journalist George Manville Fenn enjoyed "experimental gardening" (January–June 1892: 170). The Lord Mayor of London, David Evans, had "a family of eight children" (January–June 1892: 44), and Madame Arabella Goddard played concerts from just "four years old", standing "on an improvised board", because she was so small (p. 172). Pieces also included insights into production processes, such as "Tennyson himself had the kindness to assist us" (January–June 1891: 22) or Henry Irving "placed at our disposal" pictures from age 3 to 34 (January–June 1891: 45). "Portraits of Celebrities" was one of *The Strand's* "longest running and most successful serials" (Jackson, 2001: 94) and celebrities were acknowledged participants in its production.

Stead's interviews helped to develop direct speech as a means to build fame. He brought the voice of the journalist and the celebrity together and pointed them towards social, political and commercial change through revelations of true self behind the public face. "Portraits" used photography for similar ends, and Newnes later incorporated both elements in *The Strand's* "Illustrated Interviews". While Stead's interviews featured celebrities, ordinary people and experts, all interacted with the same civility, Newnes focused entirely on the famous because "Portraits" was primarily a commercial rather than a socio-political endeavour. However, the social equality in its pages reflected his liberalism too, evidenced no better than in

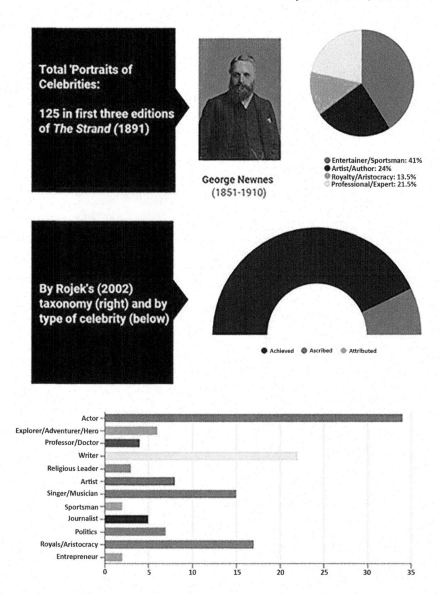

FIGURE 3.3 "Portraits of Celebrities", *The Strand,* January 1891–June 1892

Portraits of Celebrities at different times of their Lives.

MISS MARY ANDERSON.
(MADAME ANTONIO NAVARRO).

MISS MARY ANDERSON was born at Sacramento, and made her first appearance on the stage as *Juliet* in her seventeenth year —the age at which our first portrait represents her. From that day down to the early part of 1890 her career was one long course of unchecked prosperity and popularity, only broken by her withdrawal from the stage on her marriage with M. Antonio Navarro de Viana, a citizen of New York. Madame Navarro and her husband have taken up their residence at Tunbridge Wells.

FIGURE 3.3 "Portraits of Celebrities", *The Strand,* January 1891–June 1892

the first issue where Queen Victoria appeared in the same run of celebrities, just two before Haymarket theatre manager Herbert Beerbohm Tree (January 1891). Newnes' "Portraits" echoed emerging narratives of stardom developed in Stead's interviews, with text focusing on elements of beauty, unique, remarkable talent on and beyond the stage and popularity in both Britain and the USA. Pictures displayed stars both on stage and behind the scenes at home in opulent dress and with expensive furnishings on display. The dominant theme of portraits was that of achievement (86.5 per cent of those featured), but once again those who were included were from far beyond the realms of entertainment and included politicians and religious and scientific leaders.

As with the *Pall Mall Gazette* interviews, actors were a focus, and once again more women featured than men. The stage was portrayed as a transatlantic celebrity sphere, with accounts, for example, of Mary Anderson's path from "Sacramento" to the "London stage" with a series of portraits of her including one of Henry Van Der Weyde's headshots as shown in Figure 3.3 (July to December, 1891: 601). Charles Wyndram's trip "at twenty one to America", where he "made his first appearance as an actor at Washington" (ibid.: 283); or Miss Fortescue's "starring tour ... through America" (ibid.: 158). There was emphasis on fandom, such as how Mrs Beerbohm Tree's "many admirers" were particularly interested in "photographs" that showed "the intelligent child growing into the gifted girl and giving every promise of the cultivated, accomplished woman" (July to December, 1891: 40). Accompanying text listed previous roles and often focused on the path to fame from "stage school-girls" ("Miss Kate Rouke", January to June, 1891: 593) or playing a fairy for "private theatricals" ("Miss Mary Moore", July to December, 1891: 43). There was also emphasis on normality, such as how the "early life" of Miss Fortescue – the "youngest lady every admitted" to Drury Lane – was "the ordinary one of an English country gentleman's daughter". These appeared alongside descriptions of unique beauty and talent more broadly, such as how Fortescue was "adept at foreign languages" and "not only the three Rs but two more – riding and rowing". She showed incredible "talent and resource in her art" (July to December, 1891: 158). Miss Langtry's portraits showed "the blooming of the Jersey Lily from bud to full flower" (ibid.: 157). Miss Marion Terry had a "natural capacity ... aided by her grace of action and the striking charm of her appearance" (ibid.: 374). These celebrities were simultaneously just like readers – daughters, wives, former schoolchildren – and a million times better because they were extraordinarily beautiful, talented and adored. This too reflected many elements of the discourses of Hollywood stardom (Dyer, 1979). By bringing together images of celebrities and then in text instructing readers how to read them, Newnes not only created mediated discourses of celebrity but also improved the media literacy of audiences.

A feature article titled "Celebrities at Play" (July 1891: 145–149) discussed how such dynamics between journalists, celebrities and audiences changed print production. As a source of "infinite amusement to the populace", the unnamed author (probably Newnes given the familiar writing style) pondered, a "special journalism

exists mainly to chronicle the small-doings of the great" and "every newspaper now has its gossip column". "Celebrities at Play" was not simply a fluff piece. It also analysed how celebrity culture challenged reverence shown to monarchy, with the "gossipy par" (paragraph), highlighted as impossible during absolute rule and as a reflection of greater democratic and press freedoms. It discussed how revelations about the private lives of politicians are often "political spite" and "partisan animosity" – referring to the principles of attack journalism – but how it also functioned to satisfy an "insatiable ... demand for such information". The impact of "competition in the journalistic world [was] so keen that the demand supplied with as much detail as possible". Accounts of Gladstone's hobby of "tree felling" or how Richard Doddridge Blackmore – author of *Lorna Doone* – "adopted market gardening and fruit growing" were framed as giving readers the content they demanded, but were also an opportunity for political and social commentary about why journalism and celebrity cultures were so intertwined.

There are three takeaways. The first is that politicians and the royal family are still considered "celebrities" and discussed in the same way – even in the same paragraph – as, for example, actors and authors. This extends the place of politics in the "celebrity class" that emerged in 18th-century newspapers and reflects further integration of citizen/consumer and capitalism/democracy. Second, the piece describes celebrity culture as part of the social changes for a nation moving towards democracy with the "the Brown-Joneses and the Fitz-Smiths" more important members of high society (p. 145). It articulates the power of the reader as part of the democratic masses who demand such journalism and potential socio-political reasons and effects. Third, it demonstrates how New Journalists extended discourses of celebrities in print from news – the day-to-day activities of the famous – to long-form features. Those who place celebrity and political journalism as intrinsically opposed and emerging separately at different times – with the former diminishing the importance of the latter – too easily ignore the inconvenient truth that even in this "Golden Age" of journalism, the two were interwoven and that this was often both commercial activity and liberal, even radical, political activism. The next section explores these dynamics further through analyses of the most successful gossip column of British New Journalism. Democratic and aimed to level up – with aristocracy and academics, politicians, everyday folk, entertainers and creatives all on the same page – T.P. O'Connor's "Mainly About People" for the first fully formed British tabloid *The Star* (1889) reflected many of the dynamics of ordinary people made famous through rituals of celebrification that are a key part of contemporary analyses of celebrity.

T.P. O'Connor, "Mainly About People" and the political celebrity spectacle

T.P. O'Connor seized the spectacle, successes and shake-ups of New Journalism and repackaged them with a ferocity and fearlessness that was both "journalistically and politically revolutionary" (Herd, 1952: 233). Known widely as "Tay Pay" on

account of his Irish drawl, the politician was arguably the best known "of the foremost pioneers of New Journalism" during his lifetime (Wiener, 1988: 271) and turned his popularity towards attracting investors to launch *The Star* – a "radical plebeian" (Lee, 1976: 121) and affordable-for-all half-penny evening paper. It was an overnight sensation and O'Connor declared that second-day sales of 148,000 smashed all single-day records. From the outset he argued that the "mode of consumption" for journalism must be "reflected on its pages" and as an "age of hurry and multitudinous newspapers", populist, fast-paced, spectacular news production would best hold reader interest. He articulated what would become the basis of tabloid cultures:

> To get your ideas across through the hurried eyes into the whirling brans that are employed in the reading of newspaper there must be no mistake about your meaning, to use a somewhat familiar phrase, you must strike your reader right between the eyes … .
>
> *(O'Connor, 1889: 434)*

The rabble-rousing Republican enjoyed a varied journalistic career, writing political news and commentary for the *Daily Telegraph*, George Newnes' *The Million* and Stead's *Pall Mall Gazette*. He was also a political biographer and penned detailed accounts of the private lives and careers of, for example, prime ministers Disraeli (1804–1881) and Gladstone (1809–1898). His column for *The Million* – "Behind the Scenes at the House of Commons" – offered insights into the parliamentary process, but it was also often irreverent and light-hearted. He described "Beards in Parliament" and "Dandies in Parliament" and, through mixing descriptions of personal appearances with public work, aimed to demystify the parliamentary sphere in an attempt to break down barriers between the ruling class and the ruled.

This proved so popular that Newnes launched *Picture Politics* (1894), a penny illustrated monthly with text and images in the style of "Portraits of Celebrities" and O'Connor's scintillating insights into politicians' professional work and private character. O'Connor used spectacle and the dynamics of celebrity to redefine social and political realities and, in doing so, wove them into the fabric of political representation in British news media. When he was removed from his editorship within three years, it was *despite* his overwhelming commercial success and because investors viewed him as "too radical to be a liberal" (Fytton, 1954: 172). However, by this time he had made his mark on daily newspaper production, tabloid sensationalism and the celebrification of politicians. O'Connor made politicians as likely to be the subject of gossip as any other part of celebrity class and created an irreverent tabloid style for political reporting. He imported American-style cross-column story layout and headlines, use of direct speech and high-quality images and used language of urgency such as "Stop Press" graphics on news stories and "Breaking News" tags (Goodbody, 1985: 20–29; Conboy, 2004). The launch lead declared this paper would include both "politics" and "unpolitical literature", the

"humorous" and the "pathetic", the "anecdotal" and "statistical", "craze for fashions" and "short, dramatic and picturesque" human interest stories (*The Star*, 17 January 1888). It would "do away with the hackneyed style of obsolete journalism" and replace it with engaging and accessible writing, representing people as "living, breathing, in blushes or in tears". It was also affirmably on the side of its working-class readership:

> A policy will be esteemed by us good or bad as it influences for good or evil the lot of the masses... the effect of every policy must first be regarded from the standpoint of the workers of the nation, and of the poorest and most helpless among them.
>
> *(The Star, 17 January 1888)*

Whereas Stead sought power through influence over the decision-making of the ruling class, O'Connor saw the potentials of mobilising the working classes through celebrifying both them and politicians. He made ordinary people famous through spectacular fast-paced news and did so as part of his arguments for radical socio-economic, political and cultural change, such as universal suffrage, workers' rights and Irish Home Rule. Debord's *Society of the Spectacle* (1967) identified the significance of the moving image and broadcast media as mid- to late 20th-century phenomena in shaping the political and popular cultures. O'Connor as celebrity, politician and journalist used populist mass media to create spectacles to *sell* political messages to ever-larger audiences. *The Star* contrived "events and the dissemination of news" to create "legitimating symbols" (Debord, 1967: 123) for whom he envisioned as the voters of the future. O'Connor was a man of visibility in terms of both his own fame and his approach to politics and journalism, which deliberately developed spectacles and aimed them towards radical change.

Guy Debord's descriptions of how media creates spectacles to function "at once as society itself, as a part of society and as a means of unification" (p. 3), might have been written about "Mainly About People". But O'Connor's purpose could not have been more different from the 20th-century media Debord so roundly condemned. Politicians, actors and the aristocracy appeared one after the other, in multitudes, without distinction between them or details of public appearances, professional work and private lives. As Figure 3.4 shows, three specific groups appeared most – actors, royals/aristocracy and politicians – and on the front page of *The Star* they were linguistically and socially intertwined. Against Rojek's (2001) taxonomy of fame the primary narrative was "achievement", as it was for the other New Journalists. However, celebrities were also *made* through inclusion in this spectacle and many of the 490 people who appeared in the first 50 "Mainly About People" columns passed through rituals of celebrification which made them known to British audiences for the first time.

Once again this was a transatlantic narrative, with "society" figures from the fashionable New York set (Inglis, 2010) featured alongside British designers who dressed them and political leaders with whom they socialised. A trip by Prime

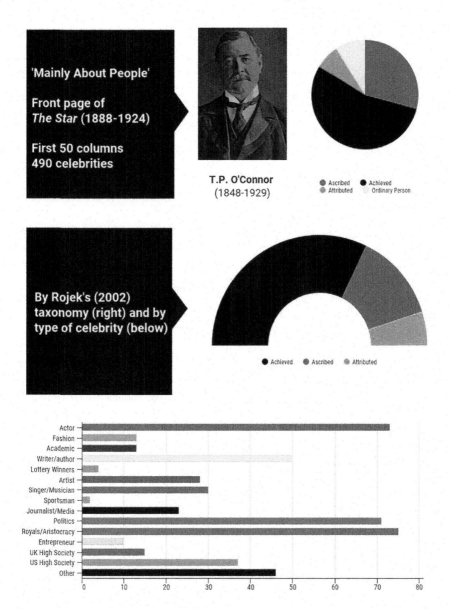

'Mainly About People'

Front page of
The Star (1888-1924)

First 50 columns
490 celebrities

T.P. O'Connor
(1848-1929)

Ascribed Achieved
Attributed Ordinary Person

By Rojek's (2002)
taxonomy (right) and by
type of celebrity (below)

Achieved Ascribed Attributed

FIGURE 3.4 "Mainly About People", *The Star*, 1888

Minister William Gladstone to America was covered as if that of a social debutante, and O'Connor pondered the expense to the taxpayer and what ordinary people would make of it all (February 1888). On one hand there was a familiarity to content about celebrities as it discussed their fashions and its designers, jewellery, social events and marriages. This kind of content, as explored in the last chapter, appeared throughout the 18th century in newspapers. However, by sprinkling this with the daily details of parliamentary politics including speeches, new acts of parliament, votes won – alongside details of what parliamentarians were wearing and their social lives – O'Connor made it part of a heady and daily celebrity spectacle. "Mainly About People" was a kind of "society of itself" that Debord (1967) described, where actors of the stage were the equal of the prime minister in order to encourage popular interest in political spheres.

For readers, there was the chance they might appear too through, for example, acts of heroism, witnessing crimes, interactions with established celebrities or political activism. Such "attributed" celebrities were often fleetingly famous, the reflection of what Rojek (2001) described as "celetoids", and included lottery winners and socialites – propelled into the spotlight and discussed alongside royalty, MPs and the stars of the London stage. O'Connor's focus was not on his own editorial voice – the "governance through journalism" which became Stead's trademark – but "strong personality", which he declared as "the task of the journalist to record" (O'Connor, 1889: 429). While Stead looked to his equals and up, O'Connor looked at people everywhere and dragged those he felt were missing into his tabloidised vision for public spheres. He wove audiences and celebrities together to encapsulate and dramatise contemporary life and, in doing so, helped make spectacles of celebrity and politics and the inclusion of ordinary people in the narrative, which was at the core of 20th-century tabloidised news narratives.

Towards the 20th century

New Journalists developed and applied rituals of celebrification to entertainers, politicians, royalty and ordinary people alike and, in doing so, created new pictures of society and the place of audiences in the mediation of them. They reimagined narratives established in the 18th-century London-based press – the melding of the political with the personal to enable citizenry, links between Romanticism, artistry and consumerism and Enlightenment rationality – with the industrialised modernity of US printed news. Stead aimed his arguments at the influential middle classes – the decision-makers – and offered visions of improvement for the poor or political interventions to appeal to their whims and philanthropy. His inclusion of ordinary people and those from other nations and cultures into the narratives of celebrity and professionalism in interviews aimed to shape hearts and minds towards a more liberal view of those from different classes or nationalities. Newnes targeted specific social groups with publications he imagined just for them, which he hoped might create social cohesion and capitalist aspiration, through which living standards might improve for all. T.P. O'Connor was a

populist who focused his demands for attention squarely at the working classes in the hope he could help bring about radical social and political change through revolutionary demands for equality. He used celebrification to demystify the ruling class and political process through an unashamedly brash and commercial approach to news, which included the masses in their spheres as both participants and audiences. He boldly declared that the main job of journalism was to account "strong personality" as a means to challenge the status quo.

Those who place celebrity and political journalism as intrinsically opposed and emerging separately and at different times – with the former diminishing the importance of the latter – ignore the inconvenient truth that even in this "Golden Age" of journalism they were interwoven threads. If journalism is the media reflection of democracy and celebrity of capitalism, then the two working together at this time were the linguistic embodiments and representations of why those two things are mutually dependent. New Journalists often placed social good and inclusion above commercial opportunity and even their own credibility. They established differences between the broad sphere of celebrity journalism – often devised and constructed by journalists with specific aims in mind – and what now became the subcategory of celebrity news, which reported events in show business and political spheres often as gossip and usually for the entertainment of the audience. Each pioneered journalistic rituals of celebrification for their own ends and sowed fertile ground for 20th-century rituals and contestations of journalism and celebrity. In a century of technological invention – where cinema, radio, television and the internet radically reimagined media spheres – the methods of New Journalists offered strands of consistency and shape for journalistic spheres. They also facilitated a dazzling incarnation of celebrity and the next big change in journalism's use of it – stardom.

Notes

1 Stead's most famous campaign targeted the scandal of the rich paying to rape the children of the poor in 1885. He produced four articles titled "The Maiden Tribute of Babylon" recounting how he bought 13-year-old Eliza Armstrong as a sex slave. Copies changed hands for twenty times their original value and more than 10,000 readers reportedly came to the *Pall Mall Gazette* offices for copies. Stead was gaoled for three months for child abduction.
2 Dunlevy (1988: 72) claims Stead published 137 interviews during this period, but examination of news archives suggests this may include interviews syndicated from other national and international publications.
3 For example, "Interview with an "Old Trader"; 26 August 1884; "Interview with an Old Congo Trader", 1 April 1884.
4 A fascinating journal article on Henry Van Der Weyde, written by his great-grandson in 2015, used the photographer's papers and discussed his patents.

References

Anderson, B. (1991) *Imagined Communities: Reflections on the Origin and Spread of Nationalism.* London: Verso.

Arnold, M. (1869) *Culture and Anarchy*. Oxford and New York: Oxford University Press (2006 reprint).

Bakhtin, M.M. (1984) *Problems of Dostoevsky's Poetics*. Manchester: University of Manchester.

Billig, M. (1991) *Ideology and Opinions: Studies in Rhetorical Psychology*. London: Sage.

Boyce, G. (1978) "The Fourth Estate: The Reappraisal of a Concept", in G. Boyce, J. Curran and P. Wingate (eds) *Newspaper History from the 17th Century to the Present Day*. London: Sage.

Braudy, L. (1986) *The Frenzy of Renown: Fame and its History*. New York and Oxford: Oxford University Press.

Cohen, R. (1994) *Frontiers of Identity*. London and New York: Longman.

Colley, L. (2009) *Britons: Forging the Nation 1707–1837*. New Haven, CT: Yale University Press.

Conboy, M. (2002) *The Press and Popular Culture*. London: Sage.

Conboy, M. (2004) *Journalism: A Critical History*. London: Sage.

Conboy, M. (2011) *Journalism in Britain*. London: Sage.

Couldry, N. (2002) *Media Rituals: A Critical Approach*. London: Routledge.

Curran, J. (1978) "The Press as an Agency of Social Control: A Historical Perspective", in G. Boyce, J. Curran and P. Wingate (eds) *Newspaper History from the 17th Century to the Present Day*. London: Sage.

Curran, J., Douglas, A. and Whannel, G. (1980) "The Political Economy of the Human Interest Story", in A. Smith (ed.) *Newspapers and Democracy: International Essays on a Changing Medium*. Cambridge, MA: MIT Press, pp. 288–348.

Danahay, M. (2012) "Richard Mansfield, Jekyll and Hyde and the History of Special Effects". *Nineteenth Century Theatre and Film*, 39(2): 54–72.

Debord, G. (1967) *The Society of the Spectacle*. 1st edn. New York: Zone Books.

deCordova, R. (1990) *Picture Personalities: The Emergence of the Star System in America*. Urbana, IL: University of Illinois Press.

Driessens, O. (2013) "The Celebritization of Society and Culture: Understanding the Structural Dynamics of Celebrity Culture". *International Journal of Cultural Studies*, 16(6): 641–657.

Dunlevy, M. (1988) *Feature Writing*. Melbourne: Deakin University Press.

Dyer, R. (1979) *Stars* (1998 edn). London: BFI.

Friederichs, H. (1911) *The Life of Sir George Newnes*. London: Hodder & Stroughton.

Fytton, F. (1954) "The Legacy of T.P. O'Connor". *Irish Monthly*, 83(969): 169–173.

Gamson, J. (1994) *Claims to Fame: Celebrity in Contemporary America*. Berkeley, CA: University of California Press.

Giles, D. (2010) *Psychology of the Media*. Basingstoke, UK: Palgrave.

Goffman, E. (1956) *The Presentation of Self in Everyday Life*. Edinburgh: University of Edinburgh Social Sciences Research Centre.

Goodbody, J. (1985) "The Star, its Role in the Rise of Popular Newspapers 1888–1914". *Journal of Newspaper and Periodical History*, 1(2): 20–29.

Greenwall, H. (1957) *Northcliffe: Napoleon of Fleet Street*. London: Wingate.

Griffen-Foley, B. (2008) "From Tit-Bits to Big Brother: A Century of Audience Participation in the Media", in A. Biressi and H. Nunn (eds) *The Tabloid Culture Reader*. New York: Open University Press, pp. 303–313.

Hartley, J. (1996) *Popular Reality: Journalism, Modernity, Popular Culture*. London: Arnold.

Herd, H. (1952) *The March of Journalism: The Story of the British Press from 1622 to the Present Day*. London: George Allen & Unwin.

Horton, D. and Wohl, R. (1956) "Mass Communication and Para-social Interaction: Observations on Intimacy at a Distance". *Psychiatry*, 19: 213–229.

Inglis, F. (2010) *A Short History of Celebrity*. Princeton, NJ: Princeton University Press.

Jackson, K. (2001) *George Newnes and the New Journalism in Britain, 1890–1910*. Aldershot: Ashgate Publishing.

Jarvie, I. (1990) "Stars and Ethnicity: Hollywood and the United States 1932–1951", in L. Friedman (ed.) *Unspoken Images, Ethnicity and the American Cinema*. Champaign, IL: University of Illinois Press, pp. 82–111.

Lee, A.J. (1976) *The Origins of the Popular Press*. London: Croom Helm.

Lloyd, C. (2020) "W.T. Stead Saw Job Offer to Become Northern Echo's Editor as a 'glorious opportunity to attack the devil'". *Northern Echo*, 4 January. Online.

Lowenthal, L. (1961) "The Triumph of Mass Idols", in L. Lowenthal and E. Cliffs (eds) *Literature, Popular Culture and Society*. New Jersey, NJ: Prentice-Hall.

Marshall, P.D. (1997) *Celebrity and Power: Fame in Contemporary Culture*. Minneapolis, MN: University of Minnesota Press.

Marshall, P.D. (2005) "Intimately Intertwined in the Most Public Way: Celebrity and Journalism", in S. Allan (ed.) *Journalism: Critical Issues*. Maidenhead, UK: Open University Press.

McLuhan, M. (1964) *Understanding Media*. London: Routledge.

O'Connor, T.P. (1889) "The New Journalism". *New Review*, 1 October. London.

Örneberg, H. and Jönsson, A.M. (2008) "Tabloid Journalism and the Public Sphere: A Historical Perspective on Tabloid Journalism", in A. Biressi and H. Nunn (eds) *The Tabloid Culture Reader*. New York: Open University Press, pp. 23–33.

Pemberton, M. (2016) *Lord Northcliffe*. London: Palala Press.

Ponce de Leon, C.L. (2002) *Self-Exposure: Human Interest Journalism and the Emergence of Celebrity in America*. Chapel Hill, NC: North Carolina University Press.

Pound, R. (1966) *Mirror of the Century: The Strand Magazine 1891–1950*. London: Heinemann.

Robinson, W.S. (2012) *Muckraker: The Scandalous Life and Times of W.T. Stead*. London: Robinson Press.

Rojek, C. (2001) *Celebrity*. London: Reaktion.

Rojek, C. (2012) *Fame Attack: The Inflation of Celebrity and its Consequences*. London: Bloomsbury Academic.

Salmon, R. (1997) "'Signs of Intimacy': The Literary Celebrity in the 'Age of Interviewing'". *Victorian Literature and Culture*, 25(1): 159–177.

Salmon, R. (2000) "A Simulacrum of Power: Intimacy and Abstraction in the Rhetoric of the New Journalism", in L. Brake, B. Bell and D. Finkelstein (eds) *Nineteenth-Century Media and the Construction of Identities*. London: Palgrave.

Schudson, M. (1978). *Discovering the News: A Social History of American Newspapers*. Basic Books: New York.

Shattock, J. and Wolff, M. (1982) "Introduction", in J. Shattock and M. Wolff (eds) *The Victorian Periodical Press*. Toronto: University of Toronto Press.

Sonwalker, P. (2005) "Banal Journalism: The Centrality of the Us-Them Binary", in S. Allan (ed.) *Journalism: Critical Issues*. Maidenhead: Open University Press, pp. 261–273.

Stead, W.T. (1901) *The Americanization of the World or The Trend for the 20th Century*. New York and London: Horace Markley. Available at: https://archive.org/details/americanizationo01stea/page/n6.

Taylor, C. (1989) *Sources of the Self: The Making of the Modern Identity*. Cambridge: Cambridge University Press.

Turner, G. (2014) *Understanding Celebrity*. 2nd edn. London: Sage.

Usher, B. (2018) "Rethinking Microcelebrity: Key Points in Practice, Performance and Purpose". *Celebrity Studies*, 15 November: 1–18.

Van der Weyden, R. (1999) "Henry van der Weyde (1839–1924)". *History of Photography*, 23(1). Online.

Wiener, J. (1988) "How New Was the New Journalism?", in J. Wiener (ed.) *Papers for the Millions: The New Journalism in Britain, 1850s to 1914.* New York: Greenwood Press, pp. 47–71.

Wiener, J. (1994) "The Americanization of the British Press, 1830–1914". *Studies in Newspaper and Periodical History*, 2: 61–74.

Williams, R. (1961) *The Long Revolution*. London: Chatto & Windus.

Williamson, M. (2016) *Celebrity: Capitalism and the Making of Fame.* London: Polity.

Press

Anon (1892) "Henry Van Der Weyde", *Tinsley's Magazine* (1867–1892), January, 32: pp. 190–192.

The Northern Echo (1870–current)

Pall Mall Gazette (1883–1921)

The Million (1892–1895)

Tit-Bits (1881–1984)

The Star (1888–1924)

The Strand (1891–1949)

4

ACTS OF CONSECRATION AND DESECRATION

Journalism and 20th-century stardoms

"Stardom" first emerged as an "image of the way stars live" when actors of the silver screen became visible beyond them (Dyer, 1979: 35). But while stars were made by Hollywood, this also relied on intertwining older discourses of celebrity with moving images and in the course of the 20th century there were other types of stars too, such as the figureheads of authoritarian politics and popular music. In each iteration journalism held a sacred place in the negotiation of persona, professional work and private lives of "the star" as both cultural "fabrications" (Morin, 1960: 134) and conditions of publicised self-identity. Stars *embodied* film's magical balance between art and industry and the established rituals of journalistic representation of celebrity offered patterns through which this glittering, hyperreal and image-heavy adjuncts of celebrity culture could perform. Stars were newsgenic, photogenic, and reliant on economies of spectacle, and this glamorous facet of the celebrity class reimagined the practices and purposes of journalism's rituals of celebrification.

There are many discussions about the differences between celebrity and Hollywood stardom at cultural, institutional and individual levels. Against Rojek's (2001: 17) taxonomy of fame, stars are optimum achieved celebrities, whose extraordinary talent and good looks place them in a field of their own. Analyses often apply Max Weber's (1922) examinations of individualised social power in politics to argue that stars possessed unique "charismatic authority" which within the context of "capitalist exploitation of film" tries too hard "to spur the interest of the masses through illusion-promoting spectacles and dubious speculations" (Benjamin, 2007 [1935]: 28). Here, I explore how the differences between journalism's discourses of stardom and its earlier, more grounded discourses of celebrity, reflect the press's adaptation to the inventions and cultural dominance of the American silver screen, economically and socially liberal publics and the role of cultural intermediaries or what Turner (2014: 150) refers to as the "smiling professions".

Discussions in this book so far have established that journalism and celebrity emerged together in newspapers as the first mass media to perpetuate ideological and political shifts in social systems and representations of what these meant for understandings and performances of self within them. Those individuals who passed through news media's rituals of celebrification often embodied such changes and offered means by which ordinary people might come to *understand* their identities as "consumers" and "citizens". Twentieth-century "stars" functioned differently. For one, they existed beyond the reach or dreams of most people. Stardom is up there and out there – entirely mediatised – and is therefore only a simulation of self-identity. This relies on journalism's rituals of celebrification and constructions of fact to mask hyperreal qualities from audiences. Of course, there were simulative dimensions to the creation of consumer and citizen identities too, but at least publics experience those. Second, stardom focused less on shapes of identity and society or radical politics than any previous iterations of celebrity journalism because its *primary* focus was *selling* cultural or consumer products or ideologies through seducing audiences with incredible visions for the potentials of life. It linked media as art, invention and commerce as Hollywood tied neatly into corporate models of ownership and profit through advertising, which emerged at the same time (Williamson, 2016).

The most vitriolic critics of Hollywood stardom, such as Adorno and Horkheimer (1977 [1944]: 354), suggested that while audiences were conned into believe they were unique, stars were actually as "mass produced as Yale locks", with a "pseudo-individuality" that rendered audiences passive receptors of manufactured homogeneous images of being. The patterns of news helped such processes. Alberoni (1972: 66–67) described how despite the fact that stars were obviously reproduced, "the collective ... perceived [them] in their individuality" and were convinced of almost god-like talents as reason for visibility. He argued the value of Weber's "charismatic authority" to understand the individual appeal of stars, but that it was equally dependent on the experiences of audiences, their disposable incomes and dreams of social mobility. Such socio-economic shifts and conditions also facilitated the invention of celebrity in the 18th-century London press and the increase in celebrity journalism and reshaped celebrity class at the end of the 19th century. This chapter explores how older discourses helped make stardom and then allowed it to fulfil quite incredible potentials. In the era of *The Image* (Boorstin, 1961), with its replication and repetition of reality, the star exploded so spectacularly it eclipsed earlier cultures of celebrity almost to the point that they were forgotten. Patterns of journalism *consecrated* stars as shining figures of the heavens and *desecrated* them to bring them crashing back to earth and consequently only true "stars" – unlike many of the celebrities we have encountered thus far – endured in the public imagination.

Consecration and desecration are, of course, religiously loaded terms, and Chris Rojek (2001: 51) discussed particularly how relationships between fans and celebrities display the "non-reciprocal emotion" of religious worship through parasocial bonds. He argued that worship of such figures is often pathological and stems from

declining belief in religion. The everyday bonds of press parasociality, as explored in the last chapter, were not at all reliant on religious idolatry but rather on everyday amenability and belief in reciprocation. When the London-based press made celebrity culture, religion was not in decline or certainly not at the levels that would make sense of such arguments. It is in relation to stars that religious terminologies truly apply as only they achieve anything like the status of gods. Rituals of consecration stem from the camp and gilded realms of Roman Catholicism, which rely on iconographic multifaceted deities, symbolic dress, the glamour and tears of the mother goddess and legions of – and shrines to – lesser saints who transcended human flaws and join the heavens. Star imagery and discourses, both in and beyond the press, draw from these things in a way that grounded and human celebrities could not. This vision of fame also extended methods of celebrification and celebritisation to make new agents of social control and tools for economic dominance for old areas of mass media and new. Acts of consecration and desecration advanced and maintained perfected reflections of self and jealously guarded against those who stepped beyond them. Stars offered an alternative system for blind adoration and worship.

The last two chapters applied taxonomies and definitions from firm analytical grounds of 20th-century celebrity culture to earlier manifestations in print media and in relation to sociological discussions from and of those times. We now find ourselves on well-trodden paths and there is no need to quantify the existence of celebrity news and journalism in the same way. However, while many examinations use journalism from this period to evidence, for example, societal meanings and purposes of celebrities and stars or to produce histories and biographies, too few focus in detail on what we can learn from how journalists shaped and used the performances of stars and celebrities and vice versa. Here, I track forward earlier rituals and patterns to demonstrate the enduring significance of journalism's representation of celebrities on social and self-construction. Through examination of news media in relation to different 20th-century stardoms – including Hollywood magazines, cinema newsreels, radio, World War 2 propaganda and the pop music press – I argue that rituals and patterns from journalism and celebrity shaped 20th-century stardom and by extension the ideological battles of society. But before we consider pertinent moments that illustrate journalism's relationship with stars, let's consider the significant impact on journalism and celebrity cultures more broadly because of their dramatic entrance onto the public stage.

Acts of consecration and desecration: how Hollywood stardom eclipsed celebrity culture

Richard deCordova's (1990) seminal *Picture Personalities: The Emergence of the Star System in America* best articulates the significance of "wider discourses" of Hollywood magazines in establishing stardom. He demonstrates how journalism helped to establish "the star" as a "symbolic identity" and a "dominant site for attention" (p. 112) through discourses from the stage, then descriptions of "picture

personalities" and then finally the individuality of stars. However, while he claims that before 1907 there was no discourse of the *film* actor (deCordova, 1990, italics added), Victorian discourses about actors of the London stage – as explored last chapter – had established not only the economic systems (Dyer, 1979; Williamson, 2016) but also, through their interactions with the press, many of the themes and imagery associated with stardom. Hollywood magazines and studios *applied* established rituals, image-based logics and dialogic interactions between celebrities and journalists to create cinema stars. The economies of the star system also relied on theatrical models of central leading characters, the commercial models of the mass-industrial press (Williamson, 2016) and the place of celebrity news and debate in distinguishing mass media products from one another (see chapter 2). Stardom *as discourse and performance* – and therefore by extension its economic and social powers – were made from 18th-century celebrity models of Romanticism and authentic self (both about and beyond the actors of the stage) and transatlantic cultures of Victorian achieved celebrity (chapter 3) which included celebrity interviews, portraits and gossip columns. Thus, the Hollywood star system was less an "emergence" and more a penumbra of established narratives of celebrity journalism by ravishing, better manufactured and multi-mediated displays.

At the same time as news moved from a print culture to a multi-platform medium – also across newsreels and radio broadcasts – Hollywood became the third "largest news source in the USA" with more "discourse around … private lives and intimate relationships" than ever before (Evans, 2005: 34). Ponce De Leon (2002: 40–52) references the significance of interviews and biographies, but declares the first "celebrity journalism" as the gossip column in late 19th-century American newspapers, focused primarily on the New York fashionable set (see also Inglis, 2010). But celebrity gossip, as chapter 2 explored, existed long before this and increased volume was just one facet of the layering and chunking of established narratives of fame with new. Such an argument broadly aligns with Christine Geraghty's (2007 [2000]: 99–100) discussions of the "extra-textually" that developed the "celebrity element of stardom", which is both "highly managed" as a means to keep stars on their pedestal or disrespectful to bring them crashing down to earth. However, this chapter also explores how journalism provided "the institutional setting for much, if not most, of the discourse on stars" (deCordova, 1990: 12) *because of* established rituals for celebrification. As such, we should also flip Geraghty's statement to consider how the star element (or adjunct) of celebrity developed and what this meant for news media. Hollywood studios and magazines used established stylistic devices as stepping-stones towards the creation of a new area of celebrity that served them first. The constitutive elements of "stardom" were the textual and image-based logics of female achieved celebrity particularly – good looks, glamour, consumerism and fashion, "unique" talent and hard work, glimpses into "private" realms and adoration of audiences, peers and journalists. More specifically, Hollywood's first magazines – *Motion Picture Magazine* (1910–1977) and *Photoplay* (1911–1980) – adapted the construction patterns, layouts, use of pictures, conversational stand-firsts, biographies and fictional stories of magazines

such as *The Strand*. There was similar familiarity with readers and directions for self-improvement, and just as George Newnes included his creative team in the "achieved celebrity" crowd (chapter 3), so too, at least in the earlier days, Hollywood magazines celebrified and interviewed studio cinematographers, agents, make-up artists, actors and their own writers too.

Both Dyer (1979: 9) and Wagenknecht (1962 [1997]: 24) discuss the first interview with a "film star" – Florence Lawrence after a staged accident (*Motion Picture Magazine*, December 1911) – and whether it was a crucial turning point for celebrity culture. In terms of the relationships between older discourses of celebrity journalism and Hollywood's magazines and promotional cultures, it was little more than an interesting footnote. Williamson (2016: 63) counters the dominant narrative that studios only released the names of players because of growing public demand about the people behind the screen (Schickel, 1985). She thinks it more likely that "rather than studios … being reluctant to publicise the names of performers in film, it did not occur to them to do so" (p. 63; see also deCordova, 1990). Many discussions consider why film actors were not *immediately* named outside the roles they played and conclude that the public demanded this information and that studio, at first unwillingly, complied and turned to journalists to filter out carefully selected material. In these accounts, there is a logic of passivity in the press's role. Certainly, given that cinema emerged towards the end of the never-ending novelty of New Journalism, as explored last chapter, newspapers and magazines were uncharacteristically slow to include Hollywood "players" in their pages. It is likely they were uncomfortable about the shifting power-balance between them and a new rival mass media competing for audiences and the control of dominant public images. Newspapers and magazines had invented celebrity and until this point dominated the representation of its many participants, including actors. For example, 18th-century actors David Garrick and Sarah Siddons or 19th-century thespian Mary Anderson only became part of the national popular because of news reports about their private lives and reviews of their on-stage performances. Most people never encountered them in the flesh. It also may have been that against the broader parameters of the celebrity class, Hollywood stardom simply felt too narrow for too much space and newsgathering. While actors had featured in celebrity news and journalism since its 18th-century origins, as evidenced in the past two chapters, they were but one component of this complex culture and class, which equally included other creatives, politicians and ordinary people made famous too. There were also significant similarities between how the motion picture industry created star systems to deal with "the *uncertainty* that particularly plagues the producers of media and cultural goods" (Hesmondhalgh, 2005: 114, original italics) and how newspapers used celebrities to build their audiences and advertising revenues over the previous 200 years. Print publishers may simply have been reluctant to embrace and help the promotional activities of rivals for audience attention, which would fit the broader approach of the mass press, who considered the maintenance of their cultural dominance in relation to economic success (Hesmondhalgh, 2005: 112–115).

Regardless of false starts – which in the scheme of how stardom developed in journalism are of little real importance – by 1914 there were firmly established Hollywood magazines and studios began to employ cultural intermediaries to build systems of promotion, which included the strategic use of journalism's rituals of celebrification. Press agents and stars made pseudo-events and circulated idealised self-images to attract the attention of the press and by extension promote films. Within five years, Hollywood magazines and the studio system were working together to *consecrate* individuals as figures of reverence for fans. Across the subsequent two decades, star interviews (as explored in the next section) developed from surface-level accounts of achievement and day-to-day life like those of 19th-century New Journalists to also offering insights into the real self of "the face" behind "the mask" (Barthes, 1957 [1975]), often influenced by the growing popularity of psychoanalysis in Hollywood circles. This had two significant impacts in terms of the relationships between journalism and celebrity. First, it made self-confession part of the "emotional labour" of celebrities, which sowed fertile ground for self-marketisation in tabloids and on television as discussed in the next chapter. Second, it risked the desecration of highly manufactured persona, something that studios particularly feared and worked hard to avoid. This demonstrated the voids between "star" and "celebrity" performances of self in journalism, which had often used public visibility to challenge social norms. The main aim of the studios, at least in the first decades, was promotion rather than influence over cultural citizenship. As such, star rebellion or political actions – acting beyond the norms of Hollywood promotional practices and their narrow lens of white, social aspiration – could lead to the press magnifying or even inventing flaws to deconstruct idolatry and titillate audiences and studios removing their systems of protection. Such tensions shaped journalism and celebrity interactions for the rest of the century.

There are some fascinating examples of acts of consecration and desecration of stars by the press in partnership with studios. For example, silent screen goddess Clara Bow – the first "it" girl after starring in a film of the same name – found fame via a fan magazine competition for a bit part in a film and was an early darling of the movie industry press. However, in 1921, tabloid newspaper *The Coast Reporter* published a series of lurid exclusives that falsely accused her of incest, lesbianism, drug addiction and bestiality. As the main source was her former personal secretary and friend – and the *Coast Reporter* editor had offered to stop publication for cash – there were prosecutions for blackmail, but reports of courtroom testimony did little to rehabilitate her image. Like Thomas Paine and Georgiana, Duchess of Devonshire, as explored in chapter 2, Bow was attacked with scurrilous stories because she challenged social norms and, in her case, emerging rules for the performance of star identity too. She was not only open about her sex life and discussed her "engagements" as euphemism for partners, but had told newspapers about her traumatic, abusive childhood and suggested other actresses were whitewashing their working-class roots to better suit the promotional demands of the studio system. This undermined their consecration of stars and made her fair game.

Bow was ostracised by Hollywood's social circles and her subsequent physical and cultural disappearance from the public eye was so complete that she was almost forgotten and even omitted from early film histories, much to the ire of some peers.[1] On one hand, press hit jobs, of course, drew from the celebritised news discourse of "attack journalism" – part of the press's rituals of celebrification since the 18th century. On the other hand, tensions between "worship" and "attack", "extraordinary" and "ordinary", and "above us" and "beneath us" were more poignant and pungent because of the image-based iconography of cinema and audiences' celebration of it.

Reimagining the celebrity interview: promotion, psychoanalysis and power exchanges in Photoplay (1914–1944)

Hollywood magazines played a significant part in developing stardom (deCordova, 1990) and between 1914 and 1944, Photoplay "reigned supreme … as the veritable doyenne of Hollywood publicity" (Petersen, 2013). Anthony Slide's (2010) Inside the Hollywood Fan Magazine detailed how "fan magazine writers" shaped Hollywood's promotional cultures, and Dyer (1979: 35–39) highlights particularly how models for "conspicuous consumption" were guided by the glamorous images and discussions of star fashion in Photoplay which, as explored over the past two chapters, was a founding discourse of celebrities in print. The New Journalism model for celebrity interviews and portraits provided powerful patterns to facilitate star performance and both sides of the exchange were grateful for such opportunities, which supported their own promotional productions and performances. These dialogic exchanges were mutually beneficial for both participants and their employers. Journalism's popular appeal "lies in its successful reconciliation between … dialogic poles" (Conboy, 2002: 19; see also Bakhtin, 1984) and interviews were mediated dialogic structures through which "self" was articulated in relation to capital, consumerism, citizenry and of course fame. Stars became models for emulation who constantly discussed consumer and luxury goods, beauty regimes, favourite fashions, the political aspects of life and self-worth. They "conspicuously displayed … success through material possessions", which vividly demonstrated "the idea that satisfaction was not to be found in work but in one's activities away from work – in consumption and leisure" (deCordova, 1990: 108). These were the most consistent themes from 18th- and 19th-century celebrity cultures as broadly circulated in print.

Between 1914 and 1944, Photoplay journalists interviewed hundreds of film actors to produce both first-person narrative pieces – written as if by the star – and third-person features. In the early days, there were around seven per edition, including with others working on Hollywood lots. Actors were usually referred to as "players" or "personalities" and interviews with them focused on promotion of film and superficial descriptions of home and work, which balanced "the exceptional with the ordinary, the ideal with the fundamentally every day" (Dyer, 1991: 34–35). Actresses, for example, usually discussed studio life and chaperones, their

beauty regimes, "keeping house" and "doing the things other girls do". Interviews with them often concluded with an editorial side-note about their special qualities such as "Many sided she is and indeed every side is charming ..." (*Photoplay*, November 1914: 52). The familiar rituals of celebrification offered by the interview guided readers to accept personalities as on the path to fame and real life was often acknowledged as not as significant as this process. For example, in "Why Film Favorites Forsook the Footlights" – part of a body of content which deCordova (1990: 102) described as an effort "to disassociate the film actor from the theatrical model" – discussions between journalist and former Broadway actor Johnson Briscoe and "film favorites" Marguerite (Peggy) Snow and Augustus Philips highlighted the falsity of the exchange.

> "And was Denver your birthplace?" I rather stupidly began
> "Why yes you can say so in print if you like," replied Miss Snow, "though as a matter of fact I generally claim Savannah, GA as my birthplace, though I was really born in Salt Lake City."
> [...]
> I arose to go and my genial interviewee, probably knowing the trials which beset an interviewer's path, said quite seriously, "You might write anything you like, and I'll swear I said it."
> But he really did say the things I have set down here.
> *(Briscoe,* Photoplay*, November 1914: 124–132)*

In his seminal sociological study, *The Presentation of Self in Everyday Life*, Erving Goffman (1956: 13) identified "performance" as any "period marked by [...] continuous presence before a particular set of observers" that aims to influence them in some way. These interviews as *mediated self-performances* existed within the "front" of a magazine, and by this time there were patterns for such exchanges, developed in the 19th-century press. Following Goffmanian logic such moments were "cynical" as neither journalists nor stars believed "the impression of reality" being staged was "the reality" (1956: 10), but with each constructing realities for their own ends. Both the journalist and the actors understood the interview as primarily a mutually beneficial exchange where "truth" was less important than processes of celebrification.

This dynamic was evident again the following month in an article entitled, "I go A-calling on the Gish Girls" (Willis, *Photoplay*, December 1914: 36–37), but by this time the purpose extended from fame building to also the perpetuation of patriarchal norms and the power of the press. On one level, the dialogic interaction between "well known *Photoplay* writer" (Anon, *The New York Dramatic Mirror*, 3 June 1914) Richard Willis and screen favourites Lilian and Dorothy Gish displayed the "extraordinary" and "ordinary" paradox described by Dyer (1979, 1986, 1991; see also Marshall, 1997 and Morin, 1960) to extend their fame. He presented their "star home" with the "connotation of conventionality, stability and normalcy" (deCordova, 1990: 107) and also framed himself as the dominant force in the

room, literally accounting his male gaze (Mulvey, 1988) as he sat opposite a "pretty" scene of "blonde" "domesticity". Dorothy Gish attempted to break his gaze on several occasions and laughed as she told him that she found the term "star" and descriptions of her as "the most beautiful blonde in the world" ridiculous, although also ensuring that he – and by extension the reader – knew she was seen as such. She declared herself a "hardworking woman" rather than a "girl" and he firmly dismissed this by describing her as "girl" throughout the rest of the piece.

Willis and the Gish Girls engaged in complex power plays of representations and performance framed primarily through male-approved, white middle-class domestic femininity, which dominated representation of female celebrity from its origins in the 18th century and arguably to the current day. They mutually *constructed* a narrative of talent, hard work and beauty through familiar narratives and there was tension when she seemed to want to step beyond them. This dialogic construction was not *only* about fame building, it was also about Willis' desire for both women and the audience to submit to *his* lens for female public worth. Ultimately, the Gish Girls as he represented them in the final piece conformed to both celebrity rituals and his journalistic dominance. This fitted wider representations of women in the magazine, as also reflected in the subsequent advertising section. No fewer than 13 adverts depicted pretty, middle-class blonde girls just like Lillian and Dorothy Gish, selling products from "arsenic skin wafers" to lighten skin to the "Ivanna Bust Builder" to improve one's shape and, of course, peroxide hair dye. This vision of stardom was white, blonde and available at a store near you. Such dynamics highlight the value of Adorno and Horkheimer's (1977 [1944]: 37) observations of gender "reproduction" which confirmed to "girls in the audience" that they "could be on screen" but also underlined "the great gulf separating them from it".

Around the same time as this interview, Richard Willis turned the representational skills honed as a celebrity interviewer towards publicity and set up one of the earliest Hollywood agencies, an early example of the now regular movement between newsrooms and public relation firms. The Willis & Inglis Agency, he claimed, was "the first to do personal publicity for the photoplayers in the west" and "the first agency on the west coast to become established as an institution negotiating business between producers and artists" (in Long, 1997: online). There were wide reports of the subsequent wealth and influence of Willis, as a "British invader" who came to "these shores as an actor", and soon Willis was working as a screenwriter too. *New York Dramatic Mirror* (1879–1922) described,

> it's a poor week that doesn't find Dickey landing one writer, two directors and three stars in jobs at anywhere from one to five thousand dollars per hold-up apiece! What does Willis do with all his money? I'll tell you. He has bought a palayshul home.
>
> *(23 October 1919)*

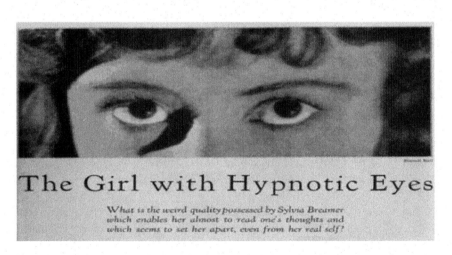

FIGURE 4.1 *Photoplay* Star Interviews (1914–1924)

He also continued to work as a Hollywood star-interviewer for several publications and, as reported in *The Moving Picture World* (1907–1927), opened his own film studio with partner Guy Inglis, sold the following year to their client and silent film star Charles Ray, who turned to direction and production. The movement between different creative professions – actor to journalist, journalist to screen-writer, actor to director and producer, journalist to publicist – indicate the creative and commercial fluidity of early Hollywood's media systems.

On the other side of the *Photoplay* interview exchange were the Gish Girls. In 1962, film journalist and historian Edward Wagenknecht dedicated *Movies in the Age of Innocence* to Lillian and Dorothy Gish and included an essay he sent to them in 1927, which led to them becoming friends. Wagenknecht (1997 [1962]: 251) referenced their place in establishing the dominance of the "blonde" and used Lillian as a contrast to "most girls" who "have definitely outlawed overtones, where everything must be frank and open, everything ruthlessly displayed, no matter how ugly it may be". He aligned her craft to that of 18th-century actor David Garrick – and this link between Hollywood stardom and the celebrities of the 18th-century stage demonstrates the enduring power of patterns of Romantic representations from the earliest celebrity journalism to this new vision of it. Wagenknecht bewailed shifts between Gish, with her natural gift, artistry and "innocence", and later female stars, sullied by psychoanalysis, sex and demands for female equality. He, at least, encapsulated how early film stars acted as embodied transition points between themes of celebrity of old and new. The rest of his piece reflects what is by contemporary standards an embarrassing 20th-century masculine obsession with sexual innocence, "the blonde", and the narrow lens for femininity, which dominates celebrity journalism as a genre.

Over the next twenty years or so, *Photoplay* regularly documented Hollywood's fascination with psychoanalysis and such stereotypes. Freudian self-exploration in the 1920s and 1930s offered another pattern for dialogic exchange aimed at unmasking the private self, which influenced the celebrity interview. Richard deCordova (1990: 143) discussed whether the emergence of cinema and psycho-analysis at the end of the 19th century was a "meaningless coincidence" or reflective of a "historical shift in ideas of selfhood, images and desire". As the cinema industry converged in Tinsel Town, it became a hive of activity for therapy as a reflection of attempts to reconcile "self" with the falsity of the constructed and mediated images. In 1924, Freud rejected a $100,000 offer from studio owner Samuel Goldwyn (1879–1974) to advise on scripts and film productions on the issue of relationships between men and women and to commercialise his study and write a story for the screen (Scull, 2015). Dyer (1979, 1986), Marshall (1997) and deCordova (1990) each referenced the significance of psychoanalysis on films and stars during the period. Marshall (1997: 14) discussed how increased knowledge of Freudian analysis influenced celebrities' "ability to engage the spectator" in a form of identification with the human characters they displayed. Dyer (1986: 8) also examined how stars "articulate[d] … ideas of personhood". As an example, he

described Marilyn Monroe's performance of female sexuality as entirely dependent on male sexuality *because of* the influence of Freudian analysis on her performance of self.

Psychoanalysis also shifted the celebrity interview from *primarily* a function of promotion to one of self-reflection and one where the star even pondered whether they were more than just cultural products. Journalists often behaved in interviews as if therapists rather than news gatherers. For Adorno and Horkheimer (1977 [1944]: 36) this reflected celebrity culture's novelty and individualism as "predecessors and successors of psychoanalysis", reduced to the "monotony of sexual symbolism" which limited meaningful sexual emancipation by controlled normative visions, such as what was evidenced in interviews and comment about the Gish Girls. Marshall (1997: 73–74) argued that Freudian behavioural psychology clarified how celebrity charisma helped "people automatically assume rational grounds for their feelings", which can lead to the emotional being plausible and integrated into the world. The interview became a ritual to rationalise public display of emotion and then, through welding it to promotional work, a site of "emotional labour" where the private self is publicly marketable (Hochschild, 1979; Biressi and Nunn, 2010). As a mutually advantageous journalistic and celebrity practice – developed as part of the affective economy of culture and politics – interviews accounted the popular and political aspects of life and offered a new pathway for cultural and collective citizenship. The reimagined patterns of the celebrity interview helped to establish the market power of such emotional work, particularly through the development of star confessionals.

For example, during the 1920s, *Photoplay* interviews often declared that they showed stars "as they really are" or "behind the screen". The number of one-to-one encounters between journalists and actors decreased significantly, but more direct speech gathered from others expanded practices of newsgathering in relation to celebrities across news media (Ponce De Leon, 2002). Professionalised, systematic promotional approaches developed by Hollywood studios and agents such as junkets and the red carpet (Turner, 2014: 33–49) masked this change in access and celebrity culture became an ever more visible phenomenon. During more intimate interviews – often conducted in private spaces – stars attempted to articulate who they "really" were away from the promotional practices that governed their market function (Dyer, 1986: 5). They could reveal themselves as different to their screen image and "might even become more marketable as a result" (Evans, 2005: 34).

Dyer (1986) and Marshall (1997: 17) explored how stars worked as "ideological" centres for capitalist societies and at the same time registered and explored anxieties of self-identity within them. For example, female stars displayed increased independence and economic emancipation, but discussions and representations of marriage – whether suffrage damaged the importance of their natural role – were "ever present" in Hollywood fan magazines (see also deCordova, 1990). In "Why I Never Married: Two Famous Screen Stars – A Man and A Woman – tell their reasons" (Anon, *Photoplay*, January 1924), gender norms and narratives were

deconstructed to explore the potential risks to the wellbeing of individuals and society more broadly, of women being able to find financial security without marriage:

BEBE DANIEL: Men as a rule want their wives for themselves. Not only do they want their time and attention, but they want their thoughts. Men for centuries have been trained to expect their wives to be subordinate to them, financially and professionally – that they should stay at home, bear children and conduct the house.

BEBE DANIEL: But if a girl has worked conscientiously for years and attained any degree of success in her profession, she isn't satisfied to abandon her ambitions any more than a man would be satisfied to give up his. It is tremendously difficult for the man. I understand that. They are seeing what has been their traditions, their very world, tumble down around them. [...]

RICHARD DIX: I suppose the truth is, though my masculine ego hates to admit it, is that the real reason is that no woman has ever been sufficiently in love with me to ever want to marry me. If one had been, she would have.

RICHARD DIX: A man is paralyzed by her many attractions, her understandableness, her mystery. They think if they can possess a woman, live with her constantly, they will find the answer to the eternal riddle. Perhaps it is one of those riddles without an answer.

RICHARD DIX: I have an awfully old-fashioned idea of marriage. That's the trouble with me. I admire the modern girl and modern woman tremendously. I look to her and appreciate all she has done for humanity and all she has done to improve herself. But – I can't always reconcile her with my idea of marriage.

Both actors spoke directly to the other and discussed the impact of their fame on personal relationships. While deCordova (1990: 111) argued politics was not "developed elaborately" in fan magazines, this performance demonstrates *the political* aspects of celebrity performance and another facet of cultural citizenry. Audiences were encouraged to choose whether shifts in gender normative roles and female emancipation were positive for the stars and for society. The emerging discourses of psychoanalysis clearly influenced the narrative with either the stars or a journalist – and my instinct is that it was the latter given each piece spoke directly to the other – specifically using Freudian language as a means to articulate social change. Dix referenced his "father complex" and "masculine ego" (*Photoplay*, January 1924: 119) and Daniels argued that "most women, feel that, until they have borne a child, they have not fulfilled the cycle of existence" (ibid.: 30), which are terms from *The Father Complex* (1909) and *Totem and Taboo* (1911–1912). Through the concepts of psychoanalysis, stars and journalists debated themes of production and reproduction – the "extraordinary self" and "ordinary life" – which has maintained their thematic dominance in celebrity journalism from their 18th-century origins.

While psychoanalysis is applied to explain shifts in news values (Kovach and Rosenstiel, 2001) and celebrity displays (Marshall, 1997; Rojek, 2001), its influence specifically on the themes and constructions of celebrity journalism and interviews needs focus. Psychoanalysis looped into the celebrity interview as a "dialogic mechanism" to establish "truth" (Bakhtin, 1984) and as a ritual of celebrification. For example, an interview by journalist Bland Johaneson with Sylvia Breamer (1897–1943) – "The Girl with Hypnotic Eyes" – showed the power of the "fronts" and "expressive equipment" (Goffman, 1956) of the interview as a framework to situate even fantastical performance of self:

SYLVIA BREAMER: I wasn't eating much in those days. Times were hard. It was snowing. I never had seen snow. It thrilled and bewildered me. The street was deserted. As I stepped down, I slipped and bumped all the way to the bottom. My head was split completely across the back. I passed out. Then as I regained consciousness, I opened my eyes and the eyes that stared into them seemed familiar, although I had never seen them before in my life. I felt secure.

SYLVIA BREAMER: Then when I was out of danger he went away and I never saw him again. He was a Hindoo. [...]

SYLVIA BREAMER: I believe in thought transference and often just for fun used to impose my will on a voluntary subject. My will is ... strong.

BLAND JOHANESON: I challenge her, Sylvia Breamer, you're a diviner.

BLAND JOHANESON: My accusation, half serious, half jocular, brought from Sylvia a grave and convincing account of this curious power with which she had been endowed.

BLAND JOHANESON: There is a law in Australia, which forbids the entrance of blacks into the country for sojourns extending over six months. The little girl was to endure the first hardship of the magnificent quantity. Fate had in store for her the separation from the devoted nurse she loved.

BLAND JOHANESON: The old soul shared the child's anguish. But life and law are inextricable and little Sylvia heard her friend consign her to the mercy of Fate and promise that the psychic bond between them should acquire elasticity to encompass the furthest corners of this world or another [...]

BLAND JOHANESON: She was the quickest subject the doctors ever had imposed his will upon – that is she was able to discard her own violation and read other people's minds with remarkable ease. The doctor predicted a brilliant future for her.

> *"The Girl with Hypnotic Eyes" (Johaneson* Photoplay,
> *February 1924: 54–48; 127–128)*

Breamer's discussions of psychic elasticity referenced Carl Jung (1875–1961) and his explorations of whether such abilities can grow from personal tragedy. Together Breamer and Johaneson (who went on to become lead film critic for the *New York Daily Mirror*) explored Jungian themes of fantasy, mystical experience, the occult and desire. Johaneson framed herself as psychoanalyst and Breamer as patient whose

personal hardships had allowed for a transformative journey. Together they articulated how mystical experiences and personal tragedy can shape both her inner being and the outer appearance of it – Breamer's "hypnotic eyes". The "stand-first" introductory paragraph highlighted this purpose, and asked, "What is the weird quality … that sets her apart, even from herself?" What we see here is an early example of the interview as a vehicle "for the production of celebrity intimacy through the relaying of the life-story" for promotional benefit (Biressi and Nunn, 2010: 50). The interview offered a stage to frame confession, introspection and the representation of a better or improved self (Redmond, 2008). Breamer accounted her life as if an "emotionally difficult psychic journey" (Biressi and Nunn, 2010: 50), and in doing so, offered the magazine something that was more marketable than an everyday account of another blonde girl next door.

Viewing the celebrity interview as psychoanalytical exchange and emotional labour – rather than *simply* a promotional practice to sell a consumer item or cultural product – encouraged stars and journalists to examine the mental effects of stardom too. By the 1930s, interviews with stars were less frequent and more detailed, averaging just one or two per edition. During this period, the voice of journalist and psychiatrist intertwined. For example, in *Phantom Daddies of the Screen* (Woodbridge, January 1934) a journalist interviewed bereaved children of film stars and estimated the psychological impact of them being able to see the moving image of their parent. In the same edition, psychologist William Fielding analysed the behaviour of Katharine Hepburn (Maxwell, *Photoplay*, January 1924: 32–33). He described her as having an "inferiority complex" – a concept developed by Alfred Adler (1870–1937) in direct response to Freud's work on psyche and childhood experience – before concluding with the journalist that she would not have become a star if she were "pretty as a child". An interview with Joan Crawford (Hunt, *Photoplay* February 1934) discussed her claustrophobia stemming from childhood trauma and struggles with the invasive nature of fame and barely mentioned her latest films. These interviews moved discourses of the private away from simplistic descriptions of domestic spaces and the things that made stars just like other girls, to discussions of innermost, secret self and the extraordinary demons that make them special.

But the new breed of 1940s movie moguls such as David Selzick, Louis B. Mayer and Jack Warner were concerned that psychoanalytical unpicking of stars' carefully constructed images reduced their promotional benefit, and ultimately studios sought greater control (McDonald, 2000). Consequently, opportunities for one-to-one interactions between celebrity and journalist reduced and there was an average of just one sit-down interview per edition. The increased use of direct speech from stars via studio cultural intermediaries masked this change. The studio system acted as both enabler and protector, used journalists to create and maintain the visibility of their stars and controlled their entry points for doing so. As a result, a new construction pattern – the Q & A – became the most popular interview form. For example, in "Truth or Consequences with Irene Dunne" (*Photoplay*, July 1942), Hollywood reporter Kay Proctor put together a series of questions,

forwarded to Dunne, quite likely via the studio press team. It appears they had no direct contact and the star even had a "get out" clause for difficult questions – the ability to take "consequences". This interview was still a self-advantaging exchange, but one in which the journalist's power was significantly diminished. Over the course of thirty years, the balance of power between journalists and stars had shifted and celebrity representation by the press was forever changed.

Power, the political and the reconstruction of fact: political stardom and celebrity in the multi-media press (1910–1945)

While magazines developed the constructive elements of stardom, at the same time new technologies revolutionised journalism both in relation to and beyond its relationships with celebrity. By the 1920s, cinema newsreels also offered audiences insights into the lives of stars beyond the parts they played, and this helped perpetuate stardom as a way of being. From the very "early days, news produced important subject matter for the cinema and also helped mould its development, stimulating production and building audiences" (Bottomore, 1998: 15). Initially, newsreels were more popular in Britain than America, where few theatre owners saw little in "free" footage. When *Pathé's Weekly* launched in August 1911, it was the first newsreel of its kind in the USA, but was part of a larger stable that originated in France with *Pathé Journal* in 1908 and then Britain with *Pathé's Animated Gazette* in 1910.

On both sides of the Atlantic, pioneering New Journalists were, again, among the first to realise the potentials of this new technology for journalism. George Newnes invested in *British Biograph* shortly before his death in 1910 (McKernan, 1998: 18) and Randolph Hearst's *News Pictorial*, launched in 1914, quickly became the biggest outlet for news film in the USA. Attributed and achieved celebrities featured from the outset, including the British royal family and actors such as Sarah Bearnhardt who was filmed as she performed for French troops (July 1916) and on arrival in New York for a "farewell tour" (June 1917). McKernan (1998: 18) outlined how newsreel producers quickly identified that content should reflect "popular illustrated newspapers" and include "pictures of celebrities, of royalty, of fashion parades, ship launches, rail crashes, sporting events, national occasions, humorous occurrences of any kind". Although initially silent, newsreels "were not wordless", with each item leading with one or two lines of text, which for celebrity stories included names, where filmed and often a reference to their most popular roles.

These dynamics shaped early radio too. Wireless ownership in the USA and Britain soared in the 1920s and reporting the activities of stars quickly became part of broadcast news. In the UK, the BBC provided radio news whereas US radio developed commercially, with numerous broadcasters clambering for listeners and as a result, celebrity news featured more frequently. Starkey and Crisell (2009: 2) discuss how radio journalism offered something new – a sense of "immediacy" facilitated by "real time" communication, which was unlike anything experienced

by audiences thus far. Major "stories broke that radio could cover more con-
temporaneously and more vividly than the press" and these included stories about
the famous, ranging from the "last illness of George V in 1936" (p. 6) and Holly-
wood stars' visits to the UK. From competitions – where audiences could "guess
the voice" – to red carpet interviews, radio journalists and stars were immediate,
intertwined and intimate visitors to the homes of listeners. Broadcast created its
own celebrities who, as explored in the next chapter, had different places in public
consciousness than Hollywood's stars and what emerged was a journalistic/pro-
motional discourse with celebrity at its centre that affected the social and political
dimensions of life at home.

As journalism moved from single medium (print) to multi-platform (print,
cinema, radio), there emerged ever more complex and multifaceted spectacles. Star
persona – constructed primarily through promotional pseudo-events – reached
large audiences who embraced new (multi-)mediated realities and beings, which
seemed all surrounding (Dyer, 1986: 4–6). So far, this chapter has discussed star
interactions with journalists, principally as mechanisms of promotion, but also as
reflections and circulations of changes in identity and society. Stars were hetero-
glossic commercial, artistic and human constructions where lines between reality
and fiction were constantly blurred. There were moments where the shrewdest star
and journalistic operators brought this starkly into view.

Arguably, the most infamous instance was Hollywood legend Orson Welles'
1938 adaptation of *War of the Worlds* and the resulting press hysteria. This moment
was part of a wider body of work through which Welles explored the power of
journalism, stardom and culture working together to construct reality, which also
included the film *Citizen Kane* (1941). Kane was based on William Randolph
Hearst (discussed in chapter 3) and the media magnate was, reported to be so
infuriated by the film he blackballed Welles several times (Lebo, 2016) and Welles
later claimed some of his reporters even attempted to frame him for a crime.
Newspapers, radio broadcasters and newsreels claimed that listeners of Welles' radio
broadcast – which was scripted using radio's new formats of "breaking news" –
were so convinced there was an alien invasion, they inundated police with calls and
some people even committed suicide. Welles' artistic exploration of a classic novel
reimagined by new(s) media structures and sprinkled with his own stardust, high-
lighted the power of new journalistic structures and public visibility to make even
the most fantastical events "real" for audiences. As he faced dozens of reporters in
the days after the broadcast, he dripped with sarcasm:

> I am of course, surprised that the H.G. Wells classic – which is the original for
> many fantasies about invasions by mythical monsters from planet Mars – I am
> extremely surprised to learn that a story which has become familiar to children
> through the medium of comic strips and many succeeding novels and adven-
> ture stories, should have had such an immediate and profound effect on radio
> listeners.
>
> *(Universal News Reel, November 1938)*

As shown on the front cover of this book, the camera panned from a wide shot showing dozens of reporters surrounding a huddled Welles and then zoomed in to him at the centre of a throng as reporters scribbled down his statement in their notepads. He sat as embodiment of the powerful simulative dimensions of journalism and celebrity when used together.

This *Universal News Reel* (1929–1967), which played in cinemas throughout November 1938, cut next to "London" and showed King George and Queen Elizabeth opening a new hospital and having tea with patients. The reality of what happened that Halloween was less significant than the power of the star to maintain the spectacle of this news event. For his part, Welles relished the myth as an illustration of the power of news and star cultures to eclipse even reality. Later, in a 1955 BBC interview, he described how the conventions of journalism – interrupting another broadcast, with live reports that "Jersey City had fallen to the Martians" – made it seem real to audiences. Reporters screamed in news bulletins (or so he claimed) that "America has not fallen" and while some of what he is saying "may seem hard to believe", "highways were jammed" with panicked families, some of whom hid in the "Black Hills of Dakota" for several weeks before being convinced by the Red Cross it was safe to leave. None of this happened. But Welles, deadpan to camera with only the slightest hint of a raised eyebrow, perhaps knew better than anyone else that this interview and his star power together could make people believe it.

His exploration of the potentials for journalism to negotiate and construct reality during war was well timed. Within six months, Britain declared war on Nazi Germany and journalism, celebrity and stardom would find new significance in helping audiences to negotiate the social and political traumas of this time. Five different types of celebrity leader – two fascist dictators, a communist one and two democratic capitalists – embodied this battle and each used the mass media's narratives of stardom and celebrity for propaganda. The frontlines of World War 2 were both military and cultural, with cinema and radio used to perpetuate iconography, ideologies and personas. A propaganda model of celebrity news worked towards acts of consecration (of our leaders) and desecration (of theirs). As Churchill declared in a speech at Harvard University in September 1943, "the empires of the future are the empires of our mind", and each was prepared to use all multi-media technologies at their disposal to win. Inglis (2010) explored how their different, but no less potent, star charisma used press, cinema and radio together to establish their authority and to construct their personas as the embodiment of the will and hopes of their people. Hitler, Mussolini and Stalin were the "startling apotheosis of the star system" (p. 159), with their public image equally reliant on style, fashion, film, iconography and public worship. Fascism and communism were discourses of both stardom and politics, which created pathological adoration in millions of people (Rojek, 2001). By contrast, Churchill's celebrity built from aristocratic fame and British Empire iconography and Roosevelt's from grounded and familial discourses of celebrity, which made people feel as if they were in safe hands. They used radio and print editorials to offer audiences

grounded images of self in direct contrast to the hyperreal stardom favoured by totalitarian counterparts.

Adorno and Horkheimer (1977 [1944]) are heavily criticised for their overly pessimistic view of the culture industries where everything is simply a commodity. But on a human level it is easy to understand how the personal cost of Frankfurt School scholars, many of whom fled Nazi Germany, shaped their views on media and "mass deception" and the dangers of stardom. Adorno and Horkheimer (1977 [1944]: 42) certainly saw similarities between authoritarian and Hollywood stardoms in creating "individual as an illusion" and demands for conformity. The media, they claimed, is full of "pseudo-individuality" that only really works to repress others. If you follow this to its logical conclusion, then the differences between self-displays in journalism and the use of rituals of celebrification by leaders of Britain and America and their enemies in Italy and Germany ultimately do not matter. They only facilitated different types of suppression. But World War 2 was not only a battle of military dominance but also a cultural one in terms of which visions of self-identity, politics and society the tools of the media should perpetuate and which it should not. Winning this ideological and cultural, as well as military, battle really mattered if capitalist democracies were to survive.

The famous five war leaders successfully used their achieved celebrity status and influence over news media to establish climates and contexts of thought that resonated with their national public/audience. As reflections of the modes of production of their time, they were men equally of politics and of visibility. Celebrity journalism offered tools to amplify their nation's *way of being,* be that a society working towards common purpose, a way of reimagining post- or pre-empire identities, conformity or progressive democracy. Perhaps it is just coincidence that Churchill and Mussolini were journalists, but because of this first career they were both clever propagandists. In 1933, Mussolini told the National Council of Italian Journalists that "fascism requires militant journalism" and created state control of news media as part of "the criteria of totalitarianism", where "absolute command over the press and radio" ensured he was always represented as he wished to be (*The Advocate*, 4 November 1933). Hitler followed his lead and established the Under-secretariat for the Press and Propaganda in 1934, which would become the Ministry of Popular Culture. Mussolini and Hitler offered parallel visions of stardom to that of Hollywood, but with much in common in terms of strategic use of iconic imagery, press performance and film, only channelled to very different ends. Their "charismatic authority" also had a distinctly Weberian (1922) flavour of consecration of ideologies to impact on followers.

This juxtaposed the more grounded version of celebrity purported by Churchill and Roosevelt. Hitler and Mussolini's overly dramatic self-displays became tools for public desecration through ridicule, such as the lyrics of anti-Hitler novelty songs circulated by the mainstream press or Chaplin's iconic *Great Dictator* (1940). Relaxed fatherly authority – rather than distinctly unBritish idolatry – was Churchill's aim when he turned to radio and newspaper editorials to reassure and rouse the nation. Luckily, both he and Roosevelt had other celebrities in their

camps. In Britain, the secure attributed-fame of the royal family shared the workload of generating celebrity news as propaganda and gave the public a star-point around which they could rally. His iconic self-image and rousing rhetoric reimagined the "British Bulldog" spirit for the fight at hand, and he was able to outsource familiar interactions with the war-hit public to the royals, who were, of course, established favourites of the national-popular. Interplays between Churchill's powerful authority ("We shall fight them on the beaches ... we will never surrender") and the royal family's ascribed authenticity (visiting bombed families; drinking tea in hospitals with wounded soldiers; staying put during the Blitz) played out across all news platforms almost daily. Such representations at once maintained continuity and calm – royal pageantry and appearances were familiar signposts for the public imagination – and created a sense of urgency to join the fight at hand.

For example, when Buckingham Palace was bombed on 13 September 1940, the Ministry of Information allowed forty reporters into the site and national and regional newspapers alike reported the attack on the nation's family as a personal affront on the entire nation. *Pathé News* filmed repair work and the king and queen inspecting the wreckage, while Churchill stressed the dastardliness of the attack on "our beloved sovereign" (Bates, 2019: online). They may have imagined it as a propaganda coup, but Nazi propagandists had misunderstood the differences between the celebrity power of the royal family and the Führer. Rather than a humiliation, the British news media made it a story of courage and resilience, which rallied those across the country also suffering the effects of Luftwaffe bombs. As Jean Seaton (2018: 219) discusses in her examination of "Broadcasting and the Blitz", "morale was seen as single and malleable and individuals subsumed in the whole". The wartime propaganda model of celebrity news relied on multi-mediated representations of the royal family as powerful, but personalised, symbols of social and personal wartime action and reaction. This worked in parallel to Churchill as a powerful symbol of effective political and military decision-making that "combined a deep, almost metaphysical romanticism, based on appeal to honour, national pride and sense of history" (Seaton, 2018: 230). Odeon Cinema managers in 1939 described how audiences would "boo and hiss" Hitler and Mussolini when they appeared on newsreels, but that "English Royalty are always loudly cheered" (Hiley, 1998: 59). In 1940, as Britain faced potential surrender in the months following the Dunkirk evacuations, 14-year-old Princess Elizabeth took to the airwaves for the first time to address the nation during the BBC's "Children's Hour":

> We are trying to do all we can to help our gallant sailors, soldiers and airmen and we are trying, too, to bear our share of the danger and sadness of war
> We know from experience what it means to be away from those we love most of all ... come on Margaret Good night and good luck to you all.
>
> *(BBC radio, 13 October 1940)*

The mixture of stoicism, sisterly affection and childlike praise for those on the front, resonated with news media and the nation, particularly the scores of parents whose children had recently evacuated. Pictures taken during the broadcast and quotations from it appeared across national newspapers in the following days, with reporters linking royal pedigree to her calm and clear style. Four years later, as Allied Forces reclaimed Belgium and France, a wide-scale propaganda campaign reported how the now 18-year-old princess and future queen was the first female member of the royal family to join the military full-time. The "plucky" young woman was both an embodied link between the military glory of royalty past and another ordinary young woman, just "doing her bit" – like so many others – part of Ministry of Information efforts to target women as key to keeping the war effort going (Seaton, 2018: 227). As Churchill wrote in a letter to the king, such performances and news representations of them were a major part of his plan for victory over hearts and minds, which confronted authoritarian stardom with a different, fully formed version of celebrity:

> This war has drawn the Throne & the people more closely together than was ever before recorded, & Yr Majesties are more beloved by all classes & conditions than any of the princes of the past.
>
> *(Winston Churchill, 5 January 1941)*

This uniquely British vision for propaganda models of celebrity and journalism grew from how the 18th-century London press combined aristocratic notions of glory and victory – "attributed" celebrity as the first narrative of fame in public arenas – and the ordinary aspects of middle-class identity that shaped the press's development of celebrity.

Mainland America was untouched by bombs and President Franklin D. Roosevelt (FDR) did not need to direct courage under fire. Instead, he continued "fireside chats" on radio, which had helped him marry "affable intimacy with the sacredness of office" (Inglis, 2010: 174) as he laid out his "New Deal" to rebuild the economy in the decade after the 1929 Wall Street crash. His authentic, quiet and natural conversational style was perfectly suited for household media and placed US political celebrity in relation to the grounded broadcast personality rather than the star – a much safer place given the dangerous idolatry playing out in Europe. However, he, like Churchill, had powerful celebrity and journalistic allies for wartime propaganda with Hollywood studios and its stars ready to support him as they had during the 1940 election campaign. As "Hollywood Dream Machine [went] to War" (Brownell, 2014: 43), they worked directly with the FDR camp, sympathetic news editors and publishing moguls to "disseminate news, politics and ideas" (p. 44).

Consecration of heroes (allies/stars) and desecration of villains (fascists/anti-stars) happened in parallel across film and news media. Hollywood was not only politicised, but also became a symbol of hope as the very best reflections of the potentials of the Western Democratic and Capitalist society. Kathryn Brownell's (2014)

history of US *Showbiz Politics* highlights how both journalists and Hollywood moguls such as Warner and Mayer turned their resources towards the war effort, first to convince the nation to join the war and second to maintain the power of Roosevelt to lead them through it. Roosevelt's 1940 re-election campaign marked "the beginning of significant changes for the entertainment industry and for the Democratic Party", changing "the explicit political advocacy of studio executives" from rarity to an expectation (p. 45). News media celebrated intercommunications between Hollywood and Washington and coverage making everyone look good. Studios released pointedly political films, such as Warner Bros. *Confessions of a Nazi Spy* (Warner Bros., 1939), which "interspersed actual newsreel and studio-produced", and as a result some Republicans accused Hollywood of being under the "influence" of "foreigners" and "Jews", too susceptible to British propaganda and too close to the FDR administration. It did little to deter their efforts. Stars such as Clark Gable, Bette Davis and Humphrey Bogart sold war bonds and performed for troops. FDR spoke at the 13th Academy Awards in 1941, where he praised how the film-industry reflected "our civilisation throughout the rest of the world … and the aspirations and the ideals of a free people and of freedom itself". He thanked "their sincere effort to help the people in our hemisphere" against "dictators and those who enforce the totalitarian form of Government".[2] Newsreels on both sides of the Atlantic used the speech as morale-boosting propaganda and this reflected Hollywood's place in the perpetuation of dominant ideologies of Western society and denied legitimacy to alternative oppositional ideologies (see also Dyer, 1979: 2). News and film industries together imagined a world where glittering, bloody fascism had no place and where the glittering, consumer freedom of Hollywood would dominate "the empires of people's minds" for the rest of the century. It went well. For the post-war generation this media battle of stardom and for freedom led to complex negotiations of self in negotiation with popular culture.

Pop stardom and the press

For Baby Boomers – born in the 15 years after World War 2 – print, radio and cinema were norms for their entire lives, and during their childhood television ownership rapidly increased too. As a result, these first multi-media natives had very different relationships with popular culture than their parents and grandparents, who had lived through different phases of development. The previous generations had experienced the emergence of Hollywood stars, the rise and fall in popularity of newsreels, the surge of radio then surpassed by television, and, in parallel, the unimaginable social and political upheavals of the first fifty years of the 20th century. The cultural melting pot of World War 2 created new interests and their children were ready for media genres and areas of journalism and celebrity to call their own. This was characterised by a desire to bring together and experiment with different cultures and art forms, including the narratives of celebrity journalism.

Pop music offered such opportunities and, together with new discourses of celebrity news and journalism on both sides of the Atlantic, a different type of star was created who "carried the ... values, attitudes and beliefs of the baby-boom generation" (Jones, 2002: 2). The performances of pop artists and the discourses about them helped *make* pop stardom in similar ways to how Hollywood magazines created film stardom. Pop idols also became dominant sites of attention and potent symbolic identities to articulate changing understandings of self and for audiences to debate them. Todd Gitlin (1997: 77) identified how the significant increase in popular culture paved the way for a generation of "the young" in the 1960s who came to "define themselves" by their taste in relation to pop culture and, particularly, music. This, and the "connected phenomenon of celebrity", stemmed from the collapse in significance of social institutions that once imparted identity, such as occupation, class and religion (pp. 77–78). While this is certainly true, it also had long-established roots in the press. Idolatry emerged to cater to fans and often faced loud condemnation by some mainstream journalists who on both sides of the Atlantic used established rituals of celebrification and the consecration and desecration tools of stardom and attack.

Pop music is arguably the area of stardom where the rituals of religion matter most, from mass gatherings at concerts and singing together to pilgrimages to the sights of death and "relics of the dead" (Rojek, 2001: 58). Rojek also highlighted how 1960s rock stars twinned elements of "the shaman with certain types of charismatic personality" to become new types of religious leader. But the sacrilegious mainstream press also desecrated pop stars with characteristic cynicism and cultures of attack. Such tensions between celebration and degradation did not damage the discourse per se, but rather became part of the patterns of resistance, embraced by young audiences who *wanted* something different to what had gone before. As a result, *open* rebellion against the dominant discourses of mainstream news became part of the narratives of pop stardom too.

The pop press as it first emerged in the UK in the 1950s may have mirrored tabloid newspapers format and written styles, but its approach to musicians on a human level was often different. *New Musical Express* (1952–current), *Record Mirror* (1954–1991) and *Melody Maker* (1926–2000) – which changed target audience to popular music fans from jazz musicians in the late 1950s – offered soft-stroke interviews, single charts, industry news and reviews of new releases and gigs. *Melody Maker* was brought into the tabloid newspaper fold of IPC Media by chairman Cecil Harmsworth King and in the early 1960s he appointed younger staff to lead both this and their main news publication, the *Daily Mirror*, and they shared celebrity news. Parallel, interrelated and at times binary discourses developed across the two publications, with *Melody Maker* music journos generally celebratory about the potentials of pop and *Daily Mirror* reporters happy to play along when it suited them, but also on the lookout for scandal and controversy. An early example of such tensions played out in the days after the much anticipated arrival of US rock 'n' roll star Jerry Lee Lewis in 1958, which was "Okay for Britain" according to *Melody Maker* (22 February 1958), but his growing popularity also resulted in

reporters from several national newspapers attending his arrival at Heathrow Airport. When *Daily Mail* journalist Paul Tanfield asked a child in his entourage who she was, he uncovered that Lewis had bigamously married the 13-year-old daughter of his cousin. This front-page tabloid news was then investigated by police (*Daily Mirror*, 26 May 1958) and resulted in the cancellation of Lewis' tour after two gigs.

Contestation between the mainstream and the music press as they negotiated and created pop stardom produced "four camps of popular music writers – academic, historians, gossips and unruly ... contentious Noise Boys" (DeRogatis, 2000: 89). The sociological shift in celebrity news towards youth culture helped forge links between pop idols and their boomer fans in journalism's discursive as well as physical spaces for performances that they inhabited together. Within a decade of *Melody Maker's* relaunch, a raft of glossy iconic popular music magazines appeared in America, including *Crawdaddy* (1966–1979), *Rolling Stone* (1967–current) and *Creem* (1969–1989). These publications were far less "newsy" and instead offered lengthy critical reviews and interviews with musicians where they looked to lift the star mask and uncover the source of musical genius. They portrayed pop music "as a manifestation of the culture of young people ... not as a malignancy requiring a cure, but rather as a potential cure for a malignant society" (Hamm, 1995: 22). In response, *Melody Maker* and *NME* expanded its features sections, although the front page still had a news-style headline until the 1990s.

Gudmundsson et al. (2000: 42) argued that by the late 1960s "rock criticism proper" refocused from news and gossip and towards explorations of tensions in artists themselves, such as conflict between the artificiality of the music industry as influenced by celebrity culture and the authenticity of the musician as artist. Their examination of the evolution of the popular music press on both sides of the Atlantic focused on how it helped make music a serious cultural genre – what Pierre Bourdieu (1984) described as "legitimate cultural form" – at the intersection of the fields of "rock" and "journalism" (pp. 42–43). The journalists who worked to legitimate music as culture were "typical child[ren] of the sixties generational gap" and Bourdieu criticised the agency of the "new intellectuals" as a "petit-bourgeois faction" (p. 43). The way journalists and these artists worked together using rituals of celebrification to build fame and in direct relation the exploration of self and society was indeed reminiscent of the celebrity journalism at the time of the bourgeois public sphere and in New Journalism. Pop stars and the music press shared their audiences and, as intermediaries between them and the artists, key journalists became significant voices of authority and leaders for taste. Many returned several times for one-to-one interviews with supportive allies in the music press.

But the established linguistic and thematic shapes of celebrity news and journalism in mainstream newspapers equally shaped public understanding of music stars. In tabloid newspapers, the Rolling Stones' thrashing guitar chords *were* the noisy reflection of rebellious attitudes. The enduring popularity of The Beatles relied on musical invention, serious critique of it and equally how they transcended

Brian Epstein's "Four Boys-One Band" promotional campaign and the front-page news of Beatlemania. Rock criticism drew from celebrity journalism's acts of consecration and desecration, use of images, interview techniques and the blurring of promotion with news and art. It was both the positive and negative together that made pop stardom such a potent social and political noise.

To conclude our explorations of journalism and 20th-century stardoms, I offer another embodied example, one that brought together many aspects through the deliberate *application* of narratives of stardom discussed so far. By the 1970s, the rituals, patterns and performances of stardom were so secure; they could even help to bring fictional, hyperreal stars to life. Avant-garde artists used the intersections of celebrity news and journalism, social and political performances of stardom and self-display as part of their craft and one stood above all in this process. David Bowie deliberately subverted the performance patterns of star and celebrity journalism to eclipse his "real self" with the entirely constructed, Ziggy Stardust.

Stardust was arguably the first *fully* formed pop *celeactor* (Rojek, 2001), specifically invented to reflect the social, sexual and media experimentation of the boomers and as a fame building that used journalism's rituals of celebrification and stardom. In particular, Bowie used one-to-one interviews as discourses of "real" to blur lines between himself and Ziggy and met with journalists at least once a week during the 18-month period of Ziggy's lifespan. Bowie later claimed this made the character real – even to him. As a result, the "grand kitsch painting" of stardom he created, "put [him]self dangerously near the line" both mentally and emotionally. But it also "provoked such an extraordinary set of circumstances" and made him a star. On balance, he decided it was worth it (*Melody Maker*, 29 October 1977). He also often discussed the place of journalists in the creation of Ziggy. For example, *Melody Maker*'s Roy Hollingworth and Bowie/Ziggy threw blame back and forth for the term "decadent rock". Was it Bowie's fault for the extravagant costumes and the gold Rolls Royce? Or Hollingworth's who, possibly, built his career by coining the term (12 May 1973)? They agreed they were both to blame. Two weeks later Bowie discussed "decadence" again, with Ray Fox-Cumming for *Disc* magazine (May 1973). Bowie and Cummings raised a mutual eyebrow at its "absurdity" and "both start[ed] giggling". Offering Cummings a "good last line", Bowie described taking his Rolls Royce to Yves Saint Laurent to buy a mundane pair of grey socks. Using the construction patterns of the interview (the last line), he blurred lines between his real self (a man who wears grey socks) and the fantastical Ziggy. The Ziggy creation was visibly unstable, but the rituals of the interview discourse – its fame-making properties and factual narrative structures – made him real. Bowie used journalists, as the arbiters of fact, to bring his character for life and offered those who did this best, numerous interviews as reward.

Bowie also drew from other imagery and themes of 20th-century stardoms including Hollywood's decadence and masks of glamour and the iconography of fascist dictators for the backdrops for stage shows. In interviews, he discussed his understanding of media based on critical reading of the works of Marshall McLuhan and other postmodern scholars who were interested in the dynamics of media

and fame (*New Musical Express*, 24 February 1973). Bowie, by trade, was an advertising artist and understood the capacity of stars to link performance of self "with the manipulations of advertising" (Dyer, 1986: 12). He launched Ziggy with "a preliminary publicity build-up", similar to those organised by studio publicists in Hollywood (Harris, 1991 [1957]; Dyer, 1979: 12). This began with a *Melody Maker* interview in January 1972, three weeks before Ziggy first appeared on stage and six months before the release of the album *The Rise and Fall of Ziggy Stardust and the Spiders from Mars* (1972).

This canon of Bowie fandom was the first time he declared himself as "gay and always had been, even when he was David Jones" (*Melody Maker*, 22 January 1972: 19). His performance was both visual and linguistic. Journalist Michael Watts – who interviewed Bowie at least four times between 1970 and 1978 – remarked how different he looked, now spikey red-haired and leather clad and how he was speaking differently too, using words such as "varda" and describing himself as a "cosmic yob". However, while creating the illusion of "being Ziggy", Bowie wanted Watts to understand that this was a creative process in which journalists had a role too. He told him that he was "more an actor and entertainer than a musician" and that he may "only be an actor and nothing else". In retrospect, Bowie was thrilled with the impact of this piece, describing it as "hilarious", because it served his purpose of "drawing bigger audiences than we had ever drawn" (*Camp Rock*, July 1973).

The interview offered a means to test the potency of the Ziggy star brand: its look, language and back-story as both self-play and normative behaviour (Cinque, 2013: 401; Rojek, 2001: 134). It is also tempting to read Bowie's revelation through a framework of "ideas around sexuality that circulated" following the path of Dyer (1986: 17) in relation to Hollywood stars such as Marilyn Monroe. The early 1970s was a time when, at the very least, *discussion* of different gender roles and sexualities was possible. *Melody Maker* had announced 1972 the "year of the transvestite" and Ziggy was launched a little more than a year after London's first gay rights marches. The star embodied the potent sexual and social changes of the time, showing how gender can be "performatively produced" with identity "the effect of the performance and not vice versa" (Longhurst, 2007: 181). Certainly, for many Bowie fans his explorations of sexuality and gender offered hope and a means by which they might explore their own too (Redmond and Cinque, 2019). But in the Ziggy interviews, Bowie was at best agnostic and often caustic about gay rights. Journalist Michael Watts certainly questioned the authenticity of Bowie's "coming out" and whether he was "shrewdly exploit[ing] the confusion surround [ing] the male and female roles". He also, prophetically, wondered whether this "expression of his sexual ambivalence" could establish "a fascinating game: is he, or isn't he?" Journalists were still playing 44 years later when Bowie died, when dozens of headlines asked variations of "Was David Bowie Gay" (For example, *Billboard*, 14 January 2016; *New York Times*, 13 January 2016; *Slate*, 14 January 2016). But whether Bowie – or rather David Jones if we strip back another layer of his self-star-making – was bi, gay or neither is irrelevant if we view this moment as

the launch of a promotional strategy for a potent celeactor using the celebrity interview as a ritual of celebrification. The facts about celeactor Ziggy Stardust – as given to journalists to disseminate – were that he was gay, in the same way he was already a star with an entourage and screaming fans before he even released a record.

While the popular music press broadly celebrated the Bowie/Ziggy character, many of the tabloid newspaper guard were horrified by the socio-cultural changes he represented. As a potential risk to stability of their ridged views around gender and sexual identities, they turned to their familiar tools of attack journalism and hit hard. *Daily Mirror* showbiz reporter Deborah Thompson produced dozens of articles describing stage shows, relationships, and collaborations. She was initially supportive because she believed his "camp" stage persona was just an act – he was really "plain David Jones back home in Beckenham, Kent" living happily with "wife Angie and baby son Zowie" (*Daily Mirror*, 22 January 1973: 14–15). However, as lines between Bowie and "gay" Ziggy blurred, her articles became increasingly hostile. Thompson, a young woman working in the misogynistic and homophobic world of 1970s British tabloid journalism, used rhetoric that was the norm in both newsrooms and publications (Holland, 1983), and given the levels of content it is clear that her editors were happy with this activity. In "Has the Star Gone Too Far" (*Daily Mirror*, 22 May 1973), she described Bowie as a "bizarre high priest" of music who "behaves more like a Soho stripper than a top pop-star" as he "bumps […] grinds […] waggles his hips". The word "bizarre" appeared in almost every piece, usually in the lead paragraph. Bowie was also "camp" (30 October 1973: 11); "odd" (28 December 1973: 5); a "weirdo" (25 April 1973: 11); and "dangerous" (26 June 1973: 7). Headmasters suspended schoolchildren for copying his sexually ambiguous hairstyle (11 September 1973: 5). A mum's letter became a news story because she feared Bowie was sexualising and corrupting her pre-teen daughter (2 October 1973: 11). "Clean cut" Cliff Richard even penned "This Rotten Pop" – where he questioned what Bowie was "trying to prove" and why he is "effeminate" despite having a "wife and child" (19 June 1973: 23).

Yet despite their hostility, Bowie continued to interact with the *Mirror*. He offered soundbites and quotes from the side of the stage and allowed their photographers into shows. The newspaper may have engaged in a process of "othering", but he was certainly more than willing to play their "other". Bowie was complicit in their misogyny and homophobia because it suited the purpose of his art and performance in making Ziggy Stardust real, in the same way as using star iconography or interviews. He understood that both consecration and desecration make stardom what it is. This was also an early tabloidised narrative of emotional labour, which, as we will see next chapter, came do dominate press representations of celebrity. The choice of interviews as the primary place to perform his fictional star highlights his understanding of the power of interactions between journalists and celebrities to create realities and form truths. As such, this marked a significant transition point for media culture between late modernity and postmodernity, with Ziggy Stardust both a simulation and a symbolic variable who embodied the

falsifications of media exchange, turned it all into art, and reimagined journalism's rituals and rites of celebrification.

On this and the other side: 20th-century journalism and celebrity cultures

When Schickel (1985) built on Boorstin's discussion of *The Image* to identify that celebrity did not exist before the moving image – which influenced many subsequent celebrity studies scholars – his arguments demonstrated how stardom so significantly shifted changed the visibility of celebrities in print it eclipsed earlier iterations. The development of performative frameworks for celebrity interviews and the power dynamic between celebrities and journalists in the process had a significant impact on the production of stars as a presentation of self-identity. Stars were sites of continuity between earlier celebrity cultures with significant thematic similarities around ordinary life and the paradox with extraordinary fame, artistry and craft, the relationships between public and private selves and consumerism. However, they were also sites of considerable change as stardom was the first, *entirely mediated* area of self-identity and its development was completely impossible without the frameworks of celebrity culture as developed in print.

Celebrity journalism, and particularly the interview in articulating stardom, is therefore as important a component as cinema's image-based displays of it. Journalistic discourses became means by which the hyperreality of stardom could eclipse reality, even to the point where the stars themselves *did not really* exist. Such powerful, symbolic and image heavy, entirely mediated displays of self-made stardom real and in doing so shaped how we may view relationships between who we are and how we live and the way we present or perform that to the outside world. The performance of self as an emotional labour – an exploration and marketisation of the dichotomies of public and private – shaped another narrative of fame that developed in news culture during this time. Often in conjunction and in parallel, tabloids and television saw the commercial and political potentials of the confessional as developed by Hollywood stars to promote their own visions for society and to control publics as consumers of them. The next chapter, *Tabloids, Television and the Neoliberal Soap Opera*, explores how this facet turned into a principal means by which celebrity constructs ideologies through emotional labour that primarily serves the interests of corporate capital.

Notes

1 In a BBC Four documentary "The Forgotten Screen Goddess", film historian Kevin Brownlow described scathing letters from Louise Brooks about his omission of Bow from his work.
2 Universal News Reel (1941), available at: www.youtube.com/watch?v=j5Dev16vwaY.

References

Adorno, T. and Horkheimer, M. (1977 [1944]) "The Culture Industry: Enlightenment and Mass Deception", in J. Curran et al. (eds) *Media and Society*. London: Edward Arnold.

Alberoni, F. (1972) "The Powerless 'Elite': Theory and Sociological Research on the Phenomenon of Stars", in S. Redmond and S. Holmes (eds) *Stardom and Celebrity: A Reader*. London: Sage, pp. 65–77. 2007.

Bakhtin, M.M. (1984) *Problems of Dostoevsky's poetics*. Minneapolis, MN: University of Minnesota Press.

Barthes, R. (1957) *Mythologies* [1972 translation]. London: J. Cape.

Benjamin, W. (2007 [1935]) The Work of Art in the Age of Mechanical Reproduction [1969 edition], in S. Redmond and S. Holmes (eds) *Stardom and Celebrity: A Reader*. London: Sage, pp. 25–33.

Biressi, H. and Nunn, A. (2010) "A Trust Betrayed': Celebrity and the Work of Emotion". *Celebrity Studies*, 1(1): 49–64.

Boorstin, D. (1961) *The Image: A Guide to Pseudo-Events in America*. Harmondsworth, UK: Penguin.

Bottomore, S. (1998) "News before Newsreels". *The Story of the Century*. London: British Universities Film and Video Council, pp. 14–17.

Bourdieu, P. (1984) *Distinction: A Social Critique of the Judgement of Taste*. London: Routledge.

Brownell, K. (2014) *Showbiz Politics: Hollywood in American Political Life*. Chapel Hill, NC: University of North Carolina Press.

Cinque, T. (2013) "David Bowie: Dancing with Madness and Proselytising the Socio-political in Art and Life". *Celebrity Studies*, 4(3): 401–404.

Conboy, M. (2002) *The Press and Popular Culture*. London: Sage.

deCordova, R. (1990) *Picture Personalities: The Emergence of the Star System in America*. Urbana, IL: University of Illinois Press.

DeRogatis, J. (2000) *Let It Blurt*. New York: Broadway Books.

Dyer, R. (1979) *Stars*. 1997 edn. London: BFI.

Dyer, R. (1986) *Heavenly Bodies: Film Stars and Society*. New York: St Martin's Press.

Dyer, R. (1991) "A Star is Born and the Construction of Authenticity", in C. Gledhill (ed.) *Stardom: Industry of Desire*. London: Routledge, pp. 132–140.

Evans, J. (2005) "Celebrity, Media and History", in J. Evans and D. Hesmondhalgh (eds) *Understanding Celebrity*. Maidenhead: Open University Press, pp. 11–56.

Hesmondhalgh, D. (2013) *The Culture Industries*. 3rd edn. London: Sage.

Freud, S. (1909) *The Father Complex and the Solution of the Rat Idea*. Trans. J. Strachey. London: Hogarth Press and Institute of Psycho-Analysis, 1955.

Freud, S. (1912) *Totem and Taboo*. Trans A.A. Brill. New York: Moffat, Yard & Co., 1918.

Gamson, J. (1994) *Claims to Fame: Celebrity in Modern America*. Berkley, CA: University of California Press.

Geraghty, C. (2007 [2000]) "Re-examining Stardom: Questions of Texts, Bodies and Performances", in S. Redmond and S. Holmes (eds) *Stardom and Celebrity: A Reader*. London: Sage, pp. 98–111.

Gitlin, T. (1997) "The Anti-Political Populism of Cultural Studies". *Dissent*, 44(2): 77–84.

Gledhill, C. (1991) *Stardom: Industry of Desire*. London: Routledge.

Goffman, E. (1956) *The Presentation of Self in Everyday Life*. Edinburgh: University of Edinburgh Social Sciences Research Centre.

Gudmundsson, G., Lindberg, U., Michelsen, M. and Weisethaunet, H. (1980) "Brit Crit: Turning Points in British Rock Criticism 1960–1990", in S. Jones (ed.) *Pop Music and the Press*. Philadelphia, PN: Temple University Press, pp. 41–64.

Hamm, C. (1995) *Putting Popular Music in Its Place*. Cambridge: Polity Press.

Harris, T. (1991 [1957]) "The Building of Popular Images: Grace Kelly and Marilyn Monroe", in C. Gledhill (ed.) *Stardom: Industry of Desire*. Abingdon, UK: Routledge, pp. 41–45.

Hesmondhalgh, D. (2005) "Producing Celebrity", in J. Evans and D. Hesmondhalgh (eds) *Understanding Celebrity*. Maidenhead: Open University Press, pp. 97–134.

Holland, P. (1983) "The Page Three Girl Speaks to Women, Too", *Screen*, 24(3): 84–102.

Hiley, L.N. (1998) "Newsfilm Audiences". *The Story of the Century*. London: British Universities Film and Video Council, pp. 59–72.

Hochschild, A. (1979) "Emotion Work, Feeling Rules, and Social Structure". *American Journal of Sociology*, 85(3): 551–574.

Inglis, F. (2010) *A Short History of Celebrity*. Princeton, NJ: Princeton University Press.

Jones, S. (2002) "The Intro: Popular Music, Media and the Written Word". *Pop Music and the Press*. Philadelphia, PN: Temple University Press, pp. 1–18.

Kovach, B. and Rosenstiel, T. (2001) *The Elements of Journalism*. New York: Crown/Archetype.

Lebo, H. (2016) *Citizen Kane*. New York: St Martin's Publishing Group.

Long. B (1997) "Richard Willis". *Taylorology: A Continuing Exploration of the Life and Death of William Desmond Taylor*, 59. Online.

Longhurst, B. (2007) *Popular Music and Society*. 2nd edn. Cambridge: Blackwell Publishing.

Marshall, D.P. (1997) *Celebrity and Power: Fame in Contemporary Culture*. 2nd edn. Minneapolis, MN: University of Minnesota Press.

McDonald, P. (2000) *The Star System: Hollywood's Production of Popular Identities*. London: Wallflower.

McKernan, L. (1998) "Cinema News Reels". *The Story of the Century*. London: British Universities Film and Video Council, pp. 17–28.

McLuhan, M. (2003 [1964]) *Understanding Media*. London: Routledge.

Morin, E. (1960) *The Stars*. London: Grove Press.

Mulvey, L. (1988) *Visual and Other Pleasures*. 5th edn. Bloomington, IN: Indiana University Press.

Petersen, A. (2013) "Those Glorious Fan Magazines". *VQR: A National Journal for Literature and Discussion*. Online.

Ponce de Leon, C.L. (2002) *Self-Exposure: Human Interest Journalism and the Emergence of Celebrity in America*. Chapel Hill, NC: North Carolina University Press.

Redmond, S. (ed.) (2008) "Special Edition on 'The Star and the Celebrity Confessional'". *Social Semiotics*, 18 (2).

Redmond, S, and Cinque, T. (2019) "*The fandom of David Bowie: Everyone says "Hi"*. Cham, Switzerland: Palgrave Macmillan.

Redmond, S. and Holmes, S. (2007) "Introduction", in S. Redmond and S. Holmes (eds) *Stardom and Celebrity: A Reader*. London: Sage.

Rojek, C. (2001) *Celebrity*. London: Reaktion Books.

Schickel, R. (1985) *Intimate Strangers: The Culture of Celebrity in America*. Chicago: Ivan R. Dee.

Scull, A. (2015) "Madness at the Movies: Why Hollywood Went Crazy for Freud". *Sydney Morning Herald*, 3 April. www.smh.com.au/entertainment/movies/madness-at-the-movies-why-hollywood-went-crazy-for-freud-20150328-1m928k.html.

Seaton, J. (2018) "Broadcasting and the Blitz", in J. Curran and J. Seaton (eds) *Power without Responsibility*. 8th edn. London: Routledge, pp. 216–245.

Slide, A. (2010) *Inside the Hollywood Fan Magazine*. Jackson, MS: University of Mississippi Press.

Starkey, G. and Crisell, A. (2009) *Radio Journalism*. Los Angeles, CA: Sage.

Turner, G. (2014a) *Understanding Celebrity*. 2nd ed. London: Sage.

Turner, G. (2014b) "Is Celebrity News, News?" *Journalism Theory, Practice and Criticism*, 15 (2): 144–152.

Wagenknecht, E. (1997 [1962]) *The Movies in the Age of Innocence*. New York: University of Oklahoma Press.

Weber, M. (1922) "The Nature of Charismatic Domination" [1956 translation], in S. Redmond and S. Holmes (eds) *Stardom and Celebrity: A Reader*. London: Sage, pp. 17–24. 2007.

Wernick, A. (1991) *Promotional Culture: Advertising, Ideology and Symbolic Expression*. London: Sage.

Williamson, M. (2016) *Celebrity: Capitalism and the Making of Fame*. London: Polity Press.

Press

Anon (1914) "Richard Willis is Turning His Attention to Poetry". *New York Dramatic Mirror*, 3 June: 29.

Anon (1918) "Willis and Inglis Build Studio". *Moving Picture World*, 5 January.

Anon (1919) "The Invader Willis". *New York Dramatic Mirror*, 23 October.

Anon (1924) "Why I've Never Married". *Photoplay*, January: 30–31, 118–119.

Anon (1973) "Daughters in Danger? A Worried Mum Writes to the Mirror". *Daily Mirror*, 2 October.

Anon (1975) "The All New Adventures of David Bowie". *Hi*, 7 June.

Bates, S. (2019) "The Windsors at War". *History Extra*, 10 September.

Hollingworth, R. (1973) "Cha… cha… cha… changes: A journey with Aladdin". *Melody Maker*, 12 May.

Holmes, P. (1972) "Gay Rock". *Gay News*, July.

Hunt, F. (1934) "I Meet Miss Crawford". *Photoplay*, February.

Johaenson, B. (1924) "The Girl with Hypnotic Eyes". *Photoplay*, February: 54, 127–128.

Lowder, B. (2016) "Was David Bowie Gay?". *Slate.Com*, 11 January. Online.

Maxwell, V. (1934) "Katharine Hepburn's Inferiority Complex". *Photoplay*, January.

Mirror Reporters (1973) "Bowie Kid's Brush Off". *Daily Mirror*, 11 September.

Proctor, K. (1942) "Truth or Consequences with Irene Dunne". *Photoplay*, July.

Rodgers, K. (2016) "Was He Gay, Bisexual or Bowie? Yes". *New York Times* online, 13 January.

Saal, H. (1972) "The Stardust Kid". *Newsweek*, 9 October.

Shaar Murray, C. (1973) "Goodbye Ziggy and a Big Hello to Aladdin Sane". *New Musical Express*, 27 January.

Shaar Murray, C. (1973) "Gay Guerillas and Private Movies". *New Music Express*, 24 February.

Thompson, D. (1973) "King of Rock and Rouge". *Daily Mirror*, 22 January.

Thompson, D. (1973) "Has the Star Gone Too Far?". *Daily Mirror*, 22 May.

Thompson, D. (1973) "David Bowie in Concert Off Shock". *Daily Mirror*, 25 May.

Thompson, D. [ed.] (1973) "This Rotten Pop by Cliff Richard". *Daily Mirror*, 19 June.

Thompson, D. (1973) "Back in Stiletto Shoes". *Daily Mirror*, 25 October.

Thompson, D. (1973) "The Odd Couple". *Daily Mirror*, 28 December.

Thompson, D. (1975) "Bowie Goes Straight". *Daily Mirror*, 21 January.

Walters, B. (2016) "David Bowie, Sexuality and Gender". *Billboard*, 14 January. Online.

Watts, M. (1972) "Oh You Pretty Thing". *Melody Maker*, 22 January.

Willis, R. (1914) "I Go-A Calling on the Gish Girls". *Photoplay*, December: 36–37.

Woodbridge, A.I. (1934) "Phantom Daddies of the Screen". *Photoplay*, January.

5

TABLOIDISM, TELEVISION AND THE NEOLIBERAL SOAP OPERA

Transcentury tabloidism (1975–2015) was convivial and cunning. It made more people visible through discourses of fame-maker, confidant, mentor, liberator, judge, jury and executioner. Television became part of news – and vice versa – and extended the press parasociality built into New Journalism[1] to convince audiences it was affirmably on their side. In reality, it acted primarily in the interests of corporations, media magnates and their political allies and manipulated journalism and celebrity discourses towards dominance of their socio-political ideologies. As a narrative that developed shortly after heavenly stardom, it kept celebrity and journalism grounded and often there appeared to be nothing "extraordinary" about those celebrified at all. This tangible fame was less interested in the extremities of human creative potential and instead filtered day-to-day parameters for lived experience through narrow market-based lenses and overwhelmed the political and emotional dimensions of cultural citizenship.

Tabloidism transformed newspapers, created new types of print publication and dominated televisual development. The linguistic and socially integrationist cultures of journalism and celebrity that emerged also proved the perfect habitus for the incubation and prodromal phases of diseased newsroom cultures.[2] Developed initially as a tool to naturalise social liberalism, this culture of news was not robust in the face of market forces and bowed to their demands. As corporations, right-wing media magnates and conglomerates extended its discourses, it became a weapon of neoliberalism – broadly defined here as a market-driven social, economic and political framework for life – which, first, took "particularly extreme forms in the UK and USA" (Hesmondhalgh, 2013: 99). This change and the swelling tide of television meant levels of celebrity journalism expanded again and in particular "emotional labour" (Hochschild, 1979, 2003; Biressi and Nunn, 2010) came to govern exchange.

Discussions of the worst tendencies of tabloidism – and particularly its relationships with celebrity and political cultures – rage endlessly among journalists (e.g. Baistow, 1985; Greenslade, 2003; Davies, 2014; Evans, 2015). None disputes the rise of celebrity content during this period as both symptom and cause of broader changes in media and society and most argue that the reprioritisation of private suffering over public information is one of its most dangerous aspects. Different scholarly approaches – traditional textual analyses of representational politics and ideology, political economy, surveillance and voyeurism and critiques of neoliberalism – universally agree on increased levels, but consider dominance in different ways. Some take binary positions, arguing that celebrity and tabloid news(room) cultures either damage public spheres and democracy (e.g. Franklin, 1997) or democratise them (e.g. Hartley, 1996). There are nuanced approaches. Turner's (2014a) compelling examination of the growth of celebrity tabloid cultures focuses on whether greater access to "public spheres to women, people of colour and a wider array of class positions" can influence politics. He concluded that while visibility has positive impacts in terms of societal and semiotic self-understanding, there is little to prove that within a liberalising market this "mutates into a more *explicitly political version* of self-determination" (p. 91, italics added). However, what he has referred to as the "demotic turn" does link into aspects of governance by journalism, and such dynamics continued to influence the use of celebrities by news media. Todd Gitlin (1997a: 35) criticised "the usurpation of public discourse by soap opera". However, he also acknowledged that belittling research into "women's television" as "trivial", "banal" or "soap opera" often stems from the "patriarchal premise that what takes place within the four walls of the home matters less than what takes place in a public sphere established (not coincidentally) for the convenience of men". He urged scholars to be mindful while analysing popular culture to balance challenges to masculine dominance over news spheres with overly optimistic readings of popular culture as facilitating inclusionary public spheres, for risk of unwittingly echoing "logic of Capitalism" (p. 80).

Of course, the logics of the market have always shaped journalism and celebrity and vice versa. As early as 1978, James Curran argued that throughout modernity's drive towards social and political improvement, newspapers helped to establish capitalist political economies. Almost forty years later, Milly Williamson's (2016) analysis of celebrity culture focused primarily on how corporatised cultural industries – including news – used celebrity to maintain their own interest and by extension the capitalist social systems in which they thrived. She highlighted the American mass industrialisation of the press and corporate conglomerates of the 20th century as leading to the current glut of celebrity news. David Hesmondhalgh's (2013 [2007]) discussions of how and why the *Culture Industries* changed from the 1980s emphasised the rise of neoliberalism and its influence on political, economic and regulatory dynamics. Shifts towards an information society, where the "knowledge economy" is crucial to the sustenance of capital were industrial and global, which resulted in greater complexities between "economic and political processes and [...] the social, cultural and institutional processes that are sometimes

conceived as being by-products of events at macro levels" (pp. 109–110). The radical changes in journalism and celebrity – and increased fluidity between these realms – reflected this, the "continuity and multiple and processes of change occurring at different rates" and the emotional, human "arational" and at times contradictory decisions of the human beings involved in the exchange (pp. 110–111).

While this book has explored instances where journalism's use of celebrity focused predominantly on political self-determination towards, for example, universal suffrage and/or active citizenry, capitalist economic values were of course also ever-present. Discussions which place popular culture in "tension [with...] traditional functions of newspapers" as part of the "crisis in modernity which is often referred to as postmodernity" (Conboy, 2002: 137; Dahlgren, 1991: 6–7) often overlook the role of celebrity journalism in both public spheres – and representations of private ones – as equal elements which helped form *both* capitalism and democracy *together*. The dominance of commodity capitalism and the collapse of belief in alternative systems – an event we might understand as the crisis of modernity and birth of postmodernity – lends sympathy to beliefs that celebrity is a malicious force for social and political ill. However, it leaves little room for considering how celebrity journalism and tabloid cultures aided access to information, recognised human need and supported aspiration and whether they can again. Here, I attempt resolution to the "tabloid debate" and demonstrate that it is not the *principle* of journalism's use of human-interest and celebrity that is at fault but rather recent *practices and purposes* as part of neoliberal ideological and corporate dominance. These focused journalism and celebrity almost entirely on the perpetuation of conservative, free-market economic and political ideologies, which actively dissuaded audiences from meaningful political action.

It is important to acknowledge that towards the end of the period examined here, I worked for nearly three years as a young "staffer" for British red-top tabloids. It was only later – during the Leveson inquiry and phone-hacking trials – that I fully understood that this coincided with an acute phase of diseased newsroom cultures and their incessant desire to exert power over others. It was a confidence-crushing experience of pride (I made it to Fleet Street against the socioeconomic odds), discomfort (this is not journalism – try a different newspaper), disgust (unethical practices are everywhere) and despair (I must get out). The "narrow focus" (Seaton, 2018: 464) of National Council for the Training of Journalists qualifications and the entirely different newsroom cultures in the regions offered little preparation or defence against news and features editors who worked to indoctrinate reporters into fevered cultures of attack. One told me to "forget" my specialism in crime and campaigns and instead turn newsgathering efforts entirely towards reality television contestants. But any public figure was considered fair game, regardless of how and why they were in the spotlight. Some appeared to relish power over people's lives and viewed the ruination of others as both blood sport and news value.

Turner (2014a: 83) describes this as one reason why phone hacking was "routine, and ... not just tolerated, but encouraged by management" at the *News of the*

World (1843–2011), and similarly, Natalie Fenton (2012: 4) suggests that it was a newsroom norm. She described how the "deeply flawed" corporate news system demanded such activity in order to produce news cheaply. While I can say with certainty that not all reporters nationwide knew or were involved in criminality – or certainly not when I became a northern correspondent shortly after Royal Correspondent Clive Goodman's arrest for listening to voice messages in 2006 – we now know that at least many Wapping-based middle managers were. They blamed woolly regulatory frameworks that suggested that intercepting communications was acceptable when in the public interest, ignorance of the law, young journalists snapping at their heels, and bullying from above.

It is difficult to reconcile justification from "middle-aged staffers" that they felt threatened by "energetic young journalists" (Curran, 2018a: 176) when many were feared and revered. This in-crowd led big stories and engaged in unethical and criminal practices without pause until the prosecution of an outsourced investigation company Whittamore Associates in 2005 and Goodman's subsequent arrest (Davies, 2014). Some ordered reporters to spy on colleagues to ensure compliance with their demands. For those caught out – or who questioned them – working life could become unbearable. Punishments included open confrontation (for regional reporters, a down-the-phone "hairdryer treatment"); financial (rejected expense claims for costly work trips); emotional (refusal of leave to attend family occasions) and psychological (constant day and night phone calls). Power lay in the capacity to terrorise others – from Cabinet ministers to TV personalities – and this began first with staff. During my time working in such cultures I clung to the Press Complaints Commission code of conduct,[3] became seriously ill and then quit. I account these experiences here to acknowledge how "skin in the game" – my own emotional labour – shaped my arguments about the dangers of unfettered and radicalised tabloid cultures.

Transcentury tabloidism and the drama of neoliberalism

How the hopeful discourses of tabloidism, journalism and celebrity facilitated neoliberal economic and political ideologies was a tragic soap opera with three sets of players: corporate news bosses and their journalists; ordinary people made famous; and mainstream politicians.

For British and later US mainstream news, this began with Rupert Murdoch's transformation of *The Sun* from a loss-making left-leaning tabloid to the nation's biggest selling daily in the 1970s. The focus on celebrity, sex and semi-naked women, scandal, sport and television (Chippindale and Horrie, 2005) affected news content globally, not only because of Murdoch's rapid purchase of multiple titles and networks but also because others followed suit due to their popularity. Stuart Allan (2005 11) spoke to former Murdochian journalists who described how influence worked at multinational News Corporation[4]. He was not involved in day-to-day decision-making but employed editors who "instinctively" knew what was "acceptable" to him and staffed newsrooms with this in mind. As a result,

there was no meaningful journalistic freedom. While particularly virulent at News Corporation, such dynamics were not a malaise of one organisation and Murdoch has become a symbolic figurehead of wider practices. Neoliberalism governed editorial decision-making across commercial newspapers, and the rituals of journalism and celebrity helped to make it the dominant media ambience for life. Few journalists who questioned the status quo of capital and market forces or capitalist democracy found voice in the mainstream. As such, while celebrity journalism included more people from outside the realms of traditional elites – as it had from the start – during this period, corporatism and the market overwhelmed democracy as the reason for doing so.

Editors hoped that increased celebrity news would stem the audience haemorrhage of 40–50 per cent in the UK and about a third in the USA between 1980 and 2010.[5] Celebrity content included increased use of attack journalism, turned now towards viciously guarding parameters of neoliberal and socially conservative societal visions. The complex synoptic and panoptic functions of news media were effective tools for the dominance of corporate capitalism and social conservatism. By this stage, journalism's role in what Foucault (2008 [1979]) referred to as "neoliberal governmentality" had very different aims to the governmentality through journalism established during New Journalism (chapter 3). While both created, rationalised and maintained social and economic systems through strategic celebrification, they had contradicting visions for what these should be. From the late 1970s onwards, reporters represented, self-presented and constituted working practices only in relation to a narrow neoliberal lens of what and "who we are" and this allowed potent symbiosis of mainstream party politics and the political aspects of our everyday lives.

Graeme Turner (2014b: 145–151) highlighted that by the 2010s (the end of the period considered here) there were three components of "celebrity news production, focusing particularly on elements of newsgathering". Journalists used press packs, premieres, award shows, junkets and interviews often negotiated through "personal contact with publicity and promotional organisations". Paparazzi "candid shots" – which might be entirely staged before being sold "directly to picture editors" (see also McNamara, 2011: 516) – provided the basis for other stories, with text written specifically for the images on display. This was revealed in shameful detail by British "snapper" George Banby, who described text-to-image manipulation as routine part of his practice (*Confessions of the Paparazzi, Channel 4, 7 February 2017*). The final principal source was tip-offs from members of the public, including those in celebrities' social circles. Each of these grew in significance as tabloidism turned its attention towards the second visible group of players in the neoliberal soap opera – "ordinary people" who were offered increased opportunities for celebrification by television and the tabloid print market.

Even fictional accounts of real life in soap and constructed reality TV narratives were made "news" and "fact" through the application of construction patterns, such as the inverted pyramid or by using direct speech. The boom of reality television and the day-to-day appearance of ordinary people on game and chat shows

is hailed by some scholars as allowing "recognition and celebration of lifestyles, beliefs and forms of life previously unrecognised or repressed" (Rojek, 2001: 191). Hartley (1996, 2009) argued this allowed greater visibility for meta-narratives of identity such as racial representation, gender, social and generational inclusion, which he argued as in itself democratising and as important as journalistic "law-making" (1996: 16) or what I have hitherto referred to as governance by journalism. Certainly, the two things together were powerful bedfellows from the outset of tabloid news media. However, while celebrity journalism offered moments of greater inclusion, market forces now dominated and those who were celebrified primarily served these interests. Indeed, some dispute whether inclusion of more people in media spheres was of itself beneficial to liberal democracy or indeed truly representative at all. Both Bonner (2003) and Couldry (2003) highlighted that commercial interest leads hierarchal editorial decision-making and inclusion/exclusion of individuals. Any democratic impact, they argue, is simply accidental, with decisions and representations governed by whether participants are mouldable assets for corporate media or political agendas or can attract audiences, by offering models for emulation, ridicule or vilification.

Certainly, the changes to tabloid newspapers, television and the growth of celebrity magazines in the late 1980s and 1990s lend sympathy to such claims. By the late 1990s, celebrity magazines included (as a representative sample) mid-market magazines such as *Hello!* (1988–present), which was a spin-off from Spanish *Hola!* (1944–present) and focused on ascribed celebrities – aristocrats, royalty – and their social circles. Achieved (talented) and attributed (media created) celebrities dominated pages of *OK!* (1993–present), *heat* (1999–present) and in the USA, the *National Enquirer* (1926–present) and *People* magazine (1974–present). Joke Hermes (1995) argued these magazines historically had the lowest cultural status of all women's magazine genres, but that the products developed and influenced long-established glossy magazines, which helped to raise their social value. Glossies such as *Vogue* (1892–present), *Vanity Fair* (1983–present) and *Cosmopolitan* (1886–present) broadened their focus from fashion to include other narratives of achievement, such as those of Hollywood or pop stars. Editors matched the celebrities to the perceived interests of readers and there was a strict hierarchy in terms of why they were famous. These magazines were hugely popular, but then in the early 2010s audience figures collapsed because of the proliferation of celebrity news available quickly online. Celebrity news in weekly or biweekly magazines was often out of date by the time it hit stands.

It is difficult to see how such magazines broadened public spheres through positive meta-representation. The celebrity class in their pages was narrow: largely white, sexualised, heteronormative women, and those who did not conform to this vision or overstepped it were often "shamed". Su Holmes (2005: 21) described in her analysis of *heat* that its success relied on intimate glances of "being in public" and offering celebrity images for the female audience to either emulate or reject because of physical flaws. The "magazine visual juxtaposition of the 'unkempt' and 'unready' self with the perfection of the glamorous image" maintained the traditions of celebrity in terms of

the "ordinary/extraordinary paradox" (Holmes, 2005: 31, see also Gamson, 2011; Dyer, 1979). This was "articulated discursively", within the boundaries of a narrow lens of what female celebrity *should* look like, which could invariably be solved via health, beauty, surgery and fashion consumer goods.

The third players in the neoliberal soap opera were politicians and their parties who used news media to resonate with voters across multiple news media platforms. This relied on increased dynamics of celebritisation of politics (at an institutional level) and celebrification of political leaders (at an individual level), and these dynamics were a potent symbol of the defeat of meaningful left-leaning politics in the 1980s and 1990s. Todd Gitlin (1997b: 78) argued that while there were some progressive gains for women and gay rights, "the spirit of an insurgent class was no longer available" as the "radical upsurge of the late 1960s had culminated [...] in anti-climax and undertow". Recessions in the UK and USA – the result of "oil shocks, a slowdown of productivity and a squeeze on profits due to increased power of organised labour" (Berry, 2019: 58) – collapsed the credibility of the left-wing Keynesian economics purported by John F. Kennedy and his Democratic ancestor F.D. Roosevelt, whom we encountered last chapter. However, their mediated performances primed the ground for other political leaders who supported free-market economics and political marketization, and as a result, neoliberal model tabloidism helped make politics into another soap opera.

Marketing and public relations grew steadily in politics from the 1980s onwards and built on established dynamics between journalists and the cultural intermediaries for the celebrity class (Corner and Pels, 2003). Numerous studies of UK political campaigns argued that pre-internet, tabloid newspaper support because of their links to political party power players was crucial to election success (Linton, 1995; Thomas, 1998). This depended on leaders who were "constructed" (and deconstructed) "in a manner that resemble[d] other public personalities" (Marshall, 1997: 214). During this period, political news shifted focus away from policy and towards political leaders, and their actions, like for other celebrities, became "semiotic hooks" (Conboy, 2014: 179) for journalists both on and beyond campaign trails. Political news resembled the coverage of "a reality television popularity contest" with image and personality ever-present and polling relentless and continuous (Corner and Pels, 2003: 2; Kellner, 2012). Rojek (2001: 181) claims such figures "in the political sphere are the ultimate achieved celebrities", and as discussed throughout this book, news media had certainly always represented politicians as part of the celebrity class. In short, the traditions of tabloidism both influenced and were influenced by key developments in television, celebrity and news, which supported shifts in politics, the political aspects of our lives and our sense of self towards neoliberal models for these things.

An ordinary world: British soap and reality television in print

Journalism's use of celebrity culture has always leaned towards scheduled pseudo-events over "unplanned" news. But, by the late 1970s, soap opera storylines,

involving some of the most influential "celeactors" of the 20th century (Rojek, 2001: 27, see also chapter 2) were regularly reported using news conventions and construction patterns and this blurred lines between reality and fiction, personal tragedy and melodrama, and commerce and victimhood. To sustain neoliberal model tabloidism, the lives and suffering of actors, the characters they played and other television personalities all became the commercial property of mainstream media and there was a growth in the area of the "smiling professions" (Turner, 2014a: 150) to broker relationships between television and the tabloids.

In the UK, Granada Television expanded its press and promotions team from the late 1960s and this group particularly brokered interviews for the press with actors from flagship show *Coronation Street*. Hollywood magazine interviews, explored in the last chapter, influenced interactions between actors and journalists. For example, Pat Phoenix who played iconic Street siren Elsie Tanner, as Hollywood starlets before her, was willing to reinvent her personal history to better suit both the show and journalists' storylines. She described how she "was born at Portunmna, Co. Galway, though I came to Manchester as a small child" (*The Weekly News*, March 1966), which mirrored Tanner's life, when she was really born in the UK.[6] This interview was constructed in the first-person narrative and Phoenix had the by-line as she described, "The Elsie Tanner in Me":

> The trouble with me is – I'm a straight talker. I can't pay lip service. I've got to mean what I say. What's worse, now and then I can't resist a 'grand gesture'. When I see a scene building up, my sense of the theatrical gets the better of me.
>
> (The Weekly News, *March 1966*)

Hazy lines between character and actor was a key component of early star interviews (see chapter 4), but against the dynamics of soap opera's "ordinariness", social and cultural narratives particularly relished the banal. For example, an interview with *Coronation Street* actor Geoffrey Hughes in *The Daily Mirror* (16 June 1983) described that there is "nothing Eddie Yeats likes better than a greasy fry-up followed by a bucket of beer at the Rovers. And away from the set Geoff Hughes is just as fond of his food and drink". Such coverage seeped into the regional press and William Roache, who played Street stalwart Ken Barlow, told the *Liverpool Echo* that he planned to "adopt an animal for his little Verity" after his character visited an animal shelter on screen (1 November 1985). Mundanity was perfect for marketing cultural products that were also about the trivialities of everyday life, and as corporate media publicity teams took tighter hold and tabloid journalists became more interested, all details of life on and off screen became part of news.

For the launch of *EastEnders* (1985–present), the BBC employed publicity officer Cheryl Ann Wilson, who worked in the studio alongside actors and fed the press insights into their private lives. Casting agents chose those who had "similar backgrounds to the characters they played" (McNicholas, 2005: 22) and Wilson pitched this gritty authenticity during press promotion. Across magazines and

tabloid newspapers, actors discussed battles with drugs, criminal convictions and how they had worked in jobs like those of their characters (McNicholas, 2005). *EastEnders'* publicity campaign built audience parasociality with actors to make them a "domestic, familiar part of the fabric of everyday life" (McNicholas, 2005: 25). Conboy (2002) highlighted how intertextuality between soap and tabloid newspapers played important roles in the instruction of viewers/readers into patterns of consumption and identity. Stereotypes and collective images of soap opera reduced the ability "to view one's own self-identity beyond that of neoliberal social structures" (2002: 150) and tragedies and private lives of soap actors became commodities too, which intensified relationships between private and public for commercial ends. Tabloid journalists used interactions with soap actors to "transfer characters out of these open-ended scenarios into ones that close down debates around sensitivities" (Conboy, 2002: 149). However, there were other consequences for actors. Progressive readings of soap opera that argue the democratic and social benefits of broader media representations often ignore exploitative components of publicity and how much press coverage is "anything but progressive" (p. 149). The marketisation of private lives and trauma of soap opera actors encouraged audiences to view traumas as saleable goods, although often they also encouraged them to seek help, should they be suffering too.

In the UK, this was particularly evident in "real-life" magazines such as *Take a Break* (1990–present) and *That's Life* (1995–present), which asked readers to sell victimhood cheaply for print alongside soap opera storylines. A particularly nonprogressive theme was female sexuality, which was portrayed in both soaps and tabloid news and magazines as intrinsically risky. On *Coronation Street*, Deidre Barlow's "lust" even led to imprisonment after she became involved with a conman. The "Free the Weatherfield One" campaign led by the *Sun* newspaper in March 1998 (Brinsford, 2015, *Metro Online*) placed blame not just on the criminal, but also on Barlow because of her poor choice in men. Even when actor Anne Kirkbride died almost twenty years later, newspaper obituaries revisited her character's "promiscuity". *Metro* described how she did not "pick [her] partner wisely" and that it is "fair to say that Deidre had a number of partners when living on the street" (*Metro*, 20 January 2015: online). A "timeline" of her life in *The Sun* intertwined the on-screen life of Barlow with Kirkbride's real one. For example, "1983: 21 million tune in to love triangle between Deirdre, Barlow and Baldwin; 1992: Meets real life hubby David on Cobbles as on-screen handyman boyfriend" (*The Sun Online*: 25 January 2015).

Another pertinent example of the soap/tabloid publications' complicit policing of female sexuality continues on *EastEnders*. Kat Slater, played by Jessie Wallace, initially arrived on "the square" as a reflection of turn of the century sexual liberation with a cackling joy for life and leopard-print stilettos (September 2000). However, within a few months, this was reframed as promiscuity as the result of childhood sexual abuse. Christine Geraghty (2006: 227) argues that this marked a shift in soap storylines from kitchen-sink realism to melodrama, which presented "a world … darker and more precarious than before [and] society under siege". The

Slater "maternal melodrama" reflected "cultural shifts in community and familial separation and tensions over power, sexuality and the family" (Franco, 2013), but as neoliberalism put the personal up for sale, the market demanded ever more sensational storylines. This extended into tabloid newspapers and magazines, which covered both plot twists and personal lives of actors in salacious, interconnected detail. Storylines were written as news with headlines such as "Kat Slater in Suicide Attempt After Abuse Memories Become Too Much" (*Metro*, 23 March 2015: online). Plot twists – such as that she was the real mother of her youngest sister – were reported as if celebrity scandals and newspapers discussed the release of "*The Secret Diary of Kat Slater*", as if it was any other celebrity autobiography (*The Guardian*, 2 Oct 2001: 22).

In parallel, the red-tops covered Wallace's private life as if a soap storyline, with accounts of drunken misdemeanours and sordid kiss-and-tells with former partners, which often concluded that "sex, rows and drink turned Jessie Wallace into her EastEnders character Kat Slater" (*The Sun*, April 2018: online). The overriding narrative was that Slater – and by this curious intertwining Wallace too – was unable to control sexual impulses and alcoholism because of abuse at the hands of men. As audiences watched both struggle, some women were inspired to speak out about their own abuse. As a young crime reporter at regional newspaper *The Sunderland Echo*, one such story arrived from court and the picture desk chose an *EastEnders* promotional shot as front-page illustration (28 September 2002). For optimistic views of the potentials of soap and tabloids for societal good, such occurrences might prove how they can politicise, expose crimes and empower victims of domestic violence and sexual abuse. Certainly, for the individual this was positive. However, the overwhelming negativity of newspapers' coverage of Slater/Wallace and constant references to the reasons for and damages to her female sexuality were more often repressive than emancipatory. For the handful of women who came forward to report their own abuse, thousands more were schooled in the dangers of female sexuality and how victims are unable to overcome trauma. The gulf between celebratory readings of individual examples and broader social advocacy for women is stark.

Those who benefited from such character/actor exploitation by the red-top press included a new breed of tabloid news brokers. The most notorious and powerful in the UK, Max Clifford, launched a 25-year relationship with tabloid news desks by befriending young *EastEnders* stars in the early 1980s. They were "at first delighted at getting free entry into glamorous nightclubs but dismayed when the paparazzi appeared" (McNicholas, 2005: 33). Some complained that Clifford was "taking over their lives" and that they needed help to "extricate them from his clutches" (ibid.). Such newspaper coverage benefited the show in terms of publicity and, usually, the careers of actors too. But when they were no longer on screen three or four times a week, the spell was broken, news content reduced, and fame often quickly faded.

More, perhaps, than any other single individual of the British celebrity industry, it was Clifford who transported the celebrification processes of tabloid newspapers

and magazines in relation to soap to the coverage of reality television. Commercial television seized this new opportunity to create celebrities, "rather than being merely the end user" (Turner, 2014a: 32), and found all too willing participants prepared to sell themselves for fame. The genre boomed in the 1990s and 2000s and programmes can be loosely categorised into four chronological groups. First, "fly-on-the-wall" shows such as *Cops* (1989–present) in the USA and *Airport* (1996–2008) and *The Cruise* (1998) in the UK became popular, and this genre later extended into celebrity fly-on-the-wall shows. Next, producers developed "contestant formats" such as *Big Brother* (1999–present), *Survivor* (1997–present), *I'm a Celebrity, Get Me Out of Here* (2002–present) and *The Apprentice* (2004–present), which were global phenomena. Berry (2019: 63) argues that this reflected neoliberal changes to media structures and the rise of entertainment conglomerates, which facilitated shows to be "traded internationally on franchises". The next dominant franchises of this kind were "talent formats" such as *Popstars* (2001), Simon Cowell's *Pop/American Idol* (2001–2003 UK; 2002–2017 USA), *X Factor* (2004–present UK; 2011–2014 USA) and the international <insert any of 58 countries here> *Got Talent* variety show (2006–present). Last, consumer cultures and social media linked "constructed reality narratives" (Usher, 2015) of US-first shows *The Hills* (2006–2010), *Keeping Up with the Kardashians* (2007–present)[7], the international *Real Housewives* (2006–present) franchises and in the UK, *The Only Way is Essex* (2010–present) and *Made in Chelsea* (2011–present). As Ruth Deller (2016: 373) succinctly put it, reality television offered opportunities for "proto-celebrities who wish to expand their fame; celebrities engaged in the work of promotion for their other endeavours … and those whose careers are in a period of 'post-celebrity' who seek to renew their fame".

Max Clifford Associates Limited (1990–2014) played an important role in the publicity and tabloid news focus on three areas of reality television: Britain's turn-of-the-century obsession with *Big Brother*, celebrity "fly on the wall" shows on cable television, and as Simon Cowell's personal press agent while he built his global talent reality franchise Syco. Clifford helped make reality television part of commercialised melodrama through the application of models developed in relation to soap opera stars and interactions with tabloid news. As press agent to the biggest "reality stars", not only Cowell but also *Big Brother*'s Jade Goody and *I'm a Celebrity* "Queen of the Jungle" Kerry Katona (who gratefully named her first son after him), Clifford regularly negotiated five-figure sums with tabloid print publications for exclusives and sacrificed other celebrities in return for positive stories about bigger earners. Tabloid editors lapped up this low-effort, pre-constructed "news" and Clifford's negotiation power became a constant part of newsgathering.

In life and death, *Big Brother* contestant Jade Goody (1981–2009) – the first British reality millionaire – best embodied the personal peaks and troughs of tabloidised reality and the neoliberal ideologies that put everything up for sale. Press agents and publicists helped her turn the value of visibility as a vilified "chav" when "in the house" to mass commercialisation of self on the outside. In some ways, Goody reflected optimistic readings of the potentials of reality television

celebrity to broaden representation. The mixed-race child of a drug addict and pimp, she grew up in extreme poverty and saw *Big Brother*, according to its first presenter Davina McCall, as her chance to "get out and escape that past life" (*Jade: The Reality Star Who Changed Britain*, Channel 4, 2019). However, as an early neoliberal-raised millennial – born in the early years of the Thatcher regime and leaving school the year of Blair's 1997 landslide – Goody seemed unable to imagine escape beyond the narrow lenses of self-marketing, wealth accumulation and consumer spending. She was one of the earliest complete prototypes for what Alison Hearn (2008: 197) later described in relation to reality television as the "branded self" – a commodity that works "and at the same time points to itself working" – and her persona practice shaped the subsequent displays of thousands of reality personalities of the millennial generation. Success depended on a vision for ordinary girls where it did not really matter if you not were pretty (get a makeover!), clever (stupidity is cute!) or talented (too posh!). Most important of all was a willingness to sell yourself completely to the panting dogs of tabloid television and news media.

Chris Rojek (2012: 170) argues that Goody marked the return of "the fool in the court of reality television" that mocked those "labelled as having Low IQ". Certainly, *Big Brother* ritualised humiliation through tasks, limited food supplies and filming housemates at their most vulnerable after plying them with alcohol. Goody was "ritually defined and culturally confined" (p. 172) by celebrification across tabloid media that revelled in condemnation of her ignorance. However, self-performance moved beyond the simple passivity of a fool. Mispronunciation of names, people and places was a principal reason for her inclusion in the show and producers encouraged her to play up to it. As one described, "in a cold-hard way as a producer, she delivered on what we thought she would. The viewers hated her. They were all appalled" (*Jade: The Reality Star Who Changed Britain*, Channel 4, 2019).

Rojek's (2012: 170) account that Goody remained a target for audiences to decry "bad taste, foolishness and vulgarity until she was diagnosed with cancer" ignores the self-agency and later fly-on-the-wall shows whereby she transformed her image from a fool to wealthy businesswoman and "respectable" mum-of-two (see also Biressi and Nunn, 2008: 155). She was a shrewd tabloid media operator who made private deals with paparazzi for a cut of their cash and turned even the most vicious attacks towards self-promotion. She laughed along with chat show host Graham Norton (*V Graham Norton*, June 2002), even though he had dressed in a naked fat suit and openly mocked her – but only after demanding a large fee, which her agent claimed to be the same as top Hollywood stars (*Jade: The Reality Star Who Changed Britain*, Channel 4, 2019). She gave interviews to the red-top tabloids who had photoshopped a pig's head on her body – after her agent negotiated a £250,000 deal for a series of exclusives. She launched businesses, such as *Jade's Salon* (*Living TV*, September 2005) and the reality shows that filmed her doing so both paid well and were publicity platforms for her products.

But unprecedented access to private realms was still not enough for some unscrupulous news editors, and tabloid reporters routinely hacked Goody's phone.

TV presenter Jeff Brazier, the father of her two sons, cites this as causing their split as both thought the other was selling details about their relationship they had agreed to keep private. And for all her tabloid savviness, Goody did not fully understand the emerging rules for playing a reality sweetheart for the press, which included being a victim rather than an aggressor. When she returned to the house as a bona fide celebrity (*Celebrity Big Brother*, 2007), she confronted a fame that was everything she was not, and the audience watched her confidence crumble before "achieved" Bollywood star Shilpa Shetty. *Big Brother* producers deliberately stoked conflict with tasks that emphasised differences in their celebrity status and class and, in an intense argument, they literally screamed tensions between "achieved" and "ascribed" celebrities in one another's face. Goody barked, "You're not some princess here. You're a normal housemate like anybody else," and Shetty replied, "Your claim to fame is this, good for you ..." (*Celebrity Big Brother*, Channel 4, 17 January 2007). Much was made of the racial dynamics of their fight, due to Goody's vile description of her rival as "Shilpa Fuckawala ... Shulpa Daroopa ... Shilpa Poppadom or whatever" (18 January 2007). But their anger was also a visceral response to the vast cultural gulfs between them, despite both being members of the celebrity class. Different pathways for fame only extenuated these dynamics. Goody vocalised the fear of the new breed of neoliberal celetoids – ordinary people whose fame was often fleeting and entirely at the mercy of tabloid media. Shetty verbalised the sneering fear of star culture that talent might no longer matter most in the arena of neoliberal celebrity and self-marketisation. Big Brother confronted Goody on air and she angrily argued she had reached for Indian-sounding words without thinking. Producers certainly must have understood that they had demanded such linguistic and cultural ignorance from her, and there was a cruel irony in that this both made and (almost) unmade her. Against a massive press backlash, they hung her out to dry anyway.

It was Goody's rise, fall and rehabilitation in front of television audiences and in negotiation with tabloid news which inspired Biressi and Nunn (2010: 50) to consider the "hard labour of the persona" (Sternberg, 1998: 426) and emotion work across the broadcast interview, reality television and confessional journalism. They used Hochschild's (1979, 2003) expansions of Goffmanian paradigms of self-presentation in relation to "where feelings come from" (2003: 7), which can be usefully applied to emotional labour in tabloid television spaces. Such emotional labour is negotiated in relation to both performance patterns and the priorities of print tabloid journalism. As they negotiated self-identity and intimacy in relation to psychoanalysis (chapter 4), Hollywood magazines created patterns and parameters for what Biressi and Nunn (2010: 54) the "public performative space for celebrity intimacy and the excavation of the celebrity persona" of tabloidism. During a series of emotional interviews, Goody, face swollen from desperate tears, stated, "I hate myself", and begged forgiveness. But *News of the World* journalists saw the incident as "manna from heaven" because it "shifted units" and they wanted to fan her collapse. Reporter Dan Evans later revealed that they had deliberately pushed her to breaking point in videoed interviews where she even admitted and apologised

for racist remarks she had never made, much to the amusement of senior editors (*Jade*, Channel 4, 2019). Goody entered celebrity rehab centre *The Priory* shortly afterwards following an emotional breakdown.

In death, the neoliberal and tabloid forces that put everything in her life up for sale completely consumed her. Max Clifford convinced her to appear on Indian *Big Brother* (*Bigg Boss*, 2006–present), where he arranged an on-air phone call telling her she had cancer. He auctioned her illness across tabloid television and print platforms – first pictures of her with no hair, rushed "fairy tale" wedding and preparations for death – for a rumoured £3 million. There were daily images of invasive hospital treatment and details of how she planned to say goodbye across the front pages of the red-top press and *OK!* bought exclusive rights to pictures of a rushed christening for her sons, which she hoped would reunite them "in heaven" (March 2009). Walter (2010: 856) argues Goody's death was "both qualitatively and quantitatively more public than that of others who had publicised their cancer" as there was no escaping it, especially for red-top and celebrity magazine readers. The market forces of neoliberalism marked a significant change in the power dynamics between journalists and celebrity, whereby *anything* – even death – is ultimately for sale to the highest bidder. With vast sums of cash at stake, press deadlines and filming schedules were more important than Goody's suffering or that of her children. *Living TV* kept the cameras rolling as she struggled to breathe in hospital and went home to die. *OK!* released a black-framed "official tribute" edition with "final words" as planned for their print schedule, which hit stands days before Goody actually passed away (*The Independent*, 19 March 2009: online). Tabloid audiences were so invested in the melodrama that they barely blinked at the obvious falsity and the edition sold two million copies. In life and death, Goody was a powerful human pseudo-event, a constructed reality narrative and the property of tabloid media who felt they had bought her outright and could do whatever they chose. She was the epitome of the ultimate demand of neoliberalism – that we should commodify all things – and as such became a sacrificial offering on the altar of its new celebrity values.

Talk television, new journalistic performances and fuzzy "real-time/ space" continuums

Neoliberal tabloid cultures completely consumed not only individuals but also entire television genres, and two discourses that originated in the USA reimagined journalism's relationship with celebrity globally. The first was the "Oprahfication" of television, where celebrities, real people and experts came together around a celebrity self-help brand. The second was the "real time" melodrama of rolling news channels whereby distant events and people appeared in our living rooms and the lines between news, celebrity and politics shifted continuums of mediated time and space.

Early chat or talk shows, simply understood, offered a new setting or Goffmanian style (1956) "front" whereby audiences could watch the interview ritual of

celebrification for themselves. The genre began in the 1950s and 1960s with Johnny Carson's *The Tonight Show* (1963–1992) and *The Phil Donahue Show* (1967–1996) and was picked up in the UK by the BBC when it launched shows such as *Parkinson* (BBC 1971–2004; ITV 2004–2007) and *Wogan* (1982–1992). Many patterns that governed the exchange in print carried over, such as displayed familiarity between interviewer and interviewee, narratives of ordinary person and "extraordinary" talent, marketing of consumer items and the adoration of fans, now physically cheering from the side-lines. In the early days this had more in common with Hollywood magazine interviews with stars than neoliberal tabloidism and celebrity cultures and focused primarily on those who had achieved fame. It was only when Oprah Winfrey gave herself freely to the world – and convinced guests and audience members to do the same – that the celebrity interview and talk show became part of narratives of suffering and self-sale.

P. David Marshall (1997: 131–149) analysed Oprah as a pinnacle of television celebrity culture and emphasised how she represented a new kind of stardom. He emphasised the "ritualization" of her personality through established television discourses and how as a narrative character she reframed these to consider "the other" so audiences might explore issues relating to women, people of colour and the social inequalities of American capitalist society. Jostein Gripsrud (2008: 39) also highlighted the importance of Winfrey and how her work, such as interviews with politicians or those on the streets during the 1992 LA riots, "belongs to the tabloid category" but that "it would not be at all fair to label it as trash". As a journalist – the youngest black female anchor on American TV news – and celebrity entrepreneur, Winfrey built her brand using techniques from tabloid press parasociality and the casual intimacy and performed intimacy of the talk show. By the early 2000s, her television and print products, including *The Oprah Winfrey Show* (1986–2011) and *O, The Oprah Magazine* (2000–present), boasted collective audience figures of more than 50 million across 140 countries, which, according to *Forbes* (1917–present), made her the America's first black billionaire in 2003. Rojek (2012: 125) argues that Winfrey, like other talk show hosts, "adopted the personae of peers" with "direct address to individual, invisible spectators by talking confidentially … as a friend, a confidante or a trustworthy counsellor". Of course, New Journalists had built these dynamics into tabloidism at the start (chapter 3), but Winfrey also fused this with dynamics of self-as-brand and tabloid journalism's use of celebrity culture to perpetuate neoliberal market values and wrapped it all up as self-improvement. Her "celebrity sign" was built on both strategic uses of earlier discourses of chat shows and "differentiations" from the patriarchal and star-focused work of her predecessors (Marshall, 1997: 139). Loroz and Braig (2015: 757–763) argue that the "Oprah Effect" of consumer attachment to a human brand was built from "autonomy, relatedness, and competence" and offered the audience/consumer a pathway to be better. As Marshall (1997: 143) argued, Oprah's celebrity sign "also emphasizes its ultimate vulnerability: because she is constructed 'from the people' [it] cannot be based on her unique merits or gifts to any great degree. Her reason for achieving exalted status … is never secure." However, her

performance linked neoliberalism directly to progressivism – a shift we will return to later in relation to mainstream politics – and by the turn of the 2000s this vision had taken hold. As such, Oprah's brand became secure because she best embodied social, economic and political orders in a way that humanised and naturalised them to her audience.

Like W.T. Stead a century before (chapter 3), Winfrey interviewed ordinary people with the same civility and celebration of triumph as when chatting to lofty stars and did so to bring marginalised voices into public spheres. Her publicly constructed persona was not that of an average person, but rather a cherished, charismatic, wealthy aunt, who offered a means by which they might lay open their weakness and find salvation. This was a double-edged sword. Condemnations of the Oprahfication of American cultural discourses often focused on the dangers of placing human interest over public interest and the socio-political over politics in media cultures. But there were other risks in building a genre around narratives of Triumph over Tragedy – referred to in British newsrooms as ToTs – as a long-standing facet of print newspapers use of human-interest stories. Ordinary people might become extraordinary through describing a terrible event and celebrities might become more authentic to audiences by revealing the intimate, but this created damaging contradictions between self-liberation, value and loss.

No other talk show host on either side of the Atlantic enjoyed the same kind of influence, and this was, at least in part, a result of her own candour. Winfrey shared devastating accounts of childhood rape as she comforted sexual abuse victims and laid bare the difficulties of being black and/or impoverished in America to white affluent social groups who dominated both the nation and her audience. As she unburdened herself, she shed physical weight and discussed how obesity was a protection mechanism for many female survivors. Her body became a focal point for discussion and debate, which challenged "from the margins" the white, thin, middle-class representation of celebrity that dominated its wider discourses from its origin to the present day (Marshall, 1997: 145). She cajoled her audience to do good work, to (culturally) shape their citizenship, to forgive themselves and others, to atone for national sins of segregation and racism, the epidemic abuse of women and children and ongoing social inequalities. She rewarded such endeavour with mass giveaways of consumer items including cars, holidays and self-help products and designed processes of reconciliation by which audiences might come to terms with white, middle-class privileges and even accept a nation where black people could hold real power. However, as "Aunt Oprah" did so, she also encouraged her audience to conform to neoliberalism's social and economic hegemony. She, like Jade Goody, embodied the dichotomies of tabloid and celebrity cultures, which offer individual pathways to emancipation for individuals and even perhaps for marginalised social groups, but also perpetuate the inequalities of neoliberal capital, not least because most people will never find paths to heal via fame and fortune.

Winfrey's self-brand ultimately helped to weld political progressivism and self-fulfilment to market forces and celebrity capital. As political historian Gil Troy (2015: 242) describes, she made "the American cult of success about her two

favourite subjects, the self and the spirit". There was something of the entrepreneurial New Journalists' vision for tabloid journalism in this too, but it also conformed to the neoliberal order of emotional labour. Such work meant that the "largely female audiences for these shows would no longer be dismissed as distracted voyeurs, but praised … . They could be understood as an avant-garde social movement" (Gitlin, 1997b: 79). This relied not only on self-endeavour to overcome trauma but also on personal growth based on economic success and, in this game, charisma won out. Growing media markets and corporations put their interests above those of individuals and, to compete, celebrities must be better performers than the ordinary person, even in the performance of suffering.

There was certainly something avant-garde in the *neoliberal apology formula* developed on *The Oprah Winfrey Show* for celebrities to atone for their sins in order to re-establish themselves in the celebrity sphere and tabloid news order. There was artistry to getting it right and significant social implications for audiences' understanding of contrition and victimhood when celebrities did or did not. Stars, from alleged paedophile Michael Jackson to cheating Olympian Lance Armstrong, drug-addicted starlet Lindsay Lohan to convicted rapist Mike Tyson, bore their souls and at times found forgiveness for – or the capacity to blind audiences to – their wrongdoing. This court of self-confession and rehabilitation embraced all celebrities, and while Winfrey only offered space to achieved celebrities, the formula seeped up and down the ladder. It influenced the admissions of reality TV personalities from Jade Goody to President Bill Clinton's apology tour as he sought forgiveness for cheating on his wife and lying about it (see Troy, 2015: 242–267) and emerged as a powerful narrative of journalism and celebrity whereby audience forgiveness could protect commercial and political interests.

Three sides of the equation needed to balance for it to work. The first was the celebrity who appeared contrite and dismayed – whether they accepted full guilt or not – and offered revelations of past trauma as a reason for their current situation. For example, Michael Jackson, with a vice-like grip on the hand of short-lived wife Lisa Marie Presley, claimed sleeping in the same bed as prepubescent boys was an innocent attempt to recapture a childhood lost to paternal violence and childhood fame (*Oprah*, 10 February 1993). As a result, many members of the 100 million global audience – including journalists – viewed him as a victim rather than an abuser. The second is the journalist or host, either Winfrey or a journalist who uses similar practices, who pressures the celebrity to dig deeper, atone for more and consider from where weaknesses and indiscretions might stem. The cause is often "exclusively revealed" as low self-esteem as the result of past trauma being accounted for the first time. Lastly, the audience, including journalists, demonstrate forgiveness. They discuss the event, applaud candour and magnanimously accept explanation before continuing to buy a celebrity product or welcoming them back into public spheres. With social media, audience demonstration of forgiveness became easier and a more important part of the equation. This apology formula established a pathway by which charismatic self-performance might mask truth and victims could be outcast from public spheres rather than aggressors. During such

moments, the power of neoliberal model celebrity and tabloid cultures allowed star charisma to eclipse fact.

If the three sides did not balance, then the apology failed, such as with Olympic gold medal cyclist Lance Armstrong's discussions of how he covered up doping. It should have been relatively straightforward as cancer was a perfect excuse for self-doubt and weakness. However, he was considered by audiences as too arrogant, unapologetic and unwilling to confess fully during his contrition interview (*Oprah!* 18 January 2013). In news and on social media his performance was rejected as "a limited confession" that only fuelled "suspicion in some quarters that it was only made because [he] was backed into a corner" (*The Guardian*, 18 January 2013: online). On other occasions, Winfrey did not fulfil her side as fully as she should have and apologised, for example, to both her audience and actress Robin Givens, Mike Tyson's former wife, for not tackling his domestic violence more strongly or challenging audience members who giggled when she described how he "socked her in the eye" (*Oprah!* 17 November 2009). In 2019, she revisited her 1993 interview with Michael Jackson, but spoke instead to his accusers. She denounced the star, having previously stated she believed he had told her the truth and described him as a seducer of both children and their families (HBO, 4 March 2019).

Oprah's emotionalised and celebrified "factual" discourse joined with technological advances such as satellite-beamed 24-hour rolling news, which shifted the time/space/reality continuums of journalism and celebrity in other ways. Mediated narratives reformed from past and distant to prescient and present and as part of a news cycle without end, which began in the US with CNN (1983–present); journalists were intimate celebrities whose opinions were forefront. Cushion et al.'s (2014) longitudinal study of rolling news between 1991 and 2012 evidenced significant shifts in journalistic practice to fill additional airtime, which included greater emphasis on the personalities of reporters and their opinions. As news moved from past to present tenses, reporters were "routinely asked to instantly react, update, and interpret … particularly in the world of politics" (p. 886). They were intervening variables between the facts and audiences' reactions to them.

Criteria and values for broadcast news now included the ability of journalists to appeal to audiences. Against the backdrop of the neoliberal economic and political systems that valued commercial bonds above all else, anchors and journalists governed authority of news broadcasts *through* audience acceptance of their authenticity. While, at least initially, this was to different degrees on either side of the Atlantic because of stricter impartiality requirements in UK broadcasting (Cushion et al., 2014), by the end of the period examined here, the insights and relationships of journalistic celebrities with mainstream politicians led news agendas almost as much as the actions of parliaments.

Rolling news interviews drew heavily from the tone of talk shows and anchors who offered audiences intimate encounters with those who found themselves in the news, celebrities and experts. The studio sets of news programmes – particularly at breakfast time or in entertainment-focused versions such as *E! News* (1991–

present) – were hybrids of traditional news studios and homes, designed with soft furnishings, sofas and fake windows. As anchors and journalists gently offered their opinion on party politics, news events and the actions of celebrities in real time to intimate peers at home, they shaped foreign and domestic policy, for example, during war, famines or terrorist attacks (Robinson, 2002). Pierre Bourdieu (1996: 46) argued that as "news anchors", like "talk show hosts", began to tell us what we "should think", they encouraged the audience to stop reasoning and become more passive in terms of reasoning with fact. Rojek (2001) highlights this as a key moment in the intimacy of celebrity, but this aspect of the celebritisation of news agendas lies at the edge of most examinations, which focus primarily on the celebrification of subjects on an individual level rather than producers and their practices. There were significant impacts. For example, Murdoch's *Fox News*, which he launched in 1986 after buying and rebranding several smaller news networks, made its anchors and reporters into celebrities. This offered "commercial and ideological ... gain" – that is, an opportunity to achieve "greater audience share and present a partial view of the world" (Cushion and Lewis, 2009: 132–133). *Fox News*' journalistic celebrities did not simply report the facts and promote public knowledge, they reshaped democratic participation and the tabloid narratives of self-improvement and worth. They were powerful tools to perpetuate Murdochian political and social hegemony and, despite the network's insistence that it is "fair and balanced", its journalistic celebrities largely support its populist, socially hard right and Republican world-view and viciously attack those of different political hues (Cushion and Lewis, 2009; *Outfoxed*, 2004).

Larry Sabato (2000 [1991]) identified these dynamics at this time as the reasons for the dominance of "Attack Journalism and Feeding Frenzies" as an "American Style" Inquisition which he argued transformed political journalism and damaged democratic participation. Sabato's study covered the pre- and early neoliberal period (although he did not identify it as such) and argued that attacks were a "spectacle without equal in modern American politics" (p. 1). He identified a new period of purification from the 1980s as part of a "new world of omnipresent journalism" facilitated by rolling television news, satellite technology and hand-held cameras (p. 34). Audiences and politicians alike perceived the press as "far more interested in finding sleaze and achieving fame and fortune than in serving as ... honest broker between citizens and government" and this contributed to "decline in citizen's confidence in, and respect for, the news media" (pp. 2–3). The amplification, acceleration and increased appetite for attack resulted in more journalists joining snarling hunts for scandal about politicians, particularly during election campaigns. As audiences turned away from print and towards television news, both areas of the press saw attacks – the uncovering of misdemeanour, the revelation of private impropriety, the personal mixed with the political – as key to holding attention. Sabato (2000 [1999]: 49) offered case-by-case studies of the "subtext predating frenzy" often including revelation of significant misdemeanour because of personal weakness. When looking for patterns one other is a politician's inability to resonate with journalists' media audience because they lacked charisma.

When the self is a brand that demands audience/voter/consumer loyalty, this is unforgiveable. Celebrated political leaders were both televisual and neoliberal, and attack journalism – now an established part of political discourse – greedily guarded neoliberalism.

Adoration, attack and the neoliberal political leader

Margaret Thatcher (prime minister 1979–1990) and Ronald Reagan (president 1981–1989) possessed "televisuality", broadly defined by Caldwell (1995) as resonance when communicating on television. Later iconic neoliberal politicians on both sides of the Atlantic such as Bill Clinton (1993–2001), Tony Blair (1997–2007) and Barack Obama (2009–2017) also resonated with what were by then, interchangeably viewed, audiences/publics/voters/viewers. However, they linked liberal markets with progressive politics, which welded them together for many voters, for good and ill. Each saw potential in manufacturing public consent through collapsed boundaries between politics, journalism and celebrity in mass media. Reagan and Thatcher offered highly manufactured images of their private lives and Gitlin (1997b: 82) describes them "old style" political celebrity leaders who "guarded their secrets" and "were never off" in public. They – and their conservative economic and social policies – enjoyed unprecedented support from largely right-wing media moguls. These included numerous UK newspaper proprietors such as *Express* group owner Victor Matthews, Lord Rothermere, owner of the *Daily Mail*, and *Telegraph* group owner Conrad Black, who according to editor Dominic Lawson "adored Margaret Thatcher almost to the point of idolatry" (Curran, 2018b: 125). Former employees claim Murdoch also "absolutely adored" Reagan and Thatcher and demanded journalists in his employ on both sides of the Atlantic did too. In the documentary *Outfoxed: Rupert Murdoch's War on Journalism* (2004), former Fox news producer Fred O'Donnell described how he "received an order from one of Murdoch's apparatchiks [... to] cut away from our newscast and start carrying a fawning tribute to Ronald Reagan which was airing at the Republican Convention". Editors were stunned to be "ordered from the top to carry propaganda". The global media world order remade the values of political journalism into tools for neoliberal dominance.

Thatcher rewarded unquestioning loyalty. In 1981, she secretly hosted Murdoch at Chequers and agreed his support in return for her help to avoid the Monopolies and Mergers Commission when acquiring *The Times* and *Sunday Times*. Former *Times* and *Northern Echo* editor Harold Evans (2015) angrily decried this moment as a "coup", which "transformed the relationship between British politics and journalism". Thatcher's "reckless engorgement of the media power of her guest" led to all "the wretches in the subsequent hacking sagas – the predators in the red-tops, the scavengers and the sleaze merchants, the blackmailers and bribers, the liars, the bullies, the cowed politicians and the bent coppers" (*The Guardian*, 28 April 2015: online). Later rewards included the Broadcasting Act (1990), which "encouraged market competition ... made television companies ... broadcasters [and] used

television public money to finance the private sector" and facilitated the dominance of global tabloid conglomerates (Williamson, 2016: 105). Clinton followed suit and, as a thank you for his own support from media conglomerates, passed the 1996 Telecommunications Act, which allowed similar deregulation of monopolies and cross-ownership – including Murdoch's News International – to link across borders. This was, reportedly, done at the bequest of lobbyists working on behalf of media companies who vied for a "piece of the cake" behind the scenes and away from the eyes of the public (*Outfoxed*, 2004).

As "corporate journalism became increasingly tabloidised, the line between news and information and entertainment blurred and politics became a form of entertainment and spectacle" (Kellner, 2012: 185). The Conservative and Republican parties were first to turn to public relations, but during this period there was a quick and unprecedented growth in press agents, spin-doctors and marketing teams across party lines (Berry, 2019: 59). Gitlin (1997b: 83) focused primarily on how this increased politicians and celebrities' interactions in news media – at events such as White House dinners, *Time* magazine parties or more recently *Vogue* Met Galas – and how at "such spectacular moments politics and entertainment, never as distinct as purists imagine, converge[d] under the sign of celebrity". News media represented political leaders as part of the celebrity crowd. They made arguments of individual over community, self-fulfilment through consumerism and glorified what the press referred to in neoliberal infancy as "Yuppie Culture". *Newsweek* magazine declared 1984 "the year of the Yuppie", with young urban professionals portrayed constantly in news media as both wealth generators and active consumers. Such displays of luxury and free-market libertarianism seemed made for television. They dressed the glossy music videos of bands on *MTV* (1981–present), sets of movies and the homes of such stars in glossy magazines. Whether actors or musicians were vocal supporters of neoliberal political leaders or not, mattered little. Yuppies "were usually … seen as embodying the 'new politics' of the late 1960s and early 1970s and the economic conservatism of the 1980s" (Carpini and Sigelman, 1986: 503). As such, they were the breathing adverts for neoliberal economic and social ideologies.

In newsrooms, the pack's ears perked up. This narrative chimed perfectly with tabloid cultures, markets and political power and, as a result, it was mainstream news that made sense of neoliberalism for most people (Berry, 2019), and to do so it celebrified those who best embodied its ideals. Numerous studies of UK political campaigns at this time (Linton, 1995; Thomas, 1998) argued that such tabloid newspaper support was crucial to election success, but depended not only on partisan support but also on shaping the political dimensions of everyday existence. However, two significant shifts happened across the generational divide between Reagan and Thatcher and Clinton and Blair. The first was the combination of neoliberalism with socially liberal progressive policies in relation to, for example, health, welfare and social exclusion. The second was greater personalised intimacy with the public, which reflected the emotional labour of neoliberal tabloid cultures.

Combining neoliberalism with social progressivism and carefully fostered para-social bonds with voters made political sense. While many people unashamedly bought into increased opportunities for consumerism, they rejected Thatcher and Reagan's visions for a "low-cost, small budget state" and were becoming more uncomfortable with conservative social intolerance. As Curran (2018b: 157) suc-cinctly puts, the "British public clung obstinately to key tenets of the post-1945 democratic consensus", including higher taxation for the rich, the National Health Service and the welfare state. In his films *Fahrenheit 9/11* and *11/9* (2004, 2018), documentary maker Michael Moore also emphasised how progressive attitudes amongst the American electorate point at opposition with presidential succession. However, it also made sense against the dynamics of journalism and celebrity that had shifted because neoliberal tabloid cultures and individualist representations of neoliberal discourses were so prevalent. British and American political leaders of the 1990s and early 2000s were attune to an audience used to private life and public work playing out together across television and in the press. They were politicians who worked well within the parameters of discourses seen on the likes of *Oprah* and in tabloids coverage of the events on soap operas. Either by design or by generational nature, the ordinary/extraordinary balance for celebrity developed by soaps, reality television and the press influenced the political performance of Clin-ton, Blair and Obama. While social progressivism may have reflected their genuine beliefs, usefully, those were also the beliefs of most voters. It is here that we might argue some democratic benefit to broader representation in public spheres. It was a moment of mediated political and economic symbiosis that facilitated significant social change. Turner (2014a) and others may argue "slippage" in relation to tabloid media's wider representation and democratic politics, but cause and effect are equally difficult to confidently separate.

The democratising element of tabloid spheres articulated and coincided with broader socio-political and cultural shifts and audience/public popularity. They gave neoliberalism a beating heart and allowed the electorate to feel better about the obvious inequalities it perpetuated. Interactions with voters from across racial, social and economic boundaries came easy to Clinton, who wrapped his political performance in charisma, empathy and the language of hope. He had "one foot planted in the solid world of the past and another in the fluid world of the present" and moved through self-phases of Southern boy, hippy activist and smooth-shaven yuppie with self-assured ease (Troy, 2015: 5). Self-performances and representa-tions of Clinton and Blair maintained many yuppie indulgences and progressive neoliberalism – what Blair referred to in speeches as the "Third Way" (1998) – depended on the Oprah dynamic of wanting to be and do better. Troy (2015: 242–243) draws parallels between Clinton and Oprah Winfrey in their repre-sentation of America as a "diverse, chaotic, accepting, yet somehow anguished and empty horizontal democracy". Clinton was to politics what Oprah was to enter-tainment – "fluid", "relativistic" and full of "come-back kid" grit. Much is written about Clinton's sex-life and impeachment scandal. Against the backdrop of the neoliberal soap opera, where the narratives of personality rather than policy

governed news, the scandal maintained rather than deconstructed his carefully crafted political persona of an imperfect human in extraordinary circumstances. This was evidenced no better than "forgiveness in the Church of Oprah" (Troy, 2015: 241), whereby he toured his apology at political rallies and news conferences. Clinton's popularity depended on effective invocation of the apology formula, and he was so good at it that he was not just forgiven but became more popular in many circles.

Tony Blair's New Labour turned televisuality towards winning over the traditionally Labour-hostile Murdochian press. This relied on both unprecedented access in social settings and his skills as a charismatic, "telegenic" (Washbourne, 2010: 44) "celebrity politician" (Street, 2004: 437). Blair "skilfully negotiate[ed] between young and old and between formality and informality" (Pels, 2003: 48) and cultivated a carefully chosen network of supportive celebrities, such as Manchester United's manager Alex Ferguson, Brit Pop icon Noel Gallagher and celebrity entrepreneurs such as British *Apprentice's* star Alan Sugar, who all partied at Number 10 (*The Telegraph,* 1 September 2010: online). His social set also included tabloid newspaper editors such as Piers Morgan and Rebekah Brooks (then Wade) (*The Guardian*, 14 January 2011: online). If they supported him, New Labour spin-doctors hoped their readers would follow suit. The charm offensive was a success. Murdoch accepted Blair into his social circle and asked him to stand as godfather for his daughter in 2010. However, such proximity, while politically useful at the time, ultimately damaged the reputation of both parliamentary politics and the press, particularly when laid out during the Leveson inquiry (Tony Blair's Testimony, 25–29 May 2012). A principal reason for Blair's vilification by members of the Labour Party was that he bowed to Murdoch. Whether he would have been prime minister and enacted his socially progressive policies had he not, haunts the party particularly as they have been unable to win an election since they openly turned away. Certainly, the Conservatives were desperate to woo Murdoch back. There were literally too many meetings between David Cameron and Rebekah Brooks for either to accurately evidence to Lord Leveson in 2012. Cameron even employed former *News of the World* editor Andy Coulson as his director of communications in the hope of winning over red-top readers and stuck by him during the early revelations of *The Guardian's* phone-hacking investigation. After Coulson's conviction, the prime minister was accused by leader of the opposition Ed Miliband of bringing "a criminal" into "the heart of Downing Street" (*The Guardian*, 25 June 2014: online).

Obama was inspired by the intimacy of Clinton and Blair's celebrified political persona construction with his "Hope, of Change, of Color, and of Youth" (Kellner, 2012: 188). However, the "impressive Internet spectacle" of his presidential campaign, which raised an unprecedented amount of money and "generated over two million friends on Facebook and 866,887 friends on Myspace" was multi-mediated in a way pre-internet political leaders and their marketing teams could not have imagined (p. 188). In the White House, Obama extended social media displays, with made-for-viral displays of "kindness" captured on mobile-phone

videos by staffers, distributed on social media and then picked up by news channels. His communications team flung White House doors open and shared intimate pictures of political and private moments. His was a performance of reconciliation between neoliberal political ideologies, the desire of the left for society to be "better" and the racial and gender-normative divides that so damaged the core of American society. It was Oprah and Clinton's neoliberal social progressivism rebranded for the internet age and liberal-minded millennials who wanted to feel good about both their social and consumer choices.

He carried it all off with a suave celebrified panache beyond that of Blair and Clinton and enjoyed such popularity, to quote the hashtag, "while being black" that it outraged conservative politicians and journalists. Murdoch's *Fox News* launched vitriolic racially charged attack after attack, with an obsessive focus on "birther" conspiracies and displays of "blackness" such as a "fist bump" with wife Michelle, which anchor E.D. Hill described as "a fist bump … or a terrorist fist jab" (8 June 2008). However, Obama's powerful televisuality and popularity offered meaningful defence. Attack journalism is a founding part of celebritised news discourses, but celebrification and charisma offers the greatest tool to combat it. Kellner (2012: 186) described Obama as a "supercelebrity … master of the spectacle". On departure from office in January 2016, he boasted an approval rating of 57 per cent according to polling firm Gallop – 23 percentage points higher than former US president George W. Bush despite incessant attacks from the right-wing press. As an optimal achieved celebrity – president as multi-media star – he was able to transcend their slurs.

Conversely, less charismatic politicians were often unable to defend themselves against the onslaught. To understand the nature of neoliberal tabloid models for politics, we must equally consider how celebritised discourses of attack guarded its parameters. As the first political leader of a mainstream party to challenge the neoliberal order for thirty years, Ed Miliband was not only a risk but also lacked the right weapons of defence. Miliband committed two offences in the mind of British right-wing newspapers. First, he argued for socialist change and against corporate dominance of news. Second, he looked awkward on camera to the extent that even his own party's marketing team were reluctant to use pictures of him on social media channels (Usher, 2016: 36). When he also criticised the ethics of tabloid media and monopolies (Helm and Boffey, *The Guardian*, 16 July 2011: online) and suggested Rebekah Brooks just resign and Murdoch's empire dismantled, a News Corporation staffer (allegedly) threatened him with, "we are going to make it personal about you". It was a full-frontal assault.

How this adversarial celebrity technique poisons political discourse through cynical use of fear of recrimination is no better evidenced than in this moment of rabid political celebrification at the end of the period examined here. This had much in common with one of the earliest examples of attack journalism as political action in relation to Thomas Paine, as explored in chapter 2, and is a fascinating example of how newsroom cultures can travel across time. Several newspapers, rather unimaginatively, labelled him "Red Ed" and *The Mail* focused on his father, historian Ralph

Miliband, who they described as a Marxist who "hated Britain" (30 September 2013) and who had "devoted his life to preaching one of history's most poisonous dogmas" (1 October 2013). During the 2015 General Election, the attack reached fever pitch. *The Sun* described Miliband's "two faces" (2 May 2015: 6) and said he was "shame-fully dishonest" (1 May: 8). He was "vacuous" (5 May: 8), "laughable" (4 May: 8) and "revolting" and would "defile" Number 10 with his "arrogance" (ibid.: 11). He appeased "Islamists" to "keep the Allah block vote". He was an "imbecile" (30 April: 13), "barmy" (30 April: 5) and could not "wear the trousers" (ibid.). He was a "lame duck" (30 April: 13), a "grisly mix of left and lefter" (30 April: 5), who wanted to spark a "class war" (1 May: 6) through "socialist lunacy" (30 April: 5). He used "slave labour" and, with a distinct whiff of anti-Semitism, was described as making a "pig's ear … out of a helpless bacon sarnie" before heading to his "three bathroom … North London" home (6 May: 1–2). Miliband was, quite simply, a "horror story" (2 May: 6) and beyond contempt. He was a "wholly owned creature of the militant union barons" – who "crumbles under fire" (1 May: 6) due to "comic idiocy" (4 May: 11) and who, as a result, could bring about a complete collapse of the economic and social security of the country (ibid.).

Without understanding the place of attack in neoliberal tabloid cultures and cultures of neoliberal model celebrity, it would be difficult to comprehend why so many journalists participated in the desecration of a mild-mannered father of two, who was widely regarded as one of politics' "nice guys" (Alistair Campbell, *New Statesman*, 6 June 2010: online). Certainly, long-embedded newsroom cultures of attack encourage "pile-on" as production practice. Maybe it did not involve as many as it would first seem, with those up the chain of command adding into copy. Ivor Gaber (2017) argues that the "othering" of Ed Miliband reflected the vast cultural and political gulfs that emerged when Labour moved left while leading newspapers had moved more to the right. While he challenges whether this affected their audiences' perception of him, the results of the 2015 election suggest that, at least, it limited engagement with his message. If as Richards (2012: 207–310) discusses, "civility and open-mindedness" are key to successful democracy, such pack mentality rendered Miliband mute to audiences/voters and therefore undermined democratic functions that depend on fair and open debate.

Two groups led his defence: journalists at left-leaning *The Guardian* and a group of teenage social media savvy "fan-girls". They created a celebrity discourse – the "Millifandom" – which superimposed his face on the body of Hollywood hunks, shared via hashtags *milifandom* or *milibae*, used to denote "before all else" (used usually to refer to a sexual partner). They attempted to shower him with the charisma he lacked on television screens and this proved the most effective part of "Miliband Fight's Back" (*The Guardian*, 2 May: 1, 8). The leader of this group emerged as 17-year-old student Abby Tomlinson, who said she was "annoyed that the media presentation of [Miliband] was a deliberate distortion" and admired his "passion for the cause of eradicating inequality" (Bromwich, *The Guardian*, 20 December 2015: online). In response, journalists attacked her too. Several *Sun* reporters "door-knocked" her grandmother, searching for negative stories, which

she discussed in a YouTube video (*WestminsterAbby*, YouTube, 11 Sept 2015). *Sun* columnist and former Tory MP Louise Mensch was accused of "bullying" the teen after several tweets directed at her and a 4,000-word rant in which she threatened to write about her again in her next column (*The Guardian*, 19 May 2015: online). Miliband lost the election, but the Milifandom interrupted the right-wing journalistic narrative, and this, for news editors, was a concern. These young women used digital self-celebrification (chapter 6) and representational celebrification techniques, to engage in what Natalie Fenton (2016: 7) described as "extraordinary politics" – taking action, fighting back and resisting the dominant discourses of news. Digital technology fractured the power of the mainstream press to represent political leaders as they saw fit. In the aftermath of the 2015 election, editors wondered whether social media had undermined their place in the neoliberal social order and decided which parts they could amplify or sacrifice in order to protect the interests of capital and their own cultural hegemony.

Themes for the 21st century

Neoliberal model tabloidism, perhaps irrevocably, maligned journalism and celebrity cultures. In the wake of the transformations that occurred during this time, audiences and digital technology morphed the extremities of neoliberalism and sacrifices were made to defend against patterns of resistance from social media empowered audiences and bring them into the fold. Against the networked reality of celebrity and political cultures across television, news and social media and the exposure during the hacking scandal, progressivist channelling of neoliberalism ate itself. This laid bare to audiences the hypocrisy of politics and news' relationships and, ultimately, this resulted in news media returning ever closer to the right-wing social conservatism of early neoliberalism.

Neoliberal tabloidism's extreme cultures of attack and contrition shaped what was now an unquestionable period of postmodernity as "the consumption of sheer commodification as a process" (Jameson, 1991: x, see also Conboy, 2002: 143). Blair's Third Way, or what Cameron later hailed as "One Nation Conservativism", collapsed and a new era dawned where celebrity and political leaders emerged, adept at using new media technologies to perpetuate their authority and authoritarianism. The next and final analytical chapter rewinds the clock slightly to demonstrate how networked media brought audiences every more visibly into displays and how this facilitated the huge social and political turmoil of the second decade of the 21st century.

Notes

1 See chapter 3.
2 See James Curran's "Moral Decline of the Press" chapter in *Power without Responsibility* (2018) for an insightful discussion of this within the context of changes to print news cultures, which inspired my candour in this chapter when I heard him speak at Leeds University that year.

3 Replaced with the Independent Press Standards Organisation Code of Practice in 2013 following the Leveson inquiry.
4 From his New York headquarters, Murdoch ruled multinational News Corporation, which included subsidiaries News Limited in Australia and News International in the UK. In 2013, after the hacking scandal, the company split.
5 Figures derived from *Communications Management Inc* (2011) comparative analysis of UK, US and Canadian print newspaper markets.
6 See chapter 4's analysis of *Photoplay* for similar examples of actors' reconstruction of personal history to facilitate fame-building with journalists.
7 This genre of "constructed reality" and its relationship with journalism, consumer culture, social media and "self-branding" is discussed further in chapter 6.

References

Allan, S. (2005) "Introduction", in S. Allan (ed.) *Journalism: Critical Issues*. Maidenhead, UK: Open University Press.

Baistow, T. (1985) *Fourth-Rate Estate*. London: Commedia.

Berry, M. (2019) "Neo Liberalism and the Media", in J. Curran and E. Hesmondhalgh (eds) *Media and Society*. New York: Bloomsbury, pp. 57–82.

Biressi, H and Nunn, A. (2008) "The Especially Remarkable: Celebrity and Social Mobility in Reality TV", in A. Biressi and H. Nunn (eds) *The Tabloid Culture Reader*. New York: Open University Press, pp. 149–162.

Biressi, A. and Nunn, H. (2010) "A Trust Betrayed': Celebrity and the Work of Emotion". *Celebrity Studies*, 1(1): 49–64.

Bonner, F. (2003) *Ordinary Television*. London: Sage.

Bourdieu, P. (1996) *On Television and Journalism*. London: Pluto Press.

Caldwell, J. (1995) *Televisuality: Style, Crisis and Authority in American Television*. New Brunswick, NJ:Rutgers University Press.

Carpini, M. and Sigelman, L. (1986) "Do Yuppies Matter? Competing Explanations of Their Political Distinctiveness". *Public Opinion Quarterly*, 50(4): 502–518.

Chippindale, P. and Horrie, C. (2005) *Stick It Up Your Punter*. London: Pocket Books.

Communications Management Inc (2011) *Sixty Years of Daily Newspaper Trends*. Online.

Conboy, M. (2002) *The Press and Popular Culture*. London: Sage.

Conboy, M. (2014) "Celebrity Journalism – An Oxymoron? Forms and Functions of a Genre". *Journalism Theory, Practice and Criticism. Special Issue: Celebrity News*, 15(2): 171–185.

Corner, J. and Pels, D. (2003) "Introduction", in *Media and the Restyling of Politics*. London: Sage.

Couldry, N. (2003) *Media Rituals: A Critical Approach*. London and New York: Routledge.

Curran, J. (1978) "The Press as an Agency of Social Control: A Historical Perspective", in G. Boyce, J. Curran and P. Wingate (eds) *Newspaper History from the 17th Century to the Present Day*. London: Sage.

Curran, J. (2018a) "The Moral Decline of the Press", in J. Curran and J. Seaton (eds) *Power without Responsibility*. 8th edn. London: Routledge, pp. 172–192.

Curran, J. (2018b) "Rise of the Neoliberal Establishment", in J. Curran and J. Seaton (eds) *Power without Responsibility*. 8th edn. London: Routledge, pp. 156–171.

Cushion, S. and Lewis, J. (2009) "Towards a Foxi-fication of 24-hour News Channels in Britain? An Analysis of Market-driven and Publicly Funded News Coverage". *Journalism Theory, Practice and Criticism*, 10(2): 131–153.

Cushion, S., Lewis, R. and Roger, H. (2014) "Adopting or Resisting 24-hour News Logic on Evening Bulletins? The Mediatization of UK Television News 1991–2012". *Journalism*, 16 (7): 866–883.

Dahlgren, P. (1991) "Introduction", in P. Dahlgren and C. Sparks (eds) *Communication and Citizenship*. London: Routledge.

Dahlgren, P. (2003) "Reconfiguring Civil Culture in the New Media Milieu", in J. Corner and D. Pels (eds) *Media and the Restyling of Politics*. London: Sage.

Davies, N. (2014) *Hack Attack*. London: Chatto & Windus.

Deller, R. (2016) "Star Image, Celebrity Reality Television and the Fame Cycle". *Celebrity Studies*, 7(3): 373–389.

Dyer, R. (1979) *Stars* (1998 edn). London: BFI.

Foucault, M. (2008 [1979]) *The Birth of Biopolitics: Lectures at the College de France 1978–1979*. Trans. G. Burchell. New York: Palgrave Macmillan, pp. 252–253.

Franco, J. (2013) "Child Abuse, Melodrama and the Mother–Daughter Plot in *EastEnders*". *European Journal of Cultural Studies*, 16(3): 267–284.

Franklin, B. (1997) *Newszak and News Media*. London: Arnold.

Gaber, I. (2017) "Othering Ed: Newspaper Coverage of Miliband and the Election", in D. Wring, R. Mortimore and S. Atkins (eds) *Political Communication in Britain: Polling, Campaigning and Media in the 2015 General Election*. London: Palgrave Macmillan, pp. 273–291.

Gamson, J. (2011) "The Unwatched Life is Not Worth Living: The Elevation of the Ordinary in Celebrity Culture". *MPLA*, 126(4): 1061–1069.

Geraghty, C. (2006) "Discussing Quality: Critical Vocabularies and Popular Television Drama", in J Curran and D. Morley (eds) *Media and Cultural Theory*. Oxford: Routledge, pp. 221–232.

Gitlin, T. (1997a) "The Anti-Political Populism of Cultural Studies", in M. Ferguson and P. Golding (eds) *Cultural Studies in Question*. London: Sage, pp. 25–38.

Gitlin, T. (1997b) "The Anti-Political Populism of Cultural Studies". *Dissent*, 44(2): 77–84.

Goffman, E. (1956) *The Presentation of Self in Everyday Life*. Edinburgh: University of Edinburgh Social Sciences Research Centre.

Greenslade, R. (2003) *Press Gang*. London: Biggleswade.

Gripsrud, J. (2008) "Tabloidization, Popular Journalism, and Democracy", in A. Biressi and H. Nunn (eds) *The Tabloid Culture Reader*. New York: Open University Press, pp. 23–44.

Fenton, N. (2012) "Telling Lies: Press, Politics, Power and the Public Interest". *Television and New Media*, 13(1): 3–6.

Fenton, N. (2016) *Digital, Political, Radical*. Cambridge: Polity Press.

Hartley, J. (1996) *Popular Reality: Journalism, Modernity, Popular Culture*. London: Arnold.

Hartley, J. (2009) "Journalism and Popular Culture", in K. Wahl-Jorgensen and T. Hanitzsch (eds) *The Handbook of Journalism Studies*. New York: Taylor & Francis, pp. 310–324.

Hearn, A. (2008) "Variations on the Branded Self: Theme, Intervention, Improvisation and Inventory", in D. Hesmondhalgh and J. Toynbee (eds) *The Media and Social Theory*. New York: Routledge, pp. 194–219.

Hermes, J. (1995) *Reading Women's Magazines: An Analysis of Everyday Media Use*. London: Polity Press.

Hesmondhalgh, D. (2013) *The Culture Industries*. 3rd edn. London: Sage.

Hochschild, A. (1979) "Emotion Work, Feeling Rules, and Social Structure". *American Journal of Sociology*, 85(3): 551–574.

Hochschild, A. (2003). *The Managed Heart: The Commercialisation of Human Feeling*. Berkeley, CA: University of California Press.

Holmes, S. (2005) "'Off-guard, Unkempt, Unready'?: Deconstructing Contemporary Celebrity in *heat* Magazine". *Continuum: Journal of Media & Cultural Studies*, 19(1): 21–38.

Jacobson, G.C. (2000) "Public Opinion and the Impeachment of Bill Clinton". *British Elections & Parties Review*, 10(1): 1–31.

Jameson, F. (1991) *Postmodernism, or, The Cultural Logic of Late Capitalism*. Durham, NC: Duke University Press.

Kellner, D. (2012) "Barack Obama and Celebrity Spectacle", in T.W. Luke and J. Hunsinger (eds) *Putting Knowledge to Work and Letting Information Play*. Rotterdam: Sense Publishers, pp. 185–210.

Linton, M. (1995) "Was it The Sun Wot Won It?" Seventh Guardian Lecture. Nuffield College, Oxford.

Loroz, P. and Braig, B. (2015) "Consumer Attachment to Human Brands: The 'Oprah Effect'". *Psychology and Marketing*, 32(7): 751–763.

Lumby, C. (1999) *Gotcha: Life in a Tabloid World*. St Leonards, NSW: Allen & Unwin.

Marshall, P.D. (1997) *Celebrity and Power: Fame in Contemporary Culture*. Minneapolis, MN and London: University of Minnesota Press.

McNamara, K. (2011) "The Paparazzi Industry and New Media: The Evolving Production and Consumption of Celebrity News and Gossip". *International Journal of Cultural Studies*, 14(5): 515–530.

McNicholas, A. (2005) "'EastEnders' and the Manufacture of Celebrity". *Westminster Papers in Communication and Culture*, 2(2): 22–36.

Pels, D. (2003) "Aesthetic Representation and Political Style", in D. Pels and J. Corner (eds) *Media and the Restyling of Politics*. London: Sage.

Richards, B. (2012) "News and the Emotional Public Sphere", in S. Allan (ed.) *Routledge Companion to News*. London and New York: Routledge.

Robinson, P. (2002) *The CNN Effect: The Myth of News, Foreign Policy and Intervention*. London: Routledge.

Rojek, C. (2001) *Celebrity*. London: Reaktion.

Rojek, C. (2012) *Fame Attack: The Inflation of Celebrity and Its Consequences*. London: Bloomsbury Academic.

Sabato, L. (2000 [1991]) *Feeding Frenzy: Attack Journalism and American Politics*. New York: Lanahan.

Seaton, J. (2018) "Industrial Folklore and Press Reform", in J. Curran and J. Seaton (eds) *Power without Responsibility*. 8th edn. London: Routledge, pp. 461–483.

Sternberg, E. (1998/2006) "Phantasmagoric Labor: The New Economics of Self-presentation". In P.D. Marshall (ed.) *The Celebrity Culture Reader*. London: Routledge, pp. 418–437.

Street, J. (2004) "Celebrity Politicians: Popular Culture and Political Representation". *British Journal of Politics and International Relations*, 6(4): 435–452.

Thomas, J. (1998) "Labour, the Tabloids, and the 1992 General Election". *Contemporary British History*, 12(2): 80–104.

Troy, G. (2015) *The Age of Clinton: America in the 1990s*. New York: St Martin's Publishing Group.

Turner, G. (2014a) *Understanding Celebrity*. 2nd ed. London: Sage.

Turner, G. (2014b) "Is Celebrity News, News?" *Journalism Theory, Practice and Criticism, Special Issue Celebrity News*, 15(2): 144–152.

Usher, B. (2015) "Twitter and the Celebrity Interview". *Celebrity Studies*, 6(3): 306–321.

Usher, B. (2016) "Me, You and Us: Constructing Political Persona on Social Media during the 2015 UK General Election". *Persona Studies*, 2(2). Online.

Walter, T. (2010) "Jade and the Journalists: Media Coverage of a Young British Celebrity Dying of Cancer". *Social Science and Medicine*, 71(5): 853–861.

Washbourne, N. (2010) *Mediating Politics: Newspapers, Radio, Television and the Internet*. Maidenhead, UK: McGraw Hill Open University Press.

Williamson, M. (2016) *Capitalism and the Making of Fame*. Cambridge: Polity Press.

Press and television primary sources

Belfast Telegraph Reporters. (2009) "Magazine Defends Jade Goody Tribute Edition". *Belfast Telegraph*, 19 March. Online.

Campbell, A. (2016) "Campbell Strikes More Positive Note on Ed Miliband". *New Statesman*, 17 June. Online.

Channel 4 (2019) "Jade Goody: The Reality Star Who Changed Britain". August.

Channel 4 (2017) "Confessions of the Paparazzi". February.

Brinsford, J. (2015) "Free the Weatherfield One". *Metro Online*, 20 January.

Bromwich, K. (2015) "Abby Tomlinson: I Still Think About How it Would Be If Ed Miliband Had Won the Election". *The Guardian*, 20 December. Online.

Express Reporters (2009) "Oprah Apologies to Givens for Flawed Tyson Interview". *The Express*. 14 November. Online.

Evans, H. (2015) "How Margaret Thatcher and Rupert Murdoch Made a Secret Deal". *The Guardian*, 28 April. Online.

Helm, T., Doward, J. and Boffey, D. (2011) "Rupert Murdoch's Empire Must Be Dismantled: Ed Miliband" *The Guardian*, 16 July. Online.

Liverpool Echo Reporters (1985) "Street Star to Adopt Animal". *Liverpool Echo*, 1 November.

McLean, G (2001) "Secrets and Lies and Now an Exclusive Extract from Soon to Be Published Secret Diary of Kat Slater". *The Guardian*, 2 October. Online.

Mirror Reporters (1983) "Grubs Up and the Chips Are Down". *Daily Mirror*, 16 June.

Payne, W. (2015) "Deidre Barlow Star Anne Kirkbride Dead, Aged 60". *The Sun*, 20 January. Online.

Phoenix, P. (1966) "The Elsie Tanner in Me". *The Weekly News*, March.

O'Carroll, L. and Wintour, P. (2014) "Andy Coulson, the Criminal Who Had David Cameron's Confidence". *The Guardian*, 24 June. Online

Ok! Magazine (1993–current). Reach PLC.

Outfoxed! (2004) R. Greenwald and A. Kitty (directors). New York: Disinformation.

The Sun (1964–current) *General Election Coverage*, 2015. 31 March–6 May 2015.

Welsh, D. (2015) "Kat Slater in Suicide Attempt after Sexual Abuse Memories Become Too Much". *The Huffington Post*, 23 May. Online.

Wintour, P. (2014) "Ed Miliband Challenges David Cameron over Andy Coulson Warnings". *The Guardian*, 25 June. Online.

6

THE STORY OF THE 21ST CENTURY

Hyperconsumerism, neopopulism and the networked applications of journalism and celebrity

In the first decade of the 21st century, networked – multi-platform and concurrent – media environments transformed journalism, celebrity and political cultures. Intercommunications between "presentational" social and "representational" news media (Marshall, 2014) were part of continuous reality and persona construction in and beyond temporal digital environments. The complex communication ecosystems that emerged, maintained journalism and celebrity's places as both sculptors and clay of capitalist democracies. But mediated ambiences and spectacles amplified and extended neoliberalism to its extremities and as a result, hyperconsumerism – a virulent extension of celebrity culture's visible consumption – and neopopulism – a conservative-reactionary ideology led by highly celebrified political leaders – dominated journalism, political and celebrity spheres. Social media displays of these things initially seemed frivolous, even comical, but by the dawn of 2020 they were naturalised and accepted by many. Arvidsson (2013) argues the term "consumer-public" best describes *consumption as public action* where lines between consumerism and production blurred in digital spaces. This chapter establishes that in networked media and against the intertwined dynamics of hyperconsumerism and neopopulism, this is a two-way exchange with *public spheres also consumer actions*. The term "consumer-public" here aims to capture the fluidity between both sides of this exchange as the parameters of digitised masses in contemporary capitalist democracies.

Early optimism that the World Wide Web would reinvigorate public spheres, and by extension the ideals of democracy, now feels like hopeless naivety. Instead, threads of journalism, celebrity, politics and the political weave familiar forms to maintain the power of corporations and political elites. While rhetoric often focuses on topical or national interest rather than emphasising global free markets or the outputs of media conglomerates, narratives of hyperconsumerism and neopopulism extend dynamics of self-marketing and political authoritarianism. The place of

journalism and celebrity in the participatory web is twofold. First, gossip-based celebrity news – now mostly written around paparazzi shots – increased considerably in reportage about many facets of fame and persona, including those of politicians. Public taste and the desire of advertisers (Williamson, 2016) channel audiences through processes of *click, consume, share* via machine-driven patterns of production. More clicks, shares and purchases of consumer products from native advertising – or political messages through demonstration of support in embedded polls and comments beneath posts – results in reporters quickly producing more content. Audiences' "real time" choices, therefore, hold more *direct* influence over the gathering, production and dissemination of news than ever before. Second, journalism's rituals of celebrification such as the interview, gossip as news and image-led portraits are reimagined, repackaged and politicised. Words and images given freely on social media are a key source for news content and influence editorial decision-making far beyond showbiz desks.

Many studies of celebrity and journalistic performances on social media extend the theoretical and methodological usefulness of Goffman's (1956) *Presentation of the Self in Everyday Life*. Certainly, as Mackey (2016) identified, Goffmanian language easily translates to goal-driven digital persona construction and pathways of self-performance between old media discourses and new. As discussed earlier in this book in relation to the celebrity interview (chapters 3 and 4), Goffman (1956: 13) considered a performance as "a period marked by [...] continuous presence before a particular set of observers", which aims to influence them in some way. The place where it occurs is the "front" (for example, a social media platform) and if a performance is replicated, then a pattern or routine forms. In this chapter, such patterns include social media optimisation for celebrity promotion, journalistic work and political campaigning. Goffman argued that the construction of persona can either be sincere, where the performer believes "the impression of reality which he stages is the reality" or cynical – only aimed at influencing observers of the exchange (p. 10). Performances are "moulded to fit into the understanding and expectations of society" and will tend to "exemplify the officially accredited values of the society" (pp. 23–24), such as capitalism and democracy or their mutations towards neoliberalism, hyperconsumerism and neopopulism. Through exploration of key platforms, celebrities, politicians and other information brokers who led and exemplified such changes, this chapter considers whether the apotheosis of journalism and celebrity's co-dependency is that their sophisticated patterns for constructing our sense and performances of self might even help collapse the media systems of liberal democracy they helped make. It looks to the successes of key platforms and the complexities of networked celebrification of a range of figures who represent the increasingly fluid economic and political dynamics of digitised consumer-publics. But first, let us consider more broadly how politics and journalism were transformed by digital realities.

The 2020 vision for politics, journalism and celebrity

By 2020, we better understood Web's capacity to shape public spheres as part of agglomerations of socio-economic and political power. Boris Johnson's landslide victory in December 2019 confirmed the Brexit referendum result and excused Tory austerity policies that disproportionately punished the poorest for the 2008 Bankers' Crash (Butler, *The Guardian*, 29 July 2019). Trump began his re-election campaign defiant in the face of impeachment. Left-wing politics seemed defeated and marginalised in mainstream news, which often appeared to relish "spectacles of opinion" (Usher, 2020) more than facts. Certainly, discursive "truth" was better suited to social media environments, where consumer-publics – a digitised hybrid of audience/public/electorate/consumer – joined debates and shaped narratives of mainstream media. At a time dominated by discussions of "fake news" and BOTs, political populism and interference and the impacts of consumerism on our self-identities, wellbeing and planet, journalism, celebrity and political cultures worked together once more to shape society, self-identities and our responses to these things.

Consumer-publics emerged as part of an all-encompassing synoptic "viewer society" (Mathiesen, 1997), where the many saw and contemplated a relatively small number of celebrities and politicians who were visible across *both* mainstream representational and presentational social media spheres. However, "ordinary people" also used tools of social and digital media and the patterns of journalism and celebrity in order to build their fame and, at least initially, often outside the control of corporate media. Social media influencers first built small but dedicated followings (Senft, 2008, 2013) and then some large-scale consumer-publics to whom they directly sold consumer products (Usher, 2018). Audiences moved beyond the role of observers and became participants who demonstrated support or disagreement in real time, promoted the work of others and produced their own content in response. Synoptic and critical consumer-publics made their opinions, emotional responses, purchasing habits and politics part of fluid and interactive journalism, celebrity and political communications.

Simultaneously, journalists, celebrities and politicians used dynamics of panopticism, defined by Foucault (1975) as a mechanism whereby individuals or institutions of governance monitor "the many" and may modify messages, policy or behaviours in response. Social media offered synopticism and panopticism "fusion with each other" (Mathiesen, 1997: 223) and agreement, disagreement, shares, retweets and likes aid both strategic persona construction as a communication pattern and practice and also news production. They amplified both consumer ambiences and political spectacles as they unfolded. Against these shifts, corporate news media began to replace journalists with other types of information broker including social-media influencers and artificial algorithmic amplifiers of what Tim Berners Lee dubbed "the semantic web" (*Bloomberg*, 9 April 2007). Machine-led content production deconstructed and reconstructed British and American public spheres as ideological constructs of democracy and began to replace them with

what once we would have considered paradoxical to "citizens" who lived there – highly discursive, but increasingly authoritarian.

For example, in the wake of the Brexit referendum and Trump's election win in 2016, Carole Cadwalladr and other investigative reporters worldwide worked together to expose Cambridge Analytica's campaigns to influence democratic decision-making via social media. Cadwalladr argued that we needed to be mindful of the dangers of the "right-wing fake news ecosystem" on democratic decision (*The Observer*, 4 December 2016). But this was covered too little by other news media and consumer-publics largely shrugged their shoulders when methods were used again. Access to social media and the ability to speak freely and publicly masked the reduction of meaningful social and political freedom. Targeted propaganda and engaging but often simplistic rhetoric of populist leaders offered convenient "truths" and many happily accepted these as the same as facts. Thus, just as relationships between journalism, celebrity and news cultures helped to establish Western capitalist democracy in the 18th and 19th centuries – and then its acute neoliberal phase in the 20th century – they once again shaped our sense of self in negotiation with these things. To return to a statement from the beginning of this book's 320-year period of examination, when John Wilkes declared "freedom of press the birth-right of every Briton", he could not conceive a time that freedom to speak and display via media could unravel the principles of citizen-based democracy.

Against these shifting dynamics, there is need to revisit Rojek's (2001: 17–21) taxonomy of fame, which has offered methodological and analytical focal points throughout this book. Published a half-decade before social media and reality television booms of the late noughties, his categories of *ascribed, achieved* and *attributed* did not cover how celebrity practices came to rely on networked performances of self or the impacts on public performance more broadly. Of course, his original categories of fame still exist and there is continued fluidity between them. But in the digital world, fame-building also relies on the skilful application of dynamics established by news media and different areas of the celebrity class. In 2018, I argued for the inclusion of the term *applied* celebrity to encapsulate strategic application as part of reality-self-display where celebrities build fame through use of longer-established components, techniques and tools across multiple media platforms. This category of the 21st-century celebrity class often uses mass communications and staged authenticity to "deliberately foster parasociality with audience members", in order to build visibility, maintain 'self-as-brand', and perpetuate consumerism" (Usher, 2018: 15). As explored in this chapter, applied celebrities are also leading influencers of political thought and action. Networked personas are carefully crafted using the rituals of journalism, celebrity promotion and reality television. But before we consider the impacts of this on individuals and institutions of media, let us first examine changes to mainstream celebrity news production and the social media performances of celebrities as part of hyperconsumerist and neopopulist mediation.

Maintained and new practices of celebrity news

Graeme Turner (2014b: 145–151) identified three components of "celebrity news production" in the early 2010s, focused primarily on newsgathering (as discussed in chapter 5). Journalists used press packs, premieres, award shows, junkets and interviews often negotiated through "personal contact with publicity and promotional organisations". Paparazzi "candid shots" – which might be entirely staged before being sold "directly to picture editors" (see also McNamara, 2011: 516) – provided basis for other stories, with text written specifically for the images on display. Such images worked perfectly to grab audience attention during the scroll/click functions of smart technology. The final principal source identified was tip-offs from members of the public, including those in celebrities' social circles. News media continued to use all these methods, but their primary source shifted in response to the presentational social media displays of celebrities. Journalists instead *watched* networked persona construction across social and mainstream platforms and then constructed stories as if news, using its long-established conventions and constructions.

There was precedent for this production practice in how the red-tops made soap opera storylines and reality television part of their news agendas (chapter 5). Journalistic voyeurism expanded from television to social media and, as a result, complexities of networked construction of self, shaped digital news systems as they developed. Deuze (2012: 269) argued that these could be broadly categorised into *open* systems – where content is sourced by audiences and moderated and edited – and *closed*, where journalists watch created material by pointing to original material, such as social media accounts (Bruns, 2005: 19). By acting as "observers of the output gates" (p. 17), celebrity news was cheaper and quicker to produce. Levels boomed once more and, in turn, this influenced both the practices and professional identities of journalists and celebrities. According to seminal studies of news and journalism such as Jeremy Tunstall's (1971) *Journalists at Work*, the work of reporters has always been "unroutine". However, many identified interviewing as the primary newsgathering activity, with specialist correspondents using 25 per cent of their newsgathering time speaking to contacts face to face and 39 per cent by telephone (Tunstall 1971: 150–151). In digital worlds, journalists instead often draw together material as it unfolds elsewhere and then drop it into search engines and social media "optimised" templates, which pre-code the inverted pyramid structure. For some news editors, the capacity to follow this process is more important than whether reporters can build contacts, investigate and interview. Indeed some "reporters" – both those covering the world of celebrity and other areas of news – *never* interview sources. This poses a significant question: are they really journalists?

In the British journalism trade press, the *Press Gazette* (2015), I suggested that the title *digital content processors* better describes this area of journalistic work and claimed there were significant implications for industry practices which were being pioneered on celebrity news desks particularly (Usher, 2015: online). The first is that quantity is more important than quality as multiple stories about celebrities are

more likely to get audiences' clicks than one exclusive, especially when factoring in time/cost ratios. The second is that news aggregation is a more valued skill than newsgathering and, as a result, not all journalists – perhaps not even most – need to source and negotiate their own stories. Finally, as news editors order reporters to get stories up quickly and correct later, speed is more important than accuracy. Unlike previous news platforms, "back-end" functionality and "front-end" audience experience allow changes in an instant and guarantee that audiences always click on latest iterations.

The interrelated success stories of *MailOnline* (2003–current) and Twitter (2006–current) best encapsulated these dynamics. Between 2008 and 2013, *MailOnline* became the world's most visited news website. When they commissioned digital agency Brand42 with the sites' post web 2.0 relaunch, the brief, according to their subsequent company analysis (2012: 2) was simple – make us "the UK's number one newspaper website" by significantly growing its average 18.7 million site visits per month. By May 2013, this reached 128 million (Usher, *Press Gazette*, 20 June 2013: online) and the site boasted biggest shares for other information categories, such as TV and showbusiness (Anon, *Comscore*, 19 January 2012: online). Brand42 enhanced "user experience, maximising editorial and imagery" in order to "engage and appeal to a younger web savvy audience, encouraging interaction and comment" (Brand42, p. 3). The "back-end" content management system was more "user friendly, flexible and responsive" (p. 6) and audiences were actively involved in dissemination via quick and easy social share functions. In June 2011, the number of visits through individual article pages shared on social media surpassed the number through the homepage and this enabled flexibility of "entry points and journeys" (pp. 5–6). By 2014, *MailOnline* employed 615 reporters, producing more than 750 articles per day, with 70 per cent of hits from outside the UK (Mance, *Financial Times*, 18 April 2015).

In parallel, the micro-blogging platform Twitter became the leading platform for celebrity/audience interactivity and a key site for digital newsgathering and dissemination. The social media site was unique in relation to its competitors, because it became a portal and aggregator for an abundance of digital content and enabled 24-hour-a-day real-time interaction between corporations, public figures and multiple complex and fluid audiences. In 2008, owner Jack Dorsey successfully pitched for additional investment (*Twitter Blog*, 24 June 2008) to improve user experience and site robustness. The "Twitter whale" graphic – which explained that the site was "over capacity" – symbolised an expanded technical support team who worked to keep the site up as active user numbers boomed. Visits were eight times higher than the year before – doubling in the previous three months of 2008 alone – and worldwide monthly unique users reached a million, tweeting around three million times a day (Arrington, *TechCrunch*, 29 April 2008: online). Five years later, Twitter was central to the formulation and circulation of celebrity and journalism, with 218 million active accounts (Bennett, *Adweek*, 4 October 2013), and between 400 million and 500 million tweets a day (Curtis, *The Telegraph*, 29 May and 6 September 2013).

Twitter worked well for the new routines of celebrity newsgathering and became the key platform not just for dissemination but also for finding content, and this later expanded to social media channels such as Instagram and Snapchat. Celebrities – in front of journalists and audiences – self-performed, promoted and offered insights into their private lives. Journalists had never experienced such unfettered access to their lives. However, inevitably cultural intermediaries who had long guarded access often moved in to govern display. In 2011, Alice Marwick and danah boyd found that most celebrity Twitter accounts were individually produced, with only around 13 per cent of the most popular showing evidence of publicity or PR involvement. Three years later, "tweeting" was also a professionalised practice with 65 per cent published on the top twenty celebrity accounts written by publicity agents or social media marketing teams (Usher, 2015). As such, "older processes of broadcasting/receiving star images and the hierarchies of stardom/fandom prevail[ed]" (Thomas, 2014: 2) and social media was co-opted quickly into the mainstream.

Zizi Papacharissi (2012: 2) argued that "presencing" on Twitter – a term introduced by Nick Couldry (2012) to describe construction of continual online existence – used "interaction […] to pursue publicity, privacy and sociality". Patterns and routines of performance are "part of the performative repertoire marking identity" and users manage "the persistence, replicability, scalability and searchabilty of their performances fluently, in environments that prompt (and in some instances reward) sharing" (Papacharissi, 2012: 4). Micropublics linked together via celebrity news shares and celebrity posts and were "regularly and publicly updated and responded to" in a way that *made them* "quasi-public network[s]" (Marshall, 2014: 164). As Figure 6.1 demonstrates, certain types of celebrity made up the Twitter top twenty at this time. They were predominantly American and included 14 pop stars, one reality television personality (Kim Kardashian) and chat show hosts Oprah Winfrey and Ellen DeGeneres. There were two footballers and Barack Obama came third, which reflected his successful digital electioneering as discussed in the last chapter. In brief, all were famous as themselves rather than for playing fictional characters, and the majority were achieved celebrities. Star visibility weighted in digital platforms towards pop music and rarer iterations in television and politics. Twitter was an extension of already existing promotional practices of self-performance and promotion for music, television and politicians and quickly became an expected part of their practices. Sustainability was key and all but one of the top twenty celebrity accounts averaged at least one tweet a day.[1]

As celebrity tweets increased, so did *MailOnline*'s use of them, with the conventions for direct speech moving quickly from "he/she tweeted" to "he/she said", which masked differences between comments gathered through interview. The dominant role for "televised personalities such as journalists and celebrities" to "actively filter and shape the news" (Mathiesen, 1997: 225) extended to social media and a clear directive from both celebrities on Twitter and "MailOnline Reporters" – click content, consume it (and perhaps buy a product) and then share it on your own social media pages. *MailOnline*'s never-ending celebrity updates

MailOnline

Twitter name & Date Joined	Followers (m)	Tweets	Daily Average	Reply (%)	Retweet (%)	Total Interactive (%)	Broadcast	Stories (June 1 2011-June 1 2014)
@katyperry: February 2, 2009	53.8	5671	3	9	20.5	29.5	70.5	711
@justinbieber: May 28, 2009	52.343.6	27,012	14	12.5	38.5	51	49	1158
@barackobama: May 5, 2007	43.6	11,891	4.5	0	19	19	81	98
@ladygaga March 26, 2008	41.5	4760	2	35	23	58	42	813
@taylorswift: December 6 2008	41.3	2231	1	1.5	51.5	53	47	589
@britneyspears: Sept 9, 2008	37.6	3666	1.75	36	32	68	32	479
@rihanna: October 2, 2009	35.7	8980	5.2	56.5	27	83.5	26.5	1163
@justintimberlake: March 25, 2009	32.6	2388	1.25	19.6	54.8	74.4	25.6	209
@theellenshow (Degeneres): August 13, 2008	29.4	8999	4	0	44.5	44.5	55.5	103
@JLo: October 27, 2009	27.9	3908	2.3	6	85	91	9	107
@cristiano (Ronaldo): June 14, 2010	26.9	1977	1.3	3.5	50.5	54	46	62
@Shakira: June 3, 2009	25.6	2981	1.6	2	72	74	26	140
@Oprah: 23 January 2009	24.5	9308	4.7	46.5	36.5	83	17	203
@Pink: April 3, 2009	23.8	5386	2.8	22	64	86	14	N/A
@ddlovato (Demi): Feb 17, 2009	22.8	11,496	8	8	53	61	39	245
@KimKardashian: March 19, 2009	21.2	17,450	9	7	16	23	77	1471
@HarryStyles: August 22, 2010	20.9	4764	3.4	59	12	71	29	580
@SelenaGomez: May 8, 2010	20.7	3256	1.7	7	14	21	79	657
@OfficialAdele: August 30, 2010	20.3	323	<1	2	32	34	66	210
@kaka (Ricardo): June 28, 2009	19.4	3499	2	0	9.5	9.5	90.5	7

FIGURE 6.1 Top twenty celebrity Twitter accounts (June 2014) and their impact on *MailOnline* news content (June 2011–June 2014)

appeared on the "sidebar of shame" and editors measured success by audience clicks. Images were instantly recognisable hooks used to capture attention as consumer-publics scrolled through social media timelines. Publisher Martin Clarke described the sidebar as "journalistic crack" (Usher, 2014: online) and articles moved rapidly between celebrations and attacks, based on physical appearance, sex lives, professional work, leisure activities or consumer habits. He credited the "sidebar" for *MailOnline*'s extraordinary audience hold of around 11 minutes, when for most newspaper websites two and a half minutes was a good show (Usher, 2015).

Popularity was also self-perpetuating. More clicks and shares meant content appeared on more Twitter timelines and reporters then produced more content again. This exposed *MailOnline*'s rapidly expanded transatlantic news audiences to discursive models of news production and the conservative, neoliberal tabloidism of the *Daily Mail* brand. Celebrity news is highly gendered, both in terms of subjects and in whom they consider the audience, which the news industry had always considered to be mostly women (Thornham, 2007: 8). As Figure 6.1 demonstrates, 4,815 of news stories were about the five women who featured most in the first four years after relaunch (@KimKardashian; @Rihanna; @LadyGaga; @KatyPerry; @SelenaGomez) – more than double the 2,107 stories produced about the top Twitter male celebrities (@JustinBieber; @JustinTimberlake; @HarryStyles; @BarackObama; @Ronaldo). During this time, *MailOnline* emphasised women's sexuality and private lives rather than achievements, emotional distress above success and unpicked at self-image through narrow idealised lenses for women's bodies. News subjects *displayed* hyperconsumerism and heteronormativity through "language and imagery" which carried the full power of "sexual, as well as, gender difference" (Holland, 2002: 18) and through value on looks above all else. Until 2014, celebrity news even appeared under the banner "FeMail" and while the web development team have since removed this term from the top of the "sidebar of shame", the lilac colour coding remains.

Both *MailOnline* and Twitter were key sites for the maintenance of neoliberal logics of mass marketisation of self and consumer culture and extended cultures of "steal the style" by offering audiences the ability to click and buy through native advertising. They helped build celebrity brands, sell their merchandise and therefore perpetuate hyperconsumerism. One group – the women who make up Brand Kardashian – emerged as particular favourites for audiences and as a result there were vast volumes of content produced about them. As Ellis Cashmore declared in Kardashian Kulture (2019), their influence on 21st-century media cultures is "undeniable" and demonstrates almost miraculous levels of engagement from fans and journalists. And, as we will see next, like many celebrities considered across the 300 years covered by this book, this new category of *applied celebrity* – which strategically uses established patterns of celebrity to construct reality and build parasocial relationships – primarily extend the "idea that satisfaction is found […] in, consumption and leisure" (deCordova, 1990: 108).

The repressive ambience of hyperconsumerism and "applied" celebrity

Twitter and *MailOnline*'s growth in popularity historically coincided with that of constructed reality television, and of those shows, *Keeping up with the Kardashians* (2007–current) and its eight spin-off shows (referred to here as *KUWTK et al.*) were standout hits. On Twitter first, then across other platforms too, the Kardashians and then their younger Jenner sisters seized the capabilities of social media to self-promote and, in doing so, helped make themselves the world's most successful reality brand and its first true "stars". This position was confirmed through Kim's place in the top-twenty Twitter accounts where all others were stars of their field; beatification in publications such as *Vogue* and invitations to the most prestigious red-carpet events such as the Met Gala. Within a decade, the family were among the most visible celebrities on the planet, with their associated shows broadcast in more than 150 countries and an average of twenty glossy magazine covers a month in Britain and America alone in 2016 and 2017. At this time, *E News* ran a daily Kardashian bulletin and lead-player Kim Kardashian-West was the most googled person on Earth. *MailOnline* placed the Kardashians right at the top of their celebrity news agenda and were an *acknowledged* participant in their brand-building efforts. They produced almost 5,000 stories about them in four years and, in thanks, Kim told *Vogue* it was her "favorite website of all time" (April 2014). The Kardashian siblings were special guests at *MailOnline* parties in places such as Cannes (Mapstone and Keeth, 25 June 2014) and were regularly snapped and filmed scrolling the "sidebar of shame". Kim was the face of the sites' first US advertising campaign which placed her "on the same page" as another Kim – Jong Il – along with the strapline "Seriously Popular". This summed up what made *MailOnline* and the Kardashians such perfect bedfellows. Each took popularity very seriously indeed.

The story arc of *KUWTK et al.* focuses on the emotional labour of "being" products, productive workers, creatives and consumers as applied celebrities and an international corporate brand. This complex reality performance works far beyond the remits of the television show and on social media, followers watch real-time snapshots of private and public moments, sometimes later shown on television too. Life also happens on news media platforms and therefore in both past and present tenses, first-person and third-person narratives and in many different time realities at once. The Kardashians built follower bases with undeniable skill, first on Twitter, and then expanded to Instagram and Snapchat. By June 2014, the principal cast had more than 85 million Twitter followers, placing them as a collective at the top of the Twitter top twenty. By June 2017, this approached 700 million Twitter, Instagram and Facebook followers and Snapchat "views" surpassed 250 million a month.

As Brand Kardashian developed, these women – managed by their mother – strategically *applied* the celebrity signs of consumer choice and lifestyle before they were internationally famous. The main narrative blurred narratives of *achievement* in

the new "open competition" (Rojek, 2001: 18) of networked reality display and visibility and as influencers of consumer habits, business, design and technological innovation. This was articulated as the ultimate affirmation of self where life is "best lived" in relation to consumer and leisure activities and the best job is to be paid for recording and publishing it. "Ascribed" visibility or "lineage" (Rojek, 2001: 17) – of famous family members, friends and partners – was also applied to the brand-building narrative. For example, the Kardashian and Jenner sisters often refer to their experiences as the children of two famous father figures – Olympic gold medalist Bruce (now Caitlin) Jenner and O.J. Simpson lawyer Robert Kardashian. They also openly discuss how they built fame from Kim's sudden notoriety after the release of a sex tape. Relationships with their "momager" Kris Kardashian/Jenner are both professional and personal and successes of one at times portrayed in their shows as the result of parental favouritism. These make for complex self-as-product dynamics.

Reality television personalities were, at first, mediated "ascribed" celebrities, created by and for mass media consumption (Rojek, 2001: 18). However, constructed reality shows such as *KUWTK et al.* differ from previous shows in two ways. First, they are often partially scripted with scenes set up and reactions agreed beforehand, and then edited into narrative arcs, where the "performances of selfhood [are] completely conditioned by the shows' narrative concepts, aesthetic concerns, production exigencies, and sponsorship imperatives" (Hearn, 2013a: 448). Cast members need to look good because they principally exist as vehicles to sell, so they are blessed with good make-up and lighting in a way earlier reality television participants were usually not. Hearn (2010: 72) argues that this worth only exists through the exploitation of this labour and therefore there is no genuine reconciliation with the self. Certainly, on the show and in news coverage about it, fame appears simultaneously emancipatory and repressive for these women, who suffer breakdowns and break-ups, betrayal and robberies and often blame such things on their fame.

The Kardashians are optimum applied celebrities – the first networked reality *stars* – because their self-agency constructs a cross-media ambience of hyperconsumerism and indoctrinates their followers into this narrative. This is ultimately repressive for both them and others because it fosters false attachments and emotions and restricts fulfilment through the lenses of consumption and visibility. For example, patterns of the celebrity interview structure Twitter interactions (#ask sessions) with the aim of promoting products (Usher, 2015). This intertwines with displays of parasocial affection, whereby individual members of the consumer-public are rewarded by direct attention, thanks and even expressions of "love you too!" (pp. 315–316). The Kardashians offer ways for fans to find identity, connection and meaning through the possibility of direct interaction and reward. As Kardashian "Dolls" share *MailOnline* stories, use their surname and pictures in social media profiles, circulate links to consumer items and talk about the shows, they not only support the circulation and promotion of Kardashian cultural and consumer products but also become *like* the products. While since the 1990s fandom has

been articulated as "a central preoccupation of the self" which "serve[s] to govern a significant part of one's activity and interaction with others" (Thompson, 1995: 222), the performance of these dynamics is now a constant part of life.

As Thompson (1995: 223) argued, the social world of fans is highly structured, with "its own conventions, its own rules of interaction and forms of expertise, its own hierarchies of power and prestige [and] its own practices of canonization", and these dynamics carry through to social media. Public canonisation of certain fans can even come from the ultimate source –celebrities themselves – offered as a reward for devotion displayed through sharing news and promotional dissemina-tions. Some turn their own social media personas over to promotional practices, making celebrity names their own, sharing continuous displays of their purchase of products and can build tens of thousands of followers of their own as a result (Usher, 2015). They become smaller-scale applied celebrities, who construct their personas as reflections of their idols to attract attention to both, and in doing so help make Brand Kardashian's celebrity-driven hyperconsumerism an "ambience" for others. As intercommunications between representational and presentational media intensified, such dynamics were familiar and particularly as part of the growth of another area of applied celebrity whose fame also now relies on the perpetuation of hyperconsumerism and the performance of parasociality – what Terri Senft (2008, 2013) dubbed "microcelebrities".

Journalism and the repressive ambience of microcelebrity

At the same time as the Kardashians gained momentum, a new breed of influencers "applied" the rituals of celebrity and reality television narratives to themselves in presentational social media environments. Soon, patterns and themes established in print, such as "ordinary" and "extraordinary" interplays, newsgathering and construction and lifestyle feature writing, became aids to persona construction and public visibility (Duffy, 2015; Usher, 2018). Prominent influencers now often also enforce a vision of self-identity that can only be "understood in relation to the imperatives of capital", with narratives centred on how products and experiences make life "better" (Usher, 2018: 17). In this world, more stuff is more, and con-sumer choices are constantly pitched to followers as if a way of life. For example, in "haul videos" consumer-publics see shown item after item and Instagram pictures often display the joy of consumption. Such posts unwittingly highlight "the paradox of the liberation of affluence" (Baudrillard, 1970; see also Gane, 1991: 30), where performance of self-fulfilment and individualised fame masks the repressive nature of consumerism and excludes those who are unable to buy from this moment of exchange. Social media becomes a *repressive ambience* where emulation is constantly encouraged by multi-platform socialised performances and followers are actively involved in purchase and displays of it (Usher, 2018). Curran and Seaton (2018: 386) argue that there are relatively few "bloggers" globally and that only 1 to 5 per cent of online users considering themselves as such in 2017. But this amalgamation of the narratives of blogging with traditions of journalism and celebrity cultures, then

interwoven with commercialism and the capacities for visible displays of self-identity on social media, now offers a clear pathway into the celebrity class.

Social media influencing brings together many new and old rituals of journalism and celebrity cultures. As for the stars of constructed reality shows such as *KUWTK et al*, two-way relationships with followers are an important pattern of micro-celebrity networked production practices. Parasociality is ritualised as a principal means to achieve popularity, in a similar way as for some New Journalists (chapter 3) or neoliberal tabloid television personalities (chapter 5) who built successful brands by creating audience intimacy, familiarity and opportunities for participation. The current dominant platforms for performance are YouTube and Instagram, and for the latter, patterns and layers of image and text, guide the viewer in how to read displays (Usher, 2018), in the same way that 19th- and early 20th-century magazines schooled audiences to read celebrities' images through associated text (chapters 3 and 4). Chris Stokel-Walker (2019: 2) describes YouTube as a "kaleidoscope … that mimics the richness, quirkiness, beauty and madness of human life". Because of cross age, cross interest and now cross platform reach (it became a "homepage App" for some satellite and cable television outlets in 2017 and 2018), YouTube is now a context and lens through which consumer-publics access and understand the world, with similarities to the socio-cultural place of the 18th- and 19th-century press in their time. "Lifestyle influencers" particularly are most likely to cross over into mainstream news and television, and there is now an established pathway into reality TV (and vice versa) that reflects the neoliberal tabloid culture of selling private life and consumer goods. Such lifestyle b/ vloggers often draw from journalistic feature construction to "amp up" their popularity amongst social media audiences, including interviews with creatives, merchandisers, hoteliers or restaurant owners. Marwick (2015: 347) clarifies, microcelebrity "can be further understood as a mind-set and set of practices" with "authenticity" and "everydayness" key to performance and "clicks, shares and likes synonymous with success". Microcelebrity not only describes the "microfamous" (Sorgatz, 2008) and a system of production to achieve fame but also, like celebrity, is an *amplifier* for systems of capital and, as we will explore later in this chapter, now politics and news too. Rituals and patterns of work now often have much more in common with mainstream celebrities and journalists than the uncensored and tantalising "camgirls" considered by Terri Senft when she coined the term in 2008.

Celebrity blogger "Perez Hilton" – the professional pseudonym/brand name of NYC-based influencer Mario Lavandeira Jr. – was a pertinent early example of such dynamics. The *PerezHilton.com* celebrity-gossip website (2005–current) was named in honour of socialite, constructed reality TV personality and hotel heiress Paris Hilton, of whom "Perez" was a self-confessed fan (*PerezHilton.com*, 24 November 2018). It pioneered many self-branding practices of digital influencers and their use of journalistic production, in this case specifically through the production of celebrity news, as not only clickable content but also part of persona construction. "Perez" built his popularity through constant negotiation of *authority* as a celebrity journalist and insider and his *authenticity* as a fan. Arnould et al.'s

(2003) examinations of relationships between bloggers and their readers argued that while authenticity and authority weave together, the authoritative voice primarily influences consumer action. "Perez's" displays of "authentic" fan and "authoritative" showbiz correspondent used celebrity news to support some celebrities and attack others. The complexities of relationships between performances, platform and production practices as blogger/journalist/platform/celebrity/self/brand enabled Lavandeira to bring Perez Hilton – a fictional "celeactor" (Rojek, 2001) who represented this new type of mediated self – to life. This real/fictional interplay allowed him to push boundaries. For example, he argued that as a gay man he did not consider homosexuality a taboo and claimed the right to "out" celebrities, when, at least in the UK, mainstream press had stopped doing so (Whittle and Cooper, 2009). Many journalists and celebrities condemned such editorial decisions as "bullying", and he certainly used elements of attack journalism in scathing and often scornful commentary about some in the public eye. Tabloid reporters not only repackaged his celebrity exclusives as if their own, but also covered such attacks on others as if "celebrity catfights". "Perez" also regularly appeared on television, including US and UK talk shows (e.g. *The Ellen Degeneres Show*, NBC, 13 October 2010; *Loose Women,* ITV, 25 April 2015) and reality shows (e.g. *Celebrity Big Brother,* Channel 5, January 2015; *Celebrity Rap Superstar,* MTV, August 2007). His self-branded shows *What Perez Says* (VH1 2007–2008) and *Perez Hilton: Superfan* (ITV 2011–2012) focused on life and work as a blogger and used "constructed reality" television formats that were partially scripted. As a transatlantic-applied celebrity, journalist and celeactor, "Perez" intertwined values of intimacy with enterprise, news dissemination with self-brand building, and used attack journalism as a means to build his own fame.

On the one hand, the "Perez Hilton" brand represents the kind of "independent entrepreneur" (Marwick, 2015: 467) explored by many examinations of microcelebrity culture, but equally his practices were an extension of long-established production patterns and themes of journalistic and celebrity cultures. On the other, as Williamson (2016: 133) suggests, Lavandeira's career "has taken on the contours of a normal trajectory into television light entertainment", particularly through reality television as the cultural home of another branch of what I describe as "applied" celebrities. His commercial success as a celebrity gossipmonger resulted in a team of reporters working for *PerezHilton.com*, and this influenced digital mainstream news production. It is referenced, for example, as a template for *MailOnline*'s "sidebar of shame" that also uses "snarky celebrity commentary", direct attacks on celebrities and news gathered from social media displays to attract "clicks" and build audiences (*The Atlantic*, 24 April 2014; *The New Yorker*, 12 April 2012). The complexities of the "Perez Hilton" brand as both presentational and representational practice encompassed celebrification of both self and others. It was an early indicator of how the practices of journalism might transform into networked spectacular self-performances.

Many microcelebrity members of the celebrity class – unlike actors, musicians, television and radio presenters and personalities before them – built fame, at least

initially, at home and without the support of mainstream media and its owners. But while Turner (2014a: 73) acknowledged they "borrowed from the publicity and promotions" of traditional celebrities and were "borrowed back again", for too long many scholars followed a line that this was a "bottom-up" process, outside "the powerful and commercialised systems sustaining celebrity culture" (Jerslev, 2016: 8). In 2018 – a decade after Senft's initial study of microcelebrity – I argued that corporate media had co-opted this narrative and that microcelebrity was now an *individualised group production practice*, with a number of media professionals involved, including press agents, publicists, content producers and fans (Usher, 2018). For example, many of the most popular microcelebrities in the UK and USA are managed by "digital-first talent agency" Gleam Futures from their offices in London and LA. The company was launched in 2010 by former *MailOnline* executive Dom Smales, who set about professionally wooing many leading names in a similar way to how Max Clifford sought out the leading names of neoliberal television and tabloid cultures, as explored in chapter 5 (Jackson, *The Guardian*, 7 August 2016). For Gleam, the emphasis is on in-house content production and the negotiation of sponsorship deals, consumer self-branded goods and appearances in mainstream media (Usher, 2018). But there is a shift in power in terms of interaction with the tabloid press. As some microcelebrities vie with news publications in terms of audience reach – and surpass them in terms of their visibility with the under-thirty target audience – they can be choosier about what they sell about themselves and to whom. Tabloid newspapers and magazines are often cut out, at least until microcelebrities also appear on reality television and join their mainstream media promotional practices. By 2016, many were doing so. Their managers brokered invitations to appear on celebrity versions of global reality conglomerate shows and, as a result, the tabloid pack were interested. As they attracted more mainstream media attention, their performances reshaped other aspects of news and social media performance, with startling impacts on public discourse and democracy. Microcelebrity as a production practice played a significant role in making journalism and politics modes "of cyber-self-presentation" (Turner, 2010: 14) with far-reaching political consequences.

Journalism, microcelebrity and (neo) populist opinion spectacles

The professional practices of journalists have transformed. Dynamics of self-branding, celebrification and audience interactivity now govern modes of production on and beyond social media. Persona construction in networked media environments increases visibility and reach, with followers, clicks, shares and likes, the markers of professional success. While British and American news have long traditions for high-profile columnists and commentators drawn from across media and political spheres, the complexities of networked practices as part of globalised news and politics have transformed structure and agency. Boundaries blur between social media influencer/microcelebrity, mainstream celebrity, journalist and political activist (Usher, 2020). Some individuals, like celebrities, act as "totems" (Rojek,

2012: 130) and establish "lines of demarcation that allows one group of people to separate themselves emotionally, politically, psychologically and culturally". And as social media consumer-publics join in the "social construction[s] of identity and public display" (Marshall, 2014: 163), the individualised visibility of journalists and their work has significantly increased (Usher, 2020).

As with celebrity culture, Twitter was the first dominant social media platform for journalism and on it there was a cultural shift away from objectivity and towards self-display (Deuze, 2012; Olausson, 2017). This revolutionised working routines, shaped by both the broadcast (one-to-many) approaches associated with journalists and the collaborative (many-to-many) interactions of influencers and their followers. Such interplays now often create "opinion spectacles" through the direct involvement of consumer-publics who inform performance, argue merit, disseminate related content (Usher, 2020). News aggregators keep an eye on trending hashtags, stories and the social media displays of other public figures and then repackage them into content. The audience forms around their social media profiles and the content disseminated to discuss and debate. Many journalists, therefore, use "rhetorically persuasive packaging" and their "own promotional skin[s]" (Hearn, 2013a: 27) to develop self-as-brand. They "colonise" the life and political choices of consumer-publics through linking strategic persona construction to news events and political opinions, in the same way that celebrities, for example, might link their "self" to consumer goods (Hearn, 2013a, 2013b). In this new model for news production – where audience comment becomes part of content and the "journalistic self" part of news – objective "fact" is too often replaced with subjective "truth". This influences the collective behaviour of consumer-publics and their processes of self-identification in relation to news and political events. Journalism – as the oldest mass media discourse for the construction of reality and persona – embraced new ways to maintain power. And as synergies between political and commercial agendas of media owners, the journalists who work for them, and social media audiences, they ritualised to form "spectacles of opinion" (Usher, 2020).

While these dynamics are at play across left and right-leaning politics, from around 2014 onwards, they supported the global growth of neopopulist politics, succinctly defined by Gianpietro Mazzoleni (2003: 5) as a "single-issue form of political action" which has a "simplicity of ... messages" that can easily be "diffused [ed] amongst electorates". Journalism and celebrity together constantly confirm the emotional and mystical elements of neopopulism whereby political leaders become saviours against the onslaught of globalism and progressivism. By nature, the celebrity class has always leaned towards the circulation of progressive, social and political liberalism as a reflection of the make-up of the culture from its origins in the 18th-century press. Key supporters of the neopopulist reorder of politics and society applied such discourses as part of their own fame-making techniques. As Margaret Canovan (1999: 2) identified long before the time of Trump and Johnson, neopopulists portray themselves as "true democrats, voicing popular grievances and opinions and systematically ignored by governments, mainstream parties and the media". They "address the people" and "speak for 'the people'" (Mazzoleni,

2003: 5). While from varied professional backgrounds – newsrooms to reality television, political activism to digital-first "microcelebrities" – by 2019 a network of neopopulist influencers worked across social and news media to influence democratic decision-making. Many described themselves primarily as journalists, but constructed their persona as if celebrities. There are legal advantages in doing so, such as protections for freedom of speech and "public interest" enshrined in European and US constitutional law.

Some who are, at least at times, placed in the neopopulist camp by social media users hail from mainstream news. For example, former *Sun* celebrity-correspondent (1988–1994) and *News of the World* (1994–1995) and *Daily Mirror* (1996–2004) editor Piers Morgan, maintains journalistic authority through visibility of its practices, such as interviewing politicians and celebrities and writing newspaper columns. Since his earliest interactions with celebrities, Morgan always featured prominently in his work – in voice and image – alongside the subjects of his content. Briefly ousted from press circles for unwittingly publishing faked pictures of British soldiers abusing Iraqi prisoners in 2004, he rebuilt his career – and exceeded previous fame – as a judge and contestant on US and UK reality television shows, including *America's Got Talent* (2006–2012), *Britain's Got Talent* (2007–2011) and as the first winner of Donald Trump's *Celebrity Apprentice* (2008). This led to his own talk shows; as *CNN's* replacement for Larry King with the relatively short-lived *Piers Morgan Live* (2011–2014); as co-anchor of ITV's *Good Morning Britain* (2015–present) and journalist-interviewer of celebrities on *Piers Morgan Life Stories* (ITV, 2009–present). When he became "editor-at-large" of *MailOnline's* US operation in 2014, he took to their free-market, conservative views and celebrity focus like a duck to water. Morgan is a curious and contradictory celebrified journalist in the tradition that goes right back to New Journalists in the Victorian press (chapter 3). He veers between celebration as a hero of liberal journalism and condemnation for circulating conservative ideologies, or vice versa depending on the political allegiance of audience members. While editor of the *Daily* Mirror (1996–2004) he was vocally opposed to the Iraq War and shifted "the paper away from an unremitting emphasis on celebrity and human stories towards a focus on international coverage towards a focus on international coverage that included a particularly critical stance towards the US and UK's bombing of Afghanistan" (Freedman, 2008: 71). More recently, he kept up pressure on the government to improve working conditions for National Health Service workers during the Covid-19 crisis. He is vocally pro-choice and anti-gun, but also an advocate, ally and friend of Donald Trump who opposes both things. Morgan was granted the only two sit-down British television interviews in the first three years of the Trump presidency and was, as of January 2020, one of only 47 people Trump followed on Twitter, chosen third after Ivanka and Donald Trump Jr. and before all other members of the Trump family. Many British journalists condemned Morgan's soft-stroke celebrity interviews, which approached the president as if he was still a reality TV entrepreneur rather than the most powerful neopopulist leader in the world. *Guardian* food-writer and BBC *MasterChef* "critic" Jay Rayner summed up the charge:

For decades I have, as a Jew, wondered how totalitarian, bigoted regimes rise to power. How does a population of ordinary, decent people allow it? Then I watch someone like @piersmorgan, once a great liberal campaigning journalist, suck up to Trump and I think "Oh. That's how."

(@jayrayner, 13 July 2018)

Morgan promptly blocked him.

Because of his relationship with Trump, Morgan is often unfairly linked by social media users to a globalised neopopulist circle of "journalistic-celebrities" despite the fact he often loudly opposes many of their views. Many of these had no training or professional experience as journalist before they were employed by news platforms. For example, outspoken alt-right darling Katie Hopkins was a combative reality television contestant (*The Apprentice* 2006; *I'm a Celebrity Get Me Out of Here,* 2007) who attracted the attention of journalists as potential "click-bait" following her verbal spas with "Perez Hilton" who appeared on the same series of *Celebrity Big Brother* (2015). Initially employed as a columnist by *The Sun,* she then joined *MailOnline* in May 2015 (Usher, 2020). In the USA, Sean Hannity was a right-wing "shock jock" who joined *Fox News* in 1996 as part of the political-opinion team during its transformation to rolling 24-hour news/celebrity culture/opinion channel (chapter 5). Both Hopkins and Hannity gained journalistic "authority" by virtue of working for established news brands and used this to perpetuate neopopulism, through condemnation of the "other" and praise for conservative political leaders. For example, in return for their support, Donald Trump has mentioned each in positive terms in speeches, interviews and tweets. Hannity, incidentally, is another of the 47 people Trump follows and the president, and Katie Hopkins, appeared semi-regularly on his *Fox News* show in 2018.

Other neopopulist "grass-root" activists *self-present* as journalists using tools of microcelebrity. For example, on YouTube and Twitter, Hopkins' has spoken in support of activist "Tommy Robinson", the self-brand name of petty criminal and far-right agitator Stephen Yaxley-Lennon. Each are "political spectacles" who perform as "symbols to other observers: they stand for ideologies, values or moral stances and they become role models, benchmarks, or symbols of threat and evil" (Edelman, 1988: 2). "Tommy Robinson" is a microcelebrity self-brand who sells Islamophobic tropes as if investigative journalism and asks social media followers for cash to do so. Like "Perez Hilton", "Robinson" increased his visibility through appearances on reality-based television (*When Tommy Met Mo*, BBC 2013; *Proud and Prejudiced*, Channel 4, 2012). Others in the neopopulist network of social media influencers and information brokers began as microcelebrities, such as *Infowars'* presenter Alex Jones (@TheRealAlexJones) and UK-based affiliate Paul Watson (@PrisonPlanet) who use YouTube as a platform to both disseminate content and build politically motivated cells of like-minded follows. By summer 2017, they boasted more than three million subscribers, 1.5 billion video views, 1.7 million Twitter followers and three million Facebook "likes" across both personal and *Infowars* (1999–current) branded social media accounts. Their microcelebrity

practice sells neopopulist politics and branded hypermasculine consumer items. In terms of content production and dissemination, it has much in common lifestyle influencers, but their spectacle construction and dissemination of news feeds into insecurities and reassurances through primarily pitting "us" against "other" using dynamics of attack journalism often directly targeted at specific individuals.

Many of these people interact – either in person, via social media or through sharing mainstream media platforms – with others within the neopopulist digital ecosystem and this is only a representative snapshot of a handful of some of the key figures. In thousands of incarnations, individuals build consumer-publics around their networked display of self, related directly to politics. By 2020, such processes had not only destabilised "conventional … discourses that build on the professional ideal of detachment" for journalists (Olausson, 2017: 13), but had begun to supplant them. Castells (2009) argued that networks construct new political forms and meanings by encouraging casual linage between private expressions and public discourse. So far, we have explored this in relation to complex performances of journalism, celebrity and political cultures facilitated by networked media environments, largely through the sphere of "presentational change". Mapping the production and personalised networks of applied celebrity journalists as part of shifting global political and media spheres, reveals how cross-platform persona construction has transformed journalism from an act of news to also a performance of self. As centralising points for content dissemination and interactivity, they reflect a new age of journalistic fluidity emerging in many deliberative democracies. Traditions of news production – interviewing, construction patterns and conventions, political commentary – converge with word-of-mouth and micro-celebrity practices as stylistic and political devices. This has both commercial and political implications, with news brands and television producers searching across media for figures who resonate with audiences and then helping to establish their journalistic authority or celebrity authenticity using their own production patterns and practices. Complexities of connectivity demonstrate the potentials of drawing together facets of facilitate political message making, the visibility of political causes and as breathing embodiments of the sentiments of journalistic organisations for which they work.

The final analytical section of this book draws together many of these threads to explore how President Trump and Prime Minister Johnson are logical extensions of the dynamics of journalism and celebrity explored in this book. Their influence and use of "representational" news as part of self-brand making and neopopulist political arguments draws from many elements of journalistic representations and fame-building techniques of the celebrity class. As we stand on the brink of the full reality of their visions for British and American mass-mediatised societies, the transformative dynamics of networked reality look set to be the story of the 21st century.

Authenticity, authority and attack: the self-brands of 21st-century neopopulist leaders

It felt fatalistic – fantastical even – that as the writing of this book drew towards conclusion, the prime minister of Great Britain is by trade a journalist who still worked for *The Daily Telegraph* until he took office and the president of the United States is a celebrity self-brand and reality television personality. Certainly, the shift towards right-wing mass-mediatised populism took many scholars by surprise, although Chris Rojek (2001) prophesised, that in the 21st-century "arts might rival the professions and labour organizations as recruitment ground for democratic leaders". By the end of the 1990s, many were also convinced that neoliberalism's ties to progressive politics meant that right-wing populism had reached its "zenith" and was on the wane (Betz and Immerfall, 1998; Mazzoleni, 2003). From the early 2000s, the overwhelming focus of "leftish academics" was how the internet supported "progressive campaigns" (Curran, 2018a: 387) and democratic exchange. None could predict that the political, social and economic instability that shook across the planet in the wake of post 9/11 terror-wars and the 2008 economic crash would coincide with the powerful narratives of networked reality and persona construction facilitated by the "semantic web".

In many ways, Boris Johnson and Donald Trump extend the neoliberal ideologies discussed in chapter 5. Certainly, Johnson – a leader of the 2016 Brexit campaign who became prime minister in 2019 – and Trump who became president in 2016 appear to support the priorities of market capital above all, apart from one thing – themselves. While ideology (for good and ill) drove neoliberal political leaders, these men are often accused of focusing first on their own ambitions and visibility. As such, they might be shift political positions quickly if there is a chance it will maintain their popularity. They may embrace dynamics of neopopulism, not because it is necessarily their beliefs, but because it offers best paths to power. Douglas Kellner (2017) expanded his use of Debord's *Society of the Spectacle* (1967) in relation to political leadership to argue that Trump is similarly "subject to the logic of spectacle and tabloidization in the era of media sensationalism, infotainment [and] political scandal" (2010: 117). Certainly, there are dynamics of spectacle in both his and Johnson's self-displays. They not only "embody the sentiments of the party, the people and the state in a similar way to [how] celebrity has to embody the beliefs and attitudes of an audience" (Marshall, 1997: 203), but reshaped these things in their image. Both are shrewd media operators who pivot and shed skins to win points and headlines. They view politics as primarily a competition for attention, build parasociality with consumer-publics to self-promote and embrace news' networked media ecosystems and their capacity to construct realities.

Trump and Johnson are complex politicised celebrity self-brands who attract members of the consumer-public to support and vote for them through noisy attention seeking and as reflective of their first jobs in corporate media industries. Trump is about the "hustle" against economic insecurity and "reality television's

gauzy promise of mini-celebrity are symptoms of, and alibis for a flawed and failing political economic system" (Hearn, 2016: 656). His campaign worked on a differ-ent register to other candidates, primarily focused on leading news agendas through consummate self-display and planned reality story arcs. Kellner (2017) argues that Trump's style of "authoritarian populism" has similarities to the media displays of mid-20th-century fascists. While he qualifies that Trump is not a fascist – and of course neither is Boris Johnson – he applies Frankfurt School Erich Fromm's (1942) discussions to consider similarities in terms of how mass media was a tool to develop "fervent mass movement outside of the conventional political party apparatuses" (2017: 21):

> Like fascists and authoritarian populists, Trump thus presents himself as the Superhero leader who can step in from outside and solve the problems that Washington and politicians have created. In the form of authoritarian idolatry described by Fromm, his followers appear to believe that Trump alone can stop the decline of the United States and make it "great" again.
>
> *(Kellner, 2017: 26)*

For example, when *Parasite* became the first foreign-language film to win Best Picture at the 2020 Oscars, Trump articulated this in opposition to liberal Holly-wood and its inclusion of South Korea, in front of an adoring red-capped crowd who cheered and booed on cue (21 February 2020). In one sense, there were similarities with Roosevelt's address to the Oscars almost eighty years earlier (chapter 4). Roosevelt had argued the importance of Hollywood film and the associated discourses of stardom to make America's cultural, political and economic a site for "hope" in the face of dictators. Trump linked the award to the "problems with South Korea with trade" and suggested that Hollywood's acceptance of for-eign film reflected poorly on its sense of national pride. Both presidents highlighted the role of Hollywood and its rituals of celebrification and canonisation in perpe-tuating American global dominance, but framed these through very different lenses of inclusion or exclusion, which reflected not only their politics but also their uses of celebrity culture to achieve political aims. Roosevelt reached out to build consensus. Trump uses similar dynamics to build cultural, social and physical walls.

Brand Boris is less about the hustle and focuses more on the "politics". While he is not unknown, he is certainly less prone to angry outbursts than Trump and Tory HQ carefully construct his social media channels. His brand (at least currently) is about "exit" – the fulfilment of mystical English green pastures, which might help the nation overcome failing political and economic systems and escape mass migration. His electioneering in 2019 worked on a different register to other politicians, with simplistic slogans and performed humour, which painted their policies as simultaneously overly complex, too naïve and betrayals of the "will of the people". Both Trump and Johnson's bombastic bluster uses self-referential opinion as qualifiers for office and petty point scoring as proof of authority. Sup-portive journalists even laugh off casual bigotry as evidence of authenticity and that

they "are who they are". And as "who they are" is primarily men of visibility, controversy is a useful tool to get attention.

There are commonalities between such branded self-performances and those of 20th-century populists. As Betz and Immerfall (1998) argued, these relied on individualised and personalised leaders, which builds authoritative charisma, but they also make it part of the authenticity of self-display:

> Movements characteristically organise themselves around charismatic and strongly personalised leaderships and are immediately and exclusively identified with highly visible and controversial leaders. These leaders are endowed with distinctive public-speaking skills and in some cases media-genic personal qualities, which they shrewdly exploit to gain popularity and media attention. They also typically employ highly emotional, slogan based, tabloid style language, combining verbal radicalism and symbolic policies with the tools of contemporary marketing to disseminate their ideas among the electorate.
>
> *(Betz and Immerfall, 1998: 2)*

There is little need for truth, only "market share, allegiance, and votes" (Hearn, 2016: 658). For supporters, celebrity status and simplistic messages are all the qualifications needed for office. Johnson and Trump are in their own ways, the crushing crescendo of the dynamics of journalism and celebrity, politics and the political and their ability to shape self-identity and society. In both Britain and America, like neoliberalism before it, neopopulism and its right-wing ideologies is in the process of being *naturalised* by journalists, celebrities, politicians and consumer-publics working together and in relation to political leadership.

As with neoliberalism, once again the tabloid press, and particularly Murdochian media, are playing a key part in this naturalisation. Senior Tory cabinet minister and *Times* columnist Michael Gove campaigned for Brexit and interviewed Trump shortly after his election victory with Murdoch in the room (Martinson, *The Guardian*, 9 February 2017). Murdoch and Trump are friends and allies and according to the *New York Times* (Chozick, 23 December 2017: online) the newspaper mogul calls the White House weekly to "offer counsel". They invited reporters to film them playing golf, appear together at dinner parties, describe one another as friends and even hug in public. *Fox News* is Trump's most fervent servant and defender and several former *Fox* employees became White House advisers. Similarly, Johnson and Murdoch know each other well. Reports of "undeclared dinners" have circulated since 2012 (*BBC* Reporters, 20 June 2012: online) and Johnson used *Sky* Executive, and ally of Murdoch, Andrew Griffith's house as Tory HQ when planning his first hundred days in office (Mason and Syal, *The Guardian*, 19 July 2019: online). Two senior *Sky* executives from the Murdochian era – including Griffith – were appointed Number 10 advisers shortly after he became prime minister.

Applied celebrities also helped processes of naturalisation and Trump is part of this group too. Neopopulist social media influencers, activists and columnists, discussed earlier in the chapter, shower Johnson and Trump with praise, and Kim Kardashian and her husband rapper Kanye West visited Trump at the White House as part of their activism for justice reform. Mainstream news platforms, and particularly those with celebrity as part of their editorial strategy, such as the *MailOnline*, cover them as both celebrities and politicians. In 2016, the Trump family usurped the Kardashians as top of the agenda, and then were briefly replaced by the Johnson brigade in the final days of the 2019 election campaign. Reporters covered White House and Number 10 policies, consumer habits and leisure activities, rumoured spats with much younger glamorous partners and the intricacies of their complex families in both news and celebrity sections of the site.

But neopopulism is primarily rationalised via social media's capacity to eclipse reality by circulating fake information and opinion as if fact. Studies of how politicians used social media before 2016 often focused on opportunities for increased dialogue with electorates (Baxter et al., 2013). Michael (2013: 46) argued that social media could support the development of a more "collaborative political culture" – but that "any such process would require authenticity on the part of politicians, informed contributions from the public, and a willingness to engage from both". Most concluded that politicians are only *symbolically interactive*, reluctant to engage in "open, dynamic forms of electronic communication with the electorate" (Baxter et al., 2013: 465). Consumer-publics – whether supportive or not – respond to Trump and Johnson as epicentres and celebrity "totems" (Rojek, 2012: 130) for networked neopopulism because their displays are structurally familiar. Journalism, the celebrification of politicians and hyperconsumerist social media ambiences have made them feel so. The Trump, Brexit and Conservative 2019 General Election campaigns spent millions on Facebook adverts to target swing voters by directly tapping into their fears and concerns. Surveys of US electorates after 2016 showed they more readily shared fake celebritised stories about Hillary Clinton, for example, than factual news (Howard et al., 2017: online). As Trump's spokeswoman, and White House staffer Kellyanne Conway famously claimed, his administration offer "alternative facts" (*NBC*, 22 January 2017), which sums up how contemporary neopopulist campaigning often works. From fake "fact-checking" websites during debates, to misinformation from the podium, it reconstructs realities by making discursive truth and rigid fact interchangeable in the minds of consumer-publics.

Publicity teams also co-opt social media consumer-publics into promotional processes in similar ways to celebrity publicity machines. Social media "fan-boys" – true believers and those working for the Russian state who engaged in information warfare (Curran, 2018a: 397) – used hashtags, emoji, memes and GIFs to communicate messages quickly within the scrolling action of smart screens. US alt-right activists developed this practice in the early 2010s to make their arguments appear less confrontational (Caiani and Parenti, 2013: 123). The "semantic web" also allowed algorithms to target voters, which proved particularly effective to tap into

and then mobilise their resentment towards specific actions both on social media and in voting booths. Trump battles on the front lines. Confrontation and attack was a facet of his self-brand and business style, such as with the contestants on his hit reality show *The Apprentice* (NBC, 2004–2017), with other celebrities and entrepreneurs and of course politicians such as Barack Obama, whom he Twitter-trolled throughout his presidency. Johnson is experienced in producing attack journalism, which was often discussed during the 2019 election campaign, when journalists – particularly those working for the left-wing red-top *Mirror* – trawled old articles for what they reported as racist, homophobic and class-bigoted comments. However, he did not need to get his hands too dirty. A thunderstorm of vitriol had "rained down on" Labour leader Jeremy Corbyn "from the first weeks of his leadership" (Curran, 2018b: 145) and Johnson only had to point towards it with the occasional comparison of his opponent to Stalin (Rayner, *The Telegraph*, 5 November 2019). In 2019, the Labour vote collapsed, particularly in its traditional white working-class heartland. Drawn out parliamentary turmoil over Brexit, the intensity of anti-Corbyn attack journalism, accusations of anti-Semitism in Labour and the successful naturalisation of neopopulism for consumer-publics all played a part in this devastating blow to the left. Johnson's election success relied on stark contrasts between networked and naturalised neopopulism with its simplistic mantra of "Get Brexit Done" and accounts and allegations of Corbyn's hopeless naivety, hateful ideologies and paradoxically too complex and too simplistic policies.

The sheer proliferation of their displays – the constant allegations of dishonesty and bigotry and what appears often to be deliberate courting of controversy – means networked neopopulism has now moved past dynamics of spectacle to become, as with hyperconsumerism, a surrounding *repressive ambience* that is potentially even more dangerous. There are two possibilities. The first is when politicians are primarily men of visibility, eventually there is no longer anything spectacular about their performance and it could burn out. On the other hand, constant news coverage and social media displays and discussions could normalise even their behaviours and rhetoric so that fewer people even question them. What is emerging so far is a sense that social media's *capacity to display* consumer choices *and debate* politics is more important than the reality of economic, social and political freedoms and masks curbs to reduce them. As an ambience, neopopulism is a significant challenge to democratic processes, but engagement and involvement of consumer-publics on social media makes it *feel* like it is part of democracy. This is a new age of democratic, economic and social unreality.

As the timeframe of this book reaches its conclusion, the world is at the beginning of the Covid-19 pandemic and both Trump and Johnson are floundering to find their narrative. Many newspapers in the UK invoke Blitz-style propaganda and represent Johnson as having the same "bulldog spirit" as Churchill, but the political leaders who led the Second World War were experienced in creating narratives of unification in the face of external threat (chapter 4) in a way our current leaders are not. Trump and Johnson's political performances are premised on identification of

enemies within and without – of "us" and "them" – and the exclusion of certain social and political groups. Bombastic bluster or snappy simplistic slogans do not work to communicate through this kind of crisis. Many conservative commentators and politicians, including Trump, look to blame the Chinese government but against their display (propaganda or not) of competence in the face of a global threat this narrative is not taking hold. Consumer-publics, so governed by hyper-consumerism, panic buy and stockpile as if it will cure the virus rather than add to the risk of it spreading. Reports of it on news and images on social media fuel hysterical purchase of more. The *New York Times* urge Americans to look to Angela Merkel and Emmanuelle Macron – the leaders of Germany and France – for accurate information in the face of crisis rather than their own president (Senior, 20 March 2020). As this networked global construction of reality and response surrounds us, across media we watch Trump and Johnson perform live and display our own lives too, as part of it all.

On the brink of new societies?

We stand on the brink of a different world. Many democratic states across the West become more authoritarian but still discursive, which is a new model for govern-ance. As the frameworks for networked construction of reality and persona, jour-nalism and celebrity have facilitated social media to become a social system where *displays* of "buy", "debate" and "vote" mask the decrease of meaningful economic, social and political freedoms. The damning consequence of neoliberalist links to progressive politics is that many who reject economic inequalities turn against pro-gressivism too. And there could not be a worse time for our democracies to become more insular and less progressive. Credible environmental forecasts predict that the 2020s will be a decade of environmental disasters, increased migration northwards and economic decline. Global health pandemics threaten our ways of life. How our societies respond to what is coming next will not only shape the planet for a gen-eration but also become the lens by which future generations view our sense of right and wrong. As hyperconsumerist and neopopulist and individualist societies, we might not find ways to share the resources we will need to survive.

Erving Goffman's (1956) argument that self-performance in public is governed by established patterns reflects how traditions of journalism and celebrity as explored across the course of this book facilitate the performances of networked neopopulism and the visibility of its leaders. Some naval-gazing right-wing jour-nalistic commentators and political leaders encountered in this chapter position themselves as direct descendants of Paine, whom we considered in chapter 2, with journalism enacted as political revolution to overthrow bastions of liberal elites. The extreme of these – such as microcelebrity/journalistic self-brands "Tommy Robinson" and Katie Hopkins – argue that only Johnson and Trump can overcome the sublimation of the white race by globalisation, unfettered immigration, inclu-sivity and political correctness. Discourses also build from traditions of transatlantic tabloidism, both the campaigning of Victorian New Journalists and the emotional

labour of its neoliberal mutation (chapter 3). Supportive newspapers use thematic and construction patterns of infotainment turned squarely against liberal politics and the progressivism of late neoliberal leaders. Inequalities of capital are useful rhetorical tools to undermine tolerance and inclusivity, paradoxically despite the priorities of the market still coming first. Rupert Murdoch's fingerprints are everywhere, and his former and current employees are key cheerleaders for neo-populist leaders (Cathcart, 2018). The cultural traditions of Murdochian news-rooms – rampant celebrification, embedded cultures of attack, cavalier attitudes of "publish first, deal with later" and governance by journalism – sowed fertile ground for this ideology reborn.

But neopopulist discourses are subject to large-scale opposition. Britain and America are polarised nations – between right and left, across generations, by race and gender – as revealed in censuses of the electorate after the presidential election and Brexit campaigns.[2] The difference in coverage about Johnson and Trump may bring into stark view the startling imbalance to the right in mainstream British news media as compared to America, but news and infotainment sites such as *Joe* (2010–current) and *Buzzfeed* (2006–current) counter this through comedy and celebritised and popular news discourses which are widely shared widely on social media. Celebrities – from iconic Hollywood stars such as Robert De Niro and Meryl Streep to music artists Lady Gaga and Miley Cyrus, television personalities Jimmy Kimmell and Seth Meyer and authors J.K. Rowling and Stephen King – openly criticise Trump on social media and in interviews (*Harper's Bizarre*, 2 October 2017). Such moments offer focal points for the synoptic behaviours of the consumer-public with millions of people sharing and commenting on social media posts and articles. Young activists who engage in what Fenton (2016: 7) describes as "extraordinary politics" – such as environmental striker and 2019 *Time* magazine "person of the year" Greta Thunberg – directly take on Trump and Johnson and become celebrities by doing so. Van Krieken's (2012: 73) analysis of the "complex and multi-layered … power relations between celebrities and their audiences" which "move in a number of directions at the same time" captures how contesta-tion can both disrupt and extend political messages through the debate that unfolds. Demonstrations of support and disagreement by celebrities and by ordinary people, in news and on social media, help form synoptic, critical consumer-publics who give feedback in "real time", and this forms fluid, interactive politicised and celebritised communications. Simultaneously, political campaign teams and their supporters in the press use dynamics of panopticism – to monitor the views and actions of "the many" – and modified messages. Social media aids the digital fusion of synopticism and panopticism as agreement and disagreement each perpetuate the visibility of leaders.

While we cannot confidently predict the future, what we can see is that the powers of journalism and celebrity as narrative tools, as areas of work and as powerful patterns for communication and self-performance show no signs of waning and, therefore, we must take lessons from the past. In the conclusion to this book, I consider whether progressivist values depend on journalists, politicians

and scholars moving away from condemnation of celebrity cultures and their impact on news agendas and instead applying constructs and conventions to their own practice, research and teaching. Those who perpetuate the hyperconsumerism and neopopulist have done so and are winning the day with the consumer-publics who make up our societies. As such, can we use celebrity and journalism better and, if so, what must be done?

Notes

1 The last 3,200 tweets before June 2014 – the number stored publicly at that time – of each of the top twenty celebrity Twitter accounts in terms of followers were coded using Seartwi analytic software.
2 Voting in America: A Look at the 2016 Presidential Election. Available at: www.census. gov/newsroom/blogs/random-samplings/2017/05/voting_in_america.html.
 Brexit Voters by Age, *Statista*. Available at: www.statista.com/statistics/520954/brex it-votes-by-age/.
 How Britain Voted in the 2019 General Election. Available at: https://yougov.co.uk/ topics/politics/articles-reports/2019/12/17/how-britain-voted-2019-general-election.

References

Arnould, E., Price, L. and Zinkhan, G. (2003) *Consumers*. New York: McGraw-Hill Higher Education.

Arvidsson, A. (2005) "Brands: A Critical Perspective". *Journal of Consumer Culture*, 5(5): 235–258.

Arvidsson, A. (2013) "The Potentials of Consumer-Publics". *Ephemera*, 13(2): 367–391.

Baxter, G., Marcella, R., Chapman, D. and Fraser, A. (2013) "Voters' Information Behaviour When Using Political Actors' Websites during the 2011 Scottish Parliament Election Campaign". *New Information Perspectives*, 65(5): 515–533.

Baudrillard, J. (1968) *Le système des objects*. Paris: Deneol.

Baudrillard, J. (1970) *La société de consummation*. Paris: Gallimard.

Betz, H. and Immerfall, S. (1998) *The New Politics of the Right: Neo-Populist Parties and Movements in Established Democracies*. New York: Palgrave Macmillian.

Bruns, A. (2005) *Gatewatching: Collaborative Online News Production*. New York: Peter Lang.

Brand42 (2012) "Mail Online: Designing a Global Success". *Brand 42*. Online.

Caiani, M. and Parenti, L. (2013) "Extreme Right Organizations and Online Politics: A Comparative Analysis of Five Western Democracies", in *Politics and the Internet in Comparative Context*. London: Routledge, pp. 135–153.

Canovan, M. (1999) "Trust the People! Populism and the Two Faces of Democracy". *Political Studies*, 47(1): 2–16.

Cashmore, E. (2019) *Kardashian Kulture*. Bingley, UK: Emerald.

Castells, M. (2009) *Communication Power*. 1st edn. Oxford: Oxford University Press.

Cathcart, B. (2018) "The Guardian Are Letting Us All Down", in *The State of the Media 2018*. London: Byline, pp. 28–29.

Couldry, N. (2004) "Teaching Us to Fake It: The Ritualized Norms of Television's 'Reality' Games", in S. Murray and L. Ouellette (eds) *Reality TV: Remaking Television Culture*. New York: New York University Press, pp. 57–74.

Couldry, N. (2012) *Media, Society, World: Social Theory and Digital Media Practice*. Cambridge: Polity Press.

Curran, J. (2018a) "Sociology of the Internet", in J. Curran and J. Seaton (eds) *Power without Responsibility*. 8th edn. London: Routledge, pp. 380–394.

Curran, J. (2018b) "Press and the Remaking of Britain", in J. Curran and J. Seaton (eds) *Power without Responsibility*. 8th edn. London: Routledge, pp. 111–155.

Curran, J. and Seaton, J. (2018) *Power without Responsibility*. 8th edn. London: Routledge.

Debord, G. (1967) *The Society of the Spectacle*. 1st edn. New York: Zone Books.

deCordova, R. (1990) *Picture Personalities: The Emergence of the Star System in America*. Urbana, IL: University of Illinois Press.

Deuze, M. (2012) *Media Life*. Cambridge: Polity Press.

Doyle, A. (2011) "Revisiting the Synopticon: Reconsidering Mathiesen's 'The Viewer Society' in the Age of Web 2:0". *Theoretical Criminology*, 15(3): 283–299.

Driessens, O. (2013) "The Celebritization of Society and Culture: Understanding the Structural Dynamics of Celebrity Culture". *International Journal of Cultural Studies*, 16(6): 641–657.

Duffy, B. (2015) "Amateur, Autonomous and Collaborative: Myths of Aspiring Female Cultural Produces in Web 2.0". *Critical Studies in Media Communication*, 32(1): 48–64.

Dyer, R. (1979) *Stars*. London: BFI.

Dyer, R. (1986) *Heavenly Bodies: Film Stars and Society*. New York: St Martin's Press.

Edelman, M. (1988) *Constructing the Political Spectacle*. Chicago: University of Chicago Press.

Fenton, N. (2016) *Digital, Political, Radical*. Cambridge: Polity Press.

Foot, K.A. and Schnieder, S.M. (2006) *Web Campaigning*. Cambridge, MA and London: MIT Press.

Foucault, M. (1975) *Discipline and Punish*. New York: Random House.

Freedman, D. (2008) "The *Daily Mirror* and the War on Iraq", in A. Biressi and H. Nunn (eds) *The Tabloid Culture Reader*. New York: Open University Press, pp. 70–80.

Gamson, J. (2011) "The Unwatched Life Is Not Worth Living: The Elevation of the Ordinary in Celebrity Culture". *MPLA*, 126(4): 1061–1069.

Gane, M. (1991) *Baudrillard's Bestiary*. London: Routledge.

Goffman, E. (1956) *The Presentation of Self in Everyday Life*. Edinburgh: University of Edinburgh Social Sciences Research Centre.

Hackley, C. and Hackley, R.A. (2015) "Marketing and the Cultural Production of Celebrity in the Era of Media Convergence". *Marketing Management*, 31(5–6):461–477.

Hearn, A. (2010) "Reality Television, The Hills and the Limits of the Immaterial Labour Thesis". *Triple C*. Online: 60–77.

Hearn, A. (2013a) "Producing "Reality" Branded Content, Branded Selves, Precarious Futures", in L. Ouellette (ed.) *Companion to Reality Television: Theory and Evidence*. Somerset, NJ: John Wiley & Sons, pp. 437–456.

Hearn, A. (2013b) "'Sentimental 'Greenbacks' of Civilization': Cartes de Visite and the Pre-History of Self-Branding", in M. McAllister and E. West (eds) *The Routledge Companion to Advertising and Promotional Culture*. New York: Routledge, pp. 24–38.

Hearn, A. (2016) "Trump's "Reality" Hustle". *Television & New Media*, 17(7): 656–659.

Holland, P. (2002) "The Politics of the Smile: 'Soft News' and the Sexualisation of the Popular Press", in S. Allan, G. Branston and C. Carter (eds) *News, Gender and Power*. London: Routledge.

Holmes, S. (2005) "'Off-guard, Unkempt, Unready'? Deconstructing Contemporary Celebrity in *heat* Magazine". *Continuum: Journal of Media & Cultural Studies*, 19(1): 21–38.

Horton, D. and Wohl, R. (1956) "Mass Communication and Para-social Interaction: Observations of Intimacy at a Distance". *Psychiatry*, 19: 215–229.

Howard, P. et al. (2017) "Junk News and Bots during the U.S. Election: What Were Michigan Voters Sharing Over Twitter?" Data Memo 2017.1. Project on Computational Propaganda, Oxford. Online.

Jerslev, A. (2016) "In the Time of the Microcelebrity: Celebrification and the YouTuber Zoella". *International Journal of Communication*, 10: 5233–5251.

Kellner, D. (2010) "Media Spectacle, Presidential Politics and the Transformation of Journalism", in Allan, S (ed.) *The Routledge Companion to News and Journalism*. New York: Routledge.

Kellner, D. (2017) *American Nightmare: Donald Trump, Media Spectacle and Authoritarian Populism*. Rotterdam: Sense Publishers.

Lange, P. (2007) "Publicly Private and Privately Public: Social Networking on YouTube". *Journal of Computer-Mediated Communication*, 13(1): 361–380.

Mackey, S. (2016) "Persona: An Old Public Relations Problem?" *Persona Studies*, 2(1): 84–96.

Marshall, P.D. (1997) *Celebrity and Power: Fame in Contemporary Culture*. Minneapolis, MN and London: University of Minnesota Press.

Marshall, P.D. (2014) "Persona Studies: Mapping the Proliferation of the Public Self". *Journalism*, 15(2): 153–170.

Marwick, A. (2013a) *Status Update: Celebrity, Publicity and Branding in the Social Media Age*. New Haven, CT: Yale University Press.

Marwick, A. (2013b) "Online Identity", in J. Hartley, J. Burgess and A. Bruns (eds) *Companion to New Media Dynamics*. Chichester, UK: Wiley-Blackwell, pp. 355–364.

Marwick, A. (2015) "You May Know Me from YouTube", in S. Redmond and P.D. Marshall (eds.) *A Companion to Celebrity*. Chichester, UK: Wiley-Blackwell, pp. 333–349.

Marwick, A. and boyd, d. (2011) "To See and Be Seen: Celebrity Practice on Twitter". *Convergence*, 17(2): 139–158.

Mathiesen, T. (1997) "The Viewer Society: Michael Foucault's 'Panopticon' Revisited". *Theoretical Criminology*, 1(2). Online.

Mazzoleni, G. (2003) "The Media and the Growth of Neo-populism in Contemporary Democracies", in G. Mazzoleni, J. Stewart and B. Horsfield (eds) *The Media and Neo-populism: A Contemporary Comparative Analysis*. Westport, CT and London: Praeger.

McNamara, K. (2011) "The Paparazzi Industry and New Media: The Evolving Production and Consumption of Celebrity News and Gossip". *International Journal of Cultural Studies*, 14(5): 515–530.

Michael, B. (2013) "Social Media, Identity and Democracy", in A. Charles (ed.) *Media/Democracy*. Newcastle, UK: Cambridge Scholars, pp. 29–47.

Olausson, U. (2017) "The Celebrified Journalist: Journalistic Self Promotion and Branding in Celebrity Constructs on Twitter". *Journalism Studies*, 19(16): 2379–2399.

Papacharissi, Z. (2012) "Without You, I'm Nothing: Performances of the Self on Twitter". *International Journal of Communication*, 6: 1989–2006.

Richards, B. (2012) "News and the Emotional Public Sphere", in S. Allan (ed.) *Routledge Companion to News*. London and New York: Routledge.

Rojek, C. (2001) *Celebrity*. London: Reaktion.

Rojek, C. (2012) *Fame Attack: The Inflation of Celebrity and Its Consequences*. London: Bloomsbury Academic.

Senft, T. (2008) *Camgirls: Celebrity and Community in the Age of Social Media*. New York: Peter Press.

Senft, T.M. (2013) "Microcelebrity and the Branded Self", in J. Hartley, J. Burgess and A. Bruns (eds) *A Companion to New Media Dynamics*. Oxford: Wiley-Blackwell.

Shoemaker, P.J. and Riccio, J.R. (2016) "Gatekeeping", in *The International Encyclopedia of Political Communication*. Hoboken, NJ: John Wiley & Sons, pp. 1–5.

Snickars, P. and Vonderau, P. (2009) "Introduction", in P. Snickars and P. Vonderau (eds) *The YouTube Reader*. Stockholm: National Library of Sweden, pp. 9–21.

Stokel-Walker, C. (2019). *(2019) YouTubers*. Kingston-upon-Thames, UK: Canbury Press.

Thomas, S. (2014) "Celebrity in the 'Twitterverse': History, Authenticity and the Multiplicity of Stardom: Situating the 'Newness' of Twitter". *Celebrity Studies*, 5 (1): 1–14.

Thompson, J.B. (1995) *The Media and Modernity*. Cambridge: Blackwell.

Thornham, S. (2007) *Women, Feminism and Media*. Edinburgh: Edinburgh University Press.

Tunstall, J. (1971) *Journalists at Work*. London: Constable.

Turner, G. (2010) *Ordinary People in the Media: The Demotic Turn*. London: Sage.

Turner, G. (2014a) *Understanding Celebrity*. 2nd edn. London: Sage.

Turner, G. (2014b) "Is Celebrity News, News?" *Journalism Theory, Practice and Criticism, Special Issue Celebrity News*, 15 (2): 144–152.

Turner, G., Bonner, F. and Marshall, P.D. (2001) *Fame Games: The Production of Celebrity in Australia*. Cambridge: Cambridge University Press.

Usher, B. (2014) "Mail Online Has Grown Tenfold Since Its 2008 Relaunch, But Is It Journalism?" *Press Gazette*, 2 May. Online.

Usher, B. (2015) "Twitter and the Celebrity Interview". *Celebrity Studies*, 6 (3): 306–321.

Usher, B. (2016) "Me, You and Us: Constructing Political Persona on Social Media during the 2015 UK General Election". *Persona Studies*, 2(2). Online.

Usher, B. (2018) "Rethinking Microcelebrity: Key Points in Practice, Performance and Purpose". *Celebrity Studies*, 15 November. Online: 1–18.

Usher, B. (2020) "The Celebrified Columnist and Opinion Spectacle: Journalism's Changing Place in Networked Public Spheres". *Journalism*, 21 January. Online.

Van Krieken, R. (2012) *Celebrity Society*. London and New York: Routledge.

Whittle, S. and Cooper, G. (2009) *Privacy, Probity and Public Interest*. Oxford: Reuters Institute. Online.

Williamson, M. (2016) *Capitalism and the Making of Fame*. Cambridge: Polity Press.

Press

Anon (2012) "Nearly 50 Percent of Internet Users in Europe Visit Newspaper Sites". *Comscore*. Press release, 19 January. Online.

Arrington, M. (2008) "End of the Speculation: The Real Twitter Usage Numbers". *Techcrunch*, 29 April. Online.

BBC Reporters (2012) "Boris Johnson's 'Dinner with Rupert Murdoch Not Declared'". *BBC News*, 20 June. Online.

Bennett, S. (2013) "How Many Active Users Does Twitter Have? And How Fast is it Growing?" *AdWeek*, 4 October. Online.

@biz (2008) "Welcoming Bijan and Jeff". *Twitter Blog*, 24 June. Online.

Bloomberg Business (2007) "Q&A with Tim Berners-Lee". *Bloomberg*, 9 April. Online.

Butler, P. (2019) "More Than 4m in UK Are Trapped in Deep Poverty, Study Finds". *The Guardian*, 29 July. Online.

Cadwalladr, C. (2016) "Google, Democracy and the Truth about Internet Search". *The Observer*, 4 December. Online.

Chozick, A. (2017) "Rupert Murdoch and President Trump: A Friendship of Convenience". *New York Times*, 23 December. Online.

Curtis, S. (2013) "Twitter Claims 15m Active Users in the UK". *The Telegraph*, 6 September. Online.

Daily Mail and General Trust plc (2008) *Annual Report*, 28 September.

Daily Mail and General Trust plc (2013) *Annual Report*, 30 September.

Harper's Bazaar Staff (2017) "50 Celebrities Who Spoke Out Against President Trump". *Harper's Bazaar*, 2 October. Online.

Jackson, J. (2016) "YouTube Star Zoella's Manager: I Knew My Business Had To Be in Social Media". *The Guardian*, 7 August. Online.

Mance, H. (2014) "MailOnline and the Next Page for the 'Sidebar of Shame'". *Financial Times*, 24 September. Online.

Mapstone, L. and Freeth, F. (2015) "Pregnant Kim Kardashian and sister Kylie Jenner hit Cannes Lions festival after party straight from MailOnline's yacht bash". *MailOnline*, 25 June. Online.

Martinson, J. (2017) "Rupert Murdoch Was in Room for Michael Gove's Donald Trump Interview". *The Guardian*, 9 February. Online.

Mason, R. and Syal, R. (2019) "Boris Johnson Uses Sky Executive's Townhouse as Campaign HQ". *The Guardian*, 19 July. Online.

Rayner, G. (2019) "Boris Johnson Compares Jeremy Corbyn to Stalin for His 'Hatred' of Wealth Creators as He Launches Election Campaign". *The Telegraph*, 5 November. Online.

Senior, J. (2020) "Call Trump's News Conferences What They Are: Propaganda". *New York Times*, 20 March. Online.

Sorgatz, R. (2008) "The Microfame Game and the New Rules of Internet Celebrity". *New York Magazine*, 17 June. Online.

Zatat, N. (2019) "16 Terrifying Boris Johnson Quotes Everyone Should Read before They Vote". *www.indy100.com*, 28 November. Online.

Digital archives

MailOnline archive.
Seartwi Twitter Analytics.

7

CONCLUSION

What's to be done?

There is a myth that dominates our understanding of journalism and celebrity and masks their place as the longest-standing media reflections of the intertwined dynamics of democracy and capitalism. It is that all these things existed independently when, in reality, they are four interlinked points within the same sphere of representation, influence and control. Journalism naturalised and rationalised celebrity, and together they created tools through which public persona became a powerful cultural signifier and prop of the socio-economic and political systems in which we live. Celebrity journalism is a principal and founding characteristic of these institutions, our collective understandings of self-identity within them, and the mediation of these things. As a genre, celebrity journalism ties together the contradictions of public and private dichotomies of capitalist democracies and humanises our place in it all. It shaped conventions, construction patterns and themes of the news industry more broadly and therefore does not reflect infection of one media realm by another but rather is part of the fabric that helped make each what they are.

The six big booms in celebrity journalism thus far each reflected societies and self-identities in flux. Technological developments both in and beyond media platforms and the capacity of audiences to engage with them because of improved literacies – for example, textual, visual or digital – enabled new types of public self to be performed and audiences to understand them. Increased disposable incomes and the desire to see and show consumer goods drove collective demands for social and political freedoms too. Tensions between the demands of ordinary people and the desires of those in elite positions of power to make these chime with their own ideologies, make money and exert control (and often all at once) shaped the rules of exchange.

Journalism and celebrity in the 18th-century London press – the first *mass-circulated* media and the first to develop enduring facets of both cultures – reflected

Enlightenment and Romantic visions for identity, demands for personalised emancipation, the liberations offered by consumerism, personalised authenticity and authority and freedom of self and speech. The notion of the consumer and citizen began here, and journalism and celebrity helped mould both things. In the late 19th century, pioneers of tabloid journalism and *mass-industrialised* news used improved communication and economic prosperity as both means and reason to bring more "ordinary people" into public spheres and engage them in politics. They campaigned for universal suffrage and social liberalism, which were important facets of the representation of celebrity in journalism for much of the 20th century, although the most powerful press barons turned these things towards different political ideals and made them tools of exclusion instead of inclusion. In the 20th century, first cinema and then pop music and their promotional intermediaries extended the discourses of celebrity created by the press in order to develop hyperreal stardom, which even had the capacity to collapse what was real in the minds of the audience. The idolatry and unquestioning adoration demanded by this sparkling self-identity reshaped social, political and economic realities through entirely mediated representations of them. As the first truly *mass-multimediated* vision of celebrity – accessed across print, cinema and radio – this rationalised cultural change and trauma and helped to extend liberalism to the kind of free-market enterprise that puts everything up for sale. The post-war generation then used popular music to reimagine such stardoms as a reflection of their identities and the creation of radical pop and rock stars embodied social change across multiple platforms at once. When television became the principal site for celebrity and journalism, in the mid- to late 20th century, a model for tabloidism emerged that dominated the representation and circulation of "collective will" and erased earlier models from public consciousness. This magnified the worst elements of both cultures and often reflected the desires of "publics" as the same thing as the demands of powerful market forces and individual owners who spread their tentacles towards increased political, social and economic control. By the second decade of the 21st century, market forces had turned the opportunities for radical change afforded by the internet towards the perpetuation of fundamentally skewed visions of democracy. These furthered the authoritarian commercial and political power of media conglomerates, owners and their allies. Journalism and celebrity became powerful tools to advance social, economic and political principles of hyperconsumerism and neopopulism – rapidly becoming the story of the 21st century – at a time when media, for the first time, was *mass-produced*.

From the start and to the current day, journalism and celebrity are characterised by threads of politics and commerce, ordinary people being made extraordinary through its rituals, interwoven public and private spheres, the constructions of reality and the celebration and contestation of new ideologies. They emerged together as tools to contain, constrain and, paradoxically, to liberate the masses. Across the course of their history, the celebrity class formed first as a broad social group, which was as likely to include politicians, authors and entrepreneurs as entertainers and royalty, then primarily focused on acting, before broadening again

to include other facets of entertainment such as music and television, commerce and politics once more. Interest in private life often outweighed that of public work and this is an underpinning factor in how members of the celebrity class of the digital era are as likely to have built their fame from the commercialisation of their private realms and self-presentation as they are via the representational media. Celebrities today might, on balance, be "achieved, attributed, ascribed" (Rojek, 2001), but are equally likely to be famous for having "applied" rituals of celebrification to themselves to attract attention (Usher, 2018a).

Once we accept these things, populist and pessimist binaries for reading celebrity news and journalism, or news as popular culture more broadly, become non-sensical. There are nuances and complexities everywhere and binaries, by nature, are often simplistic at best and hypocritically puritan at worst. Many aspects of journalism and its role in democratic society became so because it looked for ways by which it might represent celebrities, and from the early days of print the world of celebrity, as evidenced in this book, included politicians. In order to counter the worst tendencies, we must convince those who berate this area of popular culture as simply bad – bad for democracy, bad for journalism's idealised role in it, bad for our well-being or capacity to reason – that there is little sense in hitting at its nature nor lamenting its power. Rather we should organise and internationalise in order to fight against the corruption of this genre by those who look to author-itarian economic and political models to govern. Journalism and celebrity cultures are diseased because the systems of media ownership, commercial capitalism and democ-racy are too. They are also probably better than most other political and economic systems, or at least could be with reform. To place journalism and celebrity as opposing forces not only limits understanding but also narrows the space to argue for change.

Individual celebrity successes in public life and performances of private lives in public spaces of news, such as sexuality or motherhood, have both been liberating, such as the work of Georgiana, Duchess of Devonshire in the late 18th century (chapter 2) or David Bowie in the late 20th and early 21st century (chapter 4). Reports of public work and private self are usually not contradictions but mutually dependent. There is power in the complexities of visibility themselves. The female celebrities of 18th-century newspapers, from their varying cultural and social posi-tions, helped make the feminine visual and textual star discourses of the 20th cen-tury and their powerful political dimensions. These stemmed equally from public work and heartfelt throwing open of doors to private realms, where their displays of maternal and material loves and senses of self helped to make such things matter. They used their bodies and their words to cry out for the right to be independent humans beyond the mastery of their worlds. Dichotomies between liberation and repression do not lie in their performances or representations of it but in how journalistic rituals of celebrification jealously guarded the cultural parameters of their desires and decency through masculinised, white, middle-class hegemonic lenses. Similarly, the inclusion of "ordinary" people into public realms was an early facet of both cultures and here too we should focus on how practices had social

purposes. Optimistic hopes for popular news, for example, might see much good in pre-Northcliffe tabloid journalism. T.P. O'Connor's "Mainly About People" and W.T. Stead's interviews were part of their radically liberal fights for equality for working classes, women and campaigns for better health care or prison reform (chapter 3). In their pages, ordinary people were the equal of politicians and the biggest names from entertainment and they aimed to demystify the workings of government. They effected meaningful political change and influenced law making and the decisions of government. However, the purposes of bringing "ordinary people" into media realms as part of reality television or contemporary tabloid news are not the same, even when they claim to be. As part of neoliberalist social, economic and political forces, they primarily reflect commercial business decisions or attempts at social control. When many journalists or celebrities have room to speak in mainstream news, for example, it may appear that they are speaking for ordinary people, but they often only do so when this aligns with corporate interests or their own interests too. They are subordinate to the market, help markets to govern media and, too often, only gain legitimacy when allowed by the market to do so.

Suggesting a nuanced approach to journalism's use of celebrity culture can lead to accusations of apologism – perhaps particularly for those of us with a background in journalism – which swiftly pulls the shutter down on debate. For example, given its place as one of the oldest genres of the press, claims that celebrity news simply "is not journalism" are wedded to a mythical Camelot of what the press once was and overlook how reportage about celebrities helped form many of its practices. These include interview practices and the relationships between image, text and audiences' readings of them as developed in the Victorian era, to the confessional and psychoanalytical models for their practices as developed in the 20th century right up to the current gathering, production and dissemination practices of digital news. Over the past 320 years there have been horrific uses of celebrity by news and politicians, but also many moments of good. For example, radical socio-political journalism as activism from the 18th century and to the current day have often relied upon rituals of celebrification to represent individuals and collectives within public spheres. Condemnations of celebrity and populist news are also too often steered by unconscious class, gender and cultural bias. Those who bewailed that the masses were engaged in political spheres because of increased information about politicians or the campaigns of celebrities in the 18th-century press did so to exclude "the other" – the working classes – from public spheres. Matthew Arnold's description of early liberal tabloidism as of "generous instincts" but "feather-brained" (1869: 689–690) was as much a condemnation of the education of the working classes and has much in common with those who argue that 20th-century popular culture reduces society to spectacle and "dumbed down" tabloid cultures. High cultural horses have their place and critiques of popular news are important weapons to tackle extreme abuses of power. However, there are also people who have effected real change – across celebrity, popular culture and academic thought – who fight at street level, value the colour of

human life and do not judge the cultural tastes of others. They *refuse* to view themselves as superior to those who find comfort and emancipation through fandom and realise that doing so has never – and will never – convince audiences to stop being interested in celebrity nor journalists to stop writing about them.

But journalism and celebrity together could help make things better. Narratives of inclusion, liberation and activism could govern their exchanges once more. Spectacular rituals and grounded ambiences that naturalised aspects of lived experience can be used to various ends, not just anaesthetisation from what matters. The shrewdest media operators – those who have made and used these dynamics as an everyday part of their work – certainly use them to their advantage and sometimes even the most vehement critics of journalism's use of celebrity do so too. Take the phone-hacking scandal, the Hacked Off campaign, select committee hearings and the subsequent Leveson inquiry as a particularly pertinent recent example. Hacked Off turned the visibility of victims – including high-profile celebrities – and their capacity to capture public attention across news media towards their fight for long-overdue and meaningful media reform. What made "phone-hacking" a scandal to most people was not the horrors of the practice itself, nor academics or individual journalists speaking out about it, but the rituals of celebrification that created a powerful multimedia spectacle and humanised unethical newsgathering practices. We were appalled to learn that not only our favourite celebrities but also victims of crime, terror and their families had their messages listened to, and the subsequent public outrage led to Leveson, which caught the imagination of the British public beyond any inquiry in modern history. The most experienced celebrity and media workers exposed during this collective performance of "mea culpa" (and performance it was) – often not for interception of telecommunications – included editors and journalists, media magnates and leading politicians. These experienced players knew that while public sympathy leans so clearly one way, you bend to it. Some were also keenly aware that spectacles always pass and there would be time to turn the power of journalism and celebrity towards their critics to deflect and limit the damage. Those who were most vocal and visible and might find means to curb such power in the subsequent years – such as Labour leaders Ed Miliband and Jeremy Corbyn – were *inevitably* subjected to systematic and ritualised attack journalism. Such things happen in a myriad of different ways to many other celebrities, journalists and everyday people who speak out. Ultimately, the tools of celebrity and news that, albeit briefly, "humbled" powerful media operators[1] also offered means by which they could defiantly retain power. Power dynamics work many ways. Once we accept the reality that the rituals of celebrity journalism not only shore up political and economic norms but can also challenge them, we can return to questions posed at the beginning of this book: can celebrity journalism be better? Can it work effectively to formulate genuine citizen participation? And if so, what's to be done?

What's to be done by the academy and the institutions of journalism training?

When higher education supplanted newsrooms as the place where British journalists train in the early 2000s, it offered opportunities to create a generation of practically competent, legally sound, ethically aware and politically and socially critical journalists from diverse social groups. Until the past fifteen years or so, training in the UK – quite differently to its American counterpart – focused on day-to-day realities of working in regional press newsrooms. In particular, the National Council for the Training of Journalists (NCTJ) pre-entry exams and the Press Association equivalent offered solid first steps into regional newsroom rhythms of court reports, council meetings, and interviews with the leaders and members of communities. These skills were honed over two years or so before reporters sat senior professional exams, still widely referred to as the "prof-test". But this "narrow focus" (Seaton, 2018: 464) offered little preparation for the ethical realities of national newsrooms where celebritised news cultures often govern practice, fewer journalists are formally trained and working-class reporters are sometimes plucked from the regions simply to do the dirty work. While a minority of national reporters have NCTJ qualifications, in the regions, the majority still do and this has resulted in vast cultural gulfs. Decreased geographical mobility to London and the collapse of newspaper sales meant fewer reporters from the regions reached mythical Fleet Street. Instead, a new career pathway emerged where "reporters" train first to produce click-bait (epitomised by the economically successful practices of *MailOnline*, as explored in chapter 6) and then some move on to write for the main print brand where they "newsgather" in the traditional sense often for the first time. By that point, they are too often desensitised to news through lack of human interaction with real people affected and are instead led by instincts to repackage events in a way that attracts the most attention and as quickly as possible. This exasperated neoliberal tabloid cultures, sensationalism and attitudes of "publish first, think later". In short, celebrity news is now a leading part of training when, in the past, it was a relatively rare element of work until at least two or three years in the industry.

Higher education offers a better training model than this, but many of the old guard of British journalism dismiss its capacity to do so. Often, they are wedded to antiquated pathways into the industry from the regional press or Oxbridge and do not understand the slippery walls that block entry. To overcome criticisms, universities need to articulate how they effectively balance pragmatic journalistic skills with the critical, ethical and civic understanding needed for young reporters *to be able to see and debate* the reasons and consequences of their work. This must include discussion of journalism's relationship with celebrity culture from varying perspectives. We should foster such abilities through emphasising relationships between research, practice, teaching and advocacy.

In order to ensure there are more young people from outside the white middle-class norms that dominate national newsrooms (and particularly from outside of

London), we need learning pathways that ensure practical competence, solid ethical and legal foundations and civic and critical awareness. Around the time that his research focused most closely on celebrity and tabloid cultures, Graeme Turner (2009: 175–176) argued against the "increasing subordination of the teaching 'mission' … in favour of a research career" within cultural studies departments and how it was damaging both student experience and effective research. More lecturers from a practice background have been employed by universities over the past ten or so years and at the same time, as Turner (2009) decried, post-graduates often aimed for research-only careers. This helped create silos between research-active and practice-based colleagues, which limits effective curricula. For example, unhelpful divisions surrounding the capacities of "the other" to cut it at the coal-face of the industry or to understand the social and political context of their work can lead to an incapacity to articulate the value of one another's work to students and, at worse, can create entirely separate strands for learning. Turner (2009) argued the importance of teaching for effective cultural studies research and for journalism and studies of it; this must balance effective practice and critical understanding. A holistic model for research/practice/pedagogy is best suited. Students must understand the market, political and cultural pressures they will face – including how dynamics of celebrification and celebritisation may dominate their practice – and have boundaries and tools to take on those who might challenge them.

Training should reject hierarchies of value and emphasise how active production and construction of meaning works in practice. As Gitlin (1997: 78) argued in relation to effective cultural readings of social, political and celebrified media cultures, this relies on the search for "local knowledges as opposed to universal truths" and "self-challenging reflexivity" which allows the verbal rehearsals of critical arguments that they might depend upon to *survive* the realities of their careers. We must transcend interdisciplinary frameworks and create transmethodological, theoretical and practical frameworks for practice in and analysis of the complexities of communication ecosystems and view training as an act of academic advocacy in its own right. Historicising key developments in journalism and celebrity from the 18th century to the current day highlights the importance of *actively* challenging silos between academic fields and theory and practice. Like high and low cultural binaries, they make little sense.

What's to be done by journalists and their regulatory bodies?

The next section reflects the kind of advocacy needed to refocus the relationship journalism has with celebrity. In his discussion of Graeme Turner's work as an example of effective academic advocacy, John Byron (2015: 569) argued that the "theory" of such an approach is "a species of cultural studies itself – an enactment of a politically engaged cultural practice". Such governmentality through academia has much in common with the advocacy of popular journalism from the 18th century onwards. It is no coincidence that the most compelling cultural, journalism and political communication scholars – like journalists – often fight for reform.

One very New Journalist[2] model of "governance" through academia looks to large-scale and spectacular changes. In the UK, this is encouraged by the Higher Education Authority's Research Excellence Framework and their demands for "impact" and the geographical location of some leading institutions for media industry training, which are within walking distance of the power bases of Westminster and national newsrooms. As a result, arguments for reform rarely look to the regions or bottom-up transformation through the creation of a generation of better-trained journalists. But current British and American political realities make major reform of media and regulatory bodies via, for example, the second phase of the Leveson inquiry in the UK or congressional committees in the USA, improbable, if not impossible. Grassroots action, for example by modifying codes of practice, hitting the road to convince journalists to use them and convincing those who pass through institutes of training to use them as bibles of practice may make more difference than banging our heads against the closed doors of government.

In February 2020, British reality TV host and "celebrity contestant" Caroline Flack took her own life and there was a panoptic and synoptic feeding frenzy as newspapers, celebrities and social media users looked to proportion blame. Ms Flack's family released an unpublished Instagram post written in the days before her death, which suggested that a period of intense social media condemnation and tabloid attack journalism intensified mental illness that stemmed, at least in part, from scrutiny of her sex life (19 February 2020). The press went into overdrive to deflect blame onto the Crown Prosecution Service (who were pressing trial for domestic violence without the support of her partner) and social media trolls and, in doing so, intensified rumour and conjecture which may have contributed to this tragedy (*The Sun,* 17 February 2020). There was a networked spectacle and speculation when we should wait for an inquest to establish facts and as I watched it unfold, the long-standing place of attack journalism in news cultures and my indoctrination into the practice haunted me. I am no innocent. It took me two years too long to understand the different culture in national as compared to regional newsrooms and even now, almost fifteen years on, I still think about some actions and experiences as a young reporter – void of systems of support, critical understanding and advice – and despair. For example, reality television personality and pop artist Kerry Katona has described the *News of the World's* (*NotW*) attack on her as a "personal vendetta" where she was on the front page "almost every week" and became more famous, but for "all the wrong reasons". "When I think of the *News of the World*, I think of my darkest days," she told BBC pundit Victoria Derbyshire, "I complained to the Press Complaints Commission thousands of times" (*Victoria Derbyshire Show*, BBC, 15 May 2012). Ms Katona and I were born within a year of each other and in similar social and familial circumstances in economically deprived areas of northern England. She became a celebrity around the same time I became a journalist, and as two young working-class women in media spheres, we should have been allies. Instead, I took direction from men who pitted me – and dozens of other reporters – against her. Worst of all, their orders had very little to do with her at all. This attack stemmed from the breakdown of *NotW* editor Andy

Coulson's professional and personal relationship with her publicist Max Clifford, both of whom were later imprisoned for, albeit very different, abuses of power. First, positive stories about Katona made the newspaper in return for exclusives about other celebrities. Then, when Clifford broke ties with the paper, generating lurid tales about her private life became a seedy newsroom obsession. As some colleagues convinced friends, lovers and even her mother to sell the most personal of stories – which I will not repeat details of here – news production became harassment and then a blood sport. When I quit and spoke out, they were at the forefront of my mind and inevitably, as is also a matter of public record, I was attacked too.

The reason I will not repeat the scurrilous claims made against Ms Katona (or indeed myself) by members of the tabloid press is that to do so aids their attack. For example, even when defending an individual, many social media users also repeat, sub-tweet, or link to details and in doing so unwittingly perpetuate the attack. There are changes needed in relation to both audience behaviours and press and social media regulation. Press codes of practice in relation to harassment should include persistent publication as well as pursuit (Usher, 2018b). While in an ideal world we would be post-Leveson 2, we are not, and certainly further public and legal scrutiny needs to tackle the worst tendencies of British newspapers. In the world that is, the windows for reform are narrow and we need less spectacular interim steps, not least because demands for high-profile change often leads to the full power of news media pulling in political favours to prevent them. Attack journalism is one of the longest-standing press rituals of celebrification and a means by which industry exerts control and it is long overdue that we confront them head on. As a journalist, I deferred to codes of regulation every day and found many in regional and national newspapers did so too. But there was nothing in these that looked at attack journalism, and clarifications and extensions are needed to empower reporters to argue against the practice. Of course, what enforcers at IPSO and Ofcom do with code-breakers is crucial too and there are without doubt issues in terms of political and economic independence. But if we get codes right and better promote them to journalists through professional bodies, institutes of training, unions and legal and staff handbooks, we might create collective cultural change.

This should be a global change to regulation where possible, but I will begin by cleaning my own backyard. The key areas for British news media regarding the IPSO code is "harassment" and for Ofcom is "fairness". As the government have recently published a white paper relating to "Online Harms" (February 2020) that recommends Ofcom has additional powers to tackle social, commercial and criminal abuses which, for example, lead to trolling, change to the latter is pressing. There is little chance of stemming abuse on social media without also tackling the mainstream press, not least because celebrity news is freely shared on timelines and pages. At present, both IPSO and Ofcom address *persistent pursuit* as harassment or "unfair" newsgathering practices. Neither directly address abuse through *persistent publication*. To focus on IPSO first, suggested changes are in bold:

Independent Press Standards Organisation Editor's Code of Conduct

Point 3. Harassment

i) Journalists must not engage in intimidation, harassment or persistent pursuit **either when newsgathering or during publication**.

ii) They must not persist in questioning, telephoning, pursuing or photographing individuals once asked to desist; nor remain on property when asked to leave and must not follow them. If requested, they must identify themselves and whom they represent.

iii) Editors must ensure these principles are observed by those working for them and take care not to use non-compliant material from other sources.

iv) Editors must ensure that they do not engage in harassment through persistent publication –in text, image or audio-visual materials – based on or referring to sex or gender, class, race, religion, sexuality, nationality or disability, or through publication of falsehoods, rumour or conjecture.

Such moves would make the social malaise of attack journalism as celebrity news at its most vicious and vitriolic a digression rather than a norm. It would also be a tool by which issues of contempt, misidentification or misinformation about the proponents of crime and intrusion into grief, political and racially or gender orientated attacks could be punished.

For Ofcom, section 7's focus on "fairness" demands broadcasters avoid "unjust or unfair treatment of individuals or organisations in programmes".[3] But current examples do not discuss whether *targeted broadcast* against an individual might be "unjust or unfair". That is not to say that this practice would not be a breach of the code, but it does not clarify that it is. Suggested additions are as follows:

Section 7.2:

Fairness and harassment

Broadcasters must not engage in intimidation, harassment or persistent pursuit either when newsgathering or during broadcast.

Broadcasters must ensure these principles are observed by those working for them and take care not to use non-compliant material from other sources.

Editors must ensure that they do not engage in harassment through persistent broadcast – in text (online), image or audio-visual based materials – based on or referring to sex or gender, class, race, religion, disability, sexuality or nationality or through publication of falsehoods, rumour or conjecture.

Similar changes, clarifications and extensions across Western codes of journalism regulation and beyond would be a step towards minimising cultures of attack in our society. For example, the grounding principle of the American Society of Professional Journalists (SPJ) code of ethics states that journalists should be "honest, fair, and courageous in gathering, reporting and interpreting information" and the second point demands journalists "minimize harm" because "ethical journalism

treats sources, subjects, colleagues and members of the public as human beings deserving of respect". It is important to clarify such principles across *both pursuit and publication*. The Australian Press Council directly addresses "Privacy and avoidance of Harm". Principle five discusses intrusion into privacy and, six, the avoidance of "causing or contributing to substantial offence, distress or prejudice" unless "sufficiently in the public interest". These should clarify that persistent pursuit and persistent publication would equally breach the code.

The point of "public interest" brings us squarely to one of the most significant problems with newspapers and social media spheres in their consideration of celebrity. As all codes of practice usually have a "public interest" get-out clause for invasion of privacy or harassment, there needs to be more discussion of the constant conflation with what is simply interesting to members of the public. Regulatory codes define the public interest in substance, but this also needs to be clarified *in opposition* to examples that are not. In relation to celebrity journalism particularly, attack is powerful click bait. The "public interest" justification for breaches of the code often seems to be that it gets clicks and shares. Too often, amplifications of falsehood or rumour are justified by journalists because the information is already in the public domain. Even those who condemn social and news media highlight intrusive content to others and perpetuate the horrific spectacle of it all. At such times, journalists must consider how rumour, conjecture and speculation are also a form of harassment. My hope is that one of the legacies of this book will be the provision of a critical framework by which we might argue the importance of changes.

What's to be done in the spheres of celebrities, cultural intermediaries, journalists and audiences?

There is a risk this section could begin a game of "good" and "bad" celebrity. Such approaches are no less risky than binary pessimistic or optimistic approaches to reading popular and political cultures. Celebrity culture, as it emerged in newspapers, is a powerful tool for inclusion and exclusion, emancipation and repression, and for both perpetuating and challenging gender normativity and white privilege, even though, as this book evidences, the dominant representation of celebrity from origin to the current day is white and middle class. And there are models for positive journalistic use of its power. For example, at the end of the 19th and beginning of the 20th century, George Newnes created press parasociality through the creation of public media spheres that included himself and his journalists, celebrities and the ordinary people who made audiences as part of social "clubs" offering models for social and educational advancement. In the late 20th and early 21st century, Oprah Winfrey did so too and is currently on the road for her "2020 Vision Tour" of America which focuses on equality, well-being and human rights through high-profile publicly performed celebrity interviews, broadcast live on social media. Of course, both of these were/are part of commercial (self) brand-building too and for some scholars act as props of capital and the commercialisation

of private self, their value to encourage cultural citizenship and meaningful participation is limited, if not irrelevant. But they also perpetuate(d) liberal social visions for inclusion and models for self-improvement through education and therefore aid civic participation. The spectacular radicalism and activism of celebrity journalists such as Thomas Paine (chapter 2) and W.T. Stead (chapter 3) were not perfect either. By contemporary standards, many of their actions in order to demand large-scale political and social reform might arguably be considered unethical and immoral. But as examples of the powers of celebrity and journalism to empower audiences, they offered far better models than, for example, the far-right xenophobia, antisemitism and war-mongering of Lord Northcliffe whose skewed vision still dominates British tabloid cultures, or the rampant free-market vision of America purported by *Fox News*. Once again, focusing on *the purpose* of journalism's use of celebrity and the capacity for good and bad is important in order to best channel its power towards meaningful citizen participation and social change.

As mass digital production enabled self-construction of public personas beyond representational mainstream media, there are those who have turned their visibilities to better means. For example, many celebrities, journalists and ordinary people link their visibility (online) to ethical consumerism and sustainability, issues of equality and social positivity. This should be encouraged, and celebrity management systems and journalistic platforms should consider ethical and sustainable brand-building strategies as well as commercial ones. Journalists – from junior reporters to senior editors – should reflect upon their ethical parameters, think about their use of celebrity and ask themselves, what is the purpose? Is there a reason to become involved in celebrity promotional practices when content is readily available elsewhere? When does rumour and conjecture stray towards attack and how can we step back at the height of the feeding frenzy? How might an article negatively influence readers' online behaviours? Thoughtful practice at individual and, through conversations with colleagues, collective levels matter in newsrooms.

There is of course a great deal of optimism here, and some might view my belief in the power of individuals and small collectives to make media as naivety. But there are many models for such practices in the pages of this book and I am not blind to the commercial or political realities and the power of 21st-century mass-capitalised corporate media systems and monopolies. As news-platforms compete for attention in fractured digital spaces via social media platforms, celebrity is primarily about the clicks. However, there were many instances since the invention of mass media when journalists have turned the power of celebrity – and vice versa – towards meaningful political changes *even when* also valuing its commercial opportunities. What we need are firmer parameters and thoughtful practices to tackle worst tendencies.

What is coming next and how might we be ready for it?

Two things look likely to lead the next transformations of journalism and celebrity cultures and their powerful places as cultural props and representations of politics

and the political aspects of this life. Both rely on effective balances of power and the temporal, continuous and shaky real time and space continuums of digital. The first is the opportunities and consequences of greater use of artificial intelligence in news and social media platforms, which are only at the beginnings of revolutionary shifts that will transform media and our perceptions of reality. The second is how human beings with visibility – celebrities, journalists, activists and often individuals who draw from or straddle all three – offer alternative models of persona construction which focus on the sustainability of our social and economic systems, the work needed to make them better and the well-being of those living within them.

What will be the impact of "deep fake" videos, which can make any celebrity say whatever the maker wants them to? How will artificial intelligence (AI) facilitate the production and targeted dissemination of political and commercial advertising and how might this construct the realities of our world? What will be the place of virtual hyperreal celeactors-as-influencers who promote politics, pop music and consumer goods – for example, the Chinese nationalist celeactor "A Zhong" (my brother) or Silicon Valley's "Lil Miquela", who is an animated pop star used as a promotional tool? How will they influence mass perception and/or citizen engagement? These things will become clear in the coming decade and countering AI's capacity to reimagine the cultures of celebrity and journalism and eclipse political and social realities will be important. AI now works *as a journalistic communicator* through automated-writing software that "confound traditional conceptions of communication theory and practice" (Broussard et al., 2019: 673). Transmethodogical and theoretical approaches for mapping the complex communication ecosystems of mass-persona, and its increasingly flexible boundaries with celebrity culture, offer pathways by which we might make sense of the field, shape critical thought and counter this trend.

In particular, there is a risk that the speed and volume of artificial intelligence will drown out the human voice altogether. As news editors plug the names of chosen celebrities into computer platforms that can generate stories through algorithms that aggregate web content and drop it into optimised inverted pyramid structures, content could overwhelm the representation of celebrities and journalists who try to turn the value of their visibility to better ends. As Nicholas Diakopoulous (in Broussard et al., 2019: 679) argues,

> All technologies, including and especially AI technologies, embed and encode human values, reflecting choices like what data were used to train the system, how that data was defined and sampled, how algorithms are parameterized and defaults chosen, what inputs a system pays attention to, and, indeed, even whether to quantify some aspects of the world while leaving other things out. AI systems are tools built by humans to serve human means and ends. They are profoundly political, exuding the values that designers and developers build into them.

Ultimately, then, it will still be humans who will direct how and why algorithms make celebrity news. The transdisciplinary focus of this book as it looked at people, productions and purposes offers a pathway to map the human-computer interactions of journalism and celebrity. We might consider how commercial or political pressures dictate the use of AI in the mainstream better than that of radicals who work outside of it, for example, through measuring content levels across periods of time as this book did for the 18th and 19th centuries. As Broussard et al. (2019: 678) argue, "journalism is a deeply human endeavour". Both in production and in representation, it was ever thus. AI's perpetuations of journalism and celebrity cultures will become the props of social and political control like all others before them and it will "be messy, just like life" (p. 678).

Whether they use AI or not, there will be humans with beating hearts who advocate and campaign for change. If we look to young celebrity and journalism radicals, there is much to celebrate. From Revolutionary Debaters and New Journalists to current celebrity-activists such as environmentalist Greta Thunberg and female rights advocate Malala Yousafzai, across history there are many journalists and celebrities whose actions changed our societies for the better. They demonstrate how journalism and celebrity can work better as part of politics and the political, our senses of self and the societies in which we live. As I scroll social media tonight (27 February 2020), I see a picture of Greta and Malala together on Instagram. Beneath it, Greta describes herself as a fan. I fangirl too, so I screen-grab and share on Twitter. There, Noam Chomsky writes for *Open Democracy* that, "capital is coordinated and globalized". Our struggles against injustice and oppression must be the same. I think about globalised and networked spheres of right-wing political commentators and activists and agree. I retweet. Piers Morgan claims moral high ground as compared to left-leaning actress Jameela Jamil in terms of cultures of attack. She writes a heartfelt post about her mental health and asks him to stop. GOAL! Man United's Frederico Rodrigues (aka Fred) has scored against Brugge in the Europa League. Boris Johnson declares he will walk away from Brexit talks in June and rumours fly that he will marry his girlfriend as his divorce is now finalised. The "former girlfriend of Lady Gaga's new boyfriend" is a journalist and writes for *The New York Times* that watching their relationship on celebrity gossip sites is just an extension of the "parade of people" on her phone. "We used to obsess about celebrities," she writes, "and then started obsessing about one another" (Crouse, *New York Times*, 20 February 2020). Journalist Toby Young launches a "Free Speech Union" to counter what he describes as "cancel culture" from the left who close down free speech to discredit individuals they work with and make them disappear from public life. Khloe Kardashian posts a picture of herself in front of a neon sign that reads "Good American". It is the latest in a long line of consumer self-branded products. Her child smiles for the camera and mine does too. Through social media, people they will never meet know them both. It never ends. It never sleeps. High and low, private and public, politics and the political, attack and counter-attack, persona construction and representation, self

and other, blurring together in a confused haze of everything and nothing. There are no binaries.

Notes

1 Rupert Murdoch, for example, described his appearance before the Media Select Committee as "the most humble day of my life" (Culture, Media and Sport Select Committee appearance, 19 July 2011).
2 See chapter 3.
3 Relevant legislation includes, in particular, sections 3(2)(f) and 326 of the Communications Act 2003 and sections 107(1) and 130 of the Broadcasting Act 1996 (as amended), Article 28 of the Audio-visual Media Services Directive, Article 10 of the European Convention on Human Rights, and the BBC Charter and Agreement.

References

Arnold, M. (1869) *Culture and Anarchy*. Oxford and New York: Oxford University Press. [2006 reprint].

Broussard, M., Diakopoulos, N., Guzman, A., Abebe, R., Dupagne, M. and Chuan, C. (2019) "Artificial Intelligence and Journalism". *Journalism & Mass Communication Quarterly*, 96(3): 673–695.

Bulleri, F. (2020) "Toby Young Announces Free Speech Union as an Antidote to Cancel Culture". *Reclaim the Net*, 25 February. Online.

Byron, J. (2015) "Politics as Scholarly Practice: Graeme Turner and the Art of Advocacy", *Cultural Studies*, 29(4): 569–589.

Chomsky, N. (2020) "Internationalism or Extinction: Capital Is Coordinated and Globalized. Our Struggles against Injustice and Oppression Must be the Same". *Open Democracy*, 27 February. Online.

Crouse, L. (2020) "My Ex-boyfriend's New Girlfriend Is Lady Gaga". *New York Times*, 27 February. Online.

Gitlin, T. (1997) "The Anti-Political Populism of Cultural Studies". *Dissent*, 44(2): 77–84.

Her Majesty's Government (2020) "Online Harm White Paper". Department for Digital, Culture, Media and Sport and Home Office, 12 February. Online.

Rojek, C. (2001) *Celebrity*. London: Reaktion.

Seaton, J. (2018) "Industrial Folklore and Press Reform", in J. Curran and J. Seaton (eds) *Power without Responsibility*. 8th edn. London: Routledge, pp. 461–483.

Turner, G. (2009) "Cultural Studies 101: Canonical, Mystificatory and Elitist?" *Cultural Studies Review*, 15(1): 175–187.

Usher, B. (2018a) "Rethinking Microcelebrity: Key Points in Practice, Performance and Purpose". *Celebrity Studies*: 1–18. Online.

Usher, B. (2018b) (ed.) *The State of the Media*. London: Byline Media.

INDEX